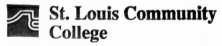

St. Louis Community College

Forest Park
Florissant Valley
Meramec

Instructional Resources
St. Louis, Missouri

New
Latin
American
Cinema

Contemporary Film and Television Series

*A complete listing of the books in this series
can be found at the back of this volume.*

New Latin American Cinema

Volume One

Theory, Practices and
Transcontinental Articulations

Edited by
MICHAEL T. MARTIN

 WAYNE STATE UNIVERSITY PRESS • DETROIT

Library of Congress Cataloging-in-Publication Data

New Latin American cinema / edited by Michael T. Martin.
 p. cm. — (Contemporary film and television series)
 Includes bibliographical references and index.
 Contents: v. 1. Theory, practices, and transcontinental articulations —
v. 2. Studies of national cinemas.
 ISBN 0–8143–2705–2 (alk. paper) ISBN 0–8143–2585–8 (pbk. : alk.
paper)—ISBN 0–8143–2706-0) (alk. paper) ISBN 0–8143–2586–6 (pbk. :
alk. paper)
 1. Motion pictures—Latin America—History. 2. Motion pictures—
Social aspects—Latin America. 3. Motion pictures—Political aspects—
Latin America. I. Martin, Michael T. II. Series.
 PN1993.5.L3N48 1997
 791.43'098—dc21

96–46741
CIP

For my mother

For the native, objectivity is always directed against him.
Frantz Fanon
Les damnés de la terre, 1961

Art frequently creates a comfortable, self-sufficient world removed from action.
Edmundo Desnoes
"The Photographic Image of Underdevelopment," 1967

We understand what cinema's social function should be in Cuba in these times:
It should contribute in the most effective way possible to elevating viewer's
revolutionary consciousness and to arming them for the ideological struggle which they
have to wage against all kinds of reactionary tendencies and it should also contribute to
their enjoyment of life.
Tomás Gutiérrez Alea
The Viewer's Dialectic, 1988

Contents

Preface

The essays, interviews, and programmatic statements collected here are devoted to the study of a theorized, dynamic, and unfinished Latin American cinematic movement. In challenging the "history of cinematic representation," the New Latin American Cinema movement is at once national and continental. Its practices reverberate throughout the First World as well as other regions of the Third World. Parented by the continent's colonial experience and forged by its continuing underdevelopment and dependency, the movement has inscribed itself in Latin Americans' struggles for national and continental autonomy.

This collection is deployed in two volumes. Volume 1 addresses the formation and continental development of the New Latin American Cinema, its theoretical foundations, thematic and aesthetic concerns, and transcontinental articulations. Contributions by pioneering filmmakers foreground the programmatic writings of the movement as they theorize the practice of an aesthetically and radically alternative cinema. Volume 2 surveys the development of the New Latin American Cinema as a national project. The contents of the volumes include significant but diffusely published essays along with several new and revised essays and interviews. While these writings are varied and extensive, they cannot pretend to exhaust all the perspectives on the subject under study. To the contrary, revisionist and other perspectives will no doubt emerge as the movement's first three decades become increasingly historicized and reassessed by film scholars and critics alike.

The volumes are intended to achieve two principal objectives. First, they serve as a basic reference tool for the study of Third World cinema in general and Latin American cinema in particular; and as primary reader/texts for faculty and students in film, cultural, and Third World studies courses. As such, readers can easily avail themselves of critical writings which first appeared in journals and monographs of limited circulation.

This collection's second objective is to map and account for the movement's diversity and innovativeness in order to explicate the socio-historical and cultural contexts of its development. In so doing, the editor hopes to invite larger debates about identity, nation, and devel-

opment in Latin America. Essays in the collection should arouse read-
ers to study the cinematographic (and increasingly video) corpus of
work of this movement, its traditions and place in world cinema.

—M.T.M.

Acknowledgments

This project has taken nearly three years to complete. For an anthology of readings this seems excessive. Identifying the numerous writings selected for the volumes, many only available in obscure film, cultural and ethnic studies periodicals and monographs, was instructive. Interminable telephone discussions punctuated by fax exchanges with authors and publishers both here in the United States and abroad rendered the experience of assembling this collection arduous at best. I have readily convinced myself that the next project I undertake will, most assuredly, not be an anthology.

However, during the development of this project I benefited, in no small measure, from the generosity and encouragement of individuals and organizations to whom I am indebted and grateful. They include my friends and comrades Lamont Yeakey, Howard Gadlin, Robert Shepard, and Leslie Damasceno; and colleagues Hamid Naficy and David Maciel. Michael Chanan, Dan Georgakas, Julianne Burton-Carvajal, Robert Stam, Randal Johnson, Paulo Antonio Paranaguá, John Hess, and Roma Gibson I thank for their generosity in granting me permission to reprint essays in this anthology.

To E. Hope Anderson and Kathryne V. Lindberg I am eternally grateful for their editorial assistance in the early drafts of the Amaral interview and the final draft of the introductory essay, respectively; to Louise Jefferson, for her translation of a section of an essay on Cuban cinema; to Timothy Barnard, for his translation and reworking of Octavio Getino's essay; and to Chuck Kleinhans and Robert Burgoyne, for their review of the prospectus and helpful suggestions for the redeployment of the contents of the anthology.

I also thank Arthur Evans, the director of the Wayne State University Press, who first suggested I had two volumes, given the scope and size of these readings. I am also indebted to my editor Kathy Wildfong, copyeditor Mary Gillis, and production manager Alice Nigoghosian of the Press for their patience and collaborative interventions during the production of these volumes.

For financial support to complete this project, I am grateful to Garrett Heberlein, Vice President for Research and Dean of the

Graduate School, and to the Office of Research and Sponsored Programs at Wayne State University.

The Unfinished Social Practice of the New Latin American Cinema: Introductory Notes

Michael T. Martin

Latin America's cinematic traditions are not of recent vintage; rather, they emerged during the first half of the twentieth century, beginning in the late 1890s, when European producers exhibited films to the local bourgeoisie in Rio, Montevideo, Buenos Aires, Mexico City, and Havana, and local film production was started in Venezuela, Argentina, Brazil, Uruguay, Cuba, and Mexico.[1] While European films served as the early models for Latin American filmmakers, and European followed by Hollywood companies dominated distribution, local production, arguably innovative and culturally distinct, alternately sparse and prolific, was established in Brazil, Argentina, Mexico, Cuba, and Venezuela, among other countries, during the first several decades of this century.[2]

Until the 1960s, however, European and North American film scholars and critics largely ignored the cinematic works of filmmakers from Latin America and other regions of the Third World, or, at best, condescendingly relegated Third World cinema to the margins of film history. During the 1970s, fiction and documentary films by Third World, particularly Latin American, filmmakers were recognized at international film festivals; and through art house exhibitions in the United States and Europe, their films received critical and popular audience acclaim. Concomitantly, North American and European, along with Latin American, film scholars have generated, in recent years, a substantial corpus of criticism and research on Latin American film practices. Monographs, anthologies, and articles in specialized film journals have put this important area of study on the cultural map.[3]

The essays, interviews and declaration/manifestoes collected here are devoted to the study of a loosely constituted, dynamic, and unfinished movement of "films of a new kind." Referred to as the "New Latin American Cinema," the movement's cultural productions and theoretical writings have increasingly and significantly contributed to film history and critical theory. Arising in Argentina, Brazil and Cuba in the late 1950s and 1960s, in response to the deepening underdevelopment and economic and cultural dependency of the continent, the movement has inscribed itself in Latin Americans' struggles for national and continental autonomy.

While of great theoretical and historical importance to the development and study of world cinema, especially to Third World cinema, the New Latin American Cinema is not a spontaneous, autonomous, unified, and monolithic project. As one observer has pointedly noted, its development as a cinematographic movement and oppositional social practice has been uneven temporally, formally (by cinematic mode/genre), and spatially between Latin America's cinematic traditions.[4] And while the proponents and pioneer filmmaker/theorists, of the New Latin American Cinema have shared aesthetic and thematic concerns, their representational strategies are as diverse as the population groups and hybrid cultures of Latin America. The differences that exist among these filmmakers are apparent in the cinematic representations of culture and identity, and arguably most evident in the films of Latin Americans who, in exile, live in the metropolises where "postcoloniality" displaces traditional community and cultural affiliations, and memory is attenuated and reconstituted.

This collection provides the setting and expanse for the consideration of the New Latin American Cinema as a national and continental project (including the diasporic/exilic experience), committed to a social practice that at once opposes capitalist and foreign domination and affirms national and popular expression. Further, these essays consider the movement's transcontinental articulations in the First World and in other regions of the Third World. The period under study begins with the formative years of the movement, the 1950s and 1960s, through developments of the 1980s; several of the essays account for developments in the 1990s. Together, the writings of filmmakers, theorists and scholars revisit the cinematic works and practices of this movement, critically explicate the socio-historical and cultural contexts of their production, and in doing so invite larger debates about cultural and national identity, and the processes of "development," underdevelopment and dependency in Latin America.

I

The collection is organized into two volumes: volume 1, *Theory, Practices, and Transcontinental Articulations;* and volume 2, *Studies of National Cinemas.* In part 1 of volume 1 the central question of a Latin ("Third World") American aesthetic is taken up in the major programmatic statements by Glauber Rocha, Julio García Espinosa, Jorge Sanjinés, and Fernando Solanas and Octavio Getino. By "aesthetic," I mean what Robert Stam has described as "the search for production methods and a style appropriate to the economic conditions and political circumstances of the Third World."[5] These declarations, along with other polemical writings by Fernando Birri and Tomás Gutiérrez Alea, delimit an "active cinema for an active spectator," and constitute the ideological and aesthetic foundations of the New Latin American Cinema movement.[6] These writings, notes Julianne Burton, were "written by film-makers whose theoretical propositions derive from the concrete practice of attempting to make specific films under specific historical conditions."[7]

Influenced by the Afro-Caribbean theorist, Frantz Fanon, Fernando Solanas and Octavio Getino, in "Towards a Third Cinema" (1969), call for a clandestine, subversive, "guerilla," and "unfinished," cinema that radically counteracts the hegemony of Hollywood and European capitalist production and distribution practices.[8] Solanas and Getino conceive of cinema, especially in the documentary mode, as an instrument for social analysis, political action, and social transformation.[9] In "An Esthetic of Hunger" (1965; "Estética de la violencia"), the Brazilian filmmaker, Glauber Rocha, inverts the social reality of underdevelopment and dependency—the "themes of hunger"—into a signifier of resistance and transformation where violence is the authentic and empowering expression of the oppressed; he inserts the filmmaker allied with the movement, *Cinema Novo,* in the continent's struggle against neocolonial domination.

Concerned with the development of a participatory and collective cinema, the Bolivian filmmaker, Jorge Sanjinés, in "Problems of Form and Content in Revolutionary Cinema" (1978), delineates a film practice in which the struggles of peasant communities are the thematics of a revolutionary cinema, and peasants are the protagonists in the cinematic recovery of their identity, culture and history. The fourth major polemic of the New Latin American Cinema, distinguished, in part, from the above statements by its post-revolutionary concerns, is "For an Imperfect Cinema" (1969), authored by the Cuban filmmaker Julio García Espinosa. Written ten years after the Cuban Revolution, Espinosa's essay rejects the technical perfection of Hollywood and

European cinema and calls for "an authentically revolutionary artistic culture" in which, drawing on popular art, filmmaker and (active) spectator are co-authors, and the problems and struggles of ordinary people are the raw material of an alternative and "imperfect" cinema.[10]

The issues addressed in the above declarations reverberate in "Cinema and Underdevelopment" (1962), and "For a Nationalist, Realist, Critical and Popular Cinema" (1984) by the Argentine documentarist and founder of the Documentary Film School of Santa Fe (Escuela Documental de Santa Fe), Fernando Birri. In "Some Notes on the Concept of a 'Third Cinema'" (1984), Octavio Getino provides important contextual information about the historical development of the "Cine Liberación" movement in Argentina, and in "Meditations on Imperfect Cinema . . . Fifteen Years Later" (1984), Espinosa clarifies and elaborates his premises for an imperfect cinema. And the recently deceased Cuban filmmaker Tomás Gutiérrez Alea, in "The Viewer's Dialectic" (1988), extends Espinosa's concerns about the relation of the cinema to the spectator and society in postrevolutionary Cuba to its mobilizing role in the ideological struggle against "reactionary tendencies" in socialist society, and, more importantly, to shaping the social process itself as a "guide for action" in which the spectator has an "active role."[11]

The writings in part 1 advance a conception of cinema as a transformational social practice, and, especially in the essays by Espinosa and Alea, as a conception in which the social processes that generate problems in society are revealed and indeterminate. Collectively, they feature a "notion of a cinema which incorporates in itself a discourse on its social and materials conditions of production,"[12] and in which the participants' principal task is to develop a "socially productive cinema" that, argues Alea, is "genuinely and integrally revolutionary, active, stimulating, mobilizing, and—consequently—popular."[13]

In assessing the early films and theoretical writings of the New Latin American Cinema, Ana M. López, resolves that they:

> signaled a naive belief in the camera's ability to record "truths" —to capture a national reality or essence without any mediation —as if a simple inversion of the dominant colonized culture were sufficient to negate that culture and institute a truly national one. Gradually, the kind of knowledge that the cinema was asked to invoke and produce acquired a different character. "Realism," no longer seen as tied to simple perceptual truth or to a mimetic approximation of the real, was increasingly used to refer to a self-conscious material practice. The cinema's powers of representation—its ability to reproduce the surface of the

lived world—were activated not as a record or duplication of that surface, but in order to explain it, to reveal its hidden aspects, to disclose the material matrix that determined it. This process was, furthermore, not an end in itself . . . but was articulated as part of a larger process of cultural, social, political, and economic renovation.[14]

In part 2 of this volume, four essays examine the development of the New Latin American Cinema as a national and continental movement. In a detailed analysis of the historical evolution of the New Latin American Cinema, Ana M. López is concerned with its dual development as a national and "pan-Latin American" cinematic movement. The movement's key practical concern to redefine the concepts of "nationality" and "nationhood" in cinema, and thereby create an alternative (and oppositional) national cinema, is illuminated by López's contrast of the elitism and failed efforts of the *Nueva Ola* to transform Argentine cinema in the 1960s, to the popular and enduring initiatives of the Documentary Film School of Santa Fe (see also the Birri essays in part 1). Moreover, in her analysis of the national contexts in which the New Latin American Cinema has developed, and is differentially manifest in the 1980s, López challenges those filmmakers of the movement who have declared that it no longer has "a special utility or serve[s] a social function."

Rejecting the extremes of "self-refexivity" and "materiality" for an approach that emphasizes the relation (and determinancy) of "contextual" factors to the film text and its interpretation, Julianne Burton draws on Western critical traditions in order to examine the New Latin American Cinema's efforts to transform, under diverse social conditions, the modes of "filmic production" and reception/exhibition, during the first twenty-five years of the movement's development. She concludes that "Latin American filmmakers' attempts to create a revolutionary cinema took as their point of departure not simply the introduction of a new content or the transformation of cinematic forms, but the transformation of the subjective conditions of film production and film viewing."

The two essays that follow are by Michael Chanan. In the first essay, Chanan takes up the key problem of cultural imperialism under global capitalism in Latin America. Tracking the North American distributors' domination of the Latin American film market, he shows how they have historically impeded local production. And conversely, he examines the counter-hegemonic efforts of several Latin American states (Brazil and Cuba), in the contemporary period, to protect their national film industries from United States transnational corporations.

In the second essay, Chanan emphasizes like Burton, contextual factors—"cultural context" and "intentionality." He is concerned with the central position and paradigmatic role of the documentary form in the New Latin American Cinema. In the context of postrevolutionary Cuba, he examines two categories of documentary—*cine didáctico* and *cine testimonio*—in a typology that conveys "the preoccupations and objectives of the New Latin American Cinema movement," and he concludes by noting that what distinguishes oppositional from Hollywood studio and European commercial cinemas is its redeployment and positioning of the spectator and filmmaker in the social process.

Part 3 of volume 1 is devoted to the articulations of the New Latin American Cinema in the First World and in other regions of the Third World, of which Latin America is a part, and to its theoretical elaboration and cultural specificity among oppositional cinemas. However Third World cinema is distinguished by national, gender, linguistic, racial and ethnic categories, among others, it shares three fundamental and dislocating factors: (1) the dual impact of the colonial and neocolonial (underdevelopment/dependency) historical and contemporary processes; (2) the enduring presence and defining influence of Western culture; and (3) the determinancy of capitalist production and distribution practices.[15]

In a recent study, Ella Shohat and Robert Stam offer four tentative criteria of Third World cinema:

> 1. A core circle of "Third Worldist" films produced by and for Third World people (no matter where those people happen to be) and adhering to the principles of "Third Cinema";
> 2. a wider circle of the cinematic productions of Third World peoples . . . , whether or not the films adhere to the principles of Third Cinema and irrespective of the period of their making;
> 3. another circle consisting of films made by First or Second World people in support of Third World peoples and adhering to the principles of Third Cinema;
> 4. a final circle, somewhat anomalous in status, at once "inside" and "outside," comprising recent diasporic hybrid films . . . , which both build on and interrogate the conventions of "Third Cinema."[16]

Three of the four categories (1, 3 and 4) predicate Third World cinema as political and historical categories, while in one (2), the geographical site of film production is the identifying characteristic. In defining Third World cinema as a political and transcontinental project, Clyde Taylor asserts that:

Films become Third World, in short, by their function, once made, "by their usefulness for the people," as Fidel Castro said, "by what they contribute to man [and women], by what they contribute to the liberation and happiness of man [and women]."

Yet even though the Third World is a mental state for which no one holds an official passpost, it would be wrong to emphasize Third World cinema's local and national preoccupations at the expense of its resolute internationalism. The making of *0 Povo Organizado* in Mozambique by Bob Van Lierop, an African American, or of *Sambizanga* (1972), about Angola, by Guadaloupian Sara Maldoror, or the Ethiopian Haile Gerima's *Bush Mama* (1975), set in Los Angeles, or Gillo Pontecorvo's *The Battle of Algiers* (1965), or the several Latin American and African films created by Cubans, or the many Third World films made by Europeans and white Americans—all suggest the cross-fertilization of an embryonic transnational Third World cinema movement.[17]

Paul Willemen's essay elaborates the "Third Cinema," concept described by Taylor, Shohat and Stam in the broader context of the debates about Left cultural theory in the 1980s. The essay, derived, in part, from the deliberations of a conference hosted by the Edinburgh International Film Festival in 1986, critically explicates the evolution of the concept of Third Cinema from the classic Latin American texts to its reformulation, as a "programme for the political practice of cinema," by Teshome Gabriel and others.[18] Willemen links the cultural theories of Bertolt Brecht and Walter Benjamin to the Latin American texts, and calls for the deployment of Bakhtinian concepts to elaborate Third Cinema's challenge to Euro-American critical theory, and contribution to the achievement of "socialist ideals."

Willemen's essay is followed by the "Resolutions of the Third World Film-Makers Meeting," a declaration made at an international conference of Third World filmmakers held in Algiers in 1973. This document remains seminal to the study and production of Third World cinema. Among the Latin American filmmakers at the conference were Fernando Birri, Humberto Rios, Santiago Alvarez, Jorge Silva, and Manuel Perez. The resolutions of the three committees formed at the conference catalog the major challenges to filmmakers in the production and distribution of Third World films, and they detail the role of and locate the filmmaker in the Third World's struggles against neocolonialism and imperialism. The Resolutions, perhaps overly ambitious, constitutes a tricontinental organizing effort during the 1970s to establish alternative and counter-hegemonic production/co-production and distribution venues for filmmakers in the Third World.

The final essay in part 3 is by Antonio Skármeta. In assessing the state of Chilean cinema in exile, Skármeta examines the supportive though problematic role of Europe in the production and exhibition of Latin American cinema. He asserts that in the aftermath of the 1973 coup against the Popular Unity Government of Salvador Allende, the Chilean filmmakers forced into exile became the motivating force in the development of Chilean cinema by gaining access "to a proper film industry" in Europe. Thus, Skármeta argues for the recognition of Europe as a site for the articulation of the New Latin American Cinema, and calls for the creation and deployment of "a distribution network of South American [and more generally Third World] cinema on a Pan-European level," in "permanent" sites of exhibition in defense of the cultures and democratic struggles they represent.

Part 4 concludes the volume with essays by B. Ruby Rich and Zuzana M. Pick. Though these essays overlap in their accounts of the formative development of the New Latin American Cinema, they address, from widely different approaches, the issues of the movement's adaptability, renovation, and identity addressed in Ana López's essay (see part 2). Rich argues for a revisionist history of the New Latin American Cinema in which spatial and temporal specificities are distinguished in the study of the movement. In discussing the evolution from "exteriority" in the 1960s, where political engagement/action against events is the central motif and *raison d'être* of the New Latin American Cinema, to "interiority" in the 1980s, where "private life . . . is assigned priority . . . [and] the emotions demand as much commitment, engagement, and action, as events did a few decades earlier," and identity, personal agency, and sexuality are foregrounded, Rich examines the films, representative of this shift, of Zuzana Amaral, Tizuka Yamaski, Maria Bemberg, Paul Leduc, Jorge Toledo, and ironically, Fernando Solanas. And Pick discusses the idea of a "continental identity," embodied in the New Latin American Cinema, as a challenge to and critique of the notions of "progress" and "development," and as a project of recovery and "self-definition" in the Latin American imaginary.

II

Whereas volume 1 focuses on the continental development of the New Latin American Cinema, volume 2 comprises a comparative approach to national cinema in Latin America. Any discussion of national cinema, however, must of necessity consider the ambiguous categories of "culture" and "identity," and the socio-historical factors that determine a national cinema's development.

Since the fifteenth century, in the ubiquitous, though uneven, development of capitalism as a global system in which international migration and settlement are a part, distinct multi-racial and multicultural formations have been forged, especially but not only in the Third World.[19] "Mixed" formations precede colonialism. In Latin America, though, they were reconfigured and racialized in the colonial process. However tentative and problematic the category, race is a defining, though historically contingent, feature in Latin America in that it is inscribed in a historical process as a social fact.

Mixed racial/cultural formations are most evident in megalopolises of the Third World, where population groups converge and cohabitate. A country like Brazil is exemplary; it is perhaps the most mixed and "hybrid" of nation-states in the world. Robert Stam and Ismail Xavier maintain, in their essay in part 2 of this volume, that "apart from the question of class, there are many 'Brazils'—urban and rural, male and female, indigenous, black, immigrant, and so forth. The view of the nation as a unitary subject has the effect of muffling the 'polyphony' of social and ethnic voices characteristic of a heteroglot culture."

The development of these "mixed" formations, where race, gender, ethnicity, and class intersect, pose complex questions about the premises upon which the concepts of "identity" and "culture" are based and understood.[20] Correspondingly, the concept of the "national" is increasingly unstable, especially given the processes of "globalization" and an inclusive and homogenizing international media environment. What constitutes a national identity and what are a nation's "extra-national" boundaries, and how they reshape national cultures, transform and create "new" identities are the subjects of renewed and critical study that challenge the normative assumptions on which these categories traditionally rest.[21] In this context, Zuzana Pick points out in her essay in volume 1, that "The experience of exile . . . has been crucial to the production of a new political agency whereby community associations are relocated, cultural specificity is renegotiated, and cultural affiliations are reconstructed. Geographic and cultural displacement has fostered decentered views on identity and nationality, stressed the dialectics of historical and personal circumstance, and validated autobiography as a reflective site."

However we interpret the above concepts, Paul Willemen contends, "The issue of national-cultural identity arises only in response to a challenge posed by the other, so that any discourse of national-cultural identity is always and from the outset oppositional, although not necessarily conducive to progressive positions" (see volume 1).

In counterpoint to the traditional discourses of identity, Shohat and Stam have theorized a dynamic model—"polycentric multicultural-

ism"—that conceives of "identity" as a multilayered and transnational concept.

> It thinks and imagines "from the margins," seeing minoritarian communities not as "interest groups" to be "added on" to a preexisting nucleus but rather as active, generative participants at the very core of a shared, conflictual history. . . . [It] rejects a unified, fixed, and essentialist concept of identities (or communities) as consolidated sets of practices, meanings, and experiences. Rather, it sees identities as multiple, unstable, historically situated, the products of ongoing differentiation and polymorphous identification. . . . [It] goes beyond narrow definitions of identity politics, opening the way for informed affiliation on the basis of shared social desires and identifications. . . . [It] is reciprocal, dialogical; it sees all acts of verbal or cultural exchange as taking place not between discrete bounded individuals or cultures but rather between permeable, changing individuals and communities.[22]

Useful, too, are the authors' formulation of nationality ". . . as partly discursive in nature, [that] must take class, gender, and sexuality into account, must allow for racial difference and cultural heterogeneity, and must be dynamic, seeing 'the nation' as an evolving, imaginary construct rather than an originary essence."[23] Their critical reworking of the concepts of identity and nationality, in contrast to racialist/nationalist discourses, is relevant to the study of the cultural-historical development of Latin America, and to the analysis of the thematics and representational strategies of the New Latin American Cinema. Their model also intersects and frames, within broader historical and cultural categories, the more recent writings in cultural criticism about black identities and diasporic culture(s).[24]

The relationship between cinema and nationhood is also a problematic and contested issue, especially among filmmakers in the Third World. What consitutes a "national cinema," in consideration of the continuing underdevelopment and dependency of the Third World and the international processes of globalization under "late" capitalism, is of ideological importance to the practices of Third World filmmakers in general, and to the New Latin American Cinema movement in particular. Ana López (see volume 1) elaborates this important aspect and objective of the movement:

> The New Latin American Cinema fits in with national cinema projects because the issue of how to define, construct, and popularize national cinemas has always been one of its primary con-

cerns. Although it has not always been discussed as such, the New Latin American Cinema posits the cinema as a response to and an activator of a different kind of nationhood or subject position of nationality than the one sponsored by dominant cultural forces. The goal has been to develop through the cinema (and other cultural practices) a different kind of national and hemispheric consciousness by systematically attempting to transform the function of the national cinema in society and the place of the spectator in the national cinema.

Roy Armes has distinguished two categories of national cinema: one that is commercial and financed by local capital that performs a largely entertainment function for local audiences, and the other that addresses "the demands of a national culture."[25] Paul Willemen, in a recent and critical review of Manthia Diawara's book on African cinema, claims that: "A 'national' cinema is a cinema that addresses—directly or indirectly, and regardless of who pays the bills—the specific sociohistorical configurations obtaining within nation states. This means that a national cinema must be able to engage with cultural and historical specificities."[26] And Andrew Higson distinguishes between two variants of national cinema:

> First, there is the possibility of defining national cinema in economic terms, establishing a conceptual correspondence between the terms "national cinema" and "the domestic film industry," and therefore being concerned with such questions as: where are these films made, and by whom? Who owns and controls the industrial infrastructures, the production companies, the distributors and the exhibition circuits? Second, there is the possibility of a text-based approach to national cinema. Here the key questions become: what are these films about? Do they share a common style or world view? To what extent are they engaged in "exploring, questioning and constructing a notion of nationhood in the films themselves and in the consciousness of the viewer"?[27]

Together, these analytical descriptions of "national cinema" imply that its defining characteristic is the cultural and historical specificities of the nation from which it emerges and develops. Moreover, Armes and Willemen concur that a national cinema can be partly constituted by a commercial sector, while all three authors seem to agree that a national cinema, to be national, must perform an important social (and transformational) function in society. In, arguably, its most revolution-

ary, transparent and popular form, a national cinema, to quote Roy Armes:

> . . . can be summarized in terms of the four general principles underlying the formation of the Salvadorean Film Institute: to respond to the interests of the working class and peasants by providing them with a cinematic instrument of expression; to produce films that will publicize the people's struggle; to contribute to raising the level of political awareness of both the masses and the peoples and governments of the world concerning the struggle; to combat disinformation and to contribute to the reordering of the international information network. Always, the aim is to forge new bonds between filmmakers and the people—the filmmakers then become one with the people, and the people become the true authors of their own national cinema.[28]

The essays, declarations, and interviews in this volume are differentiated and grouped by nation in the two regions under study—the Middle/Central America/Caribbean basin and South America. Because this approach encompasses the specificities of time and space, it facilitates the comparative study of the development of the New Latin American Cinema in the context of larger cultural and political processes within a national framework. This method of organization also invites comparisons between the movement's development in pre/revolutionary capitalist and postrevolutionary socialist nation-states in Latin America. In part 1, the national cinemas of Mexico and Cuba are studied, along with the emergent (national) cinemas of Nicaragua and El Salvador, followed by an essay on the film practices of Puerto Rican women video/filmmakers. Part 2 consists of essays on the national cinemas of Brazil, Chile, Argentina, and Bolivia, Peru, and Ecuador (the last three countries are grouped together and discussed in one essay).

As was noted earlier, and as the essays in this volume substantiate, cinematic traditions have not developed autonomously, spontaneously or evenly in Latin America (nor in other regions of the Third World). Similarly, the representation of national cinemas in the volume is uneven. Brazil, Argentina, Cuba, and Chile are given prominence because of their importance to the formation and development of the New Latin American Cinema. Mexican cinema, because of the state's near total control of film production, has tended to serve state policy rather than aesthetic programs. The essays extend my comments about the historical importance of "nationalism" in the development of the movement, the cultural and political effects of exile on the filmmaker,

how co-productions financed abroad influence filmmaking, and other current issues.[29]

I conclude with a quote from Julianne Burton who, in assessing the first twenty-five years of the movement, writes that: "the most compelling and significant aspect of the New Latin American Cinema movement, as it has evolved over the past quarter-century, has not been merely its ability to give expression to new forms and new contents, but above all its capacity to create alternative modes of production, consumption, and reception—ranging from the only apparently atavistic recourse, to artisanal modes, to the anticipation of more socialized industrial ones."[30]

Given the widening inequality and poverty in the continent, can we anticipate that Latin American filmmakers will return to or approximate the cine "denuncia," "testimonio," and "didáctico" models of political cinema prominent in the 1960s to oppose the persistence of underdevelopment and dependency in the post-Cold War 1990s?

Notes

1. See Roy Armes's critical study, *Third World Film Making and the West* (Berkeley: University of California Press, 1987), 163–173.

2. Along with Armes's study cited in note 1, see Allen L. Woll, *The Latin Image in American Film* (Los Angeles: UCLA Latin American Center Publications, 1977), 76–83; *Brazilian Cinema*, ed. Randal Johnson and Robert Stam (East Brunswick, NJ: Associated University Presses, 1982), 17–30; John King, *Magical Reels: A History of Cinema in Latin America* (New York: Verso, 1990), 7–64; and Jorge A. Schnitman, *Film Industries in Latin America* (Norwood, NJ: Ablex, 1984), 11–34, 49–54, 77–83, 91–95.

3. See the select bibliography of this volume for readings about Latin America's film practices and traditions.

4. See Armes, *Third World Film Making and the West*, 173–187.

5. Robert Stam, "Third World Cinema," *College Course Files*, monograph no. 5, ed. Patricia Erens (University Film and Video Association, n.d.).

6. These writings in translation are better known to and more widely circulated among readers. Many other essays and manifestoes by Latin Americans that are part of the New Latin American Cinema's corpus of critical writings are largely unpublished in English. Among them are: *Sobre Raymundo Gleyzer. Declaración del Comité de Cineastas* (Comité de Cineastas de América Latina); *Síntesis argumental de los films del Grupo Ukamau; Manifesto por um cinema popular* (Nelson Pereira dos Santos); *Cine e imaginación política* (Leon Hirszman); *Diez años de cine nacional* (Geraldo Sarno, Carlos Diegues, Arnaldo Jabor, Joaquim Pedro de Andrade); *Cine e imaginación poética* (Ruy Guerra); *El nuevo cine colombiano* (Ciro Duran, Mario Mitriotti, Carlos Alvarez, Jorge Silva, Luis Alfredo Sanchez, Marta Rodriguez); *Lo desmesurado, el espacio real del sueño americano* (Miguel Littín); *Una*

Cinemateca para el Tercer Mundo(Eduardo Terra); *Primer Conqreso Latinoamericano de Cineístas Independientes promovido por el Sodre a través de su departamento de Cine-Arte; Constitución del Comité de Cineastas de América Latina; Resolución de la Federación Panafricana de Cineastas y el Comité de Cineastas de América Latina*; and *Acto fundacional y estatutos de la Fundación del Nuevo Cine Latinoamericano*, among others. For a publication that includes the above writings and others in Spanish, see *Hojas D Cine: Testimonios y Documentos del Nuevo Cine Latinoamericano* (Mexico: Consejo Nacional de Recursos, Universidad Autonoma de Puebla, 1986).

7. Julianne Burton, "Marginal Cinemas and Mainstream Critical Theory," *Screen* 26, no. 3–4 (1985): 4.

8. Solanas and Getino distinguish between European commercial and European auteur cinemas. The latter, "art cinema," is viewed by the authors as preferable to the Hollywood and European film industries, but it, too, is determined by commercial interests.

9. See Peter Rist's essay, "The Documentary Impulse and Third Cinema Theory in Latin America: An Introduction," *CineAction*, no. 18 (1989): 60–61.

10. For a discussion of this important essay, see Armes, *Third World Film Making and the West*, 97–99.

11. See Julia Lesage's Prologue to Tomás Gutiérrez Alea's *The Viewer's Dialectic* (Havana: José Martí Publishing House, 1988), 11–16.

12. Rist, "The Documentary Impulse," 61.

13. Alea, *The Viewer's Dialectic*, 18.

14. Ana M. López, "At the Limits of Documentary: Hypertextual Transformation and the New Latin American Cinema," *The Social Documentary in Latin America*, ed. Julianne Burton (Pittsburgh: University of Pittsburgh Press, 1990), 407–408.

15. For a detailed explanation of these factors, see Armes, *Third World Film Making and the West*, 9–49.

16. Ella Shohat and Robert Stam, *Unthinking Eurocentrism: Multiculturalism and the Media* (New York: Routledge, 1994), 28.

17. Clyde Taylor, "Third World Cinema: One Struggle, Many Forms," *Jump Cut: Hollywood, Politics and Counter Cinema*, ed. Peter Steven (New York: Praeger, 1985), 332–333.

18. For example, see Willemen's and Gabriel's essays in *Questions of Third Cinema*, ed. Jim Pines and Paul Willemen (London: BFI, 1989).

19. Mixed formations are also manifest in First World states, where Third World people are defined as "minorities" though they may be among the numerical "majorities" in the Third World. For example, the racial and ethnic formations that have evolved in Europe were forged largely by Third World immigrants who have historically served as a source of cheap labor in European metropolises in the post World War II period.

20. Group identities—racial, ethnic, or religious—are rendered most fluid and tentative in metropolitan sites and in the urbanized areas of the Third

World, especially among elite and intellectual strata, where traditional culture and group associations are most problematic.

21. On the question of what constitutes a national identity, see the recent work of Gregory Jusdanis, "Beyond National Culture?," *boundary 2* 22, no. 1 (1995): 23–60.

22. Shohat and Stam, *Unthinking Eurocentrism*, 48–49.

23. Ibid., 286.

24. See, for example, Stuart Hall, "What Is This 'Black' in Black Popular Culture?," *Social Justice* 20, nos. 1–2 (1993): 104–114; and Paul Gilroy, *The Black Atlantic: Modernity and Double Consciousness* (Cambridge: Harvard University Press, 1993).

25. See Armes, *Third World Film Making and the West*, 65–72.

26. Paul Willemen, "The Making of an African Cinema," *Transition*, no. 58 (1992): 146.

27. Andrew Higson, "The Concept of National Cinema," *Screen* 30, no. 4 (1989): 36.

28. Armes, *Third World Film Making and the West*, 187.

29. Published research on exile includes: Zuzana M. Pick, *The New Latin American Cinema: A Continental Project* (Austin: University of Texas, 1993), 157–161; Kathleen Newman, "National Cinema after Globalization: Fernando Solanas's *Sur* and the Exiled Nation," in *Mediating Two Worlds*, ed. John King, Ana M. López, and Manuel Alvarado (London: BFI, 1993), 242–257; Abid Med Hondo, "The Cinema of Exile," in *Film & Politics in the Third World*, ed. John D. H. Downing (New York: Autonomedia, 1987), 70–76.

30. This quote is taken from the abstract of Burton's essay in volume 1, n.p.

Part I
Theorizing Political/
Aesthetic
Trajectories

Towards a Third Cinema

Notes and Experiences for the Development of a Cinema of Liberation in the Third World

Fernando Solanas and Octavio Getino

. . . we must discuss, we must invent . . .

Frantz Fanon

Just a short time ago it would have seemed like a Quixotic adventure in the colonized, neocolonized, or even the imperialist nations themselves to make any attempt to create *films of decolonization* that turned their back on or actively opposed the System. Until recently, film had been synonymous with spectacle or entertainment: in a word, it was one more *consumer good*. At best, films succeeded in bearing witness to the decay of bourgeois values and testifying to social injustice. As a rule, films only dealt with effect, never with cause; it was cinema of mystification or anti-historicism. It was *surplus value* cinema. Caught up in these conditions, films, the most valuable tool of communication of our times, were destined to satisfy only the ideological and economic interests of the *owners of the film industry*, the lords of the world film market, the great majority of whom were from the United States.

Was it possible to overcome this situation? How could the problem of turning out liberating films be approached when costs came to

Michael Chanan, ed., *Twenty-Five Years of New Latin American Cinema*. London: British Film Institute, 1983, pp. 17–27. First published in *Tricontinental* (Havana, Cuba). By permission of the editor, Michael Chanan.

several thousand dollars and the distribution and exhibition channels were in the hands of the enemy? How could the continuity of work be guaranteed? How could the public be reached? How could System-imposed repression and censorship be vanquished? These questions, which could be multiplied in all directions, led and still lead many people to skepticism or rationalization: "revolutionary cinema cannot exist before the revolution"; "revolutionary films have been possible only in the liberated countries"; "without the support of revolutionary political power, revolutionary cinema or art is impossible." The mis-take was due to taking the same approach to reality and films as did the bourgeoisie. The models of production, distribution, and exhibition continued to be *those of Hollywood* precisely because, in ideology and politics, films had not yet become the vehicle for a clearly drawn dif-ferentiation between bourgeois ideology and politics. A reformist poli-cy, as manifested in dialogue with the adversary, in coexistence, and in the relegation of national contradictions to those between two sup-posedly unique blocs—the U.S.S.R. and the U.S.A.—was and is un-able to produce anything but a cinema within the System itself. At best, it can be the *"progressive" wing of Establishment cinema.* When all is said and done, such cinema was doomed to wait until the world conflict was resolved peacefully in favor of socialism in order to change qualitatively. The most daring attempts of those filmmakers who strove to conquer the fortress of official cinema ended, as Jean-Luc Godard eloquently put it, with the filmmakers themselves "trapped inside the fortress."

But the questions that were recently raised appeared promising; they arose from a new historical situation to which the filmmaker, as is often the case with the educated strata of our countries, was rather a late-comer: ten years of the Cuban Revolution, the Vietnamese strug-gle, and the development of a worldwide liberation movement whose moving force is to be found in the Third World countries. *The exist-ence of masses on the worldwide revolutionary plane was the substan-tial fact without which those questions could not have been posed.* A new historical situation and a new man born in the process of the anti-imperialist struggle demanded a new, revolutionary attitude from the filmmakers of the world. The question of whether or not militant cin-ema *was possible* before the revolution began to be replaced, at least within small groups, by the question of *whether or not such a cinema was necessary to contribute to the possibility of revolution.* An affirm-ative answer was the starting point for the first attempts to channel the process of seeking possibilities in numerous countries. Examples are Newsreel, a U.S. New Left film group, the *cinegiornali* of the Italian student movement, the films made by the *Etats Généraux du Cinéma*

Français, and those of the British and Japanese student movements, all a continuation and deepening of the work of a Joris Ivens or a Chris Marker. Let it suffice to observe the films of a Santiago Alvarez in Cuba, or the cinema being developed by different filmmakers in 'the homeland of all," as Bolivar would say, as they seek a revolutionary Latin American cinema.

A profound debate on the role of intellectuals and artists before liberation is today enriching the perspectives of intellectual work all over the world. However, this debate oscillates between two poles: one which proposes to *relegate* all intellectual work capacity to a *specifically* political or political-military function, denying perspectives to all artistic activity with the idea that such activity must ineluctably be absorbed by the System, and the other which maintains an inner duality of the intellectual: on the one hand, the "work of art," "the privilege of beauty," an art and a beauty which are not necessarily bound to the needs of the revolutionary political process, and, on the other, a political commitment which generally consists in signing certain anti-imperialist manifestos. In practice, this point of view means the *separation of politics and art*.

This polarity rests, as we see it, on two omissions: first, the conception of culture, science, art, and cinema as univocal and universal terms, and, second, an insufficiently clear idea of the fact that the revolution does not begin with the taking of political power from imperialism and the bourgeoisie, but rather begins at the moment when the masses sense the need for change and their intellectual vanguards begin to study and carry out this change *through activities on different fronts*.

Culture, art, science, and cinema always respond to conflicting class interests. In the neocolonial situation two concepts of culture, art, science, and cinema compete: *that of the rulers and that of the nation*. And this situation will continue, as long as the national concept is not identified with that of the rulers, as long as the status of colony or semi-colony continues in force. Moreover, the duality will be overcome and will reach a single and universal category only when the best values of man emerge from proscription to achieve hegemony, when the liberation of man is universal. In the meantime, there exist *our* culture and *their* culture, *our* cinema and *their* cinema. Because our culture is an impulse towards emancipation, it will remain in existence until emancipation is a reality: *a culture of subversion* which will carry with it an art, a science, and *a cinema of subversion*.

The lack of awareness in regard to these dualities generally leads the intellectual to deal with artistic and scientific expressions as they were "universally conceived" by the classes that rule the world, at

best introducing some correction into these expressions. We have not gone deeply enough into developing a revolutionary theatre, architecture, medicine, psychology, and cinema; into developing a culture *by and for us.* The intellectual takes each of these forms of expression as a unit to be corrected *from within the expression itself, and not from without, with its own new methods and models.*

An astronaut or a Ranger mobilizes all the scientific resources of imperialism. Psychologists, doctors, politicians, sociologists, mathematicians, and even artists are thrown into the study of everything that serves, *from the vantage point of different specialities*, the preparation of an orbital flight or the massacre of Vietnamese; in the long run, all of these specialities are equally employed to satisfy the needs of imperialism. In Buenos Aires the army eradicates *villas miseria* (urban shanty towns) and in their place puts up "strategic hamlets" with town planning aimed at facilitating military intervention when the time comes. The revolutionary organizations lack specialized fronts not only in *their* medicine, engineering, psychology, and art—but also in *our own revolutionary* engineering, psychology, art, and cinema. In order to be effective, all these fields must recognize the *priorities* of each stage: those required by the struggle for power or those demanded by the already victorious revolution. Examples: creating a political sensitivity to the need to undertake a political-military struggle in order to take power: developing a medicine to serve the needs of combat in rural or urban zones; co-ordinating energies to achieve a 10 million ton sugar harvest as they attempted in Cuba; or elaborating an architecture, a city planning, that will be able to withstand the massive air raids that imperialism can launch at any time. The specific strengthening of each speciality and field subordinate to collective priorities can fill the empty spaces caused by the struggle for liberation and can delineate with greatest efficacy the role of the intellectual in our time. It is evident that revolutionary mass-level culture and awareness can only be achieved after the taking of political power, but it is no less true that the use of scientific and artistic means, together with political-military means, prepares the terrain for the revolution to become reality and facilitates the solution of the problems that will arise with the taking of power.

The intellectual must find through his action the field in which he can rationally perform the most efficient work. Once the front has been determined, his next task is to find out *within that front* exactly what is the enemy's stronghold and where and how he must deploy his forces. It is in this harsh and dramatic daily search that a culture of the revolution will be able to emerge, the basis which will nurture, *beginning right now*, the *new man* exemplified by Che—not man in

the abstract, not the "liberation of man," *but another man*, capable of arising from the ashes of the old, alienated man that we are and which the new man will destroy—by starting to stoke the fire *today*.

The anti-imperialist struggle of the peoples of the Third World and of their equivalents inside the imperialist countries constitutes today the axis of the world revolution. *Third cinema* is, in our opinion, the cinema that *recognises in that struggle the most gigantic cultural, scientific, and artistic manifestation of our time*, the great possibility of constructing a liberated personality with each people as the starting point—in a word, the *decolonization of culture*.

The culture, including the cinema, of a neocolonialized country is just the expression of an overall dependence that generates models and values born from the needs of imperialist expansion.

> In order to impose itself, neocolonialism needs to convince the people of a dependent country of their own inferiority. Sooner or later, the inferior man recognizes Man with a capital M; this recognition means the destruction of his defenses. If you want to be a man, says the oppressor, you have to be like me, speak my language, deny your own being, transform yourself into me. As early as the 17th century the Jesuit missionaries proclaimed the aptitude of the [South American] native for copying European works of art. Copyist, translator, interpreter, at best a spectator, the neocolonialized intellectual will always be encouraged to refuse to assume his creative possibilities. Inhibitions, uprootedness, escapism, cultural cosmopolitanism, artistic imitation, metaphysical exhaustion, betrayal of country—all find fertile soil in which to grow.[1]

Culture becomes bilingual.

> . . . not due to the use of two languages but because of the conjuncture of two cultural patterns of thinking. One is national, that of the people, and the other is estranging, that of the classes subordinated to outside forces. The admiration that the upper classes express for the U.S. or Europe is the highest expression of their subjection. With the colonialization of the upper classes the culture of imperialism indirectly introduces among the masses knowledge which cannot be supervised.[2]

Just as they are not masters of the land upon which they walk, the neocolonialized people are not masters of the ideas that envelop them. A knowledge of national reality presupposes going into the web of lies and confusion that arise from dependence. The intellectual is

obliged to *refrain from spontaneous thought*; if he does think, he generally runs the risk of doing so in French or English—never in the language of a culture of his own which, like the process of national and social liberation, is still hazy and incipient. Every piece of data, every concept that floats around us, is part of a framework of mirages that is difficult to take apart.

The native bourgeoisie of the port cities such as Buenos Aires, and their respective intellectual elites, constituted, from the very origins of our history, the transmission belt of neocolonial penetration. Behind such watchwords as "Civilization or barbarism," manufactured in Argentina by Europeanizing liberalism, was the attempt to impose a civilization fully in keeping with the needs of imperialist expansion and the desire to destroy the resistance of the national masses, which were successively called the "rabble," a "bunch of blacks," and "zoological detritus" in our country and "the unwashed hordes" in Bolivia. In this way the ideologists of the semicountries, past masters in "the play of big words, with an implacable, detailed, and rustic universalism,"[3] served as spokesmen of those followers of Disraeli who intelligently proclaimed: "I prefer the rights of the English to the rights of man."

The middle sectors were and are the best recipients of cultural neocolonialism. Their ambivalent class condition, their buffer position between social polarities, and their broader possibilities of access to *civilization* offer imperialism a base of social support which has attained considerable importance in some Latin American countries.

If in an openly colonial situation cultural penetration is the complement of a foreign army of occupation, during certain stages this penetration assumes major priority.

> It serves to institutionalize and give a normal appearance to dependence. The main objective of this cultural deformation is to keep the people from realizing their neocolonialized position and aspiring to change it. In this way educational colonization is an effective substitute for the colonial police.[4]

Mass communications tend to complete the destruction of a national awareness and of a collective subjectivity on the way to enlightenment, a destruction which begins as soon as the child has access to these media, the education and culture of the ruling classes. In Argentina, 26 television channels; one million television sets; more than 50 radio stations; hundreds of newspapers, periodicals, and magazines; and thousands of records, films, etc., join their acculturating role of the colonization of taste and consciousness to the process of neocolonial education which begins in the university. "Mass communica-

tions are more effective for neocolonialism than napalm. What is real, true, and rational is to be found on the margin of the law, just as are the people. Violence, crime, and destruction come to be Peace, Order, and Normality."[5] *Truth, then, amounts to subversion.* Any form of expression or communication that tries to show national reality is *subversion.*

Cultural penetration, educational colonization, and mass communications all join forces today in a desperate attempt to absorb, neutralize, or eliminate expression that responds to an attempt at decolonization. Neocolonialism makes a serious attempt to castrate, to digest, the cultural forms that arise beyond the bounds of its own aims. Attempts are made to remove from them precisely what makes them effective and dangerous; in short, it tries to depoliticize them. Or, to put it another way, to separate the cultural manifestation from the fight for national independence.

Ideas such as "Beauty in itself is revolutionary" and "All new cinema is revolutionary" are idealistic aspirations that do not touch the neocolonial condition, since they continue to conceive of cinema, art, and beauty as universal abstractions and not as an integral part of the national processes of decolonization.

Any attempt, no matter how virulent, which does not serve to mobilize, agitate, and politicize sectors of the people, to arm them rationally and perceptibly, in one way or another, for the struggle—is received with indifference or even with pleasure. Virulence, nonconformism, plain rebelliousness, and discontent are just so many more products on the capitalist market; they are *consumer goods.* This is especially true in a situation where *the bourgeoisie is in need of a daily dose of shock and exciting elements of controlled violence*[6]—that is, violence which absorption by the System turns into pure stridency. Examples are the works of a socialist-tinged painting and sculpture which are greedily sought after by the new bourgeoisie to decorate their apartments and mansions; plays full of anger and avant-gardism which are noisily applauded by the ruling classes; the literature of "progressive" writers concerned with semantics and man on the margin of time and space, which gives an air of democratic broadmindedness to the System's publishing houses and magazines; and the cinema of "challenge," of "argument," promoted by the distribution monopolies and launched by the big commercial outlets.

> In reality the area of permitted protest of the System is much greater than the System is willing to admit. This gives the artists the illusion that they are acting "against the system" by going beyond certain narrow limits; they do not realize that even anti-

System art can be absorbed and utilized by the System, as both a brake and a necessary self-correction.[7]

Lacking an awareness of how to *utilize what is ours for our true liberation*—in a word, lacking *politicization*—all of these "progressive" alternatives come to form the leftist wing of the System, the improvement of its cultural products. They will be doomed to carry out the best work on the left that the right is able to accept today and will thus only serve the survival of the latter. "Restore words, dramatic actions, and images to the places where they can carry out a revolutionary role, where they will be useful, where they will become weapons in the struggle."[8] Insert the work as an original fact in the process of liberation, place it first at the service of life itself, ahead of art; *dissolve aesthetics in the life of society*: only in this way, as Fanon said, can decolonization become possible and culture, cinema, and beauty—at least, what is of greatest importance to us—become *our culture, our films, and our sense of beauty.*

The historical perspectives of Latin America and of the majority of the countries under imperialist domination are headed not towards a lessening of repression but towards an increase. We are heading not for bourgeois-democratic regimes but for dictatorial forms of government. The struggles for democratic freedoms, instead of seizing concessions from the System, move it to cut down on them, given its narrow margin for maneuvering.

The bourgeois-democratic facade caved in some time ago. The cycle opened during the last century in Latin America with the first attempts at self-affirmation of a national bourgeoisie differentiated from the metropolis (examples are Rosas' federalism in Argentina, the Lopez and Francia regimes in Paraguay, and those of Bengido and Balmaceda in Chile) with a tradition that has continued well into our century: national-bourgeois, national-popular, and democratic-bourgeois attempts were made by Cardenas, Yrigoyen, Haya de la Torre, Vargas, Aguirre Cerda, Perón, and Arbenz. But as far as revolutionary prospects are concerned, the cycle has definitely been completed. The lines allowing for the deepening of the historical attempt of each of those experiences today pass through the sectors that understand the continent's situation as one of war and that are preparing, under the force of circumstances, to make that region the Vietnam of the coming decade. A war in which national liberation can only succeed when it is simultaneously postulated as social liberation—socialism as the only valid perspective of any national liberation process.

At this time in Latin America there is room for neither passivity nor innocence. The intellectual's commitment is measured in terms of risks as well as words and ideas; what he does to further the cause of liberation is what counts. The worker who goes on strike and thus risks losing his job or even his life, the student who jeopardizes his career, the militant who keeps silent under torture: each by his or her action commits us to something much more important than a vague gesture of solidarity.[9]

In a situation in which the "state of law" is replaced by the "state of facts," the intellectual, who is *one more worker*, functioning on a cultural front, must become increasingly radicalized to avoid denial of self and to carry out what is expected of him in our times. The impotence of all reformist concepts has already been exposed sufficiently, not only in politics but also in culture and films—and especially in the latter, *whose history is that of imperialist domination—mainly Yankee.*

While, during the early history (or the prehistory) of the cinema, it was possible to speak of a German, an Italian, or a Swedish cinema clearly differentiated and corresponding to specific national characteristics, today such differences have disappeared. The borders were wiped out along with the expansion of U.S. imperialism and the film model that is imposed: *Hollywood movies.* In our times it is hard to find a film within the field of commercial cinema, including what is known as "author's cinema," in both the capitalist and socialist countries, that manages to avoid the models of Hollywood pictures. The latter have such a fast hold that monumental works such as Bondarchuk's *War and Peace* from the U.S.S.R. are also monumental examples of the submission to all propositions imposed by the U.S. movie industry (structure, language, etc.) and, consequently, to its concepts.

The placing of the cinema within U.S. models, even in the formal aspect, in language, leads to the adoption of the ideological forms that *gave rise to precisely that language and no other.* Even the appropriation of models which appear to be only technical, industrial, scientific, etc., leads to a conceptual dependency, due to the fact that the cinema is an industry, but differs from other industries in that it has been created and organized in order *to generate certain ideologies.* The 35mm camera, 24 frames per second, arc lights, and a commercial place of exhibition for audiences were conceived not to gratuitously transmit any ideology, but to satisfy, in the first place, the cultural and surplus value needs *of a specific ideology, of a specific world-view: that of U.S. finance capital.*

The mechanistic takeover of a cinema conceived as a show to be exhibited in large theatres with a standard duration, hermetic struc-

tures that are born and die on the screen, satisfies, to be sure, the commercial interests of the production groups, but it also leads to the *absorption of forms of the bourgeois world-view* which are the continuation of 19th century art, of bourgeois art: man is accepted only as a passive and consuming object; *rather than having his ability to make history recognized, he is only permitted to read history, contemplate it, listen to it, and undergo it. The cinema as a spectacle aimed at a digesting object is the highest point that can be reached by bourgeois filmmaking.* The world, experience, and the historic process are enclosed within the frame of a painting, the stage of a theater, and the movie screen; man is viewed as a *consumer of ideology*, and not as the creator of ideology. This notion is the starting point for the wonderful interplay of bourgeois philosophy and the obtaining of surplus value. The result is a cinema studied by motivational analysts, sociologists and psychologists, by the endless researchers of the dreams and frustrations of the masses, all aimed at selling *movie-life*, reality as it is conceived by the ruling classes.

The first alternative to this type of cinema, which we could call the *first cinema*, arose with the so- called "author's cinema," "expression cinema," *"nouvelle vague," "cinema novo,"* or, conventionally, the *second cinema*. This alternative signified a step forward inasmuch as it demanded that the filmmaker be free to express himself in nonstandard language and inasmuch as it was an attempt at cultural decolonization. But such attempts have already reached, or are about to reach, the outer limits of what the system permits. The *second cinema filmmaker* has remained "trapped inside the fortress" as Godard put it, or is on his way to becoming trapped. The search for a market of 200,000 moviegoers in Argentina, a figure that is supposed to cover the costs of an independent local production, the proposal of developing a mechanism of industrial production parallel to that of the System but which would be distributed by the System according to its own norms, the struggle to better the laws protecting the cinema and replacing "bad officials" by "less bad," etc., is a search lacking in viable prospects, unless you consider viable the prospect of becoming institutionalized as "the youthful, angry wing of society"—that is, of neocolonialized or capitalist society.

Real alternatives differing from those offered by the System are only possible if one of two requirements is fulfilled: *making films that the System cannot assimilate and which are foreign to its needs, or making films that directly and explicitly set out to fight the System.* Neither of these requirements fits within the alternatives that are still offered by the *second cinema*, but they can be found in the revolution-

ary opening towards a cinema outside and against the System, in a cinema of liberation: the *third cinema.*

One of the most effective jobs done by neocolonialism is its cutting off of intellectual sectors, especially artists, from national reality by lining them up behind "universal art and models." It has been very common for intellectuals and artists to be found at the tail end of popular struggle, when they have not actually taken up positions against it. The social layers which have made the greatest contribution to the building of a national culture (understood as an impulse towards decolonization) have not been precisely the enlightened elites but rather the most exploited and uncivilized sectors. Popular organizations have very rightly distrusted the "intellectual" and the "artist." When they have not been openly used by the bourgeoisie or imperialism, they have certainly been their indirect tools; most of them did not go beyond spouting a policy in favor of "peace and democracy," fearful of anything that had a national ring to it, afraid of contaminating art with politics and the artists with the revolutionary militant. They thus tended to obscure the inner causes determining neocolonialized society and placed in the foreground the outer causes, which, while "they are the condition for change, can never be the basis for change":[10] in Argentina they replaced the struggle against imperialism and the native oligarchy with the struggle of democracy against fascism, suppressing the fundamental contradiction of a neocolonialized country and replacing it with "a contradiction that was a copy of the worldwide contradiction."[11]

This cutting off of the intellectual and artistic sectors from the processes of national liberation—which, among other things, helps us to understand the limitations in which these processes have been unfolding—today tends to disappear to the extent that artists and intellectuals are beginning to discover the impossibility of destroying the enemy without first joining in a battle for their common interests. The artist is beginning to feel the insufficiency of his nonconformism and individual rebellion. And the revolutionary organizations, in turn, are discovering the vacuums that the struggle for power creates in the cultural sphere. The problems of filmmaking, the ideological limitations of a filmmaker in a neocolonialized country, etc., have thus far constituted objective factors in the lack of attention paid to the cinema by the people's organizations. Newspapers and other printed matter, posters and wall propaganda, speeches and other verbal forms of information, enlightenment, and politicization are still the main means of communication between the organizations and the vanguard layers of the masses. But the new political positions of some filmmakers and the subsequent appearance of films useful for liberation have permit-

ted certain political vanguards to discover the importance of movies. This importance is to be found in the specific meaning of films as a form of communication and because of *their particular characteristics*, characteristics that allow them to draw audiences of different origins, many of them people who might not respond favorably to the announcement of a political speech. Films offer an effective pretext for gathering an audience, in addition to the ideological message they contain.

The capacity for synthesis and the penetration of the film image, the possibilities offered by the *living document*, and *naked reality*, and the power of enlightenment of audiovisual means make the film far more effective than any other tool of communication. It is hardly necessary to point out that those films which achieve an intelligent use of the possibilities of the image, adequate dosage of concepts, language and structure that flow naturally from each theme, and counterpoints of audiovisual narration achieve effective results in the politicization and mobilization of cadres and even in work with the masses, where this is possible.

The students who raised barricades on the Avenida 18 de Julio in Montevideo after the showing of *La hora de los hornos (The Hour of the Furnaces)*, the growing demand for films such as those made by Santiago Alvarez and the Cuban documentary film movement, and the debates and meetings that take place alter the underground or semi-public showings of *third cinema* films are the beginning of a twisting and difficult road being travelled in the consumer societies by the mass organizations (*Cinegiornali liberi* in Italy, Zengakuren documentaries in Japan, etc.). For the first time in Latin America, organizations are ready and willing to employ films for political-cultural ends: the Chilean *Partido Socialista* provides its cadres with revolutionary film material, while Argentine revolutionary Peronist and non-Peronist groups are taking an interest in doing likewise. Moreover, OSPAAAL (Organization of Solidarity of the People of Africa, Asia and Latin America) is participating in the production and distribution of films that contribute to the anti-imperialist struggle. The revolutionary organizations are discovering the need for cadres who, among other things, know how to handle a film camera, tape recorders, and projectors in the most effective way possible. The struggle to seize power from the enemy is the meeting ground of the political and artistic vanguards engaged in a common task which is *enriching to both*.

Some of the circumstances that delayed the use of films as a revolutionary tool until a short time ago were lack of equipment, technical difficulties, the compulsory specialization of each phase of work, and high costs. The advances that have taken place within each specializa-

tion; the simplification of movie cameras and tape recorders; improvements in the medium itself, such as rapid film that can be shot in normal light; automatic light meters; improved audiovisual synchronization; and the spread of know-how by means of specialized magazines with large circulations and even through nonspecialized media, have helped to demystify filmmaking and divest it of that almost magic aura that made it seem that films were only within the reach of "artists," "geniuses," and "the privileged." Filmmaking is increasingly within the reach of larger social layers. Chris Marker experimented in France with groups of workers whom he provided with 8mm equipment and some basic instruction in its handling. The goal was to have the worker film *his way of looking at the world, just as if he were writing it.* This has opened up unheard-of prospects for the cinema; above all, *a new conception of filmmaking and the significance of art in our times.*

Imperialism and capitalism, whether in the consumer society or in the neocolonialized country, veil everything behind a screen of images and appearances. *The image of reality* is more important than reality itself. It is a world peopled with fantasies and phantoms in which what is hideous is clothed in beauty, while beauty is disguised as the hideous. On the one hand, fantasy, the imaginary bourgeois universe replete with comfort, equilibrium, sweet reason, order, efficiency, and the possibility to "be someone." And, on the other, the phantoms, we the lazy, we the indolent and underdeveloped, we who cause disorder. When a neocolonialized person accepts his situation, he becomes a Gungha Din, a traitor at the service of the colonialist, an Uncle Tom, a class and racial renegade, or a fool, the easy-going servant and bumpkin; but, when he refuses to accept his situation of oppression, then he turns into a resentful savage, a cannibal. Those who *lose sleep from fear of the hungry,* those who comprise the System, see the revolutionary as a bandit, robber, and rapist; the first battle waged against them is thus not on a political plane, but rather in the police context of law, arrests, etc. The more exploited a man is, the more he is placed on a plane of insignificance. The more he resists, the more he is viewed as a beast. This can be seen in *Africa Addio,* made by the fascist Jacopetti: the African savages, killer animals, wallow in abject anarchy once they escape from white protection. Tarzan died, and in his place were born Lumumbas and Lobegulas, Nkomos, and the Madzimbamutos, and this is something that neocolonialism cannot forgive. Fantasy has been replaced by phantoms and man is turned into an extra who dies so Jacopetti can comfortably film his execution.

I make the revolution; therefore I exist. This is the starting point for the disappearance of fantasy and phantom to make way for living

human beings. The cinema of the revolution is at the same time one of *destruction and construction*: destruction of the image that neocolonialism has created of itself and of us, and construction of a throbbing, living reality which recaptures truth in any of its expressions.

The restitution of things to their real place and meaning is an eminently subversive fact both in the neocolonial situation and in the consumer societies. In the former, the seeming ambiguity or pseudo-objectivity in newspapers, literature, etc., and the relative freedom of the people's organizations to provide their own information cease to exist, giving way to overt restriction, when it is a question of television and radio, the two most important System-controlled or monopolized communications media. Last year's May events in France are quite explicit on this point.

In a world where the unreal rules, artistic expression is shoved along the channels of fantasy, fiction, language in code, sign language, and messages whispered between the lines. Art is cut off from the concrete facts—which, from the neocolonialist standpoint, are accusatory testimonies—to turn back on itself, strutting about in a world of abstractions and phantoms, where it becomes "timeless" and history-less. Vietnam can be mentioned, but only far from Vietnam; Latin America can be mentioned, but only far enough away from the continent to be effective, in places *where it is depoliticized* and where it does not lead to action.

The cinema known as documentary, with all the vastness that the concept has today, from educational films to the reconstruction of a fact or a historical event, is perhaps the main basis of revolutionary filmmaking. Every image that documents, bears witness to, refutes or deepens the truth of a situation is something more than a film image of purely artistic fact; it becomes something which the System finds indigestible.

Testimony about a national reality is also an inestimable means of dialogue and knowledge on the world plane. No internationalist form of struggle can be carried out successfully if there is not a mutual exchange of experiences among the people, if the people do not succeed in breaking out of the Balkanization on the international, continental, and national planes which imperialism is striving to maintain.

There is no knowledge of a reality as long as that reality is not acted upon, *as long as its transformation is not begun on all fronts of struggle.* The well-known quote from Marx deserves constant repetition: *it is not sufficient to interpret the world; it is now a question of transforming it.*

With such an attitude as his starting point, it remains to the film-maker to discover his own language, a language which will arise from

a militant and transforming world-view and from the theme being dealt with. Here it may well be pointed out that certain political cadres still maintain old dogmatic positions, which ask the artist or film-maker to provide an apologetic view of reality, *one which is more in line with wishful thinking than with what actually is*. Such positions, which at bottom mask a lack of confidence in the possibilities of reality itself, have in certain cases led to the use of film language as a mere idealized illustration of a fact, to the desire to remove reality's deep contradictions, its dialectic richness, which is precisely the kind of depth which can give a film beauty and effectiveness. The reality of the revolutionary processes all over the world, in spite of their confused and negative aspects, possesses a dominant line, a synthesis which is so rich and stimulating that it does not need to be schematized with partial or sectarian views.

Pamphlet films, didactic films, report films, essay films, witness-bearing films—any militant form of expression is valid, and it would be absurd to lay down a set of aesthetic work norms. *Be receptive to all that the people have to offer, and offer them the best*; or, as Che put it, *respect the people by giving them quality*. This is a good thing to keep in mind in view of those tendencies which are always latent in the revolutionary artist to lower the level of investigation and the language of a theme, in a kind of *neopopulism*, down to levels which, while they may be those upon which the masses move, do not help them to get rid of the stumbling blocks left by imperialism. The effectiveness of the best films of militant cinema show that social layers considered backward are able to capture the exact meaning of an association of images, an effect of staging, and any linguistic experimentation placed within the context of a given idea. Furthermore, revolutionary cinema is not fundamentally one which illustrates, documents, or passively establishes a situation: *rather, it attempts to intervene in the situation as an element providing thrust or rectification.* To put it another way, it provides *discovery through transformation.*

The differences that exist between one and another liberation process make it impossible to lay down supposedly universal norms. A cinema which in the consumer society does not attain the level of the reality in which it moves can play a stimulating role in an underdeveloped country, just as a revolutionary cinema in the neocolonial situation will not necessarily be revolutionary if it is mechanically taken to the metropolitan country.

Teaching the handling of guns can be revolutionary where there are potentially or explicitly viable leaders ready to throw themselves into the struggle to take power, but ceases to be revolutionary where the masses still lack sufficient awareness of their situation or where they

have already learned to handle guns. Thus, a cinema which insists upon the denunciation of the *effects* of neocolonial policy is caught up in a reformist game if the consciousness of the masses has already assimilated such knowledge; then the revolutionary thing is to examine the *causes*, to investigate the ways of organizing and arming for the change. That is, imperialism can sponsor films that fight illiteracy, and such pictures will only be inscribed within the contemporary need of imperialist policy, but, in contrast, the making of such films in Cuba after the triumph of the Revolution was clearly revolutionary. Although their starting point was just the fact of teaching, reading and writing, they had a goal which was radically different from that of imperialism: the training of people for liberation, not for subjection.

The model of the perfect work of art, the fully rounded film structured according to the metrics imposed by bourgeois culture, its theoreticians and critics, has served to inhibit the filmmaker in the dependent countries, especially when he has attempted to erect similar models in a reality which *offered him neither the culture, the techniques, nor the most primary elements for success.* The culture of the metropolis kept the age-old secrets that had given life to its models; the transposition of the latter to the neocolonial reality was always a mechanism of alienation, *since it was not possible for the artist of the dependent country to absorb, in a few years, the secrets of a culture and society elaborated through the centuries in completely different historical circumstances.* The attempt in the sphere of filmmaking to match the pictures of the ruling countries generally ends in failure, given the existence of two disparate historical realities. And such unsuccessful attempts lead to feelings of frustration and inferiority. Both these feelings arise in the first place from the fear of taking risks along completely new roads *which are almost a total denial of "their cinema."* A fear of recognizing the particularities and limitations of dependency in order to discover the *possibilities inherent in that situation,* by finding ways of overcoming it *which would of necessity be original.*

The existence of a revolutionary cinema is inconceivable without the constant and methodical exercise of practice, search, and experimentation. It even means committing the new filmmaker to take chances on the unknown, to leap into space at times, exposing himself to failure as does the guerrilla who travels along paths that he himself opens up with machete blows. The possibility of discovering and inventing film forms and structures that serve a more profound vision of our reality resides in the ability to place oneself on the outside limits of the familiar, to make one's way amid constant dangers.

Our time is one of hypothesis rather than of thesis, a time of works in progress—unfinished, unordered, violent works made with the camera in one hand and a rock in the other. Such works cannot be assessed according to the traditional theoretical and critical canons. The ideas for *our* film theory and criticism will come to life through inhibition-removing practice and experimentation. "Knowledge begins with practice. After acquiring theoretical knowledge through practice, it is necessary to return to practice."[12] Once he has embarked upon this practice, the revolutionary filmmaker will have to overcome countless obstacles; he will experience the loneliness of those who aspire to the praise of the System's promotion media only to find that those media are closed to him. As Godard would say, he will cease to be a bicycle champion to become an anonymous bicycle rider, Vietnamese-style, submerged in a cruel and prolonged war. But he will also discover that there is a receptive audience that looks upon his work as something of its own existence, and that is ready to defend him in a way that it would never do with any world bicycle champion.

In this long war, with the camera as our rifle, we do in fact move into a guerrilla activity. This is why the work of a *film-guerrilla* group is governed by strict disciplinary norms as to both work methods and security. A revolutionary film group is in the same situation as a guerrilla unit: it cannot grow strong without military structures and command concepts. *The group exists as a network of complementary responsibilities, as the sum and synthesis of abilities, inasmuch as it operates harmonically with a leadership that centralizes planning work and maintains its continuity.* Experience shows that it is not easy to maintain the cohesion of a group when it is bombarded by the System and its chain of accomplices frequently disguised as "progressives," when there are no immediate and spectacular outer incentives and the members must undergo the discomforts and tensions of work that is done underground and distributed clandestinely. Many abandon their responsibilities because they underestimate them or because they measure them with values appropriate to System cinema and not underground cinema. The birth of internal conflicts is a reality present in any group, whether or not it possesses ideological maturity. The lack of awareness of such an inner conflict on the psychological or personality plane, etc., the lack of maturity in dealing with problems of relationships, at times leads to ill feeling and rivalries that in turn cause real clashes going beyond ideological or objective differences. All of this means that a basic condition is an awareness of the problems of interpersonal relationships, leadership and areas of

competence. What is needed is to speak clearly, mark off work areas, assign responsibilities and take on the job as a rigorous militancy.

Guerrilla filmmaking proletarianizes the film worker and breaks down the intellectual aristocracy that the bourgeoisie grants to its followers. In a word, it *democratizes*. The filmmaker's tie with reality makes him more a part of his people. Vanguard layers and even masses participate collectively in the work when they realize that it is the continuity of their daily struggle. *La hora de los hornos* shows how a film can be made in hostile circumstances when it has the support and collaboration of militants and cadres from the people.

The revolutionary filmmaker acts with a radically new vision of the role of the producer, team-work, tools, details, etc. Above all, he supplies himself at all levels in order to produce his films, he equips himself at all levels, he learns how to handle the manifold techniques of his craft. His most valuable possessions are the tools of his trade, which form part and parcel of his need to communicate. The camera is the inexhaustible *expropriator of image-weapons*; the projector, *a gun that can shoot 24 frames per second.*

Each member of the group should be familiar, at least in a general way, with the equipment being used: he must be prepared to replace another in any of the phases of production. The myth of irreplaceable technicians must be exploded.

The whole group must grant great importance to the minor details of the production and the security measures needed to protect it. A lack of foresight which in conventional filmmaking would go unnoticed can render virtually useless weeks or months of work. And a failure in guerrilla cinema, just as in the guerrilla struggle itself, can mean the loss of a work or a complete change of plans. "In a guerrilla struggle the concept of failure is present a thousand times over, and victory a myth that only a revolutionary can dream."[13] Every member of the group must have an ability to take care of details, discipline, speed, and, above all, the willingness to overcome the weaknesses of comfort, old habits, and the whole climate of pseudonormality behind which the warfare of everyday life is hidden. Each film is a different operation, a different job requiring variation in methods in order to confuse or refrain from alerting the enemy, especially since the processing laboratories are still in his hands.

The success of the work depends to a great extent on the group's ability to remain silent, on its permanent wariness, a condition that is difficult to achieve in a situation in which apparently nothing is happening and the filmmaker has been accustomed to telling all and sundry about everything that he's doing because the bourgeoisie has trained him precisely on such a basis of prestige and promotion. The

watchwords "constant vigilance, constant wariness, constant mobility" have profound validity for guerrilla cinema. You have to give the appearance of working on various projects, split up the material, put it together, take it apart, confuse, neutralize, and throw off the track. All of this is necessary as long as the group doesn't have its own processing equipment, no matter how rudimentary, and there remain certain possibilities in the traditional laboratories.

Group-level co-operation between different countries can serve to assure the completion of a film or the execution of certain phases of work that may not be possible in the country of origin. To this should be added the need for a filing center for materials to be used by the different groups and the perspective of coordination, on a continent-wide or even worldwide scale, of the continuity of work in each country: periodic regional or international gatherings to exchange experience, contributions, joint planning of work, etc.

At least in the earliest stages the revolutionary filmmaker and the work groups will be the sole producers of their films. They must bear the responsibility of finding ways to facilitate the continuity of work. Guerrilla cinema still doesn't have enough experience to set down standards in this area; what experience there is has shown, above all, the *ability to make use of the concrete situation of each country*. But, regardless of what these situations may be, the preparation of a film cannot be undertaken without a parallel study of its future audience and, consequently, a plan to recover the financial investment. Here, once again, the need arises for closer ties between political and artistic vanguards, since this also serves for the joint study of forms of production, exhibition, and continuity.

A guerrilla film can be aimed only at the distribution mechanisms provided by the revolutionary organizations, including those invented or discovered by the filmmakers themselves. Production, distribution, and economic possibilities for survival must form part of a single strategy. The solution of the problems faced in each of these areas will encourage other people to join in the work of guerrilla filmmaking, which will enlarge its ranks and thus make it less vulnerable.

The distribution of guerrilla films in Latin America is still in swaddling clothes while System reprisals are already a legalized fact. Suffice it to note in Argentina the raids that have occurred during some showings and the recent film suppression law of a clearly fascist character; in Brazil the ever-increasing restrictions placed upon the most militant comrades of *Cinema Novo*; and in Venezuela the banning of *La hora de los hornos*; over almost all the continent censorship prevents any possibility of public distribution.

Without revolutionary films and a public that asks for them, any attempt to open up new ways of distribution would be doomed to failure. But both of these already exist in Latin America. The appearance of these films opened up a road which in some countries, such as Argentina, occurs through showings in apartments and houses to audiences of never more than 25 people; in other countries, such as Chile, films are shown in parishes, universities, or cultural centers (of which there are fewer every day); and, in the case of Uruguay, showings were given in Montevideo's biggest movie theatre to an audience of 2,500 people, who filled the theatre and made every showing an impassioned anti-imperialist event. But the prospects on the continental plane indicate that the possibility for the continuity of a revolutionary cinema rests upon the strengthening of rigorously underground base structures.

Practice implies mistakes and failures.[14] Some comrades will let themselves be carried away by the success and impunity with which they present the first showings and will tend to relax security measures, while others will go in the opposite direction of excessive precautions or fearfulness, to such an extent that distribution remains circumscribed, limited to a few groups of friends. Only concrete experience in each country will demonstrate which are the best methods there, which do not always lend themselves to application in other situations.

In some places it will be possible to build infrastructures connected to political, student, worker, and other organizations, while in others it will be more suitable to sell prints to organizations which will take charge of obtaining the funds necessary to pay for each print (the cost of the print plus a small margin). This method, wherever possible, would appear to be the most viable, because it permits the decentralization of distribution; makes possible a more profound political use of the film; and permits the recovery, through the sale of more prints, of the funds invested in the production. It is true that in many countries the organizations still are not fully aware of the importance of this work, or, if they are, may lack the means to undertake it. In such cases other methods can be used: the delivery of prints to encourage distribution and a box-office cut to the organizers of each showing, etc. The ideal goal to be achieved would be producing and distributing guerrilla films with funds obtained from expropriations from the bourgeoisie—that is, *the bourgeoisie would be financing guerrilla cinema with a bit of the surplus value that it gets from the people.* But, as long as the goal is no more than a middle- or long-range aspiration, the alternatives open to revolutionary cinema to recover production and distribution costs are to some extent similar to those obtained for

conventional cinema: every spectator should pay the same amount as he pays to see System cinema. Financing, subsidizing, equipping, and supporting revolutionary cinema are political responsibilities for organizations and militants. A film can be made, but if its distribution does not allow for the recovery of the costs, it will be difficult or impossible to make a second film.

The 16mm film circuits in Europe (20,000 exhibition centers in Sweden, 30,000 in France, etc.) are not the best example for the neocolonialized countries, but they are nevertheless a complementary source for fund raising, especially in a situation in which such circuits can play an important role in publicizing the struggles in the Third World, increasingly related as they are to those unfolding in the metropolitan countries. A film on the Venezuelan guerrillas will say more to a European public than twenty explanatory pamphlets, and the same is true for us with a film on the May events in France or the Berkeley, U.S.A., student struggle.

A Guerrilla Films International? And why not? Isn't it true that a kind of new International is arising through the Third World struggles; through OSPAAAL and the revolutionary vanguards of the consumer societies?

A guerrilla cinema, at this stage still within the reach of limited layers of the population, is, nevertheless, *the only cinema of the masses possible today*, since it is the only one involved with the interests, aspirations, and prospects of the vast majority of the people. Every important film produced by a revolutionary cinema will be, explicitly, or not, *a national event of the masses*.

This *cinema of the masses*, which is prevented from reaching beyond the sectors representing the masses, provokes with each showing, as in a revolutionary military incursion, a liberated space, *a decolonized territory*. The showing can be turned into a kind of political event, which, according to Fanon, could be "a liturgical act, a privileged occasion for human beings to hear and be heard."

Militant cinema must be able to extract the infinity of new possibilities that open up for it from the conditions of proscription imposed by the System. The attempt to overcome neocolonial oppression calls for the invention of forms of communication; *it opens up the possibility*.

Before and during the making of *La hora de los hornos* we tried out various methods for the distribution of revolutionary cinema—the little that we had made up to then. Each showing for militants, middle-level cadres, activists, workers, and university students became— without our having set ourselves this aim beforehand—a kind of enlarged cell meeting of which the films were a part but not the most

important factor. We thus discovered a new facet of cinema: the *participation* of people who, until then, were considered *spectators*.

At times, security reasons obliged us to try to dissolve the group of participants as soon as the showing was over, and we realized that the distribution of that kind of film had little meaning if it was not complemented by the participation of the comrades, if a debate was not opened on the themes suggested by the films.

We also discovered that every comrade who attended such showings did so with full awareness that he was infringing the System's laws and exposing his personal security to eventual repression. This person was no longer a spectator; on the contrary, from the moment he decided to attend the showing, *from the moment he lined himself up on this side* by taking risks and contributing his living experience to the meeting, he became an actor, a more important protagonist than those who appeared in the films. Such a person was seeking other committed people like himself while he, in turn, became committed to them. *The spectator made way for the actor, who sought himself in others.*

Outside this space which the films momentarily helped to liberate, there was nothing but solitude, noncommunication, distrust, and fear; within the freed space the situation turned everyone into accomplices of the act that was unfolding. The debates arose spontaneously. As we gained in experience, we incorporated into the showing various elements (a *mise en scène*) to reinforce the themes of the films, the climate of the showing, the "disinhibiting" of the participants, and the dialogue: recorded music or poems, sculpture and paintings, posters, a program director who chaired the debate and presented the film and the comrades who were speaking, a glass of wine, a few *mates*,[15] etc. We realized that we had at hand three very valuable factors:

1) *The participant comrade*, the man-actor-accomplice who responded to the summons;
2) *The free space* where that man expressed his concerns and ideas, became politicized, and started to free himself; and
3) *The film*, important only as a detonator or pretext.

We concluded from these data that a film could be much more effective if it were fully aware of these factors and took on the task of subordinating its own form, structure, language, and propositions to that act and to those actors—to put it another way, *if it sought its own liberation in its subordination to and insertion in others, the principal protagonists of life.* With the correct utilization of the *time* that that group of actor-personages offered us with their diverse histories, the

use of the *space* offered by certain comrades, and of the *films* themselves, *it was necessary to try to transform time, energy, and work into freedom-giving energy.* In this way the idea began to grow of structuring what we decided to call the *film act*, the *film action*, one of the forms which we believe assumes great importance in affirming the line of a *third cinema.* A cinema whose first experiment is to be found, perhaps on a rather shaky level in the second and third parts of *La hora de los hornos ("Acto para la liberacion"*; above all, starting with *"La resistencia"* and *"Violencia y liberacion").*

> Comrades [we said at the start of "Acto para la liberacion"], this is not just a film showing, nor is it a show; rather, it is, above all A MEETING—an act of anti-imperialist unity; this is a place only for those who feel identified with this struggle, because here there is no room for spectators or for accomplices of the enemy; here there is room only for the authors and protagonists of the process which the film attempts to bear witness to and to deepen. The film is the pretext for dialogue, for the seeking and finding of wills. It is a report that we place before you for your consideration, to be debated after the showing.
>
> The conclusions [we said at another point in the second part] at which you may arrive as the real authors and protagonists of this history are important. The experiences and conclusions that we have assembled have a relative worth; they are of use to the extent that they are useful to you, who are the present and future of liberation. But most important of all is the action that may arise from these conclusions, the unity on the basis of the facts. This is why the film stops here; it opens out to you so that you can continue it.

The film act means an open-ended film; it is essentially a way of learning.

> The first step in the process of knowledge is the first contact with the things of the outside world, the stage of sensations [*in a film, the living fresco of image and sound*]. The second step is the synthesizing of the data provided by the sensations; their ordering and elaboration; the stage of concepts, judgements, opinions, and deductions [*in the film, the announcer, the reportings, the didactics, or the narrator who leads the projection act*]. And then comes the third stage, that of knowledge. The active role of knowledge is expressed not only in the active leap from sensory to rational knowledge, but, and what is even more important, in the leap from rational knowledge to revolutionary practice . . . The practice of the transformation of the world . . . This, in

general terms, is the dialectical materialist theory of the unity of knowledge and action[16] [*in the projection of the film act, the participation of the comrades, the action proposals that arise, and the actions themselves that will take place later*].

Moreover, each projection of a film act presupposes a *different setting*, since the space where it takes place, the materials that go to make it up (actors-participants), and the historic time in which it takes place are never the same. This means that the result of each projection act will depend on those who organize it, on those who participate in it, and on the time and place; the possibility of introducing variations, additions, and changes is unlimited. The screening of a film act will always express in one way or another the historical situation in which it takes place; its perspectives are not exhausted in the struggle for power but will instead continue after the taking of power to strengthen the revolution.

The man of the *third cinema*, be it *guerrilla cinema* or a *film act*, with the infinite categories that they contain (film letter, film poem, film essay, film pamphlet, film report, etc.), above all counters the film industry of a cinema of characters with one of themes, that of individuals with that of masses, that of the author with that of the operative group, one of neocolonial misinformation with one of information, one of escape with one that recaptures the truth, that of passivity with that of aggressions. To an institutionalized cinema, it counterposes a guerrilla cinema; to movies as shows, it opposes a film act or action; to a cinema of destruction, one that is both destructive and constructive; to a cinema made for the old kind of human being, for *them*, it opposes a *cinema fit for a new kind of human being, for what each one of us has the possibility of becoming*.

The decolonization of the filmmaker and of films will be simultaneous acts to the extent that each contributes to collective decolonization. The battle begins without, against the enemy who attacks us, but also within, *against the ideas and models of the enemy to be found inside each one of us*. Destruction and construction. Decolonizing action rescues with its practice the purest and most vital impulses. It opposes to the colonialization of minds the revolution of consciousness. The world is scrutinized, unravelled, rediscovered. People are witness to a constant astonishment, a kind of second birth. They recover their early simplicity, their capacity for adventure; their lethargic capacity for indignation comes to life.

Freeing a forbidden truth means setting free the possibility of indignation and subversion. Our truth, that of the new man who builds himself by getting rid of all the defects that still weigh him down, is a

bomb of inexhaustible power and, at the same time, *the only real possibility of life.* Within this attempt, the revolutionary filmmaker ventures with *his subversive observation, sensibility, imagination, and realization.* The great themes—the history of the country, love and unlove between combatants, the efforts of a people who are awakening—all this is reborn before the lens of the decolonized camera. The filmmaker feels for the first time. He discovers that, within the System, nothing fits, while outside of and against the System, everything fits, because everything remains to be done. What appeared yesterday as a preposterous adventure, as we said at the beginning, is posed today as *an inescapable need and possibility.*

Thus far, we have offered ideas and working propositions, which are the sketch of a hypothesis arising from our personal experience and which will have achieved something positive even if they do no more than serve to open a heated dialogue on the new revolutionary film prospects. The vacuums existing in the artistic and scientific fronts of the revolution are sufficiently well known so that the adversary will not try to appropriate them, while we are still unable to do so.

Why films and not some other form of artistic communication? If we choose films as the center of our propositions and debate, it is because that is our work front and because the birth of a *third cinema* means, at least for us, *the most important revolutionary artistic event of our times.*

Translation from *Cineaste* revised by Julianne Burton and Editor

Notes

1. *The Hour of the Furnaces—Neocolonialism and Violence.*
2. Juan José Hernandez Arregui, *Imperialism and Culture.*
3. Rene Zavaleta Mercado, *Bolivia: Growth of the National Concept.*
4. *The Hour of the Furnaces.*
5. Ibid.
6. Observe the new custom of some groups of the upper bourgeoisie from Rome and Paris who spend their weekends travelling to Saigon to get a close-up view of the Vietcong offensive.
7. Irwin Silber, "U.S.A.: The Alienation of Culture," *Tricontinental* 10.
8. The organization Vanguard Artists of Argentina.
9. *The Hour of the Furnaces.*
10. Mao Tse-tung, *On Practice.*
11. Rodolfo Puigross, *The Proletariat and National Revolution.*
12. Mao Tse-tung, op. cit.
13. Che Guevara, *Guerrilla Warfare.*

14. The raiding of a Buenos Aires union and the arrest of dozens of persons resulting from a bad choice of projection site and the large number of people invited.

15. A traditional Argentine herb tea, *hierba mate*.

16. Mao Tse-tung, op. cit.

An Esthetic of Hunger

Glauber Rocha

Dispensing with the informative introduction so characteristic of discussions about Latin America, I prefer to examine the relationship between our culture and "civilized" culture in broader terms than those of the European observer. Thus, while Latin America laments its general misery, the foreign onlooker cultivates the taste of that misery, not as a tragic symptom, but merely as an esthetic object within his field of interest. The Latin American neither communicates his real misery to the "civilized" European, nor does the European truly comprehend the misery of the Latin American.

This is the fundamental situation of the arts in Brazil today: many distortions, especially the formal exoticism that vulgarizes social problems, have provoked a series of misunderstandings that involve not only art but also politics. For the European observer the process of artistic creation in the underdeveloped world is of interest only insofar as it satisfies a nostalgia for primitivism. This primitivism is generally presented as a hybrid form, disguised under the belated heritage of the "civilized world," a heritage poorly understood since it is imposed by colonial conditioning. Latin America remains, undeniably, a colony, and what distinguishes yesterday's colonialism from today's colonialism is merely the more polished form of the colonizer and the more subtle forms of those who are preparing future domination. The international problem of Latin America is still a case of merely exchanging

Randal Johnson and Robert Stam, eds., *Brazilian Cinema*. NJ: Associated University Presses, 1982, pp. 69–71. By permission of the publisher.

colonizers. Our possible liberation will probably come, therefore, in the form of a new dependency.

This economic and political conditioning has led us to philosophical weakness and impotence that engenders sterility when conscious and hysteria when unconscious. It is for this reason that the hunger of Latin America is not simply an alarming symptom: it is the essence of our society. There resides the tragic originality of Cinema Novo in relation to world cinema. Our originality is our hunger and our greatest misery is that this hunger is felt but not intellectually understood.

We understand the hunger that the European and the majority of Brazilians have not understood. For the European it is a strange tropical surrealism. For the Brazilian it is a national shame. He does not eat, but he is ashamed to say so; and yet, he does not know where this hunger comes from. We know—since we made these sad, ugly films, these screaming, desperate films where reason does not always prevail —that this hunger will not be cured by moderate governmental reforms and that the cloak of technicolor cannot hide, but only aggravates, its tumors. Therefore, only a culture of hunger, weakening its own structures, can surpass itself qualitatively; the most noble cultural manifestation of hunger is violence.

Cinema Novo shows that the normal behavior of the starving is violence; and the violence of the starving is not primitive. Is Fabiano [in *Barren Lives*] primitive? Is Antão [in *Ganga Zumba*] primitive? Is Corisco [in *Black God, White Devil*] primitive? Is the woman in *Porto das Caixas* primitive?

From Cinema Novo it should be learned that an esthetic of violence, before being primitive, is revolutionary. It is the initial moment when the colonizer becomes aware of the colonized. Only when confronted with violence does the colonizer understand, through horror, the strength of the culture he exploits. As long as they do not take up arms, the colonized remain slaves; a first policeman had to die for the French to become aware of the Algerians.

From a moral position this violence is not filled with hatred just as it is not linked to the old colonizing humanism. The love that this violence encompasses is as brutal as the violence itself because it is not a love of complacency or contemplation but rather of action and transformation.

The time has long passed since Cinema Novo had to justify its existence. Cinema Novo is an ongoing process of exploration that is making our thinking clearer, freeing us from the debilitating delirium of hunger. Cinema Novo cannot develop effectively while it remains marginal to the economic and cultural process of the Latin American continent. Cinema Novo is a phenomenon of new peoples everywhere

and not a privilege of Brazil. Wherever one finds filmmakers prepared to film the truth and oppose the hypocrisy and repression of intellectual censorship there is the living spirit of Cinema Novo; wherever filmmakers, of whatever age or background, place their cameras and their profession in the service of the great causes of our time there is the spirit of Cinema Novo. This is the definition of the movement and through this definition Cinema Novo sets itself apart from the commercial industry because the commitment of Industrial Cinema is to untruth and exploitation. The economic and industrial integration of Cinema Novo depends on the freedom of Latin America. Cinema Novo devotes itself entirely to this freedom, in its own name, and in the name of all its participants, from the most ignorant to the most talented, from the weakest to the strongest. It is this ethical question that will be reflected in our work, in the way we film a person or a house, in the details that we choose, in the moral that we choose to teach. Cinema Novo is not one film but an evolving complex of films that will ultimately make the public aware of its own misery.

New York, Milan, Rio de Janeiro
January, 1965
Translated by Randal Johnson and Burnes Hollyman

Problems of Form and Content in Revolutionary Cinema

Jorge Sanjinés

Revolutionary cinema must seek beauty not as an end but as a means. This proposition implies a dialectical interrelation between beauty and cinema's objectives, which must be correctly aligned in order to produce an effective work. If that interrelation is missing, we end up with a pamphlet, for example, which may well be perfect in its proclamation but which is schematic and crude in its form. The lack of a coherent creative form reduces its effectiveness, destroys the ideological dynamic of the content and merely locates for us what is on the surface, the superficialities, without giving us any of the essence, the humanity, the love: categories that can only issue from a sensitive and responsive means of expression, capable of revealing the truth.

Collective Work

Revolutionary cinema is in the process of formation. Certain conceptions about art that bourgeois ideology has deeply instilled in those artists who have been formed within the parameters of western culture are not so easily or quickly changed. Nevertheless, we think it is a process that will succeed in purging itself through contact with the people, by integrating them into the creative process, by elucidating the aims of popular art, and by leaving off with individualistic positions. Today there are many group efforts and collective films, and,

Jorge Sanjinés and the Ukamau Group, *Theory & Practice of a Cinema with the People*. CT: Curbstone Press, 1989, pp. 38–53. First published in *teoría y práctica de un cine junto al pueblo*. Mexico: Siglo Veintiuno Editores, 1979. By permission of the publisher.

what is very important, there is the participation of the people who act, who come forward, who create directly, determining the form of the film in a process where the immutable script is disappearing or where the dialogue, during the act of filming, spontaneously issues from the people themselves and from their prodigious capacity. Life begins to be expressed in all its power and truth.

As we already maintained in an article on this question, revolutionary cinema cannot be anything but collective in its most complete phase, since the revolution is collective. Popular cinema, in which the fundamental protaganist will be the people, will develop individual histories when these have meaning for the collective, when these serve the people's understanding, rather than that of one individual, and when they are integrated into the history of the collective as a whole. The individual hero must give way to the popular hero—numerous, quantitative—and, in the process of elaboration, this popular hero will not only be the internal motive of the film but its qualitative driving force: participant and creator.

Language

A film about the people made by a screenwriter isn't the same as a film made by the people *through* a screenwriter, inasmuch as the interpreter and translator of that people becomes their expressive vehicle. With a change in the relations of creation comes a change in the content and, in parallel, a change in the form.

In revolutionary cinema, the final product will always be the result of individual abilities organized toward one same end, where the spirit and life-breath of a whole people, and not just the problems of one man alone, is captured and transmitted. The problems of the individual, which assume overblown proportions in bourgeois society, are resolved within revolutionary society through the process of confronting the problems of society as a whole, and are reduced to a normal level because their solutions are encountered in the course of being integrated into revolutionary society: where the aloneness that causes all psychological neuroses disappears forever.

The loving or apathetic treatment by a filmmaker of an object or of men becomes evident in his work, mocking his sense of being in control. What the filmmaker thinks and feels is manifested in the expressive means he chooses to use. His selection of language forms reveals his attitude and, therefore, a film tells us not only something about the subject it treats but also something about the filmmaker.

When we shot *Blood of the Condor* with the peasants in the remote community of Kaata, our purpose deep down—though we desired to

contribute politically with our work by denouncing the *gringos* and showing a social picture of Bolivian reality—was to achieve recognition for our abilities. There's no denying it, just as we can't deny that during the filming our relationship with the peasant actors was still a vertical one. We were employing a formal treatment that led us to select scenes according to our personal likes, without taking into account their communicability or their cultural meaning. Scripts had to be memorized and repeated exactly. Though the soundtrack played an important role in the resolution of certain sequences, we didn't give importance to the needs of the viewer, for whom we said we were making that film, who required clear, visual images and who later complained when the film was shown.

Thanks to the confrontation of our films with the people, thanks to their criticisms, suggestions, advice, protests and confusions due to our misunderstanding of the ideological relationship between form and content, we were slowly distilling a language and incorporating the creativity of the people themselves, whose notable expressive and interpretative abilities demonstrate a sensibility that is pure, free of stereotypes and alienations.

While filming *The Courage of the People*, many scenes were shot in the same place as the events discussed with the actual protagonists of those historical accounts we were reconstructing, with those who at bottom had more of a claim on deciding how things ought to be reconstructed than we did. On the other hand, they were interpreting things with a force and conviction that was unattainable by a professional actor. These *compañeros* wanted not only to transmit their experiences with the intensity they possessed, but they knew what were the most important political objectives of the film and, therefore, their participation brought to it a fresh militancy. They possessed a clear consciousness of how the film was to serve, spreading its denunciation of the true facts throughout the country, and they were prepared to make use of it as they would a weapon. We, the components with the film equipment, became the instruments of the people who were expressing themselves and fighting through our medium!

The dialogue was drawn from their precise memory of the events, or else became the expression of their thoughts about the events, as in *The Principal Enemy*. The peasants used the scenes to liberate their repressed voice, and they told the judge or boss in the film what they really wanted to say about the truth. Cinematic reality and actual reality are interwoven and merge as one. What is artificial has to do with mere extraneous factors, but through the revealing, creative actions of the people the cinematic reenactment meshes with actual reality.

When we decided to use sequence shots in our latest films, we were spurred on by the surging demands of the content. We had to use shots that integrated the participation of the viewer. Jumping right away to close-ups of the assassin—in *The Principal Enemy*—in the crowded plaza where the popular tribunal was held didn't serve our purposes, because the surprise that is always produced by directly cutting to a close-up was opposed to what we were trying to develop in the sequence shots, which was to engage the participation of the viewer by means of the internal power of the people's collective participation. The simple movement of the camera interpreted differing points of view, the dramatic demands of the viewer that would enable him to quit being a viewer so as to become an actual participant. Occasionally the sequence shots would lead us into a close-up, sparing what distance is in fact possible in the approach, or else would open up the field between shoulders and heads in order to bring us physically closer to see and listen. To cut to a big close-up is to brutally impose the viewpoint of the filmmaker, his own interpretation of reality, on the viewer. To move from a general shot with other people in it to a closeup has a different meaning, embodies a different attitude, which is more coherent with what is taking place, with the actual content. While filming *The Principal Enemy*, we often felt compelled to break with this kind of treatment because of purely technical limitations; failures in the sound equipment through overuse, noise from the "blimp," or the camera's noise filter hampered our shooting in sequences, and we had to break the filming up into parts. Also, the high degree of improvisation that goes along with popular participation made it difficult to conceptualize successive cuts with any degree of continuity. Somehow, though, that experience was for us totally justified, because the whole process of making the film became, simultaneously, a rich process of discovering new elements (at least they were new to us). It was a totally different school of cinema than the one in which we had learned our ABCs, and we were often amazed by what was taking place before our very eyes!

Put another way, there is the subjective treatment of things that goes hand-in-hand with the needs and attitudes of a certain individualist cinema as opposed to an objective, nonpsychological, sensoral treatment that facilitates the participation and needs of a popular cinema.

The presence of a collective protagonist, rather than an individual protagonist, informs the objective treatment and distance needed to engage the viewer in reflection. Not only did the search for an ideological coherence help convince us of the need to do away with the individual protagonist—the hero and focus of every story in our

culture—but also our observation of the primordial and essential characteristics of indigenous American culture. Indians, through their social traditions, tend to conceive of themselves first as integral members of the group, and then as isolated individuals. Their way of living is not individualistic. They understand reality as the complex integration of everything and everyone, and they act on the basis of this understanding very naturally, since it is an inseparable part of their world view. At first it is bewildering to understand what it means to think of oneself in this way, because it is a whole other way of thinking and involves a dialectic opposite to that of individualism. The individualist exists alone and above everything and everyone; the Indian, on the other hand, exists solely in interaction with everything and everyone. When that equilibrium is upset, the Indian becomes disoriented and nothing makes any sense. The great Peruvian political thinker, Mariátegui, referring to concepts of freedom, said that the Indian is never less free than when he is alone. I remember an interview we recently filmed where a peasant was demanding the presence of his *compañeros* from the community so that he could feel confident and comfortable about what he was saying. Exactly the reverse would happen with an ordinary citizen, who would want to be alone in order to feel secure!

In revolutionary art we always encounter the stylistic mark of a people and the life-breath of a popular culture that embraces a whole community of men and women, with their particular way of thinking and conceiving reality, and their love of life. Its aim is to arrive at the truth *through* beauty, and this is what differentiates it from bourgeois art, where beauty is pursued even at the cost of lying. By observing and incorporating popular culture into our work, we will be able to fully develop the language of a liberating art!

Distribution of Revolutionary Cinema

The distribution of revolutionary films constitutes a major problem and raises questions that require urgent solving.

Militant anti-imperialist films are the object of special persecution and censure in the majority of countries where their purpose is most likely to be fulfilled. This situation has greatly discouraged whomever doesn't view the work of a revolutionary filmmaker as being done simply when the work of filming and editing is done, that the problems of distribution are problems of realization that cannot be dismissed because of the immediate impossibility of resolving them; similarly a film must not cease to exist because it may be impossible to distribute it at that precise political moment. From the moment the

problems of one dominated country become the problems of other dominated countries, that pretext is invalidated.

We must remember that the political dynamic of our countries, at least the majority of them, is constantly changing, and that the ebb and flow of the internal contradictions of each country creates favorable periods when these films can be widely distributed. It is a matter then of struggle! And in the struggle you must know when and where to shoot, and when to keep your head down in the trenches.

To censor ourselves, to disguise our film's content, to symbolize them, is to fall into opportunism and into operations dangerously useful to the enemy, who well knows how to manipulate materials that do not confront it head-on to its advantage.

A true revolutionary film has the right to exist, and the necessity of distributing it is implicit in its essence. Revolutionaries today can fight the same enemies wherever they are. Naturally, they could wage this struggle under better conditions through the enemy's own controlled means of communication, but when this isn't possible they must take up another position on the battlefield, which is the world exploited by imperialism. What cannot be tolerated is remaining in Paris, comfortably vegetating. Revolutionaries don't have vacations nor does the revolution take a break.

Nowadays revolutionary films can be seen in many European countries generally through some television networks or in specialized movie theaters. This distribution, as well as screenings at frequent film festivals, reaches viewers who can be classified *grosso modo* into two groups: the passive viewer and consumer of culture or entertainment who is in the majority, and that other viewer whose attitude towards this cinema is consistent with his advanced thinking and who extracts information to be used in the formation of new ideas and concepts. We believe this last type of viewer is each day becoming more numerous in Europe, and, therefore, the distribution of our films in Europe is justified (one could also justify this distribution on the basis of the economic support it provided, which meant selling copies to television networks and movie theaters, even though filmmakers in nearly every instance received next to nothing from these dealings).

In the United States, in the very bowels of the imperialist enemy, revolutionary cinema is being distributed. Many films are shown by universities and progressive organizations, shedding light on the problems of our peoples and showing the real workings of the system, the atrocities it commits against the world it subjugates. This has resulted in a deepening of solidarity with our peoples and a strengthening of the anti-imperialist struggle raised by progressive North American sectors who are well-acquainted with the exploitation, the dehumani-

zation, the racism in the U.S., all of which are also caused by capitalist ideology.

Nevertheless, we Latin American filmmakers are mainly interested in distributing our cinema in our countries, whether they be our own or our brother countries. We have said that this task is very difficult and also dangerous: Carlos Alvarez, the screenwriter of *What is Democracy?*, was jailed along with his *compañera* by the Colombian military, accused of subversion for his cinematic work! Walter Achugar was detained and tortured in Uruguay; Félix Gómez, of the Ukamau Group in Bolivia, spent close to 18 months in a concentration camp for having in his possession a case containing props for our film *The Courage of the People*. Antonio Eguino, director of photography for the same film, was arrested and detained for 15 days, during protests by university students and broad progressive sectors, for the offense of having in his possession a copy of *The Courage of the People*. Filmmakers and actors on the left have been imprisoned by Pinochet, and today we still know nothing of their fate! A good part of the most committed Latin American filmmakers have been prohibited from returning to their countries. But, despite the persecution and repression, Latin American cinema continues to be produced and, in some countries, there exists a true effervescence that will quickly bear fruit in new values and new experiences. The circulation of Latin American films, though restricted, has never been stopped, and it is even increasing where conditions are favorable. In Venezuela, Colombia, Panama, Peru, Ecuador, Mexico, film festivals have been organized and Latin American cinema is widely distributed. In Venezuela and Panama they even held festivals for Cuban cinema. What is mainly lacking in these countries where distribution is possible is a more systematic and organized effort to consistently bring this cinema to the people. This is why the present Ecuadorian experience, which we will talk about in more detail, is so important.

In Bolivia, before the ominous outbreak of fascism, the films of the Ukamau Group were widely distributed. *Blood of the Condor* was seen by close to 250,000 people! We weren't satisfied with its distribution through the conventional commercial channels, so the film was brought to the countryside using a portable generator and equipment in order to screen it in villages that were without electricity. The result was uplifting: the film contributed to the ousting of the Peace Corps of *yanqui* imperialism, because it caused a stir and led to the formation of university and official commissions that studied its suspect activities and thus called for its expulsion.

In Chile, before and during the government of the Popular Unity, our films were being distributed through commercial channels, as well

as being shown in factories and in the countryside. In Argentina, there have been interesting distributing experiences by organizations like the Cinema Liberation Group which distributed its materials widely among the workers.

Right now, in the present political moment, we think Ecuador is where one of the most interesting political experiences of anti-imperialist cinema is taking place. At the moment, films such as *What is Democracy?, Cerro Pelado, The Hour of the Furnaces, Compañero President, NOW, Revolution, That's the Way It Is, Blood of the Condor, The Courage of the People*, and *The Principal Enemy*, have been widely distributed in the universities and worker's centers. For reasons of cultural identity and the fact that the people of Ecuador face the same problems as the rest of Latin Americans, some of these films have reached a surprising number of viewers: in two and a half months *The Courage of the People* was seen and discussed by nearly 40,000 workers in the area of Quito alone! Based on statistics we collected and taking into account the work of distributing our films among the peasants in the countryside, we calculate that in just one year approximately 340,000 workers, peasants and students came to see the films of our group. We feel very pleased and proud that our films have reached so many people in a country as small as Ecuador. This fact is in large part due to the efforts of the Cinema Department of the Central University, to the enthusiasm of the *compañeros* of the Cinema Club of the National Polytechnic School. Both institutions have concentrated their work in the mass-based organizations and in the trade unions, but they have also brought films into the interior of the country and to the countryside. Other universities, trade unions and peasant organizations, as well as priests committed to truly helping the poor, are also openly distributing this material with an intensity that is remarkable. In the case of the films by the Ukamau Group, it is possible that factors of cultural identity, like the fact that Quechua is spoken in parts of the films, greatly influence their being accepted and widely distributed. However, we think this is due chiefly to an identification with the socio-political dilemma that these films confront. The discussions and interviews we had with viewers were characteristic: they either insisted on their identity with the problems of Bolivia and Ecuador, or they simply didn't give any importance to the question of nationality in the film and discussed it as something in its own right.

We are going to conclude this article by citing the opinions of workers and peasants who are actually seeing and demanding to see these films, but first we want to call attention to the Ecuadorian experience and call for cinema to be immediately brought to the people in

those countries where it's possible to do so. The attitude and practices of movie theaters and institutions that show these materials must change, in order to transform the static movie houses devoted to sterile pleasure, contrary to the meaning of this cinema, by using portable equipment that can be set up in factories and in communities, initiating a dialogue with the people that benefits both the viewers and those showing the film, because that relationship will change during the process of interaction itself, and also because a give-and-take exchange of information will be facilitated.

Translated by Richard Schaaf

For an Imperfect Cinema

Julio García Espinosa

Nowadays perfect cinema—technically and artistically masterful—is almost always reactionary cinema. The major temptation facing Cuban cinema at this time—when it is achieving its objective of becoming a cinema of quality, one which is culturally meaningful within the revolutionary process—is precisely that of transforming itself into a perfect cinema.

The "boom" of Latin American cinema—with Brazil and Cuba in the forefront, according to the applause and approval of the European intelligentsia—is similar, in the present moment, to the one of which the Latin American novel had previously been the exclusive benefactor. Why do they applaud us? There is no doubt that a certain standard of quality has been reached. Doubtless, there is a certain political opportunism, a certain mutual instrumentality. But without doubt there is also something more. Why should we worry about their accolades? Isn't the goal of public recognition a part of the rules of the artistic game? When it comes to artistic culture, isn't European recognition equivalent to worldwide recognition? Doesn't it serve art and our peoples as well when works produced by underdeveloped nations obtain such recognition?

Although it may seem curious, it is necessary to clarify the fact that this disquiet is not solely motivated by ethical concerns. As a matter of fact, the motivation is for the most part aesthetic, if indeed it is possible to draw such an arbitrary dividing link between the two

Michael Chanan, ed., *Twenty-Five Years of New Latin American Cinema*. London: British Film Institute, 1983, pp. 28–33. By permission of the editor.

terms. When we ask ourselves why it is we who are the film directors and not the others, that is to say, the spectators, the question does not stem from an exclusively ethical concern. We know that we are film-makers because we have been part of a minority which has had the time and the circumstances needed to develop, within itself, an artistic culture; and because the material resources of film technology are limited and therefore available to some, not to all. But what happens if the future holds the universalization of college level instruction, if economic and social development reduce the hours in the work day, if the evolution of film technology (there are already signs in evidence) makes it possible that this technology ceases being the privilege of a small few? What happens if the development of video-tape solves the problem of inevitably limited laboratory capacity, if television systems with their potential for "projecting" independently of the central studio render the ad infinitum construction of movie theatres suddenly superfluous?

What happens then is not only an act of social justice—the possibility for everyone to make films—but also a fact of extreme importance for artistic culture: the possibility of recovering, without any kind of complexes or guilt feelings, the true meaning of artistic activity. Then we will be able to understand that art is one of mankind's "impartial" or "uncommitted"[1] activities. That art is not work, and that the artist is not in the strict sense a worker. The feeling that this is so, and the impossibility of translating it into practice, constitutes the agony and at the same time the "pharisee-ism" of all contemporary art. In fact, the two tendencies exist: those who pretend to produce cinema as an "uncommitted" activity and those who pretend to justify it as a "committed" activity. Both find themselves in a blind alley.

Anyone engaged in an artistic activity asks himself at a given moment what is the meaning of whatever he is doing. The simple fact that this anxiety arises demonstrates that factors exist to motivate it—factors which, in turn, indicate that art does not develop freely. Those who persist in denying art a specific meaning feel the moral weight of their egoism. Those who, on the other hand, pretend to attribute one to it buy off their bad conscience with social generosity. It makes no difference that the mediators (critics, theoreticians, etc.) try to justify certain cases. For the contemporary artist, the mediator is like an aspirin, a tranquillizer. Like a pill, he only temporarily gets rid of the headache. The sure thing, however, is that art, like a capricious little devil, continues to show its face sporadically in no matter which tendency.

No doubt it is easier to define art by what it is not than by what it is, assuming that one can talk about closed definitions not just for art

but for any of life's activities. The spirit of contradiction permeates everything now. Nothing, and nobody lets himself be imprisoned in a picture frame, no matter how gilded. It is possible that art gives us a vision of society or of human nature and that, at the same time, it cannot be defined as a vision of society or of human nature. It is possible that a certain narcissism of consciousness—in recognizing in oneself a little historical, sociological, psychological, philosophical consciousness—is implicit in aesthetic pleasure, and at the same time that this sensation is not sufficient in itself to explain aesthetic pleasure.

Is it not much closer to the nature of art to conceive of it as having its own cognitive power? In other words, by saying that art is not the "illustration" of ideas which can also be expressed through philosophy, sociology, psychology. Every artist's desire to express the inexpressible is nothing more than the desire to express the vision of a theme in terms that are inexpressible through other than artistic means. Perhaps the cognitive power of art is like the power of a game for a child. Perhaps aesthetic pleasure lies in sensing the functionality (without a specific goal) of our intelligence and our own sensitivity. Art can stimulate, in general, the creative function of man. It can function as constant stimulus toward adopting an attitude of change with regard to life. But, as opposed to science, it enriches us in such a way that its results are not specific and cannot be applied to anything in particular. It is for this reason that we can call it an "impartial" or "uncommitted" activity, and can say that art is not strictly speaking a "job," and that the artist is perhaps the least intellectual of all intellectuals.

Why then does the artist feel the need to justify himself as a "worker," as an "intellectual," as a "professional," as a disciplined and organized man, like any other individual who performs a productive task? Why does he feel the need to exaggerate the importance of his activity? Why does he feel the need to have critics (mediators) to justify him, to defend him, to interpret him? Why does he speak proudly of "my critics"? Why does he find it necessary to make transcendental declarations, as if he were the true interpreter of society and of mankind? Why does he pretend to consider himself critic and conscience of society when (although these objectives can be implicit or even explicit in certain circumstances) in a truly revolutionary society all of us—that is to say, the people as a whole—should exercise those functions? And why, on the other hand, does the artist see himself forced to limit these objectives, these attitudes, these characteristics? Why does he at the same time set up these limitations as necessary to prevent his work from being transformed into a "tract" or a sociological essay? What is behind such pharisee-ism? Why protect oneself and

seek recognition as a (revolutionary, it must be understood) political and scientific worker, yet not be prepared to run the same risks?

The problem is a complex one. Basically, it is neither a matter of opportunism nor cowardice. A true artist is prepared to run any risk as long as he is certain that his work will not cease to be an artistic expression. The only risk which he will not accept is that of endangering the artistic quality of his work.

There are also those who accept and defend the "impartial" function of art. These people claim to be more consistent. They opt for the bitterness of a closed world in the hope that tomorrow history will justify them. But the fact is that even today not everyone can enjoy the Mona Lisa. These people should have fewer contradictions; they should be less alienated, but in fact it is not so, even though such an attitude gives them the possibility of an alibi which is more productive on a personal level. In general they sense the sterility of their "purity" or they dedicate themselves to waging corrosive battles, but always on the defensive. They can even, in a reverse operation, reject their interest in finding tranquillity, harmony, a certain compensation in the work of art, expressing instead disequilibrium, chaos, and uncertainty which also becomes the objective of "impartial" art.

What is it, then, which makes it impossible to practice art as an "impartial" activity? Why is this particular situation today more sensitive than ever? From the beginning of the world as we know it, that is to say, since the world was divided into classes, this situation has been latent. If it has grown sharper today it is precisely because today the possibility of transcending it is coming into view. Not through a *prise de conscience*, not through the expressed determination of any particular artist, but because reality itself has begun to reveal symptoms (not at all utopian) which indicate that "in the future there will no longer be painters, but rather men who, among other things, dedicate themselves to painting" (Marx).

There can be no "impartial" or "uncommitted" art, there can be no new and genuine qualitative jump in art, unless the concept and the reality of the "elite" is done away with once and for all. Three factors incline us toward optimism: the development of science, the social presence of the masses, and the revolutionary potential in the contemporary world. All three are without hierarchical order, all three are interrelated.

Why is science feared? Why are people afraid that art might be crushed under the obvious productivity and utility of science? Why this inferiority complex? It is true that today we read a good essay with much greater pleasure than a novel. Why do we keep repeating then, horrified, that the world is becoming more mercenary, more util-

itarian, more materialistic? Is it not really marvelous that the development of science, sociology, anthropology, psychology, is contributing to the "purification" of art? The appearance, thanks to science, of expressive media like photography and film made a greater "purification" of painting and the theatre possible without invalidating them artistically in the least. Doesn't modern-day science render anachronistic so much "artistic" analysis of the human soul? Doesn't contemporary science allow us to free ourselves from so many fraudulent films, concealed behind what has been called the world of poetry? With the advance of science, art has nothing to lose; on the contrary, it has a whole world to gain. What, then, are we so afraid of? Science strips art bare and it seems that it is not easy to go naked through the streets.

The real tragedy of the contemporary artist lies in the impossibility of practicing art as a minority activity. It is said—and correctly—that art cannot exercise its attraction without the co-operation of the subject. But what can be done so that the audience stops being an object and transforms itself into the subject?

The development of science, of technology, of the most advanced social theory and practice, has made possible as never before the active presence of the masses in social life. In the realm of artistic life, there are more spectators now than at any other moment in history. This is the first stage in the abolition of "elites." The task currently at hand is to find out if the conditions which will enable spectators to transform themselves into agents—not merely more active spectators, but genuine co-authors—are beginning to exist. The task at hand is to ask ourselves whether art is really an activity restricted to specialists, whether it is, through extra-human design, the option of a chosen few or a possibility for everyone.

How can we trust the perspectives and possibilities of art simply to the education of the people as a mass of spectators? Taste as defined by "high culture," once it is "overdone," is normally passed on to the rest of society as leftovers to be devoured and ruminated over by those who were not invited to the feast. This eternal spiral has today become a vicious circle as well. "Camp" and its attitude toward everything outdated is an attempt to rescue these leftovers and to lessen the distance between high culture and the people. But the difference lies in the fact that camp rescues it as an aesthetic value, while for the people the values involved continue to be ethical ones.

Must the revolutionary present and the revolutionary future inevitably have "its" artists and "its" intellectuals, just as the bourgeoisie had "theirs"? Surely the truly revolutionary position, from now on, is to contribute to overcoming these elitist concepts and practices, rather

than pursuing *ad eternum* the "artistic quality" of the work. The new outlook for artistic culture is no longer that everyone must share the taste of a few, but that all can be creators of that culture. Art has always been a universal necessity; what it has not been is an option for all under equal conditions. Parallel to refined art, popular art has had a simultaneous but independent existence.

Popular art has absolutely nothing to do with what is called mass art. Popular art needs and consequently tends to develop the personal, individual taste of a people. On the other hand, mass art (or art for the masses), requires the people to have no taste. It will only be genuine when it is actually the masses who create it, since at present it is art produced by a few for the masses. Grotowski says that today's theatre should be a minority art form because mass art can be achieved through cinema. This is not true. Perhaps film is the most elitist of all the contemporary arts. Film today, no matter where, is made by a small minority for the masses. Perhaps film will be the art form which takes the longest time to reach the hands of the masses, when we understand mass art as *popular* art, art created by the masses. Currently, as Hauser points out, mass art is art produced by a minority in order to satisfy the demand of a public reduced to the sole role of spectator and consumer.

Popular art has always been created by the least learned sector of society, yet this "uncultured" sector has managed to conserve profoundly cultured characteristics of art. One of the most important of these is the fact that the creators are at the same time the spectators and vice versa. Between those who produce and those who consume, no sharp line of demarcation exists. Cultivated art, in our era, has also attained this situation. Modern art's great dose of freedom is nothing more than the conquest of a new interlocutor: the artist himself. For this reason it is useless to strain oneself struggling for the substitution of the masses as a new and potential spectator for the bourgeoisie. This situation, maintained by popular art, adopted by cultivated art, must be dissolved and become the heritage of all. This and no other must be the great objective of an authentically revolutionary artistic culture.

Popular art preserved another even more important cultural characteristic: it is carried out as but another life activity. With cultivated art, the reverse is true; it is pursued as a unique, specific activity, as a personal achievement. This is the cruel price of having had to maintain artistic activity at the expense of its inexistence among the people. Hasn't the attempt to realize himself on the edge of society proved to be too painful a restriction for the artist and for art itself? To posit art as a sect, as a society within society, as the promised land

where we can fleetingly fulfill ourselves for a brief instant—doesn't this create the illusion that self-realization on the level of consciousness also implies self-realization on the level of existence? Isn't this patently obvious in contemporary circumstances? The essential lesson of popular art is that it is carried out as a life activity: man must not fulfill himself as an artist but fully; the artist must not seek fulfillment as an artist but as a human being.

In the modern world, principally in developed capitalist nations and in those countries engaged in a revolutionary process, there are alarming symptoms, obvious signs of an imminent change. The possibilities for overcoming this traditional dissociation are beginning to arise. These symptoms are not a product of consciousness but of reality itself. A large part of the struggle waged in modern art has been, in fact, to "democratize" art. What other goal is entailed in combating the limitations of taste, museum art, and the demarcation lines between the creator and the public? What is considered beauty today, and where is it found? On Campbell soup labels, in a garbage can lid, in gadgets? Even the eternal value of a work of art is today being questioned. What else could be the meaning of those sculptures, seen in recent exhibitions, made of blocks of ice which melt away while the public looks at them? Isn't this—more than the disappearance of art—the attempt to make the spectator disappear? Don't those painters who entrust a portion of the execution of their work to just anyone, rather than to their disciples, exhibit an eagerness to jump over the barricade of "elitist" art? Doesn't the same attitude exist among composers whose works allow their performers ample liberty?

There's a widespread tendency in modern art to make the spectator participate ever more fully. If he participates to a greater and greater degree, where will the process end up? Isn't the logical outcome—or shouldn't it in fact be—that he will cease being a spectator altogether? This simultaneously represents a tendency toward collectivism and toward individualism. Once we admit the possibility of universal participation, aren't we also admitting the individual creative potential which we all have? Isn't Grotowski mistaken when he asserts that today's theatre should be dedicated to an elite? Isn't it rather the reverse: that the theatre of poverty in fact requires the highest refinement? It is the theatre which has no need for secondary values: costumes, scenery, make-up, even a stage. Isn't this an indication that material conditions are reduced to a minimum and that, from this point of view, the possibility of making theatre is within everyone's reach? And doesn't the fact that the theatre has an increasingly smaller public mean that conditions are beginning to ripen for it to transform itself into a true mass theatre? Perhaps the tragedy of the

theatre lies in the fact that it has reached this point in its evolution too soon.

When we look toward Europe, we wring our hands. We see that the old culture is totally incapable of providing answers to the problems of art. The fact is that Europe can no longer respond in a traditional manner but at the same time finds it equally difficult to respond in a manner that is radically new. Europe is no longer capable of giving the world a new "ism"; neither is it in a position to put an end to "isms" once and for all. So we think that our moment has come, that at last the underdeveloped can deck themselves out as "men of culture." Here lies our greatest danger and our greatest temptation. This accounts for the opportunism of some on our continent. For, given our technical and scientific backwardness and given the scanty presence of the masses in social life, our continent is still capable of responding in a traditional manner, by reaffirming the concept and the practice of elite art. Perhaps in this case the real motive for the European applause which some of our literary and cinematic works have won is none other than a certain nostalgia which we inspire. After all, the European has no other Europe to turn to.

The third factor, the revolution—which is the most important of all —is perhaps present in our country as nowhere else. This is our only true chance. The revolution is what furnishes all other alternatives, what can supply an entirely new response, what enables us to do away once and for all with elitist concepts and practices in art. The revolution and the ongoing revolutionary process are the only factors which make the total and free presence of the masses possible—and this will mean the definitive disappearance of the rigid division of labor and of a society divided into sectors and classes. For us, then, the revolution is the highest expression of culture because it will abolish artistic culture as a fragmentary human activity.

Current responses to this inevitable future, this incontestable prospect, can be as numerous as the countries on our continent. Because characteristics and achieved levels are not the same, each art form, every artistic manifestation, must find its own expression. What should be the response of the Cuban cinema in particular? Paradoxically, we think it will be a new poetics, not a new cultural policy. A poetics whose true goal will be to commit suicide, to disappear as such. We know, however, that in fact other artistic conceptions will continue to exist among us, just as small rural landholdings and religion continue to exist.

On the level of cultural policy we are faced with a serious problem: the film school. Is it right to continue developing a handful of film specialists? It seems inevitable for the present, but what will be the

eternal quarry that we continue to mine: the students in Arts and Letters at the University? But shouldn't we begin to consider right now whether that school should have a limited lifespan? What end do we pursue there—a reserve corps of future artists? Or a specialized future public? We should be asking ourselves whether we can do something now to abolish this division between artistic and scientific culture.

What constitutes in fact the true prestige of artistic culture, and how did it come about that this prestige was allowed to appropriate the whole concept of culture? Perhaps it is based on the enormous prestige which the spirit has always enjoyed at the expense of the body. Hasn't artistic culture always been seen as the spiritual part of society while scientific culture is seen as its body? The traditional rejection of the body, of material life, is due in part to the concept that things of the spirit are more elevated, more elegant, serious, and profound. Can't we, here and now, begin doing something to put an end to this artificial distinction? We should understand from here on in that the body and the things of the body are also elegant, and that material life is beautiful as well. We should understand that, in fact, the soul is contained in the body just as the spirit is contained in material life, just as—to speak in strictly artistic terms—the essence is contained in the surface and the content in the form.

We should endeavor to see that our future students, and therefore our future filmmakers, will themselves be scientists, sociologists, physicians, economists, agricultural engineers, etc., without of course ceasing to be filmmakers. And, at the same time, we should have the same aim for our most outstanding workers, the workers who achieve the best results in terms of political and intellectual formation. We cannot develop the taste of the masses as long as the division between the two cultures continues to exist, nor as long as the masses are not the real masters of the means of artistic production. The revolution has liberated us as an artistic sector. It is only logical that we contribute to the liberation of the private means of artistic production.

A new poetics for the cinema will, above all, be a "partisan" and "committed" poetics, a "committed" art, a consciously and resolutely "committed" cinema—that is to say, an "imperfect" cinema. An "impartial" or "uncommitted" one, as a complete aesthetic activity, will only be possible when it is the people who make art. But today art must assimilate its quota of work so that work can assimilate its quota of art.

The motto of this imperfect cinema (which there's no need to invent, since it already exists) is, as Glauber Rocha would say, "We are not interested in the problems of neurosis; we are interested in the problems of lucidity." Art no longer has use for the neurotic and his

problems, although the neurotic continues to need art—as a concerned object, a relief, an alibi or, as Freud would say, as a sublimation of his problems. A neurotic can produce art, but art has no reason to produce neurotics. It has been traditionally believed that the concerns of art were not to be found in the sane but in the sick, not in the normal but in the abnormal, not in those who struggle but in those who weep, not in lucid minds but in neurotic ones. Imperfect cinema is changing this way of seeing the question. We have more faith in the sick man than in the healthy one because his truth is purged by suffering. However, there is no need for suffering to be synonymous with artistic elegance. There is still a trend in modern art—undoubtedly related to Christian tradition—which identifies seriousness with suffering. The specter of Marguerite Gautier still haunts artistic endeavor in our day. Only in the person who suffers do we perceive elegance, gravity, even beauty; only in him do we recognize the possibility of authenticity, serious- ness, sincerity. Imperfect cinema must put an end to this tradition.

Imperfect cinema finds a new audience in those who struggle, and it finds its themes in their problems. For imperfect cinema, "lucid" people are the ones who think and feel and exist in a world which they can change; in spite of all the problems and difficulties, they are convinced that they can transform it in a revolutionary way. Imperfect cinema therefore has no need to struggle to create an "audience." On the contrary, it can be said that at present a greater audience exists for this kind of cinema than there are filmmakers able to supply that audience.

What does this new interlocutor require of us—an art full of moral examples worthy of imitation? No. Man is more of a creator than an innovator. Besides, he should be the one to give *us* moral examples. He might ask us for a fuller, more complete work, aimed—in a sepa- rate or co-ordinated fashion—at the intelligence, the emotions, the powers of intuition.

Should he ask us for a cinema of denunciation? Yes and no. No, if the denunciation is directed toward the others, if it is conceived that those who are not struggling might sympathize with us and increase their awareness. Yes, if the denunciation acts as information, as testi- mony, as another combat weapon for those engaged in the struggle. Why denounce imperialism to show one more time that it is evil? What's the use if those now fighting are fighting primarily against im- perialism? We can denounce imperialism, but should strive to do it as a way of proposing concrete battles. A film which denounces, to those who struggle, the evil deeds of an official who must be brought to jus- tice would be an excellent example of this kind of film-denunciation.

We maintain that imperfect cinema must above all show the process which generates the problems. It is thus the opposite of a cinema principally dedicated to celebrating results, the opposite of a self-sufficient and contemplative cinema, the opposite of a cinema which "beautifully illustrates" ideas or concepts which we already possess. (The narcissistic posture has nothing to do with those who struggle.) To show a process is not exactly equivalent to analyzing it. To analyze, in the traditional sense of the word, always implies a closed prior judgment. To analyze a problem is to show the problem (not the process) permeated with judgments which the analysis itself generates a priori. To analyze is to block off from the outset any possibility for analysis on the part of the interlocutor.

To show the process of a problem, on the other hand, is to submit it to judgment without pronouncing the verdict. There is a style of news reporting which puts more emphasis on the commentary than on the news item. There is another kind of reporting which presents the news and evaluates it through the arrangement of the item on the page or by its position in the paper. To show the process of a problem is like showing the very development of the news item, without commentary; it is like showing the multifaced evolution of a piece of information without evaluating it. The subjective element is the selection of the problem, conditioned as it is by the interest of the audience—which is the subject. The objective element is showing the process—which is the object.

Imperfect cinema is an answer, but it is also a question which will discover its own answers in the course of its development. Imperfect cinema can make use of the documentary or the fictional mode, or both. It can use whatever genre, or all genres. It can use cinema as a pluralistic art form or as a specialized form of expression. These questions are indifferent to it, since they do not represent its real alternatives or problems, and much less its real goals. These are not the battles or the polemics it is interested in sparking.

Imperfect cinema can also be enjoyable, both for the maker and for its new audience. Those who struggle do not struggle on the edge of life, but in the midst of it. Struggle is life and vice versa. One does not struggle in order to live "later on." The struggle requires organization—the organization of life. Even in the most extreme phase, that of total and direct war, the organization of life is equivalent to the organization of the struggle. And in life, as in the struggle, there is everything, including enjoyment. Imperfect cinema can enjoy itself despite everything which conspires to negate enjoyment.

Imperfect cinema rejects exhibitionism in both (literal) senses of the word, the narcissistic and the commercial (getting shown in estab-

lished theatres and circuits). It should be remembered that the death of the star-system turned out to be a positive thing for art. There is no reason to doubt that the disappearance of the director as star will offer similar prospects. Imperfect cinema must start work now, in co-operation with sociologists, revolutionary leaders, psychologists, economists, etc. Furthermore, imperfect cinema rejects whatever services criticism has to offer and considers the function of mediators and intermediaries anachronistic.

Imperfect cinema is no longer interested in quality or technique. It can be created equally well with a Mitchell or with an 8mm camera, in a studio or in a guerrilla camp in the middle of the jungle. Imperfect cinema is no longer interested in predetermined taste, and much less in "good taste." It is not quality which it seeks in an artist's work. The only thing it is interested in is how an artist responds to the following question: What are you doing in order to overcome the barrier of the "cultured" elite audience which up to now has conditioned the form of your work?

The filmmaker who subscribes to this new poetics should not have personal self-realization as his object. From now on he should also have another activity. He should place his role as revolutionary or aspiring revolutionary above all else. In a word, he should try to fulfill himself as a man and not just as an artist. Imperfect cinema cannot lose sight of the fact that its essential goal as a new poetics is to disappear. It is no longer a matter of replacing one school with another, one "ism" with another, poetry with anti-poetry, but of truly letting a thousand different flowers bloom. The future lies with folk art. But let us no longer display folk art with demagogic pride, with a celebrative air. Let us exhibit it instead as a cruel denunciation, as a painful testimony to the level at which the peoples of the world have been forced to limit their artistic creativity. The future, without doubt, will be with folk art, but then there will be no need to call it that, because nobody and nothing will any longer be able to paralyze again the creative spirit of the people.

Art will not disappear into nothingness; it will disappear into everything.

Translated by Julianne Burton

Note

1. *Una actividad desinteresada* in the original.

Meditations on Imperfect Cinema . . . Fifteen Years Later

Julio García Espinosa

Some years ago, around 1969, when we finally began to accomplish films that were well-made and coherent, I wanted to do some thinking aloud, with the idea of stimulating an internal discussion about the danger of turning out well-made films which went no further, and didn't develop more substantial changes within existing dramaturgy. As I had always believed that new content requires new forms, I put this analysis into the essay entitled "For an Imperfect Cinema."[1]

Many people thought it was about making bad films. In truth, the essay allowed people to think this because to some extent there are indeed times when a documentary on what's going on in El Salvador or Guatemala, although badly made, can be more important from a cultural point of view than a film which is, as we used to say, well-made. But this wasn't the only issue. I have to confess that perhaps we also had a sensation of impotence in the face of large-scale technology, the whole technical development involved in cinema made with lots of resources. But at the basis of the question there was a dilemma: either you tried to make an artistic cinema, estranged from a public which had the potential for substantially changing reality, and these films would then be sent to the cinémathèques and become part of an anthology of great films; or you made films which posed, let's say, the denunciation of a reality disguised by aesthetics, and which finally spoke to our exposed innards. And I have always thought that the spectator ends up not irritated but enjoying the aesthetic pleasure

Screen, vol. 26, nos. 3–4, 1985, pp. 93–94. By permission of the publisher and Michael Chanan.

offered by films—I'm really talking about fictional cinema—which
denounce particular situations. There are a great number of war films
with pretensions of denouncing war which at the same time are great
spectacles of war; and in the end the spectacle is what you enjoy
about them. So to speak clearly: art is essentially a disinterested activ-
ity, but if we're in a phase when we have to express interests, then
let's do it openly and not continue to camouflage it. And therefore, if
art is substantially a disinterested activity and we're obliged to do it in
an interested way, it becomes an imperfect art. In essence, this is how
I use the word imperfect. And this I think isn't just an ethical matter,
but also aesthetic.

This is what I posed at the end of the '60s, and personally I think it
still applies. For myself, if I had the chance of producing cinema, I'd
carry on doing it with facts rather than words, and this is the path I'd
try to follow. I am inclined to say that we have three key problems.
The problem of the addressee: nearly always we make films for an
addressee, that's to say, a public, that isn't the one that is participating
in the changes, or isn't even potentially able to do so. That's to say,
it's a public that has no awareness yet, to whom we address our prod-
ucts, hoping that it will become conscious and participate with those
who are making changes. And it has always seemed to me more effec-
tive, if this unaware public should become aware, to dedicate our
production to those who are indeed struggling, who are indeed in the
course of producing changes. I think that by defining this addressee
properly, it improves the chances of a much more consequential dra-
maturgy.

Then there was the question of quality. What exactly is quality?
And what is modernity in the cinema? When we talk about life, we
can certainly talk about, say, the quality of a city, say Paris. This is
not a city which can serve us well as a model for what cities have to
be like, neither Paris, nor New York, nor any overdeveloped city. But
I might well find the quality of a city like Hanoi much more to the
point; I can find in the midst of all the imperfections of a city like
Hanoi, more elements of quality in terms of human beings than what
we used to think of as the qualities of Paris or New York. I believe it
is similar in the case of the qualities of cinema, in relation to contem-
poraneity and authenticity: that of producing an image without make-
up that is nonetheless more attractive. I think that the attitude of going
to the realities is what produces modernity and contemporaneity in the
cinema. What does it mean for a film to be modern? Often it's mod-
ern because of its photography, or its montage, its rhythm—I mean
exactly what gives a film modernity. And I think that the path we're
travelling is the search for modernity which goes beyond the theme of

the film. And I believe this is a path which has to become ever more consequential.

There are also other problems which greatly affect this search for what I called imperfect cinema—and this includes what I have called the economy of waste, basically created above all by the great countries of developed capitalism, which try to incite us to unnecessary consumption. So much so that in recent meetings with Latin American filmmakers, we've seen that the problem is no longer whether we're socialist or capitalist. That's to say, on the one hand are the capitalists and they're able to stay capitalist as long as they consume what is produced by the world centers of capitalism. But when those underdeveloped countries want to produce for themselves as well, then they won't let them be capitalist. And this is a system which carries with it a great waste of resources, of labor power and primary materials. I think that one of the most rigorous means we should use to analyze works of art, in this case of cinema, is the question of up to what point a work of art contributes towards eliminating the culture of waste.

Our countries, that is, the underdeveloped countries, aspire to one day leaving underdevelopment behind; but in spite of planting the idea of a new economic order, these countries cannot aspire to reach the level of the most highly developed countries of the capitalist world. They will never reach this level because this level can only be occupied by so many millions of people in the world. It cannot be an answer for all the inhabitants of the globe. Yet there are people who have suffered great scarcities who think that this is the goal they have to reach. When we talk about a new economic order, we have to accompany it with a new cultural order, of a new position towards a culture which can help to create a mentality that will truly understand what the new economic order means, which is not the artificially high levels of consumption of the developed countries of capitalism. And this is also, to my understanding, part of the idea to which I gave the confusing name of imperfect cinema.

Translated by Michael Chanan

Note

1. See the preceding essay in this volume.

Cinema and Underdevelopment

Fernando Birri

The following answers should all be understood and very concretely so, as concerned with a sub-cinematography, that of Argentina and the region of underdeveloped Latin America of which it is a part. Furthermore, they reflect the point of view of a film director from a capitalist and neocolonialist country, the opposite pole from the situation in Cuba.

What Kind of Cinema Does Argentina Need?
What Kind of Cinema Do the Underdeveloped
Peoples of Latin America Need?

A cinema which develops them.

A cinema which brings them consciousness, which awakens consciousness; which clarifies matters; which strengthens the revolutionary consciousness of those among them who already possess this; which fires them; which disturbs, worries, shocks and weakens those who have a "bad conscience," a reactionary consciousness; which defines profiles of national, Latin American identity; which is authentic; which is anti-oligarchic and anti-bourgeois at the national level, and anti-colonial and anti-imperialist at the international level; which is pro-people, and anti-anti-people; which helps the passage from underdevelopment to development, from sub-stomach to stomach, from sub-

Michael Chanan, ed., *Twenty-Five Years of New Latin American Cinema*. London: British Film Institute, 1983, pp. 9–12. By permission of the editor.

culture to culture, from sub-happiness to happiness, from sub-life to life.

Our purpose is to create a new person, a new society, a new history and therefore a new art and a new cinema. Urgently.

And with the raw material of a reality which is little and badly understood: that of the underdeveloped countries of Latin America (or, if you prefer the euphemism favored by the Organization of American States, the developing countries of Latin America). Understanding— or, rather, misunderstanding—of these countries has always come about by applying analytical schemes imposed by foreign colonialists or their local henchmen (whose particular mentality has deformed such ideas even further).

What Kind of Cinema Does Argentina Have at the Moment?

One with a solid industrial tradition, whose Golden Age was in the 30s and 40s (Lucas Demare's *La Guerra Gaucha*, for example). It conquered the markets of Latin America, then prostituted itself under Peronism, before recovering once again, culturally speaking, under the guidance of Torre Nilsson, during the so-called "revolution of liberation" (actually a military dictatorship). It then evolved into an independent movement in which the left began to play a role. This development coincided with Frondizi's rise to power in 1961–2, when more than fifteen new feature directors and many more directors of shorts took their places in the national cinema. After the 1962 *frondizazo*, however, and during the provisional presidency of Guido, such independent efforts turned in on themselves, and "dependent" production became dominant once again. Only one independent film was made, Manuel Antín's *Los venerables todos*, the very epitome of alienation.

The problem is that cinema is a cultural product, a product of the superstructure. So it is subject to all the superstructure's distortions. In the case of cinema these are exacerbated further than in the other arts due to its nature as an industrial art. In countries like ours, which are in the throes of incipient industrialization, political shocks make this condition chronic.

Furthermore, cinema is a language. A language, like others, which enables communication and expression at both the mass and personal levels. Here as well things get out of balance as bourgeois attitudes— which are either reactionary or, at best, liberal and always sub-cultural —typically give most attention to the "cinema of expression." This cinema (typified by Torre Nilsson) is set in opposition to "commer-

cial" cinema (such as that of Amadori, Demare or Tynaire). At its
height, in 1955, this opposition became a veritable battle within the
structures of bourgeois culture. "Expression" won—and now where
are we? What and who is to benefit from such "expression" (à la
Torre Nilsson, Kohon, Kuhn, Antín)? The navel of Buddha? "Com-
mercial" cinema has won its audience by any method going; or more
precisely, the worst methods going. We cannot support it. The "cin-
ema of expression" uses the best methods, and scorns the mass audi-
ence. We cannot support it either. Once again, the contradiction
between art and industry is resolved very badly, except for the
"select" minority which makes up the audience of the "cinema of ex-
pression," for whom such a solution is perfectly satisfactory.

We have already pointed out that cinema manifests the cultural and
economic values of society's superstructure. Neither its generic lack
of culture nor its economic precariousness precludes it from these cat-
egories. Argentina, Latin America, 1963: a bourgeois superstructure,
semi-colonial and underdeveloped. Its cinema, therefore, expresses
these conditions, consciously or unconsciously if it favors them, al-
ways consciously if it is against.

This is the fact of the matter, and there is no way round it, like it
or not, and whether or not we care to recognize it. It is true wherever
you look, from Lucas Demare and Torre Nilsson, as representatives of
those in favor, to the short filmmakers Oliva and Fisherman, new di-
rectors who have declared themselves against.

For the first group, those who are consciously or unconsciously in
favor of the existing order of things, no problem arises. The super-
structure keeps them, pampers them, and gives them official credits,
prizes, national exhibition, "Argentinian Film Weeks" abroad, interna-
tional festivals, travel as representatives of national culture, and press
coverage of their triumphs and supposed triumphs (in its local news-
papers an anxious but finally negative European criticism transforms a
failure into "a polemical and very worthy film," as happened with An-
tín's *Los venerables todos* in Cannes in 1963, or Nilsson's *Homenaje
a la hora de la siesta* in Venice in 1962). The superstructure serves
them, when all is said and done, as a pedestal. A fragile enough ped-
estal for eternal glory, you may admonish us. Certainly, but mean-
while, down here, in the here-and-now, it keeps them able to produce
films.

The only problems these directors have ever had to face have come
from personal rivalry or, at worst, from the irrational infraction of
some ultramontane moral taboo (as in the case of Beatriz Guido, for
example) to do with sex or violence, never from any "political" of-
fense. Such sins were rapidly forgiven, like those of prodigal children,

when from 1957 onwards new and independent currents began to appear in our national cinema, pursuing not expression but ideas. Among those representing these currents were Murúa, Feldman, Martínez Suárez, Alventosa, the Institute of Cinematography at the National University of the Litoral, sectors of the Association of Short Film Directors, Cinema Workshops, the Association of Experimental Cinema, the Nucleus Cinema Club, *Cinecritica* magazine, the writer of this article.

Given This Situation, How and Why Was the Institute of Cinematography at the National University of the Litoral Formed?

Today the Institute of Cinematography is a material fact. But in 1956 it was only an idea.

This idea was born at a time when Argentinian cinematography was disintegrating, both culturally and industrially. It affirmed a goal and a method. The goal was realism. The method was training based in theory and practice.

To locate this goal historically, remember that the dominant characteristic of Argentinian cinema at that time was precisely its "unrealism." This was true of both its extremes. The opportunism of the numerous box-office hits (such as those of the main studio Argentina Sono Films, or the Demare-Pondal Ríos *Despues del silencio*, or *chanchada* comedies) and the evasiveness of the few "intellectualized" films (Torre Nilsson's *La casa del angel*, Ayala's *El jefe*) made the cinematographic images of the country they presented to audiences equally unreal and alien. Popular and art cinema were falsely made out to be irreconcilable opposites, when what were actually being discussed were "commercial" and "elitist" cinema.

Our objective was a realism which would transcend this tendentious duality. In it we were joined by other non-cinematic groups all of whom shared the aspiration towards an art which would be simultaneously popular and of high quality.

To locate our method historically, remember that the national cinema industry had always been founded on the purest empiricism, usually manifest in a frustrating degree of improvisation.

Remember also that at this time there was not even a plan for a National Film School, despite the inclusion of the idea in the 1957 Decree Law 62 (it was not carried through). The teaching facilities which did exist made no impact on the industry itself, much less on public opinion.

We should be wary of schematic generalization, for there were exceptions which proved the rule and we must give credit to the significant positive moments on the curve of the old national cinema (such as Mario Soffici's *Prisioneros de la tierra*, or Hugo del Carril's *Las aguas bajan turbias*). But any objective analysis must finally lead to the general negative conclusion recorded here.

The goal and method I have described, those of a realist cinematography and a theoretico-practical training, came together polemically in the Documentary School at Santa Fe. They did so as a simultaneously critical and constructive contribution—or constructively critical, if you prefer—to national cinema, and as a response to a need for national transformation which we believe exists throughout Latin America, given the continent's common condition of underdevelopment.

It was these artistic principles which inspired our work from *Tire Dié*, the Institute's first film of social inquiry, to *Los inundados*, our first fictional feature, which synthesized our experience. On the way we also made *Los 40 cuartos*, a documentary which was banned and whose prints and negative were confiscated under the 1959 Decree 4965, which was passed by provisional President Guido to suppress "insurrectionary activities." This banning and confiscation remain in force to the present day. *Los inundados* synthesizes the experience of the Institute, enlarging its scope and giving it its fullest expression both professionally and as entertainment, in the best senses of these terms. For these reasons, and because it answers to the founding intentions of the Santa Fe Documentary School, both experimental and academic, this film bears the responsibility of being our movement's manifesto, carried forth under the banner of a national cinematography which is "realist, critical and popular."

What Are the Future Perspectives for Latin American Cinema?

Seen from the general perspective of developments in cinema, and given that this is an Argentinian film, a Latin American film, the most important thing right now if we are to ensure such a future is that the film should be seen. In other words, the most important thing is exhibition and distribution.

The starting point for this statement is the fact that our films are not seen by the public, or are only seen with extreme difficulty. This happens—and we denounce the fact—not because of the films themselves or our public, but because the films are systematically boycotted by both national and international distributors and exhibitors, who are linked to the anti-national and colonial interests of foreign produc-

ers, above all those of North American cinema and the monopoly it has imposed on us. Of about 500 films shown in 1962, 300 were in English, and most of them North American, while some 30 were Argentinian.

An additional fact: Latin America has a potential market of 200 million spectators, more than enough to provide a natural market for our films. It would save us the effort of sporadic entry into other markets, and the outlay of hard currency which is being drained away in importing mediocre foreign films.

The urgent need, and only firm solution, must therefore be to guarantee the distribution and exhibition of nationally produced films in each of our countries individually, and in Latin America as a whole. This must come about through government action. The procedures may be different, but in the same way that a government can cancel an oil contract so, for the same reasons of the social good and with the same authority, that same government can and should regulate the prejudicial cultural and economic exploitation that comes with the uncontrolled flow of foreign films into its territory. Exhibitors and distributors justify their permanent blocking of nationally produced films by appealing to the spectator's right to choose what films he or she wishes to see. But this free-market sophism omits one small detail: that for an audience to choose a film, it must first be exhibited, which generally does not happen with national films, or does so only in appalling conditions. State aid, bank credits, and prizes are also means of stimulating the development of Latin American cinema, so long as inflation is avoided by making ticket-receipts the basis of the system. Film must be funded by its audience. As well as maintaining financial health, the fact that the audience pays for its tickets confirms its interest in the film, and keeps filmmakers committed to their audience.

Such a solution must be complemented by a reduction in non-essential industrial costs. We must have low-cost production. This may not provide an overall or permanent solution but it is at the very least the beginning of a solution in current circumstances. If it is valid for independent production in developed countries, it is even more so in underdeveloped countries. Such a formula would protect the independent producer from the fluctuations of recovering capital in a market where income from nationally produced films is uncertain. Furthermore, a more rapid recovery of production costs would allow the possibility of continuous investment in new productions. Low costs would also allow participation by non-state capital, which would free the filmmaker of all, or almost all, dependence on official credits, which restrict freedom, and always bring with them censorship and self-censorship. This kind of production also renews expressive

creativity, because it requires the replacement of the traditional crew
by a more functional method of operation, adapted to the actual condi-
tions of filming. Such a conception and practice of making films not
with the resources one would like but with those which are possible,
will determine a new kind of language, hopefully even a new style,
the fruit of convergent economic and cultural necessity. We Latin
American filmmakers must transform all such technical limitations
into new expressive possibilities, if we are not to remain paralyze by
them.

In the same way, the moment has come not only to oblige the
"commercial" circuits to carry national films, but also to set up
"independent" circuits in trade unions, schools, neighborhood associa-
tions, sports centers and in the countryside through mobile projection
units. A circuit based in existing grass-roots organizations, where
films can be shown which, because they are openly didactic (or docu-
mentary) or ideologically progressive, come up against the greatest re-
sistance from "commercial" distributors and exhibitors.

For What Audience Do You Yourself Make Films?

Having set aside any residual notions of "art for art's sake," and com-
mitted ourselves to "useful" creation, we find our intention of the last
few years, that of making films not for ourselves but for the audience,
is no longer enough. Following our most recent experience, which
was our first with a fictional feature shown to a so-called "ordinary"
or "commercial" audience, we can no longer put off defining the audi-
ence—or, more precisely, the *class* of audience, in the economic and
historical sense of the term—for whom we are making our films.

We'll not delay the answer. We are making our films for a work-
ing-class audience, both urban and rural. This is our most fundamental
purpose. Let us spell it out very clearly. We are interested in making
our future films *only* if they reach a working-class and peasant audi-
ence, an audience made up of workers from the existing industrial
belts of our great cities, the urban and suburban proletariat in areas of
newer industrialization, and peasants, small farmers and herdsmen on
both small immigrant farms and large estates belonging to the oligar-
chy (where film, if it speaks the people's own language, can be a
means of culture of unequalled impact, given existing rates of liter-
acy). Then, having made this clear, let us add that we also wish to
reach sections of the petty bourgeoisie and even of the bourgeoisie
proper (the so-called "national bourgeoisie"), including them in the
audience for this new cinema which seeks to awaken consciousness,
and which is directed towards spectators who are open to being en-

lightened and also to working out matters for themselves in a new light.

But I am talking about Argentina as it is now, where there is no such cinema and no national cinema to stimulate the gathering together of such an audience, and where even if such a cinema did exist there would be nowhere to show it.

As for the rest of Latin America, we would say from what we know of it that the audience which interests us—I should say, which preoccupies us—will be made up of the same sections of the population everywhere, depending on variations in the degree of backwardness or development in each country, or whether it is dominated by an agricultural and rural economy, or is in the process of industrialization. To conjure away any fetishes which may make this proposal seem utopian, we would recall that the audience which already sees our "national films"—which are so scorned by the bourgeoisie and only accepted with reservations by the petty-bourgeoisie—is in its great majority already made up of the kinds of people we have described. But there is an urgent need here for large-scale market research, complete with tables and social statistics. Even in our country we still lack such research. It must be one of the priority tasks of the CLAC (Latin American Cinematography Centre) as it documents, analyzes and plans film production.

What Is the Revolutionary Function of Cinema in Latin America?

Underdevelopment is a hard fact in Latin America. It is an economic and statistical fact. No invention of the left, the term is used as a matter of course by "official" international organizations, such as the UN, or Latin American bodies, such as the OAS or the ECLA, in their plans and reports. They have no alternative.

The cause of underdevelopment is also well known: colonialism, both external and internal.

The cinema of our countries shares the same general characteristics of this superstructure, of this kind of society, and presents us with a false image of both society and our people. Indeed, it presents no real image of our people at all, but conceals them. So, the first positive step is to provide such an image. This is the first function of documentary.

How can documentary provide this image? By showing how reality *is*, and in no other way. This is the revolutionary function of social documentary and realist, critical and popular cinema in Latin America. By testifying, critically, to this reality—to this sub-reality, this

misery—cinema refuses it. It rejects it. It denounces, judges, criticizes and deconstructs it. Because it shows matters as they irrefutably are, and not as we would like them to be (or as, in good or bad faith, others would like to make us believe them to be).

As the other side of the coin of this "negation," realist cinema also affirms the positive values in our societies: the people's values. Their reserves of strength, their labors, their joys, their struggle, their dreams.

The result—and motivation—of social documentary and realist cinema? Knowledge and consciousness; we repeat: the awakening of the consciousness of reality. The posing of problems. Change: from sub-life to life.

Conclusion: to confront reality with a camera and to document it, filming realistically, filming critically, filming underdevelopment with the optic of the people. For the alternative, a cinema which makes itself the accomplice of underdevelopment, is sub-cinema.

Translated by Malcolm Coad

For a Nationalist, Realist, Critical and Popular Cinema

Fernando Birri

The new Latin American cinema, which we continue to call "new" in order to exorcise any possible regression, is now about 25 years old. It was born in Cuba with *El megano* by García Espinosa, Gutiérrez Alea, Alfredo Guevara and José Massip; in Brazil with Nelson Pereira dos Santos; and in Argentina with the Documentary Film School of Santa Fe. Something I always like to remember is that it was born without any kind of, let's say, confabulation between us, but because it was in the air. We can now understand it with great clarity, thanks to something the Italians call *il senno di poi*, that is, the sign that comes afterwards, seeing history through the other end of the telescope. It was born because in that moment, in the middle of the '50s, in different places in Latin America, a generation of filmmakers was growing up who wanted to provide a reply to some of the problems of the moment, and who brought with them more questions than answers. They were questions that came from an historical necessity, a necessity in the history of our peoples; in the history of people awakening with great strength to the consciousness of occupying their place in history, a place denied us for so many years, a place which, once and for all, as the title of the beautiful Nicaraguan film has it, is a place of bread and dignity. These two ideas, I believe, explain something of the tension out of which the new Latin American cinema was created and motivated.

When we were born, nothing was clear and resolved; we had no recipes of prefabricated formulae. What we did know was that in

Screen, vol. 26, nos. 3–4, 1985, pp. 89–91. By permission of the publisher.

some ways this continent was so rich, so complex, so contradictory, so coarse, so exaltant in other ways, that it was a continent that was not reflected in the images produced by the three major Latin American cinemas, the only ones that existed: the Mexican, the Brazilian and the Argentinian cinemas.

This new cinema was born with two or three keys to comprehension, analysis, interpretation and expression. What were they? I remember that when *Tire dié* came out in 1958, it was accompanied by a short manifesto arguing for a national, realist and critical cinema. These were the three keys which in one way or another tried theoretically to illustrate a concrete formulation, the film that was *Tire dié*. From *Tire dié* we passed to *Los inundados*, which is already a fictional film though with a documentary base—and this is another constant in the new Latin American cinema, that is, the documentary support. A characteristic that has been progressively accentuated is the rupture with traditional genres: with what is traditionally understood by documentary; with what is traditionally understood or understandable as narrative.

Nelson Pereira dos Santos had always worked in narrative cinema. But apart from being the first attempt of this kind at Santa Fe, *Los inundados* was an attempt to achieve a greater diffusion of the film object, to explore the possibility of more extensive communication by the film with its public. And in that sense, the narrative construction has a much greater power of communication, and can embrace a much wider horizon than the documentary. Narrative cinema adds to the three previous keys the new key of the popular. In this way, the theoretical postulate which accompanied our work was the call for a national, realist and critical cinema, but, additionally, it was intrinsically related to a fourth, the popular, which is to say, it tried to interpret, express and communicate with the people.

This is also related to another tendency which the new Latin American cinema has always had, which is its aspiration to being an active cinema. What does this mean? It means that in the last instance it is a cinema which is generated within the reality, becomes concrete on a screen and from this screen returns to reality, aspiring to transform it. This is the fundamental idea. Over the years I have often asked myself what could be a common denominator for the new Latin American cinema. If I had to give a brief definition, I would say that it's a cinema which corresponds to what I called and continued to call a poetics of the transformation of reality. That's to say, that it generates a creative energy which through cinema aspires to modify the reality upon which it is projected. We applied this concept to documentary as much as narrative, to short as well as medium and long films, and

now we're applying it also to television, to which we are now equally dedicating our forces. In this concept of a poetics of the transformation of reality it is necessary, among other things, to have no abyss between life and the screen.

Federico García Lorca once introduced Pablo Neruda very beautifully at the University of Madrid, many years ago, before 1936, when Pablo wasn't yet fully Pablo. I remember that Federico said that Pablo was a poet—and he would have wanted to say this of our cinema— closer to blood than to ink, closer to death than philosophy, and who carried in his blood—and I would say this is true of our celluloid— that grain of madness without which it's not worth living. In short, the cinema that started to be made 25 years ago was a utopia, and now this cinema exists and has a continental dimension. This is an important datum. It is the only cinema in the history of cinema that expresses a continent in all the diversity of its cultural-historical connotations but which, at the same time, belongs to an economic infrastructure which perpetuates its so-called underdevelopment, and which places us face to face with common and shared problems of existence.

In this sense, then, it seems to me that the characterizations we're trying to develop of an active cinema for an active spectator—a spectator who doesn't consume passively as if merely digesting celluloid —also has another aspect: that it's a cinema of and for liberation, for economic, political and cultural liberation, and also the liberation of the image, which is to say, of the imagination. This also seems to me a characteristic of the new Latin American cinema, present in its origins, and course of development, deepening and clarifying with daily practice. And we feel this liberation of the image to be valid in the face of the successive crises through which the new Latin American cinema has passed. It was reflected in the Havana Film Festival in 1981, when we conducted a seminar on cinema and poetic imagination. This cinema, though it has to do above all with reality and has to intervene in the real in order to transform it, cannot do without the word poetic and the creative energy which the word contains. It is intrinsic in the need to expand our horizons. It is like the tension of an arrow in flight towards a target it has not yet reached. That is the new poetic-political cinema which is being produced in Latin America; and another indication of the crisis that is manifest in this Fifth Havana Festival (1984). Crisis is a word which manifestly some people don't at all like because it means above all change. Certainly, if the change is towards old age, senility, arteriosclerosis, one can understand . . . if the change is from life to death, obviously this crisis is fatal. But if the crisis is the first cry of the baby at its birth, or the rupture or

laceration of an adolescent who is beginning to pose the big questions which perhaps have no answer, the big insoluble questions, then it's very positive because it's a crisis of growth and a crisis of maturation.

Translated by Michael Chanan

Some Notes on the Concept of a "Third Cinema"

Octavio Getino

1. Antecedents

The first reference to the concept of a "Third Cinema" appeared in the Cuban film journal *Cine cubano* in March of 1969, in an interview with members of the Argentine *Cine Liberación* group. At that time, the group maintained that "there is a growing need for a "Third Cinema," one that would not fall into the trap of trying to engage in a dialogue with those who have no interest in doing so. It would be a cinema of aggression, a cinema that would put an end to the irrationality that has come before it; an *agit* cinema. This does not mean that filmmakers should take on exclusively political or revolutionary themes, but that their films would thoroughly explore all aspects of life in Latin America today. . . . This cinema, revolutionary in both its formulation and its consciousness, would invent a new cinematographic language, in order to create a new consciousness and a new social reality."

A few months later, in October 1969, the article "Towards a Third Cinema: Notes and Experiences Regarding the Development of a Liberation Cinema in the Third World" (see the essay in this volume by Solanas and Getino) appeared in the journal *Tricontinental*, published by OSPAAAL in Paris. With these notes, the group hazarded a few theoretical definitions of a Third Cinema's objectives and methodol-

Tim Barnard, ed., *Argentine Cinema*. Toronto: Nightwood Editions, 1986, pp. 99–108. Reprinted with revisions. Originally published as "Algunas observaciones sobre el concepto del 'Tercer Cine'" in *Notas sobre cine argentino y latinoamericano*. Mexico: Edimedios, 1984.

ogy. Certain ambiguities remained in this formulation of the theory, however, so these were clarified during the Latin American Filmmakers' Conference held in Viña del Mar, Chile, with the publication of the article "Militant Cinema, an Internal Category of Third Cinema." These publications had a significant effect on young filmmakers, not only in Latin America and the Third World but also in the developed countries, including the United States, Canada, France and Italy, and they were reprinted in books and specialized journals. From that time on, *Cine Liberación* as a group did not return to these themes. Its principal members—Fernando Solanas, Gerardo Vallejo, and the author of these notes—did, however, continue to discuss them in articles, interviews and debates published in specialized journals around the world.

It was essential that I note these antecedents in order for me to analyze—in a provisory and strictly personal manner—the value these theories on the Third Cinema, elaborated 10 years ago, may have today.[1]

The National Context as the Generator of Theory and Practice

The attempt to create a Third Cinema in Argentina was bound up in our own particular historical and political circumstances, marked during the last years of the 1960s by increasing levels of organization and mobilization within the popular resistance movements. Greater cohesion between the middle and working classes also developed during this period of military rule, culminating in 1973 with the resounding electoral victory of the *Frente Justicialista de Liberación*, led by the Peronist movement and supported by every progressive sector in the country.

The practical work of *Cine Liberación* was thus conditioned by the simultaneous growth of national resistance movements and the campaign to democratize the country. This situation basically defined the orientation and theories of the group. The language of the films produced by members of the group was similarly informed by the political reality of Argentina. In opposition to the prevailing notion of an *auteur* cinema, we developed this notion of a Third Cinema, an *agit* cinema, a cinema made collectively.[2] We didn't fully realize at the time the extent to which the Argentine reality of the late 1960s defined the content and the form of our work and its parallel theoretical elaboration. In turn, our work was destined to contribute to the development and the liberation of our country, as well as to certain debates in film circles. This is not to deny whatever universal value certain aspects of the theory may have; it is worth emphasizing, however, that

the value of theories such as these is always dependent on the terrain in which the praxis is carried out. Any attempt to consider an ideological construct universal would be erroneous without consideration of the national context at its root.

Practice as the Generator of Theory

In order to understand fully the ideas behind Third Cinema, we must note that its theoretical component arose after, and not before, the practical work of making films: that is to say, after the production and distribution of *La hora de los hornos* (The Hour of the Furnaces), directed by Solanas, which was begun in 1966 and finished in 1968.

Both Solanas and myself, while making this film, amassed a considerable amount of theoretical material. It was for our own use, as reflections on our ongoing practical work. It was this material that we drew upon when we developed the theories which were published between 1969 and 1971. It is difficult to imagine the subsequent international exposure of these theories had the film not existed. It was only through the existence of the film that we were able to refute the criticism of those who opposed our theories.

With this film, we demonstrated for the first time that it was possible to produce and distribute a film in a non-liberated country with the specific aim of contributing to the political process of liberation. To do this, we had to develop a different way of using film than that which had existed until that time.[3] It thus remains difficult even today to separate the concept of Third Cinema from the film *La hora de los hornos*, a demonstration of the interdependence of theory and practice. It is this practice which should be the principal focus of analysis today as it stimulated, even determined, the kinds of theories we put forward 10 years ago.

The Social Context as Mediator

The production and distribution of *La hora de los hornos* was possible, as I have already noted, because of the strong offensive of a popular resistance movement against a military government in full retreat. This opposition movement, basically led by the Peronist party, had a strong national tradition and organizational structure through the trade unions and on the local community level. This facilitated the distribution of alternative films through decentralized parallel circuits which would have been impossible to maintain under different political circumstances. Even so, the continuation of this practice required a theoretical base capable of guiding its development.

Another factor which should be noted in this discussion of the theories of the Third Cinema movement is the social background of

the filmmakers in the *Cine Liberación* group.[4] By the mid-1960s, as
the "developmentalist" economic policies of the military rulers proved
disastrous, the increasingly impoverished middle class began to seek a
way out of the impasse in any manner available to them. During this
same period, the well-organized working class frustrated several at-
tempts to subvert certain fundamental democratic institutions in the
Argentine political process. It was also a time when events abroad,
particularly the Cuban revolution, were having an effect in Argentina.
This revolution was being idealized, even by the middle class, as a
universal model of political organization for Latin America.

Naturally the working class, hardened by decades of struggle in
which it was the principal—and often solitary—protagonist, experi-
enced this period differently than the middle class. Historically, the
working class exercised a hegemony on the process of national libera-
tion. The middle class could only hope to join this revolutionary pro-
cess, from which it had previously kept its distance at every critical
historical juncture.

La hora de los hornos, and the other films made by *Cine Libera-
ción*, must be analyzed in this context, that of middle class intellectu-
als caught up in insurrectionary mobilizations, influenced by the
cultural and political traditions of the working class movement but
still embodying contradictions inherited from the neo-colonization of
Argentina.

For my part, I believe that we too were not free of this dynamic.
Cine Liberación was, before anything else, our fusion as intellectuals
with the reality of the working class. This determined the tentative
and inconclusive nature of our proposals. "Until now," we emphasized
in "Towards a Third Cinema," "we have put forward practical propos-
als but only loose ideas—just a sketch of the hypotheses which were
born of our first film, *La hora de los hornos*. We thus don't pretend
to present them as a sole or exclusive model but only as ideas
which may be useful in the debate over the use of film in non-liber-
ated countries."

2. The Theory and Practice of Third Cinema in Argentina

We can identify three principal stages in the work of the *Cine Libera-
ción* group:

i) that of the group's formation and initial activities as part of the
 resistance against the Argentine military governments of Onganía,
 Levingston, and Lanusse;

ii) that of its open collaboration with the democratic and popular government in power in 1973–74, until the death of President Perón;
iii) that of its withdrawal into a new form of resistance, which is the current stage, the stage of exile.

The First Stage: 1966–1970/71

This first stage of the group's activities is delineated, approximately, by the years 1966 and 1970/71. This was the period when the work with the greatest international impact was produced. I refer here primarily to the film *La hora de los hornos*, directed by Solanas and on which I worked as co-author: this film established the base from which the group would work, both within Argentina and abroad. When the film was finished, we began the other, no less important task of setting up parallel distribution circuits for the film through trade unions and community and Peronist Youth organizations.

During this period young filmmakers began to organize, together with Peronist activists and other progressive groups, giving rise to testimonial films and documentaries about what was happening in Argentina at the time. The national trade union CGT [Confederación General de Trabajadores], for example, put out the newsreel *Cineinformes de la CGT de los argentinos* at this time.

As work progressed on the practical levels of production and distribution, the group published its three major theoretical pieces: "La cultura nacional, el cine, y *La hora de los hornos*" ("National Culture, Cinema, and The Hour of the Furnaces," Fernando Solanas and Octavio Getino, *Cine cubano* no. 56/57, Havana, March 1969); "Hacia un tercer cine" ("Towards a Third Cinema," Solanas and Getino, *Tricontinental* no. 13, OSPAAAL, Paris, October 1969); and "Cine militante: una categoría interna del tercer cine" ("Militant Cinema, an Internal Category of Third Cinema," Solanas and Getino, mimeograph, Viña del Mar, 1971). The group also published material in the periodicals *Notas de Cine Liberación* and *Sobres de cultura y liberación*. The latter was published by a united front of visual artists, students and political activists with objectives similar to our own. We also made films throughout this period, of course, which were always barred from conventional distribution circuits. It was only through the popular organizations that we were able to distribute them.

The Second Stage: 1971–1974

This stage, which saw our work having fewer international repercussions, led instead to our films really taking root in national life. We ran the risk of having our films censored and began to make films

intended for commercial release through normal distribution channels. The first film to do this was Gerardo Vallejo's *El camino hacia la muerte del Viejo Reales* (Old Man Reales' Road to Death, 1970). I made *El familiar* (The Relative, 1973) and Solanas made *Los hijos de Fierro* (The Children of Fierro, begun in 1972 and finished in 1977 in exile). Similar films, made outside our group but from the same "liberation cinema" perspective, should be noted as well, especially *Operación masacre* (Operation Massacre, 1972) by Jorge Cedrón.

Numerous short films were made in regional centers throughout the country. In Tucumán, for example, Vallejo made *Testimonios tucumanos* and later *Testimonios de la reconstrucción*, which were screened on the regional television network operated by the university of that province.

This new approach required us to formulate new ideas in our written material as well. The magazine *Cine y Liberación* appeared in 1972 and reflected the popular resistance which by then was poised to take power. It was also during this period that we made two important documentaries in Madrid with Perón for the Peronist movement, *Actualización política y doctrinaria para la toma del poder* (Political and Theoretical Renewal Towards the Taking of Power) and *La revolución justicialista* (The Justicialist [Peronist] Revolution). In order to distribute these films, we used—and expanded—the parallel circuits we had developed for *La hora de los hornos*. The demand for these two films, particularly the latter, in fact surpassed the demand for our earlier film, and we made more than 50 16mm copies of *La revolución justicialista*.

This double-edged production strategy, with some films aimed at commercial audiences and others made for the parallel circuits, was accompanied by the organization of filmmakers, and not only activists but others from the mainstream of the industry who were being politicized by events of the day. At this time, our group was composed of filmmakers, critics, actors, independent producers, short filmmakers, technicians and film workers united by the pressing need to develop a project of national liberation, both for the country and for its cinema. With the liberation of the country in 1973 we were able to take part in the formulation of new policies in the film industry. It was during this period that I was asked to head the film classification board, a task I shared with all those concerned with the real development of our film industry.[5]

It did not take long before the group's work in this period was denounced, by the extreme Left before anyone else, who accused us of being "opportunists" and "bureaucrats." Afterwards the extreme Right joined in with different but undoubtedly more forceful arguments. As

far as the Left is concerned, there were some extreme tendencies at work in the country at that time, which had little popular support. Their leaders confused tactics with strategy and the means with the end. Their film activity they called "guerrilla cinema," which appropriated our theories of several years earlier and adopted them as a dogmatic bible. They saw in our work a supposed retreat into pro-government propaganda, not distinguishing between support for a government elected by 70% of the people and support for the armed forces. This ultra-Left offensive, launched in order to create obstacles to the democratic process, attempted to initiate a "popular revolutionary war" which actually led to the creation of minuscule ghettoized groups as alienated from the national will as were the paramilitary groups of the far Right.[6]

The Third Stage: 1974–

From 1974 on, after the death of Perón, the political project that the majority of the people had set in motion a year earlier began to falter. The imperialist offensive, visible in the events around us in Uruguay, Bolivia and Chile,[7] coincided with this weakening, which unfolded rapidly. It became clear that the force and cohesion of the popular movements in those countries—and in Argentina—were not as strong as we had imagined. In addition, the international solidarity promised us by those who make revolutionary chatter a way of life failed to materialize, this aid coming only after our defeat and to the benefit of the military government.[8]

We are now living in a time when the repression is so severe that we can't make films either above ground or underground. To speak of a "guerrilla cinema," for example, would be absurd. To attempt to make that kind of cinema in Argentina today would undermine the position of the working classes rather than strengthen it. *Cine Liberación* thus abandoned the use of "guerrilla" tactics, which to our mind had validity during the popular offensive but ceased to do so after 1973. It was precisely during this latter period that "militant cinema," at least that form of it practiced by us, in fact deepened its militancy by involving itself in the everyday political tasks of the masses, renouncing all forms of vanguardism which were outside the newly created democratic process.

As we had established during the earlier stage of our work, we prefer to err with the people rather than to take the "correct line" without them. It was not a coincidence, then, that just as we launched *La hora de los hornos* the orthodox Marxist Left, in Paris and Buenos Aires, joined the Right and attacked our position. We were "populist" and "fascist" to the former yet "subversive" and "communist" to the latter.

Both groups used essentially the same intimidation tactics, differing only in their choice of adjectives to describe us.

The change in our practical course during this period modified our theoretical positions, although these were not set out in written form as they were during the earlier stage. Instead, we strove to realize some of the ideas we had formulated earlier, particularly our search for a new film language capable of expressing our social reality with more insight and rigor. This entailed opening up to new genres and styles which could not be classified as documentary films. We wanted to contribute to the decolonization of our country's movie screens and thus put an end to the cultural and economic dependency of our film industry.

We thus entered into a period of critical revision and self criticism. To do so in the realm of practice seems to me the best method, in that the self criticism is constantly being verified by the concrete rendering of ideas, ideas that are always tied to the necessities of the national reality and to questions of political strategy.

Translated by Timothy Barnard

Notes

1. This article was written in the late 1970s while the author was in exile in Peru and when Argentina was ruled by its bloodiest military dictatorship ever, which not only suppressed radical filmmaking but virtually dismantled the commercial film industry [trans.].

2. In *Cine Liberación*'s schema, "First Cinema" was the classical cinema of Hollywood and Western Europe; "Second Cinema" was the *auteur* cinema which sprang up in these same centers in the early 1960s; and "Third Cinema" was a radical liberation cinema produced in the Third World and marked not only by different aesthetic and political concerns but by its challenge to the very system of commercial film production and consumption [trans.].

3. Not only was *La hora de los hornos* seen semi-clandestinely through a network of trade unions and activist groups, as the author mentions below, but it was structured in a way to generate audience discussion in an attempt to render the film-viewing experience less passive [trans.].

4. Solanas, for example, was an extremely successful director of short advertising films in the early 1960s and as late as 1965 had attempted to make a fiction film in the mainstream of the film industry [trans.].

5. The classification board was a committee of censors appointed from influential interest groups like the church, the military, "moral defense" groups, etc. Getino revamped the appointment procedure to include trade unions, academics and the general public as among those groups represented. For a brief period—until Perón's death in 1974 and Getino's subsequent replacement by a fanatical censor—no films other than pornography were cut or

banned and the classification system was revised to include warnings of such things as overt racism alongside the usual moral cautions [trans.].

6. The film group Getino is referring to here is that known as *Cine Grupo de la Base*, whose principal figure was Raymundo Gleyzer. The group made the film *Los traidores* (The Traitors), about the betrayal of Peronism by strong-arm reactionary trade union bosses—Peronism was always an untenable and contradictory alliance of Left- and Right-wing elements—in 1974. Gleyzer was abducted by a paramilitary death squad in 1976 and is counted among the country's "disappeared" [trans.].

7. There were military coups in Bolivia in 1971 and in Chile and Uruguay in 1973 [trans.].

8. Getino is referring to the seemingly inexplicable cordiality between the U.S.S.R. and the Argentine military regime, which was engaged in a brutal campaign against domestic agents of "international communism" [trans.].

The Viewer's Dialectic

Tomás Gutiérrez Alea

Introduction

Twenty years after taking power, the Revolution has left behind its most spectacular moments. Back in those days our shaken land offered an image, an unusual and one-time-only image: that incredible caravan accompanying Fidel as he arrived in Havana, the bearded rebels, the doves, the vertigo of all the transformations, the exodus of the traitors and timorous ones, the henchmen's trials, and the enemy's immediate response and, as for us, we experienced the nationalizations, the daily radicalization of the revolutionary process followed by the armed confrontations, the sabotages, the counterrevolution in the Escambray mountains, the Bay of Pigs invasion and the October Missile Crisis.

Those events in themselves evidently revealed the profound changes occurring at a pace nobody could have foreseen. For cinema, it was almost sufficient just to record events, to capture directly some fragment of reality, and simply reflect the goings-on in the streets. These images projected on the screen turned out to be interesting, revealing and spectacular.[1]

In these circumstances, stimulated or, rather, pressured by ever-changing reality, Cuban cinema emerged as one more facet of reality within the Revolution. Directors learned to make films while on the go and played their instruments "by ear" like old-time musicians.

Tomás Gutiérrez Alea, *The Viewer's Dialectic*. Havana, Cuba: José Martí Publishing House, 1988, pp. 16–41. By permission of the Agencia Literaria Latinoamericana.

They interested viewers more by what they showed than by how they showed it. In those first years Cuban cinema put the emphasis on the documentary genre and little by little, as a result of consistent prac- tice, it acquired its own physiognomy and dynamism which have en- abled it to stand with renewed force, beside more developed film styles which are older but also more "tired."

Now all of that has become part of our history; our consistent revo- lutionary development carries us inevitably toward a process of matur- ation, of reflection, and analysis of our accumulated experiences.

The current stage of institutionalization we are living through is possible only because it is based on the high degree of political awareness which our people have attained as a result of years of in- cessant fighting. But this stage also requires the masses' active, in- creased participation in the building of a new society. Increasingly, a greater and greater responsibility falls on the masses and, for that rea- son, we can no longer let the public merely cling enthusiastically and spontaneously to the Revolution and its leaders and, to the extent that the government passes on its tasks to the people, the masses have to develop ways of understanding problems, of strengthening their ideo- logical coherence and of reaffirming daily the principles which give life to the Revolution.

Everyday events occur now in a different way. The images of the Revolution have become ordinary, familiar. In some ways we are carrying out transformations that are even more profound than earlier ones, but they are not as "apparent" now nor are they immediately visible to the observer. These changes, or transformations, are not as surprising nor do the people respond to them only with applause or with an expression of support. We no longer crave the same kind of spectacular transformations as we did fifteen or twenty years ago. Cu- ban cinema confronts that new and different way of thinking about what social processes are going to hold for us because our film draws its strength from Cuban reality and endeavors, among other things, to express it. Thus we find it no longer sufficient just to take the cameras out to the street and capture fragments of that reality. This can still be a legitimate way of filmmaking, but only when, and if, the filmmaker knows how to select those aspects which, in close interrelation, offer a meaningful image or reality, which serves the film as a point of both departure and arrival. The filmmaker is immersed in a complex mil- ieu, the profound meaning of which does not lie on its surface. If filmmakers want to express their world coherently, and at the same time respond to the demands their world places on them, they should not go out armed with just a camera and their sensibility but also with

solid theoretical judgment. They need to be able to interpret and transmit richly and authentically reality's image.

Furthermore, in moments of relative détente, capitalism and socialism air their struggle, above all, on an ideological level and, on that level, film plays a relevant role both as a mass medium, in terms of diffusion, and as a medium of artistic expression. The level of complexity at which the ideological struggle unfolds makes demands on filmmakers to overcome completely not only the spontaneity of the first years of the revolutionary triumph but also the dangers inherent in a tendency to schematize. Filmmakers may fall into this trap if they have not organically assimilated the most advanced trends, the most revolutionary ones, the most in vogue, especially those which speak to the social function which the cinematic show ought to fulfill. That is, filmmakers create cultural products which may attain mass diffusion and which manipulate expressive resources that have a certain effectiveness. Film not only entertains and informs, it also shapes taste, intellectual judgment and states of consciousness. If filmmakers fully assume their own social and historical responsibilities, they will come face to face with the inevitable need to promote the theoretical development of their artistic practice.

We understand what cinema's social function should be in Cuba in these times: It should contribute in the most effective way possible to elevating viewer's revolutionary consciousness and to arming them for the ideological struggle which they have to wage against all kinds of reactionary tendencies and it should also contribute to their enjoyment of life. . . . With this much in mind, we want to establish what might be the highest level which film—as a show—could reach in fulfilling this function. Thus, we ask ourselves to what degree a certain type of show can cause the viewers to acquire a new socio-political awareness and a consistent action thereof. We also wonder what that new awareness and action consists of that should be generated in spectators once they have stopped being spectators, that is, when viewers leave the movie theater and encounter once again that other reality, their social and individual life, their day-to-day life.

Capitalist cinema, when reduced to its state as a commodity, rarely tries to give answers to these questions. On the other hand (and for other reasons) socialist cinema has not ordinarily fully met that demand. Nevertheless, finding ourselves in the midst of the Revolution, and at this particular stage of building socialism, we should be able to establish the premises of a cinema which would be genuinely and integrally revolutionary, active, mobilizing, stimulating, and—consequently—popular.

The expressive possibilities of the cinematic show are inexhaustible: to find them and produce them is a poet's task. But on that point, for the time being, this analysis can go no further, for I am not focusing on film's purely aesthetic aspects but, rather, trying to discover in the relation which film establishes over and over again between the show and the spectator the laws which govern this relation and the possibilities within those laws for developing a socially productive cinema.

"Popular" Film and People's Film

Of all the arts, film is considered the most popular. Nevertheless, this has not always been the case. For a long time, confusion reigned as to whether film was an art or not and that confusion continues to exist around film's popular nature.

Today it can still be said that cinema is marked by its class origin. During its short history, it has had moments of rebellion, searching and authentic success as an expression of the most revolutionary tendencies. Nevertheless, to a large extent, cinema continues to be the most natural incarnation of the petty bourgeois spirit which encouraged cinema at its birth more than eighty years ago.

At that time, capitalism was entering its imperialist phase. In the beginning, the modest invention of a machine made to capture and reproduce reality's moving images was no more than an ingenious toy used at fairs where spectators could let themselves be transported to the farthest reaches of the world without moving from their seats. Very soon the toy left the fairground but that does not mean to say that it achieved a more dignified and respectable status. It developed into a real show-business industry and began to mass produce a kind of merchandise able to satisfy the tastes and to encourage the aspirations of a society dominated by a bourgeoisie which extended its power into every corner of the world. From the beginning, cinema developed along two parallel paths: "true" documentation of certain aspects of reality and, on the other hand, the pursuit of magic fascination. Film has always moved between those two poles: documentary and fiction. Very soon cinema became "popular," not in the sense that it was an expression of the people—of the sectors most oppressed and most exploited by an alienating system of production—but, rather, in the sense that it could attract a heterogeneous public, the majority, avid for illusions.

Perhaps more than any other medium of artistic expression, cinema cannot get rid of its state as a commodity; the commercial success it achieves pushes it on to vertiginous development. It has become a

complex and costly industry and it has had to invent all kinds of for-
mulae and recipes in order that the show it offers pleases the broadest
public; huge audiences are what cinema depends on for its very sur-
vival. Therefore it was cinema's state as a commodity and its
"popular" nature—more than the fact that it was a medium still in its
infant stage—that provoked the resistance which existed in circles that
paid unconditional reverence to "cultured" art; they did not want to
elevate cinema to the category of true art. Art and the people didn't
get along.

Then there were those who thought that cinema, to be art, should
translate the master works from universal culture and therefore many
pretentious, gilded, heavy and rhetoric works, which had nothing to
do with the emerging film language, were filmed. Aside from those
detours, cinema constituted a human activity which fulfilled better
than others a fundamental necessity for enjoyment. In film practice, as
it directed itself fundamentally toward that objective, film language
began to mature and discover expressive possibilities which enabled
cinema to achieve an aesthetic assessment although without intending
to do so.

Hollywood cinema, with its pragmatic sense, developed furthest in
that direction. It was the most vital and the richest in technical and
expressive discoveries. As of the beginning of this century, it devel-
oped different genres—comedies, westerns, gangster films, historical
superproductions, melodramas—which rapidly became "classics."
That is to say, the genres consolidated themselves as formal models
and reached a high level of development; at the same time, they be-
came empty stereotypes. They were the most effective expression of a
culture of the masses as a function of passive consumers, of contem-
plating and heartbroken spectators, while reality demands action from
them and, at the same time, eliminates all possibilities for that action.

Cinema can create genuine ghosts, images of lights and shadows
which cannot be captured. It is like a shared dream. It has been the
major vehicle used to encourage viewers' false illusions and to serve
as a refuge for viewers. It acts as a substitute for that reality in which
the spectators are kept from developing humanly, and which, as a sort
of compensation, allows them to daydream.

Film equipment and the means of film production were invented
and created in the interests of bourgeois tastes and needs. Film rapidly
became the most concrete manifestation of the bourgeois spirit, in ob-
jectifying its dreams. Clearly, for the bourgeoisie, film did not repre-
sent an extension of work, nor of school, nor of daily life with its
many tensions; it was neither a formal ceremony nor a political dis-
course. The first thing burdened spectators looked for in cinema was

gratification and relaxation to occupy their leisure time. Surely, most cinematic production rarely went beyond the most vulgar levels of communicating with the public. The important thing was how much money could be obtained with the product and not to concern for high artistic quality.

In the 1920s the European avant-garde also made its incursion into filmmaking and left behind a few works which explored a vast range of expressive possibilities. But that was a vain attempt to rescue film from the vulgarity to which commercialism had condemned it. It could not put down roots. However, thanks to a few exceptional works, that movement was not completely sterile.

But it wasn't until the creation of Soviet film that the art world began to officially accept the evidence that not just a new language had been born but also a new art. This was because of the theoretical preoccupation of the Soviet directors and the practical support given to the new medium. "Collective art *par excellence*, destined for the masses," it was called then. Soviet cinema attained a real closeness to the movement of radical social transformation which was taking place. It was a collective art because it combined diverse individuals' experience and because it drew nourishment from artistic practice in other media as a function of a new art, a specifically different art, which became definitely accepted as such. It was destined for the masses, and popular, because it expressed the interests, aspirations and values of broad sectors of the population which at that time were carrying history onward. That first moment of Soviet cinema left a deep imprint on all filmmaking that was to follow and, today, the most modern filmmaking continues to drink from its fountains and nourish itself from that cinema's explorations, experiments and theoretical achievements which still have not been completely tapped.

The first years of sound-track filmmaking coincided with the capitalist economic crisis of 1929. Cinema consolidated itself as an audiovisual medium and the production apparatus became so complex that, for a long time, it was neither possible to produce films outside the big industry nor to side-step that industry's interests. In spite of that, in the 30s, the U.S. film industry produced a few works with a critical vision of society and the times. These films maintained all the conventions of an established and purified medium, but they also demonstrated an authentic realism in dealing with important contemporary themes. This cinema, which spoke about social conflicts afflicting everyone, arose at a favorable time, but very soon veered towards complacent reformism. Those were the years of the Hays Code,[2] also known as the code of propriety, an instrument for censorship and propaganda which responded to the interests of big finance capital and

which indicated the narrow ideological straits which U.S. cinema would traverse for a long time.

Toward the end of World War II, with wounds still open and under politically favorable circumstances, Italian neo-realist cinema emerged. With all its political and ideological limitations, it was a living, fecund movement insofar as it went the route of an authentically popular cinema.

In the heat of the post-war period in France, a "new-wave" of young directors appeared who threw themselves impetuously into revolutionizing filmmaking without going beyond the limits of the petty bourgeois world. Among them, Godard stands out as the great destroyer of bourgeois cinema. Taking Brecht as his point of departure —and the New Left as his point of arrival—he tried to make revolution on the screen. His genius, inventiveness, imagination, and clumsy aggressiveness gave him a privileged place among the "damned" filmmakers. He managed to make anti-bourgeois cinema but he could not make people's cinema. Noteworthy epigones like Jean-Marie Straub, admirable for his almost religious asceticism, have already institutionalized that position and some think they are making a revolution in the superstructure without needing to shake up the base . . .

Another phenomenon inscribed in those searches for a revolutionary filmmaking practice is that cinema called "parallel," "marginal" or "alternative." This cinema has emerged in the last few years due to the development of technology and equipment which permit the production of relatively cheap films. It lies within the reach of small, independent groups and revolutionary militants. In this cinema, revolutionary ideology is openly put forth. It is a political cinema which should serve to mobilize the masses and channel them toward revolution. As a revolutionary practice it has been effective within the narrow limits in which it operates but it cannot reach large numbers, not only because of the political obstacles it encounters within the distribution and exhibition system, but also because of its style. Most people continue to prefer the more polished product which the big industry offers them.

In the capitalist world—and in a good part of the socialist world— the public is conditioned by specific conventions of film language, by formulae and genres, which are those of bourgeois commercial filmmaking. This occurs so often that we can say that cinema, as a product originating from the bourgeoisie, almost always has responded better to capitalism's interests than to socialism's, to bourgeois interests more than to proletarian ones, to a consumer society's interests more than to a revolutionary society's interests, to alienation more

than to non-alienation, to hypocrisy and lies more than to the profound truth . . .

Popular cinema, in spite of its many notable exponents, and few exceptional phenomena, has not always been able fully to fuse revolutionary ideology with mass acceptance. As for us, we cannot accept simple numerical criteria to determine the essence of a people's cinema. Clearly, in the final analysis, when we talk about the *broad* masses, we mean the people. But such a criterion is so wide and so vague that it becomes impossible to apply any kind of value judgment to it. The number of inhabitants in a country, or any sector of a country, is no more than a group as a whole, which considered as such, abstractly, is meaningless. If we want to find some kind of concrete criterion of what *popular* means it is necessary to know what those people represent, not just in terms of geographical location, but also in terms of the historical moment and their specific class. It is necessary to distinguish within that broad group which groups—the broad masses—best incarnate, consciously or unconsciously, the lines of force which shape historical development or, in other words, move towards the *incessant betterment of living conditions on this planet*. And if the criterion for determining *popular* accepts as its basis that distinction, we can say that its essence lies in what would be the best *thing* for those broad masses, i.e., that which best suits their most vital interests.

It is true that short-term interests sometimes obscure the long-term ones, and that one may often lose sight of one's final objectives. To be more precise: *popular* ought to respond not only to immediate interests (expressed in the need to enjoy oneself, to play, to abandon oneself to the moment, to elude . . .) but also to basic needs and to the final objective: transforming reality and bettering humankind. Therefore, when I speak about popular film, I am not referring to a cinema which is simply accepted by the community, but rather to a cinema which *also* expresses the people's most profound and authentic interests and responds to these interests. In accordance with this criterion (and we must keep in mind that in a class society, cinema cannot stop being an instrument of the dominant class), an authentically popular cinema, that is, a people's cinema can be fully developed only in a society where the people's interests coincide with the state's interests; that is, in a socialist society.

During the construction of socialism, when the proletariat has not yet disappeared as a class exercising its power through a complex state apparatus and differences persist between city and countryside, between intellectual and manual work, when mercantile relations have not yet disappeared, and along with them certain manifestations—

conscious or unconscious—of bourgeois ideology (or, even worse, petty-bourgeois ideology), when there is still an insufficient material base to depend on and, above all, when imperialism still exists somewhere in the world, art's social function acquires very specific shadings in keeping with the most urgent needs and objectives, the most immediate tasks people set for themselves when they begin to feel owners of their destiny and work for its fulfillment.[3] In this case, art's function is to contribute to the best enjoyment of life, at the aesthetic level, and it does this not by offering a ludicrous parenthesis in the middle of everyday reality but by enriching that very reality. At the cognitive level, it contributes to a more profound comprehension of the world. This helps viewers develop criteria consistent with the path traced by society. On the ideological level, finally, art also contributes to reaffirming the new society's values and, consequently, to fighting for its preservation and development. If it is true that at this stage the ideological level is given priority, its effectiveness here stands in direct relation to the effectiveness of the aesthetic and cognitive level.

I will try to establish which approaches might be appropriate for cinema, as one of art's specific manifestations, to be able to move toward those objectives.

From Film Show in Its Purest Sense to the "Cinema of Ideas"

As with literature, film has proceeded to establish certain basic genres according to the expressive needs of each specific material. In the same way that we have journalism—magazines and newspapers—fictional literature and essays with all their variety and shadings, all their own resources and characteristics, in film we have newsreels, shorts and feature-length films. Superficially we can point out affinities between newsreels and daily journalism, between shorts and certain kinds of articles and reports—the kind which usually appear in magazines and between feature-length films and fictional literature, especially novels, or—and we see this more and more—the essay. But these similarities are rather obvious at first glance. Of more interest is to define some peculiarities of the basic cinematic genres and to underline the fact that, as also happens in literature, this division is conventional, and the frontiers which separate them do not hinder the interchange of expressive resources and their own specific elements.

Newsreels offer primarily direct reportage of contemporary events; certain events with a specific significance are selected by the camera and projected on the screen to inform us about what is happening in the world. One usually does not receive a profound analysis of these

events' significance but because of their very selection and form of presentation political criteria and, obviously, ideology are manifest. First of all, because of the emphasis on information, the newsreel's validity is short-lived. Nevertheless, and at second glance, these newsreels constitute a body of material that is testimony to an epoch, and the importance of which is not always predictable. That is, these newsreels can acquire increased historical value and constitute the raw materials for analytic re-elaboration at a later date. Such a double function turns the newsreel into a most important political instrument. The emphasis here lies in its ideological (political) and cognitive aspects. The aesthetic aspect is subordinate to them, which is not to say that it does not exist or cannot—or should not—play a decisive role in the greater or lesser efficacy of the other two aspects.

The short film offers more variants. It can be a primarily informative report. It can be a documentary in which the events—images and sounds—brought to the screen are not captured directly from a real-life event but, rather, creatively elaborated by the director to emphasize a deeper meaning with an analytic objective. Here the cognitive aspect takes primacy. Also, the short film may include fictional works —little cinematic poems, the narration of a short story, etc. It is generally 20–40 minutes long; that length presupposes a more elaborated structure than the newsreel and more complexity in treating a theme. Consequently, the form allows the filmmaker to go into greater depth in terms of both information and analysis. Thus, its operation—its transcendency—is broader, and the aesthetic aspect usually takes on a certain significance.

The feature film is usually fiction. The plots are completely fabricated according to a preconceived idea and developed on the basis of dramatic principles. All this corresponds to an established convention, which can be either a support or a hindrance to the best and most coherent concretion of the idea which will serve as point of departure. On the other hand, in Cuba, we have extensively developed a type of feature-length documentary in which real-life events are recreated or shown exactly as they are captured by the camera at the moment of their occurrence. These events are arranged in such a way that they function as elements of a complex structure, through which the film can offer a more profound analysis of some aspect of reality. In addition, news reportage can be turned into a feature-length film, but that format is used infrequently and is generally determined by the exceptional importance of the events registered by the camera which on the screen are re-ordered so as to facilitate viewers' better understanding of them.

In Cuba, normal movie theater programming consists of a news-reel, a short documentary (or reportage) and a fiction feature. Thus, the basic genres, distinct but complementary, are seen in one sitting. Viewers can experience *various levels of mediation which bring them closer to or farther away from reality* and which can offer them a bet-ter understanding of reality. This game of approximations, produced through seeing various genres at one screening, does not always have the greatest coherence nor achieve the greatest level of "productivity," because they are films made independently of each other which may possibly be connected *a posteriori*. Nevertheless, this possibility of connections throws light on what could be achieved here, even if we are considering just the framework of a single film, in the elaboration of which the filmmaker has kept in mind this whole broad range of levels of approximating reality.

I want to focus on that genre which best answers the concept of "show" and which constitutes the basic product in any cinema: the feature fiction film.

First, I want to put aside a very specific genre: educational film. Even when operating with the same elements and resources as "show"-film, educational films are organized in terms of a special function: to complement, amplify, or illustrate, in a direct manner, classroom teaching. They are like textbooks but not a substitute for them. A student's attitude vis-à-vis educational film is radically differ-ent from the spectator confronting "show"-film. Classroom teaching demands of students a conscious effort, one directed toward acquiring specific knowledge. In contrast, spectators go to "show"-film in their leisure time to relax, to seek diversion, for entertainment, and to enjoy themselves . . . and if viewers do learn something, it is of a different nature and does not constitute the viewers' primary motivation.

Now then, without departing from the framework of "show"-film, and more specifically fictional film, we can find various options in the emphasis, according to the film's condition as a show or as a vehicle of ideas. We must keep in mind, of course, that always, to some ex-tent, the show remains a bearer of ideology.

The superficial interpretation of the thesis which holds that the function of cinema—of art in general—in our society is to provide "aesthetic enjoyment" at the same time as "raising the people's cul-tural level" has again and again led some to promote additive formu-lae in which the "social" *content* (that, which is considered to be the educational aspect, creator of a revolutionary consciousness and also, at times, the simple diffusion of a slogan) must be introduced in an at-tractive *form*, or, in other words, adorned, garnished in such a way as to satisfy the consumers' tastes. It would be something like producing

a sort of ideological pap for easy digestion. Obviously, it is only a simplistic solution which considers form and content as two separate ingredients which you can mix in proportion, according to some ideal recipe. Furthermore, this attitude considers the spectator a passive entity. Such a perspective can only lead to bureaucratizing artistic activity. It does not have anything to do with a dialectical understanding of the process of an organic integration of form and content, in which both aspects are indissolubly united and, at the same time as they oppose each other, they interpenetrate each other, even to the point where they can take over each other's functions in that reciprocal interplay. That is, we are dealing with a complex and rich process of contradictions and possibilities for development, in which the formal, aesthetic and emotional aspects, on the one hand, and the thematic, educational and rational aspects, on the other, reveal certain affinities but also their own peculiarities. The diverse modalities of their mutual interaction (to the degree to which that interaction is organic, consistent with the premises which generate it) give rise to various levels of "productivity" (in terms of functionality, effectiveness and fulfillment of assigned functions . . .) in the work's relation to the spectator.

Later on, I will offer some considerations about the relation between the cinematic show and the spectator, and try to untangle certain mechanisms through which that relation takes place. For the time being, I only wish to point out that those various levels of productivity —or functionality—which the show may provide and which derive primarily from the manner in which the emphasis is distributed among the above mentioned aspects *are not excluding levels.* That is to say cinema, especially fiction film, is basically a show. Its function as a show in the purest sense, is to entertain, distract and offer an enjoyment that comes from representation. Represented are actions, situations and diverse things which have as their point of departure reality —in its broadest sense. These things constitute a fiction, another different, new reality which will enrich or expand the reality which has been already established or known up to this point.

Simple show is healthy to the extent that it does not obstruct viewers' spiritual development. But, one cannot forget that in the midst of a society immersed in class struggle, the recreational spirit which enlivens the show tends somewhat to reinforce the established values, whatever they are, since the show serves generally as an escape valve in the face of problems and tensions generated by a conflicting reality. At this level what is emphasized is the emotional aspect in general. Thus show, in its purest sense, just seeks to generate emotions in the spectator and to provide sensory pleasure, as, for instance, a sports event does. We should not view this with mistrust except when super-

ficiality becomes stupidity, when happiness becomes frivolity, when healthy eroticism becomes pornography, when, under the guise of simple entertainment, show becomes a vehicle for affirming bourgeois cultural traits, and when—consciously or unconsciously—it incarnates bourgeois ideology. That is, even "entertainment" films, which apparently "say nothing" and are seemingly simple consumer objects, could also fulfill the elemental function of spiritually enriching the spectator if they did not, to use a coined expression, contain "ideological deviationism." The concept of consumption in a capitalist society is not— and should not be—the same as in a socialist one.

But if we want to go further, if we want film to be good for something more (or for the same thing, but more profoundly), if we want it to fulfill its function more perfectly (aesthetic, social, ethical, ideological . . .), we ought to guarantee that it constitutes a factor in spectators' development. Film will be more fruitful to the extent that it pushes spectators toward a more profound understanding of reality and consequently, to the extent that it helps viewers live more actively and incites them to stop being mere spectators in the face of reality. To do this, film ought to appeal not only to emotion and feeling but also to reason and intellect. In this case, both instances ought to exist indissolubly united, in such a way that they come to provoke, as Pascal said, authentic "shudderings and shakings of reason."

Thus, it is not a question of an emotion to which one can add a dose of reason, ideas, or "content." Rather, it is emotion tied to the *discovery* of something, to the rational comprehension of some aspect of reality. Such emotion is qualitatively different from that which a simple show will elicit (suspense, the chases, terror, sentimental situations, etc.), although it might well be reinforced or impeded by those.

On the other hand, when cinema, in the well-intentioned process of shaping its objectives—to aptly fulfill its social function—neglects to fulfill its function as show and appeals exclusively to reason (to the viewers' intellectual efforts) it noticeably reduces its effectiveness because it disregards one of its essential aspects: enjoyment.

The development of art is expressed not only in a successive change in its functions according to the various social formations which generate art throughout history, but also as an enrichment and a greater complexity of the resources which art has at its disposal. From the magician cave artist to the artist of the scientific era, the *objet d'art* has taken on various successive functions: an instrument to dominate natural forces, an instrument for one class to dominate another, for affirming an idea, for communicating, for self-awareness, for developing a critical consciousness, for celebration, for evading reality, for compensation, or for simple aesthetic enjoyment. . . . In every

historical moment the accent is placed on one or another of these functions and the others are rejected. Nevertheless, we must not forget that all of these functions form one single body of accumulated experience and, out of all of them, some valuable element endures which will enrich the others. The various levels of comprehension (or of interpretation) of an artistic work become superimposed and express art's accumulation of multiple functions over the course of history. Thus, a cave artist is present in all true art, and if he was never effective enough to attract real bison, certainly he was able to mobilize the hunters. Suggestion continues to operate with greater or lesser success, according to the specific circumstances of each particular work. That is how so many artistic works operate when they prefigure victory over an enemy and exalt a warrior's heroism. But the course of history has given us another type of artist who works as well through reason, through understanding and who, in specific circumstances, fully attains his objective. The various functions which art has fulfilled have enriched artistic activity with new expressive resources. The magnificent arsenal of resources accumulated throughout history which contemporary art has at its disposal permits it to fully exercise its functions at all levels of comprehension, suggestion and enjoyment.

Show and Reality: The Extraordinary
and the Everyday

Regarding those films which are usually seen on television and which mature spectators may feel uncomfortable with and find meaningless because they cannot coherently relate the films to the complex images of the world which they have formed during their lives, people may well ask, "What does this have to do with reality?" A child might answer with another question, "Well, isn't it just a movie?" The questions remain pending, of course. It would be a hard task to explain to a child how, for mature people, the sphere of reality is constantly articulated in more detail in one's mind, and how some things are left behind. It happens in such a way that an adult's image of the world comes to be very different from a child's. Mature adults keep discarding more or less apparent layers of reality, in order to draw closer and closer to its essence. They discriminate and assess reality's different aspects as a consequence of an ever deeper understanding of reality. That is why a mature person probably feels dissatisfied vis-à-vis such a film. But, on the other hand, the child's question does not allow for a quick, superficial response. Certainly a film is one thing and reality is another. We cannot forget that those are the rules of the game. Of

course, film and reality are not—cannot be—completely divorced from each other. A film forms part of reality. Like all man's works included in the field of art, film is a manifestation of social consciousness and also constitutes a reflection of reality.

With regard to cinema, there exists a condition which can be deceptive. The signs which cinematic language employs are no more than images of separate aspects of reality itself. It is not a question of colors, lines, sounds, textures and forms, but of objects, persons, situations, gestures, and expressions . . . which, freed from their usual, everyday connotation, take on a new meaning within the context of fiction. Film thus captures images of isolated aspects of reality. It is not a simple, mechanical copy. It does not capture reality itself, in all its breadth and depth. However, cinema can reach greater depth and generalization by establishing new relations among those images of isolated aspects. Thereby, those aspects take on new meaning—a meaning not completely alien to them, and can be more profound and more revealing—upon connecting themselves to other aspects and producing shocks and associations which in reality are dilute and opaque because of their high degree of complexity and because of day-to-day routine.

Here we may find the beginnings of a revealing operation—bound to reach an ever-growing degree of complexity and richness—which is specific to cinema because it is a language nourished by reality and which reflects reality through images of real objects which can actually be seen and heard as if it were a large ordering and sorting-out mirror. Such a way of looking at reality *through* fiction offers spectators the possibility of appreciating, enjoying, and better understanding reality.

But that must not confuse us. Cinematic realism does not lie in its alleged ability to capture reality "just like it is" (which is "just like it appears to be"), but rather lies in its ability to reveal, through associations and connections between various isolated aspects of reality—that is to say, through creating a "new reality"—deeper, more essential layers of reality itself. Therefore, we can establish a difference between the objective reality which the world offers us—life in its broadest sense—and the image of reality which cinema offers us within the narrow frame of the screen. One would be genuine *reality;* the other, fiction.

Now I would like to elaborate on how the cinematic show offers viewers an image of reality which belongs to the sphere of fiction, the imaginary, the unreal. In this sense it stands in relative opposition to the very reality it belongs to. Of course, the sphere of the real, in its broadest sense, includes social life and all man's cultural manifesta-

tions. Therefore, it encompasses the sphere of fiction itself, of show— as a cultural object. But, evidently, in fact, it is really a question of two different spheres, each with its own peculiarities, which can be characterized not only as two aspects of reality, but as two *moments* in the process of approximation to its essence. Show can be conceived as a mediation in the process of grasping reality. The moment of the show corresponds to the moment of abstraction in the process of understanding.

The artistic show inserts itself to the sphere of everyday reality (the sphere of what is continuous, stable and relatively calm . . .) as an extraordinary moment, as a rupture. It is opposed to daily life as an unreality, an other-reality, insofar as it moves and relates to the spectator on an ideal plane. (In this being *ideal* —separation from everyday life —it expresses its unusual and extraordinary character. Therefore, show is not opposed to the typical, but rather it can incarnate the typical as it is a selective process and an exacerbation of outstanding— significant—traits of reality.) We cannot say, however, that it is an extension of (daily) reality but, rather, that it is always an extension of (the artists' and the viewers') subjective reality to the extent that it objectifies man's ideological and emotional content.

Cinema can draw viewers closer to reality without giving up its condition of unreality, fiction, and other-reality as long as it lays down a bridge to reality so that viewers can return laden with experiences and stimulation. The sum of experience and information which viewers gain on the basis of this relation may not go beyond that—more or less active sensory level—, but can also bring about in viewers, once they have stopped being viewers and are facing that other aspect of reality (the viewers' own life, their daily reality), a series of reasonings, judgments, ideas and thus a better comprehension of reality itself and an adaptation of their behavior, of their practical activity. The spectator's response follows the moment of the show; is a result of the show . . .[4]

The most socially productive show surely cannot be one which limits itself to being a more or less precise ("truthful," servile . . .) reflection of reality just as reality offers itself in its immediacy. That would be no more than a duplication of the image we already have of reality, a redundancy, in short and, as such, would lack interest. We could hardly say that it is a show. If we claim that the show, that which manifests itself through what we call *fiction*, is introduced as a moment of rupture, of disturbance in the midst of daily reality, and in this sense opposes it and negates it, we must establish very clearly what this negation of reality ought to consist of so that it becomes socially productive.

There is a story of a painter, Chinese for all we know, who once painted a beautiful landscape in which you could see mountains, rivers, trees . . . rendered with so much grace, in accordance with the dictates of his imagination, that all a viewer needed was to hear the birds' songs and feel the wind pass between the trees to complete the illusion of standing in front of a real landscape and not a picture. The painter, once finished, stood there enraptured contemplating the landscape which had flowed from his head and hands. . . . He was in such ecstasy that he began to walk toward the picture and feel completely enveloped by the landscape. He walked among the trees, followed the course of the river, and withdrew further and further into the mountains until he disappeared toward the horizon.

A great finale for a creative artist, probably. But similar experiences of aesthetic ecstasy for any viewers ought to be conditioned so that they do not lose their way back and so that they can return to reality both spiritually enriched and stimulated so as to live better in it. For that reason, whatever the landscape of the Chinese painter offers with all of its mysterious charm, it represents the absolute negation of reality and thus (keeping to the plane of metaphor) death or insanity.

A show which exercises this kind of fascination for the spectator can be characterized as a "metaphysical negation" of reality. That is, a negation which tries to abolish reality through an act of evasion. Of course, nor would this be the most socially productive kind of show.

But, for a long time now, that has been the ideal kind of show for a class which is essentially hypocritical and impotent, but which has been capable of inventing the most sophisticated justification mechanisms to try to hide from itself the most profound levels of reality which it cannot—or does not want—to change. But that is not the case in a society which is rebuilding itself on a new basis, whose objective is to eliminate all vestiges of exploitation of man by man, which demands all its members' active participation and consequently the development of each person's social consciousness. Metaphysical negation, which tries to abolish reality through an act of evasion, opposes dialectical negation, which aims to transform reality through revolutionary practice. As Engels said, "Negation in dialectics does not mean simply saying no, or declaring that something does not exist, or destroying it in any way one likes."[5] Further on he says, ". . . therefore, every kind of thing has its characteristic kind or way of being negated, of being negated in such a way that it gives rise to a development, and it is just the same with every kind of conception or idea."[6] Therefore, a show which is socially productive will be that which negates daily reality (the false crystallized values of daily or

ordinary consciousness) and at the same time establishes the premises of its own negation; that is, its negation as a substitute for reality or an object of contemplation. It is not offered as a simple means of escape or consolation for a burdened spectator, rather, it propitiates the viewers' return to the other reality—that which pushed them momentarily to relate themselves to the show, to become absorbed, to enjoy, to play. . . . They should not return complacent, tranquil, empty, worn out, and inert; rather, they should be stimulated and armed for practical action. This means that show must constitute a factor in the development, through enjoyment, of the spectators' consciousness. In doing that, it moves them from remaining simple, passive (contemplative) spectators in the face of reality.

The Contemplative and the Active Spectator

Show is essentially a phenomenon intended for contemplation. People, reduced momentarily to the condition of spectators, contemplate a peculiar phenomenon, the characteristic traits of which aim at the unusual, the remarkable, the exceptional, the out of the ordinary.

Certain real phenomena—natural or social phenomena—can indeed manifest themselves spectacularly: natural forces unleashed, grandiose landscapes, wars, mass demonstrations. . . . They constitute a show insofar as they break down the habitual image we have of reality. They offer an unfamiliar image, a magnified and revealing one, to the people contemplating them—the spectators. And just as reality can manifest itself spectacularly, so too can real show, the kind people provide for themselves in play or in artistic expression, be more or less spectacular in the degree to which it distances itself from, or draws closer to, daily reality. But in any case, show exists as such on behalf of the spectator. By definition spectators are people who contemplate and whose condition is determined not just by the characteristics or the phenomenon, but rather by the position which they as individuals (subjects) occupy in relation to it. People can be actors or spectators in the face of the same phenomenon.

Does this mean that the spectator is a passive being? In a general sense, not only all knowledge but the entire complex of interests and values which make up consciousness is shaped and developed, both socio-historically and individually, through a process which has as its point of departure the moment of contemplation (sensory consciousness) and culmination in the moment of rational or theoretical consciousness. We can say, therefore, that the condition of being spectator, as a moment in the process of the subject's appropriating or

interiorizing—a reality which includes, of course, the cultural sphere as a product of specific human activity—is fundamental.

But clearly, contemplation itself does not consist of a simple, passive appropriation by the individual: it responds to a human need to improve living conditions and already bears within it a certain activity. This activity can be greater or lesser depending not only on subjects and their social and historical locus, but also—and this is what we want to emphasize—on the peculiarities of the contemplated object, and on how these can constitute a stimulus for unleashing in the viewers another kind of activity, a consequential action beyond the show.

When I refer to "contemplative" spectators, I mean ones who do not move beyond the passive-contemplative level; inasmuch as "active" spectators, taking the moment of live contemplation as their point of departure, would be those who generate a process of critically understanding reality (including, of course, the show itself) and consequently, a practical, transforming action.

Viewers looking at a show are faced with the product of a creative process of a fictitious image which also stemmed from the artist's act of live contemplation of objective reality. Thus a show can be directly contemplated as an object in itself, as a product of practical human activity. But viewers can also refer to the more or less objective content reflected by the show, which functions as a mediation in the process of understanding reality.

When a relation takes place only at the first level, that is, when show is contemplated merely as an object in itself and nothing more, "contemplative" spectators can satisfy their need for enjoyment and aesthetic pleasure, but their activity, expressed fundamentally in accepting or rejecting the show, does not go beyond the cultural plane. Here the cultural plane is offered to people as a simple consumer object, and any reference to the social reality that conditions it is reduced to an affirmation of its values or, in other cases, to a complacent "critique."

In capitalist society, the typical consumer film show is the light comedy or melodrama. It has invariably had a "happy ending" and has provided, and to a certain degree continues to provide, a rather efficient ideological weapon to promote and consolidate conformism among large sectors of the population. First, there is a plot. In its numerous situations we are made to feel that the stable values of society are threatened, via the hero who incarnates those values, which, on an ideological plane, make up his physiognomy. That is to say, those are the values which (people almost never understand why this happens) have become sacred ideas and objects of worship and veneration

(homeland as an abstract notion, private property, religion, and generally all that which constitutes bourgeois morality). In the end those values are saved, and we leave the movie theater with the sensation that all is well, that there is no need to change anything. One veil after another has been drawn over the reality that prevents people from being happy and forces them to turn what could be an amusing game, a healthy entertainment, into an attempt at evasion onto which the individual, trapped in a web of relations preventing him from knowing and fully developing himself, hurls himself.

Show, as a refuge in the face of a hostile reality cannot but collaborate with all the factors which sustain such a reality to the extent that it acts as a pacifier, an escape valve, and conditions the contemplative spectator vis-à-vis reality. The mechanism is too obvious and transparent and has been denounced all too often.[7] Many solutions have been suggested for such an irritating situation, which inverts the role of the spectator-subject submitting him to the sad condition of object.

The "happy ending's" discredit, in the midst of a reality whose mere appearance violently disproved the rosy image sold to people, led to the use of other more sophisticated mechanisms. The most spectacular one, surely, has been the "happening," where the game with the spectator is taken to a level which is presumably corrosive for an alienating and repressive society. Not only does the happening give spectators an opportunity to participate, but it even drags them in against their will and involves them in "provocative" and "subversive" actions. But all this goes on, of course, clearly *within* the show where anything can happen and many things can be violated. What prevails is the unusual, the unexpected, the surprise, and the exhibitionism. . . . Furthermore, it can be as useful as a ritual which helps to shape a specific behavior. Generally, it can be very funny, especially for those who can afford to just look at things from above because undoubtedly that would give them a certain kind of relief for, in spite of the happening's seemingly truculent and disquieting appearance, it is an ingenious expedient, which in the final analysis helps to prolong the situation, not to change anything; in other words, to just sit and wait while those below reach some kind of an agreement.

In cinematic show, of course, there is no room for this kind of means to facilitate or provoke spectators' "participation" on the basis of unpredictability. Nevertheless, the problem of spectators' participation still persists. It demands a solution that is within—or better, based on—the cinematic show itself, which reveals how simplistically this problem has often been approached. The first thing this uneasiness reveals is something we frequently forget but which nevertheless may be an axiomatic truth: *the response one wants to arouse in the*

spectator is not only that which is elicited during the show, but also that which is elicited vis-à-vis reality. That is to say, what is fundamental is real participation, not illusory participation.

During periods of relative stability in a class society, there is minimal individual social participation. In one way or another, through physical, moral or ideological coercion, the individual's activity takes place mainly within the framework of the direct production of material goods, which mostly serve to meet the exploiting class' needs. Individual action outside this framework is illusory.

However, at those times when the class struggle is exacerbated, the level of people's general participation grows. At the same time, a leap occurs in the development of social consciousness. In those moments of rupture—extraordinary moments—spectacular events occur within social reality, and when faced with them, individuals take a stand in keeping with their own interests. Without a doubt, it is above all in these circumstances that we see revealed what Aimé Césaire referred to as the "sterile attitude of a spectator."[8] Reality demands that people take sides when faced with it, and that demand is fundamental to the relationship between man and the world at all times throughout history. If we consistently assume as a principle that "the world does not satisfy man, so he decides to change it through his activity,"[9] we must remember that man's activity, that taking of sides which becomes practical, transforming action, is conditioned by the type of social relations existing at any given moment. And in our case, in a society where we are building socialism, reality also demands partisan activity and a growing level of social participation from all those individuals who make up this society. This process is only possible if accompanied by a parallel development in social consciousness. The cinematic show falls within that process insofar as it reflects a tendency of the social consciousness which involves the spectators themselves and insofar as it can affect the spectators as a stimulus, but also as an obstacle, for consequent action. And when I speak about consequent action, I am referring to this specific type of participation, historically and socially conditioned, a concrete participation which implies people's adequate response to the problems of social reality, especially those of an ideological and political nature. What this is about, then, is stimulating and channeling spectators to act in the direction of historical movement, along the path of society's development.

To provoke such a response in the spectator it is necessary, as a first condition, that reality's problems be presented in the show, that concerns be expressed and transmitted, that questions be posed. That is to say, it is necessary to have an "open" show.

But the concept of "openness" is too broad; it is present at every level where the artistic work operates. By itself, openness does not guarantee the spectator's consequent participation. In the case of an open show presenting concerns that are not only aesthetic—as a source of active enjoyment—but rather conceptual and ideological, it becomes (without ceasing to be a *game* in the sense that every show is) a serious operation because it touches on underlying levels of reality.

Nevertheless to achieve the greatest efficacy and functionality, it is not enough for a work to be open—in the sense of indeterminate. The work itself must bear those premises which can bring the spectator to discern reality. That is to say, it must push spectators into the path of truth, into coming to what can be called a dialectical consciousness about reality. Then it could operate as a real "guide for action." One should not confuse openness with ambiguity, inconsistency, eclecticism, arbitrariness . . .

What can the artist base himself on in order to conceive a show which would not just pose problems but would also show viewers the road they ought to take in order to discover for themselves a higher level of discernment? Undoubtedly, here art must make use of the instruments developed by science for research; art must apply all methodological resources at hand and all it can gain from information theory, linguistics, psychology, sociology, etc. Show, insofar as it becomes the negative pole of the reality-fiction relationship, must develop an apt strategy for each circumstance. We must not forget that, in practice, spectators cannot be considered abstractions, but, rather, people who are historically and socially conditioned, in this way, the show must address itself first of all to concrete spectators to whom it must unfold its operative potential to the fullest.

Translated by Julia Lesage

Notes

1. Patricio Guzmán, in notes he wrote before making *Battle of Chile*, said at that time—the months which preceded the fascist coup—he never would have made a fictional film with actors reciting a text, because reality itself, which was unfolding before his very eyes, was changing tremendously. In times of social convulsion, reality loses its everyday character, and everything which happens is extraordinary, new, unique . . . The dynamics of change, the trends of development, the essence are manifested more directly and clearly than in moments of relative calm. For that reason, it attracts our attention and in that sense we can say it is spectacular. Surely, the best thing to do is to try to capture those moments in their purest state—documentary— and to leave the re-elaboration of those elements reality offers for a time

when reality unfolds without any apparent disturbance. Then fiction is a medium, an ideal instrument, with which to penetrate reality's essence.

2. This famous code sets forth, among other things, that film "builds character, develops right ideals, inculcates correct principles, and all this in attractive story form." Regardless of any discrepancy from the "right ideals" and "correct principles" which this revealing document tried to promote, it is interesting to see how it resorts to the most puerile mechanism—that spectators "hold up for admiration high types of characters." Without a doubt, that mechanism is the one which best reveals reactionary attitudes, because its only purpose is to mold an idealized and complaisant image of reality. (Moley, R., *The Hays Office*, "Code to Govern the Making of Talking, Synchronized and Silent Motion Pictures," New York: Bobbs-Merrill, Co., 1945, p. 246).

3. In the thesis about artistic and literary culture contained in the *Plataforma Programática del Partido Comunista de Cuba* (Havana: Ed. DOR, 1976, p. 90) we can read, "Socialist society calls for art and literature which, while providing aesthetic enjoyment, contribute to raising the people's cultural level. An extremely creative climate, which impels art and literature's progress as the legitimate aspiration of working people, must be achieved. Art and literature will promote the highest values, enrich our people's lives and participate actively in shaping the communist personality."

4. Certainly, TV has brought into the home the most spectacular images of reality. For example, I think about an average American drinking beer while watching television and seeing Saigon's police chief put a bullet through the skull of a prisoner in full public view, and all of this in color. Therefore, the *representation* of those moments has to adjust to new circumstances. But the most important thing is that an act so powerful, so unusual, so naked, once it is screened as show—that is to say, once its contemplation is made available to the viewers—is found to have notably reduced its potential as a generator of a consequent reaction in practice. Probably, the surprise would make the viewer jump up from his chair, but following that, he would go to the refrigerator to open up another beer, which would make him sleep soundly. After all, those events have become little by little everyday facts of life. What would we have to do to move this viewer? It is not enough that the show be real—and that it might be happening at the very moment that one looks at it—to generate a "productive" reaction in the spectator. For that it would be necessary, possibly, to resort to more sophisticated mechanisms.

5. Engels, F., *Anti-Dühring*, Moscow: Foreign Languages Publishing House, 1962, p. 194.

6. *Ibid.*, p. 195.

7. Brecht said: "The bourgeois passes beyond, in the theater, the threshold of another world which has no relation at all to daily life. It enjoys there a kind of venal emotion in a form of a drunkenness which eliminates thought and judgment" (Quoted in V. Klotz, *Bertolt Brecht*, Buenos Aires: La Mandragora, 1959, p. 138).

8. "And most of all beware, even in thought, of assuming the sterile attitude of the spectator, for life is not a spectacle, a sea of griefs is not a proscenium, a man who waits is not a dancing bear . . ." (Césaire, Aimé, *Cahier d'un retour au pays natal*, Éditions Présence Africaine, Paris, 1971, p. 62).

9. Lenin, V.I., *Cuadernos filosóficos*, Havana: Editora Política, 1964, p. 205.

Part 2
Continental Development: Socio-historical Contexts and Modes of Production/ Consumption

An "Other" History

The New Latin American Cinema

Ana M. López

> The notion of Latin America exceeds all nationalisms. There is a common problem: misery. There is a common objective: the economic, political, and cultural freedom to make a Latin American cinema. An engaged, didactic, epic, revolutionary cinema. A cinema without frontiers, with a common language and common problems.
>
> Glauber Rocha, *Revolução do Cinema Novo*

I

By 1955–57, filmmaking in Latin America had suffered irreparable reverses. In Brazil, the bankruptcy of the Hollywood-modeled Vera Cruz studios in 1954 had proven that an industrial structure and capitalization were not sufficient to guarantee the development of a Brazilian cinema. From 1955 to 1957, production figures hovered between 25 and 36 films per year and consisted primarily of *chanchadas* made in Rio de Janeiro for domestic consumption.[1] In Argentina, the *coup d'état* that ousted Perón in 1954 also dismantled all state protection of the cinema and paralyzed an already waning industry. Although Argentine production had topped 50 films per year in the late 1940s and early 1950s, by 1957 annual production had dropped to 15 films. In Chile, the moribund state enterprise for the cinema, Chile Films, struggled for survival and only one or two na-

Radical History Review, no. 41, 1988, pp. 93–116. By permission of the publisher.

tional films were produced per year. In Cuba, a disastrous trend of Cuban-Mexican co-productions wound down and national production almost disappeared. Bolivia had never recovered from the advent of the sound cinema and had released no national films since 1938.

By 1968–69, although total production figures for most Latin American nations were not much greater, a tremendous difference in the nature of filmmaking and filmic reception was evident.[2] In Argentina, the efforts of Fernando Birri at the Documentary School of Santa Fe had challenged the otherwise prevalent industrial mode of filmmaking, and other radicalized young filmmakers had taken the cinema —conceived of as a tool for demystification and revolution—underground. In Brazil, the innovative Cinema Novo movement emerged from the ashes of the failed industrial efforts of Vera Cruz to revitalize the Brazilian cinema. In the decade following the triumph of the revolution in 1959, Cuba became the first Latin American nation where it was possible to construct a new cinematic culture on a national scale by reorganizing all aspects of the cinematic experience. In Chile, the national cinema was already synonymous with Popular Unity and the Allende political experiment.[3] In Bolivia, young filmmakers like Jorge Sanjinés challenged the hegemony of the state filmmaking apparatus and subverted its principles to produce a cinema for the majority Indian population of the nation.

In all Latin American nations, the 1960s were years of cultural and political effervescence, and the cinema—conceived of as an aesthetic, cultural, and political/ideological phenomenon—was self-consciously immersed in the maelstrom of popular and intellectual debates. In Brazil, Argentina, Chile, Cuba, and Bolivia cine clubs, film societies, film magazines, and museum exhibitions mobilized an active interest in national film culture and amateur filmmaking as committed activities. Throughout the continent—in nations as radically different as Argentina, Bolivia, and Cuba—the cinema's role in society and its relationship to the continent's struggle for liberation were redefined in the late 1950s and 1960s. By 1968 or 1969, the cinema of Latin America could rightly be called the New Latin American Cinema, a pan-Latin American cinematic movement dedicated to the people of the continent and their struggles for cultural, political, and economic autonomy.

By comparison to the standard or dominant cinematic movements and national cinemas, the New Latin American Cinema is peculiar: a marginal, politicized, often clandestine cinematic practice that has managed to give expression to new forms and contents; to create alternative modes of production, consumption, and reception; to produce great box office hits as well as utterly clandestine films; and, in short,

to change the social function of the cinema in Latin America. It is a challenge to scholars because it spans a somewhat nebulous 25- to 30-year period (from the late 1950s to the present), at least a dozen countries (which today include the Central American nations), and every genre or cinematic mode of production, while maintaining a tenacious, albeit often problematic, unity.

It is a "movement," but one much larger than any of the cinematic practices usually studied under this category, and one more unified than the international modernist or avant-garde cinemas. Unlike other "new cinema" postwar movements (such as Italian Neorealism, the French New Wave, the New German Cinema), its unity is not limited to the desire for nationalist expression and differentiation from the Hollywood "pleasure machine." Furthermore, the New Latin American Cinema is a political cinema committed to praxis and to the sociopolitical investigation and transformation of the underdevelopment that characterizes Latin America. It is thus one that cannot be properly understood in isolation from political, social, economic, cultural, and aesthetic forces.

The nature of the movement itself, then, demands that the analyst rethink the categories which are normally utilized to construct film historical discourses. Telling and analyzing the development of this movement entail much more than providing a list of "first films" and dates and identifying the "great men and women" and the "nations" behind them. If we cannot pin the movement down to a nation, to a hard-and-fast periodization, to the artistry of individual *auteurs*, or to a general dominant aesthetic, then we have to begin by investigating other alternatives for structuring history if it is going to explain as well as trace the specificity of this cinema.

In this essay, I will provide an analysis of the historical development of the New Latin American Cinema. My primary concern is to analyze the difficulties involved in the historical study of this cinema and my focus will be upon the complex network of determinants that catalyzed the movement's emergence and, later, its efforts to achieve pan-Latin American unity. In this process, I will also account for a number of specific problems related to the nature of the cinema in Latin America and its international position: the problems of influence, pan-Latin Americanism and nationalism, dependence and independence, "otherness" and cultural domination and hegemony. This essay addresses recent debates among Latin American filmmakers and among scholars of Latin American film that have questioned the status (and even the very existence) of the New Latin American Cinema. Questions such as "Is the New Latin American Cinema dead?" "Has it ever existed?" have echoed in places as disparate as the International

Festival of New Latin American Cinema in Havana (annually),
the Edinburgh Film Festival (1985), the Second New Latin American
Cinema Festival in Iowa (1986), and the pages of countless journals.
Some have argued that the New Latin American Cinema as a move-
ment is best defined in political terms: the movement coheres and ex-
ists because it is the cinematic elaboration of radical left aspirations
for Latin America. As such, it represents a radical "break" from exist-
ing cinematic practices. Others have argued that the New Latin Amer-
ican Cinema is a "fiction" and that the national cinema movements
that make up the New Latin American Cinema are far too disparate to
be discussed as a coherent "movement." In this essay, although af-
firming the existence and continued political viability of the New
Latin American Cinema, I present a different way of defining the
movement that takes into account its historical evolution from and its
transformation of national and international cinematic practices.

II

What is the New Latin American Cinema? The term represents an at-
tempt to impose unity on a number of diverse cinematic practices; a
political move to create an order out of disorder and to emphasize
similarities rather than differences. It acquires its cultural and political
currency retroactively, as it is used to redefine and value contesta-
tional cinematic movements that emerged independently in different
countries. Unlike other "new" cinemas in Europe, the New Latin
American Cinema is not traceable to a "miracle year" (like 1959 for
the French New Wave) or to a single manifesto (like the Oberhausen
document for the New German Cinema). It emerged slowly, its differ-
ence from other practices becoming gradually more pronounced, its
goals coalescing throughout the 1960s and 70s. As terms go, it is a
critical handle fraught with as many definitional inconsistencies as the
French "New Wave" or the "New" German Cinema. But unlike these
other critical categories which self-destructed as the different concerns
of their practitioners became evident in their third and fourth films,
the appropriateness and cultural currency of the term "New Latin
American Cinema" has continued to grow, so much so that today the
term seems to have become completely institutionalized. Fifteen years
ago we could speak of a "Third Cinema," an "Imperfect Cinema" or a
"Cinema of Hunger," but today these terms have become practically
obsolete and are subsumed under the far more powerful and empower-
ing "New Latin American Cinema."[4]

When the term is used today it always implies a socio-political atti-
tude that constitutes the principal source of unity for these films and

practices. That attitude can be summarized as a desire to change the social function of the cinema, to transform the Latin American cinema into an instrument of change and of consciousness-raising or *concientización*. Always conceived of as a challenge to the hegemony of the Hollywood import and foreign control of cinematic institutions and as an active agent in the process of cultural decolonization, the New Latin American Cinema is not just a filmmaking movement; it is a social practice intimately related to other movements struggling for the socio-cultural, political, and economic autonomy of Latin America.[5] And it is a social practice that revels in the diversity and multiplicity of its efforts to create an "other" cinema with "other" social effects as a prerequisite of its principal goal to reveal and analyze the "reality," the underdevelopment and national characteristics, that decades of dependency have concealed.[6]

In the 1950s a confluence of factors gave rise to conditions that would set the stage for the emergence of the New Latin American Cinema as a movement. Politically, these were tempestuous years characterized by the rise of nationalism and militancy. Massive political changes took place throughout the continent: the *bogotazo* in Colombia in 1949, the unfinished workers' revolution in Bolivia in 1952, liberal reforms in Guatemala in 1954 which provoked U.S. intervention, the suicide of the populist Brazilian President Vargas in 1954, the military overthrow of Argentine President Perón in 1955, and, most significantly, the guerrilla war in Cuba which led to the establishment of a socialist regime in 1959. In the 1960s, the continued success of the Cuban revolution served as a central inspiration for social change and the rise of guerrilla and radical-left movements throughout the continent. With the mobilization of the middle classes in support of sweeping socio-political changes, this political turmoil was translated into a kind of cultural effervescence which, when linked to the traditionally *engagé* position of Latin American intellectuals and the growing student activism of the period, set the stage for broad cultural changes which decisively affected the cinema.

First of all, the context of filmic reception—of exhibition and consumption—began to change. The emergence of cine clubs, specialized film publications, film societies, and film festivals in the 1950s and early 1960s led to a different awareness of the cultural significance of the cinema. Although most of these organizations and activities were spurred by an interest in the burgeoning European art cinema, this interest served to shift attention away from the Hollywood model to alternative practices such as Italian Neorealism. In fact, in the context of production—the second realm to be considered here—Neorealism

was a revelation to those struggling to create national cinemas in the
face of underdevelopment and the failures of industrial efforts.

In the classical sense of the term, Neorealism constituted an episte-
mological break for international filmmaking by representing the for-
merly unrepresented.[7] It explicitly rejected the Hollywood mode of
production with its low budgets, non-actors and location shooting;
demanded an awareness of the links between cinematic production
and expression; and upheld, in Rossellini's words, "a moral position
from which to look at the world."[8] And it was young Latin American
filmmakers such as Fernando Birri in Argentina, Nelson Pereira dos
Santos in Brazil, and Julio García Espinosa and Tomás Gutiérrez Alea
in Cuba, who had either trained at the Centro Sperimentale di Roma—
the birthplace of Neorealism—or who had been strongly influenced by
the movement, who produced the films that are cited as the precursors
of the New Latin American Cinema: Birri's *Tire Dié* (1956–60), dos
Santos' *Rio Quarenta Graus* (1955) and Alea and Espinosa's *El Me-
gano* (1954). Exhibiting a shared concern for representational authen-
ticity and a rejection of the Hollywood mode of production in favor of
more artisanal forms, these films were nevertheless part of national
rather than pan-Latin American efforts to change the social position of
the cinema.

III

How do these independent, nationalistic cinematic movements become
the New Latin American Cinema? Two historiographical issues must
be addressed before addressing this question: influence (and its rela-
tionship to cinemas striving for difference and "otherness") and
nationalism.

Influence is generally thought of as the opposite of originality and
difference, the most desirable traits for identifying the specificity of
cinematic practices. The film historian/critic always struggles to estab-
lish the difference between the object of study and other practices.[9] To
a large extent, film scholarship's fascination with the identification of
oppositional film practices—be they the film noir, the women's film,
the structural avant garde, or the New Latin American Cinema—must
be seen as an effect of our interest in discontinuity as a progressive
strategy that can be contrasted to an assumed standard, fixed, and con-
tinuous history or institution—specifically, the Hollywood cinema. In
the context of the New Latin American Cinema, our contemporary in-
terest in difference, when combined with this cinema's own discursive
reinforcement of its status as an "other" and the critics' own political
commitment, has led many to overlook the essential function of influ-

ences in the process of forging a New Latin American Cinema from disparate and geographically distant national cinemas. And yet one of the most telling and defining characteristics of that cinema has been its ability to transform and improvise upon existing models of cinematic production.

Although distinct in style, function and motivation from the European movements, the strong national cinemas of Brazil, Argentina and Cuba in the early '60s were indeed developed in the context of the cinematic innovations that had emerged from Europe and in the context of each nation's unique cinematic histories.[10] Their "otherness" is predicated on their inseparability from and their relationship to the dominant, for it is in the nature of cultural production in dependent nations always to be caught in a struggle for self-definition.[11] Thus when we look at the influence of Neorealism—or the French New Wave or the Soviet cinema—on the development of the New Latin American Cinema, it is not to deny that cinema originality, otherness, or a political viability that is specific to its relationship with Latin American social structures, but to claim for that cinema a special status as a particular kind of transformational practice.

The issue of nationalism and the New Latin American Cinema is related to the question of influences. In fact, if it were not for the phenomenon of influence, the New Latin American Cinema could not possibly be thought of as a movement, for it is the reciprocal and collaborative influences among different national (and nationalistic) movements that gives rise to this cinema. It is particularly important, for example, to consider the influence of Cuba and the Cuban cinema on the development of the New Latin American Cinema as a movement.

The concept of a national cinema has been much discussed in Latin America, even though few of these nations have been able to establish national cinematic industries. The cinema as a national necessity has never been a concern of Hollywood, even though classic Hollywood films may indeed turn on the screw of national identity, as Philip Rosen has recently argued.[12] But in Latin America, the importance of nationality in the cinema has been a hotly debated issue almost since the birth of the cinema.[13] In the face of what has always been perceived as the dominating and stifling presence of other cultures and ideologies, the cinema was identified early on as a crucial site for the utopian assertion of a collective unity identified as the nation.

The New Latin American Cinema fits in with national cinema projects because the issue of how to define, construct, and popularize national cinemas has always been one of its primary concerns. Although it has not always been discussed as such, the New Latin American

Cinema posits the cinema as a response to and an activator of a differ-
ent kind of nationhood or subject position of nationality than the one
sponsored by dominant cultural forces. The goal has been to develop
through the cinema (and other cultural practices) a different kind of
national and hemispheric consciousness by systematically attempting
to transform the function of the national cinema in society and the
place of the spectator in the national cinema. As Cuban filmmaker/
theorist Tomás Gutiérrez Alea has argued, the goal is to promote a
spectator that "ceases to be a spectator in the real world and that con-
fronts reality not as a given but as a process in which one can have an
active role."[14] The films of the New Latin American Cinema, ranging
from documentaries like *Por Primera Vez* (*For the First Time*, 1967,
Cuba, Octavio Cortazar), *La Hora de los Hornos* (*The Hour of the
Furnaces*, 1968, Argentina, Fernando Solanas and Octavio Getino),
and *La Batalla de Chile* (*The Battle of Chile*, 1973–78, Chile, Patricio
Guzmán and the Equipo Tercer Año collective) to fiction films such as
Memorias del Subdesarrollo (*Memories of Underdevelopment*, 1968,
Cuba, Tomás Gutiérrez Alea), *El Chacal de Nahueltoro* (*The Jackal
of Nahueltoro*, 1968–9, Chile, Miguel Littín) and *El Coraje del
Pueblo* (*The Courage of the People*, Bolivia, 1971) consistently com-
plicate the protocols necessary for their reception, mixing documen-
tary and fictional modes of representation in order to alter the
signifying work of the cinema and thereby engage their audiences at
different levels.[15]

A different concept of nationalism and nationhood in the cinema
lies at the heart of the New Latin American Cinema's attempts to
change the social function of the cinema in Latin America. The proc-
esses whereby national cinemas begin to exhibit and/or articulate the
principles of the New Latin American Cinema are complex and de-
pendent upon mutually determining relationships among a series of
socio-political, cultural, and cinematic changes. I shall briefly outline
some of these changing relationships in Argentina as an illustration
of the mechanics of the process of redefining the desire for a na-
tional cinema—a process that was also taking place in Brazil and in
Cuba (albeit for different reasons and taking different forms in each
country).

IV

Although the Argentine cinema already had a long history before
World War II, the national industry was unable to recover from a crip-
pling war-time decline even under the protectionist policies of the po-
pulist government of Juan Perón.[16] The Cinema Law of 1957—also

known as the Decreto Ley 62-57 and in force until 1973—did not serve as a stimulus for the industrial development of the national cinema, but it had one positive side-effect. By providing as much as 50 per cent of the production costs of national productions, it allowed directors to become their own producers and stimulated a series of independent productions that seemed to change the physiognomy of the Argentine cinema by reintroducing national characters.[17] Leopoldo Torre Nilsson, for example, managed to set up his own production company (Producciones Angel), to retain complete artistic/financial control of his films, and to become the first European-style, self-expressive *auteur* of the Argentine cinema. At the other end of the spectrum, filmmaker/producer Fernando Ayala, took the cinema on as a medium for social criticism and analysis by adapting films from contemporary critical-realist Argentine literature and bringing to the screen topics that had previously been considered taboo.

Stimulated by the intellectualized cinema of Torre Nilsson and provoked by the social criticism of Ayala, young *cine-clubistas* took advantage of the general industrial decline to apply for state-guaranteed production loans and to debut their first features in 1959–1961. The principal filmmakers that emerged in this period were Simon Feldman, José A. Martínez Suárez, Manuel Antín, David José Kohon, Rodolfo Kuhn, and Lautaro Murúa. With the exception of Murúa, these young cineastes adopted the cinema as a vehicle of personal expression. Sharing the spirit of the "Young Turks" of the *Nouvelle Vague* in France, their films were narratively experimental, personal, and cosmopolitan and exploited the streets of Buenos Aires as locales for almost autobiographical self-expression.[18]

Although the *Nueva Ola* coheres as the product of a specific Argentine historical conjuncture (delimited by the political optimism of the middle classes under President Frondizi, the state's film subsidy program, and the growth of cinema culture), it is not a traditional cinematic movement that exhibits many similarities in styles and/or themes. Rather, the coherence of the *Nueva Ola* lies primarily in its class positions and ambivalences, for it was (with the possible exception of Murúa) an intellectualized cinema designed for a small, elitist, Buenos Aires audience and its major achievement was to bring to the screen and assert, with the technical fluidity of the European cinema, the world-view and individualistic experiences of the Buenos Aires middle-class.

Although deeply influential, the *Nueva Ola* was not able to transform the Argentine cinema or to become *the* Argentine cinema. From an economic perspective, the *Nueva Ola* was not a commercial success in Argentina and Argentina's position in the international market

precluded the extensive exportation of most of its films. Politically, the overthrow of President Frondizi in 1963, the factionalized military government of 1962–63, and the ineffectual civilian rule of President Illia from 1962 until 1966, also crippled the burgeoning movement (and the hopes of the bourgeoisie). Although the *Nueva Ola* was formally and thematically innovative, it did not attempt to change the economic base of film production, distribution, and exhibition and was, therefore, unable to survive the constraints of a small and closed market struggling to generate profits. Furthermore, its thematic concerns—inscribed within the cosmopolitan, middle-class problematic of Buenos Aires—failed to generate a national character/identification that was appealing to the majority of the primarily working-class Argentine film-going public.

However, in the margins of the *Nueva Ola*, another group was experimenting with a different kind of filmmaking at the Instituto Cinematográfico and the Documentary Film School of the Universidad del Litoral in the province of Santa Fe. Here, Fernando Birri, a graduate of the Centro Sperimentale in Rome, proposed that what Argentina needed was not a "new" cinema, but a new *Argentine* cinema:

> It's a matter of a national *toma de conciencia* [consciousness raising], of a take-over of our country. This is what I propose to the Argentines: that they occupy Argentina, that they capture her spiritually and materially. . . . I am not interested in proposing an aesthetic defense of reality and/or realism. What interests me is that the cinema be good for something, and for that something to be of help in constructing our reality.[19]

Against the blandness of the commercial cinema and the elitism of the *Nueva Ola*, Birri proposed a popular cinema that would document previously unrepresented aspects of national reality and that could be accepted by larger segments of the population; a cinema which addressed the non-elites of Argentina. This cinema was not to be based on autobiography, intuition, or lived experience, but on the systematic observation and study of the phenomenon being filmed. What Birri called for as a "national" cinema was a realist cinema with social commitments and aspirations. Although neither Birri nor the Instituto were highly productive in absolute terms, their work reverberated deeply within Argentina and, later, throughout all of Latin America.[20]

Although these cinematic activities and experiments in Argentina are articulated exclusively within the national sphere and are not yet linked to a New Latin American Cinema movement, they serve as an example of the transformations of "nationalism" and "national" cin-

ema that were necessary for the development of that pan-Latin American consciousness. Similar transformations were taking place in this period in Cuba and in Brazil. Both the Cinema Novo movement and the Cuban revolutionary cinema emerge as efforts to affirm a different kind of national consciousness and to redefine the role of the national cinema in society.

The national is the turning point of these cinematic discourses in Argentina, Brazil, and Cuba and of the New Latin American Cinema as a whole, but the movement is also related to the national at another, more complex, level. Even though global capitalism is often identified with economic internationalization and the need to transform all the citizens of the world into equal consumers of manufactured goods, we must be careful not to assume that any textual, historical, or intertextual expression of nationalism in the cinema constitutes a rejection of that capitalist domination.[21]

Capitalism is also a system based on the commodification and isolation of all experience, on the breakdown of experience into discrete (and marketable) units among which we must certainly include the creation and maintenance of underdeveloped nations serving the purposes of this system. Furthermore, dependence operates through internal as well as external forces and the national (or, as it is commonly called in this instance, bourgeois nationalism) may be articulated in the service of those same forces of international capitalism. It is precisely as a movement that stresses a particular set of nationalist positions and that articulates these positions across a terrain much broader than the national sphere that the New Latin American Cinema acquires its revolutionary cultural significance. It does not just represent a national cultural response to the specific forces of development and underdevelopment of a particular nation state, but an attempt to incorporate the importance of the national within the necessarily pan-Latin American nature of any such class-cultural struggle.

In order to outline the development of the New Latin American Cinema, it is necessary to analyze the process whereby a number of national cinemas throughout the continent coalesced into the New Latin American Cinema. How does the Latin Americanism of the New Latin American Cinema emerge? In what contexts? Given what incentives or motivations? How is it fostered and preserved?

V

Having established their own identity against the commercial products that preceded them, against the Hollywood cinema, and in relation to the more progressive strands of the European cinema, the national

movements of Argentina, Brazil, and Cuba began to turn towards the Latin American continent and, finally, began to take notice of each other. This is not to imply that the *cinemanovistas* in Brazil, the *nuevaolistas* and Fernando Birri in Argentina, and the filmmakers of the ICAIC (the Instituto Cubano de Arte y Industria Cinematográficos) in Cuba did not know of one another's existence prior to the mid-1960s. But until the early 1960s there had been few systematic efforts to establish cinematic exchanges and, most importantly, the filmmakers themselves had not begun to think of their work in relation to other Latin American filmmaking, nor had they begun to conceive of their overall cultural projects as exceeding the limits of their national borders. This cinematic isolation was as marked in Brazil and Argentina as it was in Cuba, where the ICAIC devoted most of its energies to producing a didactic national cinema first (primarily documentaries) with scarce resources and experienced personnel.[22] When the process of cinematic exchange began, it slowly changed the nature of the cinema that was produced in each country. It was no longer just a question of provoking a national *toma de conciencia* of underdevelopment through the critical realism of an engaged *auteur*: that *toma de conciencia* became more and more a Latin American priority that included the national but sought to be of Latin American consequence as well. The individual projects and goals of national cinemas always remained distinct and clearly identifiable. But the national became contextualized and articulated in relation to a "popular" and a "political" that exceeded the boundaries of exclusively national concerns and increasingly became Latin American.

The first articulations of the New Latin American Cinema project took place as a result of a series of international meetings that began in the early 1960s. Films from a number of Latin American nations had participated in the major international film festivals (Cannes, Venice, etc.), but few countries had been simultaneously represented at any one festival and, most significantly, there had been little discussion of the specific problems of the cinema in Latin America. Film festivals held in Latin America itself had, until the 1960s, been devoted to the European art cinema rather than regional productions. Although Uruguay's Festival Internacional de Cine Documental Y Experimental (International Documentary and Experimental Film Festival) sponsored by SODRE (the Radio-Electric Broadcasting Society) had already served as an important forum for Latin American films, its emphasis on the documentary had somewhat limited the scope of its influence.

It must be noted, however, that the 1958 SODRE festival, featuring British documentary filmmaker John Grierson as guest of honor and

the photo-reportage work of Fernando Birri and the Documentary School of Santa Fe, was an important precursor for the New Latin American Cinema because the first pan-Latin American association of film producers and directors (PRIDAL—Productores y Realizadores Independientes de America Latina) was created there as an outcome of discussions among filmmakers. Albeit short-lived, this organization pioneered by calling for increased cooperation and collaboration among independent Latin American filmmakers (and included among its members, filmmakers Nelson Pereira dos Santos [Brazil], Patricio Kaulen [Bolivia], Leopoldo Torre Nilsson, and Simon Feldman [Argentina]).[23]

However, the first sustained encounters between diverse Latin American filmmakers took place on foreign soil, in a series of festivals sponsored in Italy by a Jesuit cultural group dedicated to strengthening the relationship between the "New" and "Old" worlds. At the third of these events, the 1962 Festival of Latin American Cinema in Sestri Levante, a large and diverse group of film directors, critics, and producers (including Alfredo Guevara [Cuba], Rodolfo Kohn [Argentina], Glauber Rocha, and Walter da Silveira [Brazil]) were able to meet and discuss the future of the cinema in Latin America and the collective responsibilities and goals of each nation, filmmaker, and critic. In the resolutions drawn up at this meeting, following a panel discussion chaired by Edgar Morin and entitled "The Cinema as an Expression of Latin American Reality," the participants agreed to "condemn the cultural and cinematic isolation provoked by the foreign control of film production and exhibition" and to work to establish a base for collaboration among the different Latin American national cinemas and cultures.[24] This Sestri Levante festival thus served to situate the filmmaking projects and problems of individual nations in the context of the entire hemisphere and it furthermore allowed for important contacts to be established among filmmakers working in markedly different national cinematic conjunctures.[25]

Two years after the impetus of Sestri Levante, the Cine Club of Uruguay sponsored a festival featuring the independent cinemas of the Southern Cone countries, but the Latin American spirit was not officially reinvoked as such until the 1967 Viña del Mar Festival and the first "Encuentro de Cineastas Latinoamericanos" (Meeting of Latin American Filmmakers). The activities of this festival, although sponsored by a small society of amateur filmmakers and originally designed to increase tourism to this resort area of Chile, were to resonate for the next decade as the events that provided the impetus for the New Latin American Cinema movement.

By the 1967 Festival, the promise of Sestri Levante had already begun to be realized: there were already a considerable number of Latin American films to watch, discuss, and attempt to distribute. It had become apparent that filmmakers could indeed begin to talk about a "New Latin American Cinema" that exceeded the boundaries of each individual nation and coalesced as a larger and far more powerful entity. Furthermore, the films that could be shown already exceeded the products of "national" movements (in Cuba, Brazil, and Argentina) and included the works of filmmakers working in relative isolation in countries as diverse as Uruguay and Bolivia (respectively represented by Mario Handler's *Carlos* [1965] and Jorge Sanjinés' *Revolución* [1964]).

The Viña festival also provided the stimulus for the creation of a Latin American Center for New Cinema and the Cinemateca del Tercer Mundo in Montevideo. Although short-lived, the Center and the Cinemateca played a crucial role in the development of alternative distribution systems and of closer working relationships among Latin American filmmakers through pioneering collaborations, cross-national exchanges, experiments with alternative exhibition strategies, and—in 1969—the publication of a journal—*Cine del Tercer Mundo* —emphasizing Latin American Oppositional filmmaking rather than a single national cinema.

In 1967, *Cine Cubano* published a report of this first meeting of Latin American filmmakers which proclaimed a new solidarity and the "birth" of the New Latin American Cinema:

> Despite the diversity of its creators, its nationalities, and its modes of expression, there exists in Latin America a cinema strongly opposed to the denaturalizing marks of yankee imperialism and its Latin American branches. This is a cinema that is strongly tied to the aspirations and needs of its people, a cinema that has offered a number of proofs of its very serious professional and artistic commitments.[26]

Recognizing the importance of this first meeting of Latin American filmmakers, the Cubans heralded it as a "first step" in the collaborative process of creating a cinema for Latin American liberation. And in fact, what was perceived as the most important effect of the Viña meeting was its demonstration of the unity of purpose of the New Latin American Cinema.[27]

This unity of purpose was again displayed at the 1968 Second Meeting of Latin American filmmakers which took place in Mérida (Venezuela), under the auspices of the Centro de Cine Documental at

the Universidad de los Andes, alongside the first Muestra de Cine Documental Latinoamericano. Some of the most influential films of what was already recognized as the New Latin American Cinema were screened at this festival: Fernando Solanas and Octavio Getino's *La Hora de los Hornos* (1968, Argentina), Mario Handler's *Me Gustan los Estudiantes* (1968, Uruguay), Marta Rodríguez and Jorge Silva's *Chircales* (1968, Colombia), and Octavio Cortázar's *Por Primera Vez* (1967, Cuba).

Different avenues for film practices, different alternatives for a cinema of and against underdevelopment within the New Latin American Cinema were already established and would be further developed. From fiction to documentary, from shorts to feature-length films, from clandestine productions to the products of an already established industry—all these options were exercised, debated, and evaluated in the context of the cinematic/cultural/political needs of individual nations and in the context of the New Latin American Cinema's project for Latin American solidarity and liberation. In the resolutions drawn up at this meeting, the following definition of the movement was proposed:

> A cinema committed to national reality; a cinema which rejects all evasive and deformative formulas and indifference and ignorance, in order to confront the problematic of the sociological, political, economic, and cultural processes which each country, according to its particular situation and characteristics, is living through; a cinema which creates works permeated by realism, whether they be fictional or documentary, simple testimonies, profound analyses, or agitational tools. A cinema born in impossible conditions, because of the infinite passion of its authors, as an act of faith. An act of faith that must not only overcome material problems of production, but which must also struggle against problems of interpretation, the comprehension of new contents, and the formal elaborations of those contents. A cinema that even when produced encounters another obstacle: finding new and appropriate distribution/exhibition channels so that the films can be seen and truly accomplish their objectives.[28]

At this and the several meetings that were held in subsequent years (Viña del Mar in 1969, Mérida in 1970 and 1977, Caracas in 1971 and 1974) the different projects of the New Latin American Cinema were consolidated and implemented and the movement and its practitioners gained strength and solidarity. From this point on, it was no longer a question of working to establish a New Latin American Cinema, for that cinema was already "un acto irreversible," an irreversible

fact of history, as Julio García Espinosa would later herald at the opening of the IV International Festival of the New Latin American Cinema in Havana (1982).[29]

VI

In the period 1968 to 1973 it was fairly easy to discern what was and what was not part of this cinematic movement. The films of the New Latin American Cinema were revolutionary, explicitly political, called for an end to underdevelopment, poverty, oppression, hunger, exploitation, illiteracy, and ignorance. Many, like the powerful Argentine film-essay *The Hour of the Furnaces*, took on the medium as an explicit political instrument, and insisted that the cinema should and could be used as a "gun" in the struggle for the political and economic independence of Latin America (for example, the films of Mario Handler in Uruguay or of Santiago Alvarez in Cuba).

Others, in the fictional domain, took on the cinema as a vehicle for entertainment, but transformed and demystified its standard parameters: *Lucia* (1969, Cuba, Humberto Solas), *La Tierra Prometida* (*The Promised Land*, 1973–4, Chile, Miguel Littín), *Antonio das Mortes* (1968, Brazil, Glauber Rocha). They were films which showed Latin Americans the faces of their peoples and the problems of their nations, that celebrated national characteristics and popular culture, that sought to contribute to the end of all the shared ills of the continent. They were realist, historical, inventive films that took up the margins of traditional filmic practices as their own terrain, that subverted and deconstructed the traditional distinctions and categories of the dominant cinema to tell "other" stories, to show "other" facts. From the documentaries' explicit call to arms to the fiction films' analysis and rediscovery of national history, the films of the New Latin American Cinema asserted a utopian dream of continental collectivity, the dream of José Martí's "Nuestra America" in cinematic form.

In less hyperbolic terms, it is perhaps simpler to identify the New Latin American Cinema by clarifying what it did not include. With the exception of Cuban films, in this period the New Latin American Cinema did not include industrial films, or any film that relied on the structures and strategies of the dominant sector in their production methods, aesthetics, distribution, or in their relationship to audiences. These were independent films, marginal cinemas on the fringes of existing industries (Argentina, Brazil, Mexico) or artisanal practices in nations without a developed national cinematic infrastructure (Chile, Uruguay, Bolivia, etc).

Cuba was and is a case apart. At the time the only socialist nation of Latin America, its films have always been seen as contributing to the New Latin American Cinema project. In fact, the Cubans have been instrumental in promoting the idea and—through extensive collaborative arrangements—the very existence of the New Latin American Cinema project. The role Cuba has played in fostering the New Latin American Cinema has yet to be fully detailed: a listing of coproductions and Latin American exhibitions and distribution agreements is not enough to explain the influential role of the ICAIC and the Cuban Revolution itself throughout the continent. For example, in the 1980s, the annual International Festival of New Latin American Cinema has become a mecca for Latin American filmmakers, producers, and distributors who travel to Havana to simultaneously engage in film "business" and theoretical seminars. However, what must be clarified is that the New Latin American Cinema is far from being simply a Cuban "construct." The desire for this cinema—exemplified in the Cinema Novo and in the Nueva Ola, for example—both predates and exceeds the boundaries of Cuba's influence and the national priorities of its own cinema.

It is important to emphasize the impossibility and the obdurate continued viability of the New Latin American Cinema project in the late 1970s and '80s. In this period, Latin America was beset by a wave of repressive regimes, military *coups d'état*, failed socialist experiments and revolutionary efforts, ballooning foreign debts, and worsening economic conditions. Military coups (in, for example, Chile [1973], Uruguay [1973], and Argentina [1976]) and long-term repressive military regimes destabilized the New Latin American Cinema project within many nations. In the early 1980s, the social promise of the 1960s seemed to exist only in the ashes of revolutionary efforts to change the continental order of things. The New Latin American Cinema, often forced into exile or silenced by censorship and repression at a national level, assumed an increasingly pan-Latin American character, as is well evidenced by the Chilean and Argentine cinemas in exile.

But the New Latin American Cinema was simultaneously challenged by another problem. From a practical standpoint, the New Latin American Cinema project seems antithetical to the industrialization of cinematic production.[30] A cinema designed to subvert, demystify, and challenge the dominant cinema, common-sensical developmental assumptions, and political givens is marginal almost by definition and not particularly concerned with commercial imperatives. However, a desire for a different kind of industrialization of the cin-

ema has also been a constant concern of the New Latin American Cinema.

To make the national cinema strong, to encourage sustained production, to maintain and raise popular interest in the cinema: these are all concerns of the New Latin American Cinema that cannot be addressed from the margins, but that demand discussion in the context of mainstream national cinematic production, state protection of the national cinema, and that cinema's commercial or popular potential. Thus, in those nations with a developed (or developing) cinematic infrastructure, the New Latin American Cinema, in its search for ways to become a popular cinema, gradually found itself incorporated into mainstream—albeit somewhat modified—commercial operations. When combined with political pressures, this trend towards industrial practices altered the nature of the New Latin American Cinema project. So, for example, in Brazil, we must take into account the hegemonic power of the state organism for the cinema, Embrafilme; in Argentina, the recent redemocratization has also made possible the growth of the industrial filmmaking sector and the production of a number of significant and very successful films; and in Cuba, although still a case apart, the longevity of ICAIC as the state apparatus for the cinema has also meant that the Cuban cinema is an official (rather than a marginal) cinema with rather different national imperatives.

Today it is no longer as easy to distinguish what is and what is not part of the New Latin American Cinema project as it was in 1968. On the one hand, the ideals and practices of the New Latin American Cinema have become the norm for the continent. Even filmmakers working within different national industrial sectors have a different consciousness of their potential social effect and political goals and exhibit their concerns according to the options available in their specific political-social conjunctures. But on the other hand, there are constant claims (from within, but especially from outside the movement) that, in fact, the New Latin American Cinema is finished; that its specificity has disappeared; or, as Chilean filmmaker Patricio Guzmán claimed at a round table discussion at the Havana Festival of 1980, that it repeats itself, with the implication that it has ceased to have a special utility or serve a social function:

> It seems that we are still operating based on the premises of the sixties even though we are entering the decade of the eighties. In certain ways, some of our works are twenty years too late.[31]

However, the changes in the New Latin American Cinema since 1968 have, indeed, been significant: the range of options had grown,

the range of social functions this cinema has been asked to play has changed. Here we must consider the important differences between a cinema of resistance in exile (Chile), an official cinema in Cuba, a revolution-in-transition cinema in Nicaragua, a cinema struggling for a revolution in Salvador, a proto-industrial cinema in Argentina and Brazil. We must also consider that as a result of improved pan-Latin American relations (in the cinematic realm), co-productions are increasingly common. Co-productions provide the financial resources necessary for larger scale productions, but they also make the definition of the "nationality" of many films problematic. (For example, Chilean director Miguel Littín's *Alsino y el Condor* [1983] was shot in Nicaragua with the full co-operation of the state film organism [INCINE], with funding and technical assistance from Mexico, Costa Rica, and Cuba.) Furthermore, the introduction of video has increased access to the media and, as a result, in many nations video production has taken over the oppositional spaces occupied by the cinema in the early 1960s.

If, indeed, the New Latin America Cinema "repeats itself," then we must analyze the terms of those repetitions. Does it repeat itself thematically, stylistically, in its calls for specific kinds of actions, in its forms of expression, in its commitments? Some of these "repetitions," would seem to be unavoidable for a committed cinema, others questionable. But wholesale assertions of a lack of accomplishment in the New Latin American Cinema must be challenged with the continued growth of filmmaking throughout the continent, with the continued collaborative ventures among Latin American filmmakers and producers, with the increasing importance of the Havana Film Festival as the number of participating nations and films increases annually, with the efforts of the Committee of Latin American filmmakers and the recently formed Foundation of Latin American Filmmakers and Third World Film School (located in Cuba) to continue developing and fostering the future of a popular cinema of and for Latin America.

In light of these transformations, to claim that the New Latin American Cinema is dead—a corollary of the claim that it repeats itself—is to deny the movement the ability to adapt to changing conditions. The New Latin American Cinema is, for the most part, no longer necessarily a marginal cinema. But this does not mean that it has given up its politics. Rather than proclaim its death, what seems more appropriate is to call for an analysis of how it has changed, for close studies of its expressive and social strategies and commitments.

Notes

Research for this essay was made possible, in part, by research grants from the Mellon Foundation and the Roger Stone Thayer Center for Latin American Studies at Tulane University and the kindness of the staff of the Cuban cinematheque in Havana.

1. *Chanchadas* are light musical comedies, a unique Brazilian film genre, that were the mainstay of Rio de Janiero producers between 1940 and 1960. For more information about Brazilian film production in this period, see Randal Johnson and Robert Stam, eds., *Brazilian Cinema* (East Brunswick NJ, 1982).

2. Argentina, 40 feature films for 1968 and 41 for 1969; Brazil, 54 for 1968 and 53 for 1969; Chile, 5 each year; Cuba, 3 each year; and Bolivia, none in 1968 and 2 in 1969. See Jorge A. Schnitman, *Film Industries in Latin America: Dependency and Development* (Norwood, NJ, 1984) for data for Argentina, Brazil, Chile, and Bolivia; and Arturo Agramonte, *Cronologia del Cine Cubano* (Havana, 1966) for Cuban data.

3. Although Salvador Allende did not become president of Chile until 1970, when his *Unidad Popular* coalition won the national elections, Allende and his political platform had long been a factor in Chilean political life. In fact, in 1958 Allende and the FRAP party had almost won the national elections.

4. "Third Cinema" was the term used by Argentine radical filmmakers Fernando Solanas and Octavio Getino to distinguish their cinematic practice from the "first cinema" (industrial filmmaking) and the "second cinema" (*auteurist* cinema privileging the director). See their *Cine, cultura y descolonización* (Buenos Aires, 1973). The term "Imperfect Cinema" was coined by Cuban filmmaker-theorist Julio García Espinosa as part of an argument proposing that technical "perfection" need not be the central preoccupation of Latin American filmmakers. See his *Por un cine imperfecto* (Caracas, 1973). Brazilian filmmaker Glauber Rocha is responsible for proposing the term "cinema of hunger" to describe what the films of Latin America should emphasize: the continent's underdevelopment and its metaphoric and real "hungers." See his "An Esthetic of Hunger" reprinted in translation in Johnson and Stam, *Brazilian Cinema*, 68–71.

5. The names and films that could be cited here are too numerous, although special mention must be made of individuals like Humberto Mauro in Brazil; "El Nego" Ferreyra and Mario Soffici in Argentina; Enrique Díaz Quezada in Cuba; Luis Castillo in Bolivia; El "Indio" Fernández in Mexico; and Pedro Sienna and Salvador Giambastini in Chile.

6. It is important to note that the struggle against dependency in Latin America—in the cinematic realm as well as in other areas—has always had two fronts: first, the struggle against external control, domination, and influence; second, the struggle against the internal forces that ally themselves—consciously or not—with foreign interests.

7. As Robert Kolker argues in his *The Altering Eye* (New York, 1983).

8. Maurice Scherer and Francois Truffaut, "Entretien avec Roberto Rossellini," *Cahiers du Cinema* 37 (July, 1954), cited by David Overby, "Introduction," *Springtime in Italy* (Handem, Conn., 1978), 1.

9. Influenced by contemporary crisis thought in theory (the theoretical tendency that—stemming from Foucault, Althusser and others—searches for and valorizes gaps, breaks, and discontinuities in order to reject the linearity and teleology of traditional continuous histories), film scholarship of the last decades has often seemed to project into the film practices that constitute its "object" its own theoretical and practical desires.

10. For a detailed analysis of this process, see my *The New Latin American Cinema*, forthcoming, University of Illinois Press.

11. I am referring here to the debate among Julianne Burton, Teshome Gabriel, and others in the pages of *Screen*, Nos. 3/4 (1985) and No. 1 (1986). The debate centered on the relationship between "first world" theory and criticism and "third world" cinema. Although both sides emphasized the need to preserve the "otherness" of third-world cinema, one side argued for the impossibility of doing this without theory while the other focused on the inappropriateness of the theoretical structures of the developed world for this object of study.

12. Philip Rosen, "Securing the Historical: Historiography and the Classical Cinema," *Cinema Histories, Cinema Practices* (Los Angeles, 1984), 17–34.

13. See my "A Short History of Latin American Film Histories," *University Film and Video Association Journal* 37, No. 1 (1985), 55–69. The importance of the issue of the national in cinema discourses in Brazil has been traced by Maria Rita Galvao and Jean-Claude Bernardet, *Cinema: Repercussoes em caixa de eco ideologica (As ideias de "nacional" e "popular" no pensamento cinematografico brasileiro)* (Sao Paulo, 1983).

14. Tomás Gutiérrez Alea, *Dialectica del Espectador* (Havana, 1972), 57.

15. See my "At the Limits of Documentary: Textual Transformation and the New Latin American Cinema," in Julianne Burton, ed., *Documentary Strategies: Society/Ideology/History in Latin American Documentaries, 1950–1985*, University of Pittsburgh Press, 1990, 403–32.

16. The reasons for the collapse of the Argentine industry during World War II are too complex to elaborate fully here. Suffice it to say that Argentina's "neutrality" during the war and its subsequent trade problems, coupled with an internal lack of direction and weak capitalization, brought the once-successful industry to an almost complete standstill. For further data see Domingo di Núbila, *Historia del Cine Argentino* (Buenos Aires, 1959) and Schnitman, *Film Industries in Latin America*.

17. The most notable directors who became producers were Leopoldo Torre Nilsson and Fernando Ayala. For further details, see my "Unleashing the Margins: Argentine Cinema, 1956–1976," in John King, ed., *Dossier: Argentine Cinema*, forthcoming by the National Film Theater and the British Film Institute.

18. Among the *Nueva Ola* films premiered in 1959–61 were: Simón Feldman's *El Negoción* (1959) and *Los de la Mesa 10* (1960); José Martínez Suárez's *El Crack* (1960) and *Dar la Cara* (1962); Manuel Antín's *Carta a Mamá* (1961) and *La Cifra Impar* (1961); David José Kohon's *Prisioneros de una Noche* (1960) and *Tres Veces Ana* (1961); and, *Los Jovenes Viejos* (1961) and *Los Inconstantes* (1962). Less interested in exploring the cosmopolitanism of Buenos Aires, Lautaro Murúa's first two films, *Shunko* (1960) and *Alias Gardelito* (1961), almost constituted a "rural" cinema because of their focus on the underprivileged rather than the privileged living within Buenos Aires itself.

19. Fernando Birri, "Nace una experiencia cinematográfica," *La Escuela Documental de Santa Fe* (Santa Fe, 1964), 17.

20. Of the Instituto's projects, the best known are the mid-length social documentary *Tire Dié* and the feature-length "fiction" *Los Inundados*. However, Birri's theoretical and political propositions are so consonant with what was being expressed in other parts of Latin America that he is often referred to as the "father" of the New Latin American cinema.

21. See, for example, Armand Mattelart's discussion in his "Introduction," *Communication and Class Struggle: 1. Capitalism, Imperialism* (New York, 1979), 57–70.

22. For a detailed history of the development of the ICAIC and the Cuban revolutionary cinema, see Michael Chanan, *The Cuban Image* (Bloomington, Indiana, 1986).

23. See Julianne Burton, "Cinema," *Cambridge History of Latin America*, Vol. 4, 1987.

24. "III Exposición de Cine Latinoamericano," *Cine Cubano 7*, (1963), 2.

25. Additional information about the Sestri Levante festival was obtained from Leonel Magin Hinojosa, "La Crisis: Componente Inseparable de la Vida; Entrevista con Manuel Pérez Paredes," *Cine Cubano* 100 (1981), 29–45 and from texts of the festival proceedings in the archives of the Cinemateca de Cuba, Havana, Cuba.

26. "Viña del Mar y el Nuevo Cine Latinoamericano," *Cine Cubano* 42–43–44 (1967), 3.

27. See, "Extractos de una Entrevista con Alfredo Guevara Publicada en Bohemia 31 Marzo 1967," *Cine Cubano* 42–43–44 (1967), 147.

28. "Editorial: El Desafío del Neuvo Cine," *Cine al Día* 6 (1968), 2.

29. Julio García Espinosa, "Somos un Acto Irreversible," *Cine Cubano* 105 (1983), 3.

30. Cinematic industrialization entails not only extensive capitalization and production on a grand scale, but also the establishmment of distribution and exhibition circuits through which to reach the mass audience necessary to recoup costs and generate profits. Above all, an industrialized cinema is a mainstream cinema, that is, a cinema that is part and parcel of a society's dominant ideology and not one that can easily subvert and/or demystify that society's givens.

31. Patricio Guzmán, "Cine Latinoamericano: Exilio, crisis y futuro," *Cine Cubano* 99 (1981).

Film Artisans and Film Industries in Latin America, 1956–1980

Theoretical and Critical Implications of
Variations in Modes of Filmic Production
and Consumption

Julianne Burton

Foreword

A decade ago, when the quest for "revolutionary" cinema was at its height and the theorists' call for a "materialist" cinema at its most insistent, a French film journal of some prominence on the left declared that bourgeois cinema would never be genuinely threatened "until films are produced which say everything about themselves: their economy and their means of production."[1]

Part I of the monumental documentary trilogy, *The Battle of Chile* (1975–1979), ends with scenes from the abortive military coup of June 1973, "dress rehearsal" for September's successful takeover. Along the streets of downtown Santiago, incongruously, people run in the direction of the camera, scrambling for shelter. Searching beyond them, the lens locates and zooms in on a tank surrounded by military personnel—a surreal object on that all-too-ordinary streetcorner. One soldier, pistol in hand, looks directly at the camera for an instant, raises his gun, turns away, then abruptly turns back again, arm extended. The image wavers, seems to lose its axis and, after a momentary vertiginous blur, goes blank. The cameraman has apparently filmed his own summary execution at the hands of the Chilean armed forces.

What image could say more about itself and its "means of production" than that its recording cost the recorder his life? Yet to recog-

Working Papers, No. 102. Latin American Program, Woodrow Wilson International Center for Scholars, Smithsonian Institution. Washington, D.C., 1981, pp.1–25. By permission of the publisher.

nize this is to be simultaneously wrenched from sheltered security within the "closed world" of the film-text and ejected into the chaotic and threatening (because even less completely knowable) realm of history, politics, social context. Who was the victim? Did he really die? Why?[2]

In its overprescriptive extremism, Cinéthique's formula for revolutionary filmmaking is no more ideologically defensible than the illusionist imperative which requires a film to *conceal* everything about itself and its means of production. The blindspot of "modernist" criticism, based as it is on a restrictive definition of materiality, lies in the failure to recognize that "saying everything" about the process of production of an artifact within the artifact itself threatens to obliterate that artifact's potential relationship to any referent outside itself. Content is increasingly displaced by the contentlessness of self-reflexivity in a potentially infinite regression.

Yet the ultimate sterility of the extremist demand that film "say everything about itself and its means of production" neither cancels out the importance of some filmmakers' commitment to saying *something* about the means of production of the film text *within* the film text, nor does it obviate the potential validity—even necessity—of a line of critical inquiry which takes the material and social conditions of film's elaboration as its point of departure. As a corrective to an immanent reading which, in so scrupulously walling-off the text from its surroundings, betrays its own origins in an idealized "art for art's sake," this critical-methodological exploration will endeavor to steer equally clear of the inverted peril, materiality for materiality's sake.

Latin American Filmmakers on Latin American Film: A Descriptive Montage

At the New Latin American Cinema festival in Merida, Venezuela in 1968—an event which marked the continent-wide takeoff of this politically-committed film movement with premiers of such documentaries as Fernando Solanas' and Octavio Getino's *The Hour of the Furnaces* (Argentina, 1968), Mario Handler's *I Like Students* (Uruguay, 1968), Jorge Silva and Marta Rodriguez' *The Brickmakers* (Colombia, 1968), and Carols Alvarez' *Asalto* (Colombia, 1968)[3]—the following characterization of the fledgling movement was put forth:

> A cinema which is committed to national reality. A cinema which rejects all evasive and deformative formulas, along with indifference and ignorance, in order to confront the complex of sociological, political, economic, and cultural problems which

each country, according to its particular situation and characteristics, is living through. A cinema which creates works that exude realism, whether they be fictional or documentary; simple testimony, profound analysis, or agitational tools. A cinema born in impossible conditions of production, brought forth by an act of faith and the infinite patience of its authors.[4]

One year later, the makers of the epic documentary *The Hour of the Furnaces*, proponents of a "third" cinema in opposition to Hollywood ("first cinema") and European-style *auteurism* ("second cinema"), defined their project in the following terms:

> Countering a cinema of characters with one of themes, a cinema of individuals with one of masses, an *auteur*-dominated cinema with one created by an operative group, a cinema of neocolonial misinformation with one of information, a cinema of escape with one that recaptures the truth, a cinema of passivity with one of aggression. To an institutionalized cinema, [the third cinema] counterposes a guerrilla cinema; to movies as spectacles, it proposes a film-act or action; to a cinema of destruction, one that is both destructive and constructive; to a cinema made by and for the old kind of human beings, a *cinema fit for a new kind of human being, for what each one of us has the potential to become.*[5]

In 1969, Cuban filmmaker and theorist Julio García Espinosa proposed an "imperfect cinema" based on a "new poetics . . . whose true goal will be . . . to disappear as such," a cinema of "process" rather than "analysis" which cultivates a plurality of forms and does not disdain film's natural vocation to entertain.[6] As part of the polemic generated by his essay, he wrote in 1972:

> Until now, we have viewed the cinema as a means of reflecting reality, without realizing that cinema in itself is a reality, with its own history, conventions, and traditions. Cinema can only be constructed on the ashes of what already exists. Moreover, to make a new cinema is, in fact, to reveal the process of destruction of the one that came before. . . . We have to make a spectacle out of the destruction of the spectacle. This process cannot be individual. . . . What is needed is to perform this process jointly with the viewer.[7]

In 1970, Brazilian feature filmmaker Glauber Rocha, assessing the accomplishments of the Cinema Novo movement in a U.S. film journal, concluded that "The great contribution of Cinema Novo is to

change the old structure and to permit complete freedom and development of the director as his own producer and distributor."[8] As the 1970s progressed, various filmmakers and groups developed more specific and differentiated practices. In 1972, the Bolivian Ukamau Group, under the direction of Jorge Sanjinés, evaluated and criticized their own cinematic trajectory from films of "effects" (denunciation), to films of "causes" (analysis), to a new kind of interactional cinema which would recapture the Bolivian peoples' historical past while at the same time becoming itself a component in determining the future shape of that history. This goal, the filmmakers realized, presupposed a transformation on the level of film form:

> Since ours was a cinema which sought to develop parallel to historical evolution, but which also sought to influence the historical process and to extract its constitutive elements, it could no longer confine itself to conventional forms and structures. Such content demanded a complementary form which would break traditional molds. . . . If it was absolutely necessary to work with reality and the truth, manipulating live, everyday history, it was for the same reasons absolutely necessary to find forms which would not detract from or betray their content.[9]

In contrast, Argentina's clandestine *Cine de la Base* collective, accustomed to working in the documentary mode, began experimenting with fictional forms in the belief that narrative cinema was more accessible to their target audience, the working class, and that fictional film offered a greater potential for synthesis and subjective, personalized analysis. In their stylistic experimentation, they subordinated formal means to desired political ends:

> Our goal is to intervene on a very concrete level in the political relations of the Argentine process with a brand of cinema which we define as militant and class-based. We build this cinema based on the needs of the people's social and political organizations. Ours will consequently be a more utilitarian cinema than that of the bourgeoisie.[10]

Finally, as one last fragment in this collage of participant observations on the goals, characteristics, and functions of the New Latin American Cinema, we quote Cuban director Tomás Gutiérrez Alea's belief in the importance of realizing the "social function" of cinema: "equipping the spectator with critical insights into reality, to the extent that he ceases to be a spectator and feels moved to actively participate in the process of daily reality. In other words [what is needed are] not

only works which help to interpret the world, but which also help to transform it."[11]

This assemblage of impressions, however inevitably arbitrary, touches upon several crucial issues which will receive more sustained and systematic attention in the pages which follow: issues dealing with realism (the concepts of reality, history, and change; of realism and antithetical forms; of the relationship between representation in the text and the complex contextual reality outside of it); issues of pluralism versus prescriptivism in cinematic genre, style, language, and form; the relationship between films of the developed world and films of the dependent sector (cultural nationalism, cultural colonialism); the material conditions of production and reception and the potential for transforming them; the possibilities for collaborative rather than individualized creativity and for extending that collaboration beyond the sphere of the producers and into the sphere of the consumers.

Realism and "Reality": A Direct or a Mediated Relationship?

It is obvious from the string of quotations above that, like Brecht in the theater, militant Latin American filmmakers began from the premise that film was a vehicle for apprehending the real world in order to change it. In contemporary critical thought, however, the concept of "the real" is highly problematic. While use of the notion among Latin American filmmakers has undergone a certain evolution, it has never been the target of as much suspicion as it has among critical circles in developed Western countries, where "rank empiricism" is as unwelcome as bad manners. The problem deserves consideration on its own merits, and for the light it sheds on other differences in concept and practice between the underdeveloped and the developed sectors— practitioners of "practical theory" on the one hand, and theoreticians of "theoretical practice" on the other.

Fernando Birri, founder of the first documentary film school in Latin America (La Escuela Documental de Santa Fe, Argentina, in 1956) begins the book which chronicles that seminal experience quoting Chilean poet Pablo Neruda:

> I speak of things that exist.
> God save me from inventing things while I'm singing![12]

At that time, Birri believed that certain techniques in and of themselves—specifically documentary realism—provided the means of

discovering reality and correcting the distortions imposed by econom-
ic, political, and cultural dependency. The documentary vision, he
maintained, was the *true* vision: "how reality *is*; it cannot be other-
wise."[13] According to Birri, "the Documentary Film School of Santa
Fe was born as a realist response to historical circumstances and con-
ditions which were also realist."[14] For many other Latin American
filmmakers as well, especially at the inception of the movement, a
commitment to film as an agent of social change in the real world
translated into the obvious equivalent of formal realism.

As British feminist and film theorist Christine Gledhill aptly ob-
serves,

> Realism in [the] general sense is the first recourse of any op-
> pressed group wishing to combat the ideology promulgated by
> the media in the interests of hegemonic power. Once an op-
> pressed group becomes aware of its cultural as well as political
> oppression, and identifies oppressive myths and stereotypes, . . .
> it becomes the concern of that group to explore the oppression
> of such images and replace their falsity, lies, deception and es-
> capist illusion with reality and the truth.[15]

She goes on to identify some problematic aspects of this uncritical
embracing of realist forms. "Realism" as a formal modality in film in-
volves a complex interplay of technical and human mediations; "the
real" therefore cannot simply be discovered but has to be constructed
in order to be conveyed. Since "reality" is not after all a self-evident
given, there is no simple alternative reality to fill the gap left by the
displacement of the "false" reality which is being denounced, so the
counter or alternative reality ("true" reality) must also be constructed
in this second sense.

Fifteen years after Birri and his students shot the "first social sur-
vey film" made in Latin America—*Tire dié* (Toss Me a Dime, 1958)
—a team of Chilean filmmakers began meeting to develop a metho-
dology for a documentary on the broadest possible scale: a "survey"
of the political, economic, social, and cultural configuration within
their nation as it struggled to make the first "legal and democratic"
transition to socialism. That the epistemology of documentary realism
had, by this subsequent historical moment, become immeasurably
more problematic is evident from the fact that the *Equipo Tercer Año*
spent two months analyzing existing approaches to documentary film-
making and formulating their own composite methodology. They
opted for a synthetic method precisely because they recognized that
social and political "reality" could no longer be captured by simply

aiming a camera and shooting, given that "too many events result from many invisible processes which culminate very often in an external event of little or no historical relevance."[16] This acknowledgment of components of the real which are not immediately manifest is a crucial step in developing more nuanced, complex, and functional notions of the relationship between film and the world outside it which it simultaneously purports to apprehend and to transform.

Franco-Swiss filmmaker Jean-Luc Godard's famous dictum—"Bourgeois filmmakers focus on the reflections of reality. We are concerned with the reality of the reflection."[17]—clearly inspired in Bertolt Brecht's "metarealistic" devices to denaturalize and rupture the process of representation, stands as a kind of rallying cry for a whole generation of "modernist" filmmakers, critics, and theoreticians who, according to a growing number of writers, betrayed the motivating spirit behind Brechtian aesthetics. Sylvia Harvey summarizes the crux of this difference in her important book *May '68 and Film Culture*:

> Like the modernist filmmakers, Brecht certainly places an emphasis on the fact of representation, and on the problems entailed in the selection of certain means of representation. *But* this emphasis is made only in terms of a tension which exists between the fact of representation and "that which is represented." What is preserved is a sense of something *outside of* and beyond the fact of representation, . . . a social reality to which the representation refers.[18]

Among Latin American filmmakers who have also drawn inspiration from Brecht, the transformative impulse linking formal strategies to potential changes in the world beyond the film-text has been much more urgently conserved. As Octavio Getino observed recently in assessing oppositional film practice in Argentina:

> Given the smog of falsehood and equivocation which invades every last pore of a dependent nation, in our countries the representation of multiple and contradictory facets of whatever reality requires research, study and first-hand knowledge. But such activities in turn require a social practice oriented toward positively transforming that reality which one aspires to know. Without this commitment, it will prove difficult if not impossible to achieve genuine first-hand knowledge.[19]

The Illusion of Reality Versus the
Reality of Illusion

This split between the "immanent" and the "external"—between those for whom the film-text constitutes the only universe of discourse and (theoretical) action, and those who maintain that transit between the real world and the text and back again is not only possible but essential and inevitable—replicates itself in several critical and theoretical issues which recur in the following pages. It is, in fact, pivotal to the central project of this essay: the postulation of a critical methodology based on "modes of filmic production and consumption" defined *not* as exclusively immanent to the film-text but as originating in and exerting an impact upon the world outside it. Marc Zimmerman, a literary critic and theorist, expresses the dilemma as between a linguistics-derived epistemology based on Ferdinand Saussure and the notion of exchange, and a Marxist epistemology rooted in production. "At stake, then," he summarizes, "is the issue of whether the world is to be conceived in terms of a metabolism between thought and reality or between thought and sign . . . and, at the extreme, whether reality includes, or is nothing more than, a system of communication or of signs."[20]

To acknowledge that representation is inevitably also interpretation —partial, selective, mediated, imperfect—is not necessarily to conclude that representation is inevitably false or futile. The difference between these two positions is, in the last analysis, not so much an epistemological or intellectual as an ideological or political one. The obsession with film's suspect nature as an inherently "illusionist" mode and the hypostatization of the relations within the text as the only possible object of analysis correlate all too neatly with the kind of relativizing critical agnosticism of a critic like Roland Barthes who, for all his brilliance and political savvy, failed to see that the doctrine of infinite polysemousness (the meanings of a text can never be fixed) in fact assumes a hegemonic position even as it pretends to abdicate one. Only if one is prepared to renounce one's stake in the social issues addressed by the (film) text can one afford to maintain that no reading is "privileged," that is, more compelling, effective, or *real* than any other. To take refuge in the inviolability of the text, in the *jouissance* of its "infinite productivity," cloaking oneself in "the myth of the purity of eternal becoming," to use Jonathan Culler's apt phrase, is to attempt to live outside history. Only those fully secure in the status quo can permit themselves the luxury of such an illusion. Among Latin American political filmmakers, the price of participation has been abandoning such illusions.

"Revolutionary Cinema": An Idea Whose Time Has Passed?

As I undertake the following assessment of two decades of oppositional Latin American filmmaking practice, I am painfully aware that the issue of defining revolutionary cinema is not the burning question it was a few years ago—in Europe and North America at least. There is a certain historical irony in trying to address this problem at a time when three not unrelated phenomena are obvious: first, films from the Third World are less fashionable in the metropolitan countries than they were a few years ago; second, film production itself, in many Latin American countries at least, has been considerably curtailed; and, finally, the artificiality of the "Third World" as a political and ideological construct, even within the socialist sector, has been made patently clear by recent events in Africa and Asia.

Traditionally, the attempt to define a revolutionary cinema has oscillated between the two poles of formal analysis and the articulation of explicit content. This attempt to define revolutionary cinema on the basis of the forms and relationships immanent in the film-text itself has met with dubious success and has been to a large extent abandoned by bourgeois film critics not only because of changing historical circumstances, but also, and more important, because of a basic misconception in the enterprise itself. The project of defining a phenomenon described by a signifier ("revolutionary") which denotes sweeping transformations of power relationships in society is doomed to failure if it insists on inviolate textual self-sufficiency and the extraneousness of the larger social context out of which the film is generated and to which it is directed. To try to "revolutionize the means of representation" or to verify that achievement, intertextually and without recourse to extratextual referents and receptors—however frequently it may have been attempted—is an undertaking doomed to failure.

The capacity of the "culture industry" to expropriate, co-opt, and neutralize subversive or potentially revolutionary themes is notorious and needs no further amplification here. The cooptability of form is a more complex issue; but, at the risk of grossly oversimplifying, the problem might be briefly discussed in the following terms. Since forms exist in history, they also evolve. In fact, the very essence of form evolution seems to hinge on a rather pendular oscillation between poles of classicism and experimentation in which the "new" is in another sense simply the "different" in a process which seems ultimately constrained to repeat variations of itself, renewed but seldom completely deflected by occasional modifications from outside this

pendular swing. Many Latin American filmmakers have insisted upon
the dialectical unity of content and form while tending to view the lat-
ter as a function of the former. As Armando Roffe, editor of the Ven-
ezuelan film journal *Cine al día*, expresses it, "Form is content
transforming itself into form."[21] We have but to recognize the histori-
cal and practical impossibility of *sui generis* formal innovation and
the lack of any guarantees against its enlistment in the service of a
less-than-altruistic master before acknowledging that, as the custodian
of the "revolutionary" essence of art, form is virtually as pessimistic
as content.

Armand Mattelart, a leading communications theorist who, prior to
the 1973 coup d'etat, had lived and worked in Chile for several years,
argues *a propos* of that experience that "New forms, new contents,
even new media are not enough. The new content of a new means of
communication must be tied to a new social practice."[22] If both form
and content have been proved assimilable by late capitalism's all-de-
vouring drive to contain expressions of dissent, *process* is the one
component element of the cultural artifact that has proved itself less
palatable, as recent experiments with "partial" versions of workers'
control in advanced capitalist factory production have indicated. Pro-
cess, or *practice*, is accessible through an investigation of the social,
historical, political, and economic *context* of the film in the course of
its elaboration and reception and, more specifically, through the analy-
sis of the modes and relations of filmic production, distribution, and
exhibition as the most promising tool for articulating the dialectical
relationship between text and context.

Towards a Contextual Criticism:
The Praxis Connection

The extent to which the contextualizing impulse lies at the very foun-
dation of the New Latin American Cinema is obvious from Fernando
Birri's assertion that "What was needed was a school which would
combine the basics of filmmaking with the basics of sociology, histo-
ry, geography, and politics, because the real undertaking was a quest
for national identity. . . ."[23] It is thus not surprising that Latin Ameri-
can filmmakers have consistently, if sometimes only implicitly, called
for a more contextualizing kind of criticism. According to Venezuelan
filmmaker Jacobo Borges, "If this cinema forms a part of that process
of breaking off from the patterns of dependency, its stage of definition
corresponds to the stage of that process. Thus, its conceptualization
cannot be understood except to the degree that one perceives the (his-
torical) movement which gives it form and context."[24] Brazilian film-

maker Leon Hirszman offers a complementary admonition: "The critic, if s/he wishes to truly understand Third World cinema, must keep in mind that the material conditions of production exert a determining influence on the form."[25] Leading Brazilian critic Jean-Claude Bernardet stipulates that "The material of the film must not mask the original social situation which gave it birth," but, on the contrary, make it manifest. He cites the early documentary *Aruanda* (Linduarte Noronha, 1959), shot in the Brazilian Northeast under particularly precarious conditions, as having "succeeded in conveying the expressive potential of an aesthetic which assumes the poverty of its own means as fully as [it assumes] that of the film's protagonists."[26] Jacobo Borges has declared that "Third World cinema is neither a form nor a style but an attitude."[27] Because that unifying attitude realizes itself at the level of actual praxis—a praxis consistent with and potentially capable of transforming the world which the filmmakers simultaneously depict and address—one essential role of the critic is to provide entry into that context and discern the components of the filmmakers' constitutive practice.

The importance of this role is perhaps particularly apparent to a critic from the metropolitan sector whose primary scholarly-critical focus has been on the emerging cinema of the Third World. The inevitable sense of disorientation at the absence of a common cultural ground translates into the search for a core of contextualization sufficient to the task of making the film under study accessible in another cultural context. Although films can be transferred to other social, historical, political, class, and cultural contexts, the act of abstracting them from their original context necessarily subjects them to a certain inevitable reification. They cease to be a process in order to (appear to) become simply a *product*. Their nature as the intersection of dynamic historical and social forces and personalities cedes to the appearance of a static, particularized, "crystalized" object of contemplation, a reproducible and hence immutable commodity.

The most constructive and meaningful critical relationship to the tradition of oppositional filmmaking in Latin America seems to me to consist in the investigation and articulation of the range of alternative modes of production and consumption developed in diverse circumstances over the past two decades in all their variety and specificity. Basic to this critical ambition is the belief that the transformation of relations of production and consumption which particular Latin American films have catalyzed in their original social, historical, geographical, and political context(s) and of which they are themselves the product, is somehow inscribed within them at the level of form and content—though not, however, in any mechanical, automatically

perceptible, or completely knowable way. Although these inscriptions are selective, inconsistent, perhaps contradictory, at times invisible, and resistant to quantification or schematization, the task of the critic must include the attempt to demonstrate how interacting contextual factors impact upon the film text itself and the interpretation of that text at a given point of reception (cognizant that the latter is also a product of interacting contextual factors).

It is not a matter of substituting extrinsic for intrinsic (immanent) criticism, but rather of allowing the extrinsic to illuminate the intrinsic by reconstituting part of the process by which the extrinsic originally informed the intrinsic. This effort is both motivated and validated by the general recognition that the creation of a film is in most circumstances a more socialized and externalized—in short, *knowable*—phenomenon than the creation of a piece of fiction, for example, or a painting. The point is not to attempt to constitute a single "objective text" but to argue that a film's contextual environment at the time of production is relevant to any historically sensitive subsequent interpretation of that text's content, form, and function.

Towards A Theory of Artistic Production:
The Precursors

In "The Author as Producer," one of the few charting essays into this unmapped territory, Walter Benjamin called for a reformulation of the question: not "how does a work of art stand in relation *to* the relationships of production of a period," but "how does it stand *in* them?"[28] Benjamin draws a distinction between attitude and actual practice. The former position can be deduced from the content of the work; the latter can only be verified through knowledge of the actual process of creation, through what Benjamin calls "technique"—both the aesthetics (form) and the actual technical (and social) means by which the work is produced.

Benjamin observes that "the place of an intellectual in the class struggle can only be determined, or better, chosen, on the basis of his position in the process of production."[29] Believing with Marx that material conditions determine consciousness and not vice versa, Benjamin insists that a writer (artist) must experience his solidarity with the proletariat not merely ideologically, but *as a producer*. He credits Brecht with elaborating the concept of "functional transformation" (*Umfunktionierung*): ". . . do not simply transmit the apparatus of production without simultaneously changing it to the maximum extent possible in the direction of socialism."[30] Benjamin offers two criteria for determining the "exemplary character" of a production (i.e., pro-

ductive process or productive apparatus): first, that it lead other products to itself and, secondly, that it "present them with an improved apparatus for their use."[31] "And," he adds, in a challenge which reveals the link between production and the modes of perception (one which Cuban theorist Julio García Espinosa will echo two decades later), "the apparatus is better to the degree that . . . it is capable of making co-workers out of readers or spectators."[32]

In order to "operationalize" Benjamin's concept of the author (or filmmaker) as producer, it is clear that the critic must extend his or her energies into the related fields of economic and social history and, above all, sociology. In *Marxism and Literature*, Raymond Williams explains that, "As so often, the two dominant tendencies of bourgeois cultural studies—the sociology of the reduced but explicit 'society' and the aesthetics of the excluded social remade as a specialized 'art' —support and ratify each other in a significant division of labour. It is this division now ratified by confident disciplines which a sociology of culture has to overcome and supersede, insisting on what is always a whole and connected material process."[33]

A third and final source of inspiration and endorsement comes from the work of a Latin American theorist. In *La producción simbólica: Teoría y método en sociología del arte* (1979), the Argentine sociologist Néstor García Canclini, writing from his Mexican exile, proposes a sociology of art based on the social relations of art as a symbol-making process. "Art," he maintains, "not only *represents* relations of production; it *realizes* them."[34] He concludes his investigation into the practice of the plastic arts in Argentina during the 1960s with the assertion that "Changes in the works themselves are more intelligible when interpreted as part of the transformation of social relations among the members of the *artistic field*. The consequence of this sociological affirmation for artistic practice is obvious: as much as a complex of images never before seen, creating a new art requires another way of producing those images and of understanding them: generating a new mode of relationships between human beings."[35]

Out of the "Absent Center" and Into the Breach

The present essay is an attempt to locate and fill the "absent center"[36] of a theoretical discourse which increasingly calls for, but to date has not succeeded in, producing a sustained and systematic analysis of the "modes of cultural production." The goal is to redeem for film criticism the social and material nature of artistic activity; to argue why the style, forms, and content of a filmwork merit consideration as products of a specific social practice and expressions, *among other*

things, of an artist's social relations. My "data field" derives from a quarter century of politically-committed Latin American film practice —the most sustained, concerted, and at the same time varied effort in world film history to produce a revolutionary cinema in all senses of the term. Like Raymond Williams, I am interested in those points in the history of art when creative practice becomes struggle. "The active struggle for new consciousness through new relationships"[37] is a phrase which aptly defines the New Latin American Cinema movement.

Towards a Working Definition of Modes of Production in Film

In contemporary critical parlance, "production" can refer to the material or technological apparatus, to organizational infrastructures, to the social relations which constitute and are constituted by the film-artifact, or to its "self-production as a chain of significations."[38] Contemporary film theory and criticism have concentrated their attention virtually exclusively on three of these four meanings. The study of the signifying practices *within* the text, directly indebted to structuralism and semiotics and only indirectly influenced by Marxist thought (primarily through Louis Althusser's idiosyncratic reading of *Capital*), has tended to concentrate on articulating the ideological dimension of the film-text. (The most extreme embodiment of this tendency occurs not in film but in the literary theory of Pierre Macherey, who argues that "the text produces itself—unfolds and activates its multiple lines of meaning without conformity to 'intention,' pre-given narrative model, or external reality.")[39] Parallel to this celebration of immanence, there has been a marked interest in film technology, often referred to as "the material apparatus," largely motivated by the potential function of this apparatus as a bearer of ideology. This line of inquiry's ability to postulate the relevance of phenomena external to the film-text *on* the film-text is largely dependent on how the concept of ideology is understood. A disproportionately smaller amount of research, most of it historical rather than sociological in nature, has taken the organizational infrastructure of the film industry as its object —notably in studies of the Hollywood studio system. Such studies are seldom informed by any concept of a mutually influential dynamic between the film product, the organizational structure in which it is produced, the organization structure in which it is consumed, and the larger social context.

In order to integrate the dynamics of social relations and other extratextual phenomena into the concept of artistic production, it is

therefore necessary to abandon the humanists' realm and to make camp instead with the sociologists and political scientists among whom "modes of production" in the concrete socioeconomic sense is, at present, very much at the center of discourse—constituting, in fact, a hotly contested terrain.

Back to the Source: Marx's Concept of Modes of Production

Marx states in *Capital*:

> Whatever the social form of production, laborers and the means of production always remain factors of it. . . . For production to go on at all they must unite. The specific manner in which this union is accomplished distinguishes the different economic epochs of the structure of society from one another.[40]

In the capitalist mode of production, the only conceptually and analytically developed mode examined in Marx's work, he stipulates that "the separation of the free worker from his means of production is the starting-point given."[41] One of his most suggestive passages on the general topic of production and consumption, from the *Gründrisse*, directly addresses the question of artistic production and formulates a dialectical interaction between production and consumption:

> Production not only supplies a material for the need but it also supplies a need for the material. As soon as consumption emerges from its initial state of natural crudity and immediacy —and, if it remained at that stage this would mean that production itself had been arrested there—it becomes mediated as a drive by the object. The need which consumption feels for the object is created by the perception of it. The object of art—like every other product—creates a public which is sensitive to art and enjoys beauty. Production thus not only creates an object for the subject, but also a subject for the object. Thus, production produces consumption (1) by creating the material for it; (2) by determining the manner of consumption; (3) by creating the products initially posited by it as objects, in the form of needs felt by the consumer. It thus produces the object of consumption, the manner of consumption, and the motive of consumption. Consumption likewise produces the producer's inclination by beckoning to him as an aim-determining need.[42]

Thus, for Marx, "production, distribution, exchange and consumption" constitute "members of a totality, distinctions within a unity."[43]

Out from the Source: Marx Interpreted

Among social scientists, the concept of modes of production is open to dispute on both the level of theoretical elaboration and that of practical application: what are the noncapitalist modes of production and in what societies do they exist or have they existed? The "Asiatic mode" is a case in point. While some social scientists go about employing the concept as the basis of their analysis of specific societies, others insist that there is not now nor ever was any such mode of production. Other alleged modes of production, "coined" subsequent to Marx—the colonial mode, the lineage mode, the colonial slavery mode, etc.—are just as subject to having their existence called into question as soon as they are identified.

Among the various modes-of-production theorists, I have found John G. Taylor's work the most useful. In *From Modernization to Modes of Production: A Critique of the Sociologies of Development and Underdevelopment*, he ties the entire problematic to questions of dependency and "transitional social formations" in the Third World. Taylor rejects the sociologies of development and underdevelopment as "teleological and economistic," arguing instead for using the discourse of historical materialism to analyze Third World reality "as a social formation which is dominated by an articulation of two modes of production—a capitalist and a non-capitalist mode—in which the former is, or is becoming increasingly, dominant over the other."[44]

Taylor distinguishes three historical periods in the development of capitalism's penetration of the noncapitalist world: the export of merchant capital, commodity export, and the export of finance capital. Imperialism as such only occurs with the latter phase. The degree to which capitalism is actually complicitous in maintaining precapitalist divisions of labor and relations (a thesis which Taylor puts forth convincingly) is open to general debate, much of which hinges on such competing concepts as "articulation," "dislocation," "dissolution," and "transcendance." However the relationship between coexisting capitalist and precapitalist modes is conceptualized, the important point is that this postulation of two or more modes of production whose "interdependence" is a function of their eventual incompatibility, opens up a crucial space for maneuver, as Taylor's discussion of the notion of "dislocation" makes clear:

> Imperialist penetration intervenes economically, politically and ideologically within these dislocated levels in order to ensure

the increasing dominance of the capitalist mode of production and to create that restricted and uneven form of development [characteristic of Third World formations]. . . . Yet it is also the case that the existence of these dislocations, and the effects that imperialist penetration has upon them in trying, as it were, to adapt them to the political and ideological reproductive requirements of a capitalist mode of production, can produce—in specific conjunctures in the transition—the possibility for the emergence of the preconditions for the constitution of a different mode—a socialist mode—of production.[45]

Precisely the uncertainty, relativity, and unpredictability of the process of establishing hegemony of capitalist over precapitalist modes of production accounts for the inextricably related phenomena of oppression—either physical (direct violence) or ideological (indirect violence through manipulation, "cultural colonization," etc.)—and resistance—again, either on a direct physical level (land takeovers, popular uprisings) or an indirect ideological level (political slogans, for example, or the means of artistic expression). Taylor grants the indirect means more weight than the direct: "The forms of physical oppression can establish pre-conditions . . . [but] it requires both an ideological and a political foundation, a commitment to its adequacy as a superior form of production in the ideologies that structure daily life, and a permanent access to political power to guarantee its perpetuation."[46]

Among the oppositional media in Latin America, film has been the most outspoken, the most trenchant, and the most generalized in challenging the hegemony of dependent (or "transitional") capitalism on both the ideological and the political levels. Most significantly, it has also posed that challenge on the much more concretized level of social relations in the labor process, access to the means of production and the means of distribution, and appropriation of the surplus of creative labor.

Under the capitalist mode of production, direct producers are separated from their means of production and are thus no longer able to maintain themselves through their own unmediated labor. Deprived of agricultural crops or handicraft production or whatever constituted the basis of their prior subsistence, they are left with only their labor power to sell. In "selling themselves" as the only possible response to their severance from their original means of production, their relationship to their own reproduction becomes mediated by capital (in the form of wages or salary) and by the appropriator of the surplus-value which they produce, the capitalist.

Hangovers and Harbingers: Old Artisanal and
New Industrial Modes

To the degree that they have been consciously aware of constituting their films through an alternative mode of production, and circulating their films through an alternative mode of consumption, many Latin American filmmakers in the dependent sector have referred to the "artisanal" nature of their work. The connotation of feudal crafts production is not fortuitous. Under the feudal mode of production, craftspeople constituted an exception to the defining criteria in that their relations of production "were not marked by relations of economic dominance."[47] Unlike the feudal peasantry, who had practical control of, but did not own, their means of production, feudal artisans enjoyed both practical control of the tools and materials necessary to their production ("real appropriation" in Marxist terminology) *and* actual [or "formal"] ownership of the same tools and materials. Experiments in cooperative production and distribution have represented an intermediate strategy between the atavistic reassertion of artisanal modes and a more anticipatory attempt to reorganize the industrial bases of film production and consumption under the principles of a socialist rather than capitalist mode of production.

Marx's affirmation (already cited) of the unitary nature of production, distribution, and exchange provides the theoretical basis for postulating the category of "modes of filmic consumption" as a necessary complement to "modes of filmic production." Even without this theoretical support, however, the necessity of such a formulation is obvious from only the most elementary grasp of film as an art form which developed under capitalism and from the specific nature of this commodity which is the schizophrenic offspring of an unholy marriage between art and industry.

Sylvia Harvey observes that with the development of cultural production as commodity production under capitalism and the consequent exchange of cultural objects in the marketplace, "the most powerful instance of ruling class control lies in the control . . . over exchange and distribution."[48] For the majority of oppositional filmmakers in Latin America, this was not a self-evident truth, but had to be learned the hard way. Filmmakers first concentrated their efforts on reappropriating the means of production. The victory of having actually produced a finished film was subsequently undercut, if not negated, by the difficulties of guaranteeing that product access to its intended (or to any) market. Filmmakers thus realized that in addition to producers (in the traditional cinematic sense), they had to become distributors as well. The numerous obstacles to the successful outcome of this battle

prevented the combatants from seeing that another guarded fortress loomed on the horizon: the exhibition sector. Only relatively recently have filmmakers succeeded in penetrating this bastion, finally cognizant of the need to take control of the entire three-part process.[49]

For the purposes of analysis, rather than specifying "modes of distribution" and "modes of exhibition," it has seemed more practical to subsume both categories under the single formulation, "modes of filmic consumption." This category also includes the process of *reception* which, consistent with "reception theory" in literature, conceives of the spectator as subject rather than object, as active rather than passive or inert.

<div align="center">GENERAL MODEL</div>

MODES OF PRODUCTION

MODES OF CONSUMPTION { MODES OF DIFFUSION { MODES OF DISTRIBUTION
 MODES OF RECEPTION MODES OF EXHIBITION

The Possible Versus the Necessary

Some theorists would call into question the validity of not only the concepts of "modes of filmic production" and "modes of filmic consumption" but the very attempt to address the modes-of-production question in any sphere but the strictly economic. Immanuel Wallerstein, for example, is quite categorical on this issue: "Neither individual units of production nor political or cultural entities may be described as having a mode of production; only economies.[50]

That discord is so rife among social scientists is dismaying to a humanist who looks to those "more solid" disciplines for greater rigor and, by (no doubt naive) extension, consistency. Short of abandoning the specific practical project at hand in order to plunge into the melee currently taking place in the theoretical arena, the alternative to critical action would mean consigning oneself to spectator status and standing by as competing theoreticians slug it out among themselves, patiently awaiting the unlikely eventuality that one might sooner or later be declared "the winner." To paraphrase Fernando Solanas' and Octavio Getino's position on the feasibility of creating revolutionary cinema prior to the revolution, there eventually comes a point when the debate as to whether or not a theory of modes of artistic production is *possible* must be subordinated to consideration of whether or not it is *necessary*. Having concluded that it *is* necessary, and well apprised by now of the intricacy of (some of) the issues involved and the fragility of the instruments available to examine them, let us declare, at the risk of wantonly debasing the coinage, the following: (1)

that the term "modes of production" is here used loosely—as is the wont of humanists—to denote the various and variable component processes of film production, distribution, exhibition, and reception, and (2) that there exists in Latin America a spectrum of oppositional film practices ranging from the artisanal to the industrial mode wherein *both* poles are counterposed against the dominant production mechanisms and relations within the capitalist mode.

An Art Form Born under the Sign of Capital

At the end of the nineteenth century, when filmmaking was in its infancy, the act of making a film could be as individualized and private as the composition of a symphony or the sculpting of a block of wood. In this incipient medium, the artist retained potential control over all aspects of the creative process—from the conception of a theme and selection of participants and location, through the actual filming, and including the processing, editing, and exhibition of the final product. Sometimes these multiple functions were shared, but even this cooperative model retained basically artisanal forms of organization. This situation was, however, extremely short-lived. As the commodity potential of this novel curiosity, this frivolous amusement (whose status as an art form would only be conferred by the passage of time *and* the impact of the market), became quickly apparent, the organization of its production and dissemination became proportionately more complex and fragmented. Technological developments worked to reinforce this increasing division of labor, as did economic tendencies toward agglomeration and control of the maximum number of components inherent to the filmmaking process. The structural analogies between the organization of a studio or film production company and an automobile manufacturing plant are not coincidental, but instead testify to the fact that both production processes were organized under and by a capitalist economic system.

Soviet documentarist Dziga Vertov was one of the first to point out how closely the development of the cinema was linked to the development of an advanced capitalist mode of production. "The camera," he observed, "hasn't had a chance. It was born when there was not a single country where Capital did not reign."[51] Vertov succeeded in winning that machine over to his own and his government's purposes through the kind of brilliant and innovative strategies which are in fact the subject of a film such as *Man with a Movie Camera*. Others express a more pessimistic view of the film medium's potential to serve an alternative form of social organization or even contribute to the project of subverting the form under which it was itself conceived.

Stanley Aronowitz, who argues this negative position apropos of even the films of the Soviet "Golden Age" in his article, "Film—The Art Form of Late Capitalism,"[52] maintains in another essay on the labor process and the logic of capital that "Technology that is developed within the framework of bourgeois relations of production is nothing but the objectification of those relations, and would tend therefore to subvert the socialist intentions of a society that refused to recognize that formulation."[53] Others, believing in the relative autonomy of the technological apparatus, would argue vehemently against the "gross determinism" of such an assertion.

Throughout its history, the film medium has always revealed its double edge to anyone who scrutinized it. Like Marx's oft-quoted appraisal of religion as both the highest expression of human aspirations and an opiate which dulls those same aspirations, film (indeed, all cultural production) must be appraised in terms of its positive and negative, constructive and destructive, alienating and liberating effects and potential. Eisenstein saw this clearly. His enthusiasm for art and specifically film as a vehicle for cultural and political reinfranchisement was counterbalanced by his suspicion of the "narcotic" effects of the medium. Among the insights in that cornucopia of observations on the nature of "Art in the Age of Mechanical Reproduction" was Benjamin's subtle perception that, in addition to transforming the art object itself, the new medium also transformed the viewers' attitudes and forms of perception, encouraging passive, "distracted" viewing rather than a more active involvement.

Thus the apparent "democratization" of the film medium when compared to older art forms is problematic. The potential for an ever-expanding radius of participation and access is effectively contained because the new technology is "deployed within a patriarchal, discriminatory and class system, which both organizes demands and stigmatizes popularity."[54] The tendency away from privatization is kept in check by the countervailing mechanisms of alienation.

Necessarily and inevitably, any project to "revolutionize" the film medium, to convert it to the needs of society rather than the exigencies of capital, must develop ways to challenge the alienation of the producer and the receiver intrinsic to the medium as it has been organized under capitalism. For if—as members of the Frankfurt School have maintained—science, technology, and the components of everyday life have been increasingly "subsumed" under and transformed by the sign of capital, art, though certainly not impervious, is arguably the sector which is most resistant to this process. Yet, on the other hand, within the sector of potential resistance constituted by artistic production, given its industrial base and its highly developed require-

ments for technological infrastructure and capital investment, film is the most vulnerable medium. If the industrial side of its nature explains and reinforces its vulnerability to simply becoming a passive reproducer and disseminator of capitalist ideologies, its artistic dimension is the locus of its subversive potential.

The range of choices involved in the selection of themes, materials, techniques, styles, kinds of technology, levels of collaboration and participation, and alternatives to organized methods of production and exchange generates a space for potentially subversive action. For to exist and be structured under a late capitalist mode of production is not necessarily to replicate it. As Néstor García Canclini observes, "A fundamental difference, above all in capitalist societies, exists between the *general* socio-economic structure and the *particular* socio-economic structure of the *artistic field*."[55] To actively oppose existing modes of production and consumption, to subvert existing structures and invent new ones, is to bridge the gap between art as imaginary or symbolic practice and art as social practice. "Fantasy" and "reality" become united at the level of action.

The "Utopian" Element in Artistic Practice

The divorce between the imaginary and the real, the subjective and the objective, the imperfect actuality and the utopian possibility, is a cleavage which pervades Western thought. Herbert Marcuse, examining the legacy of Freud in the light of Marx and other social theorists, finds this split at the core of repressive social forms. Against the repressive "reality principle" he explores the liberating potential of fantasy and utopia:

> Imagination [phantasy] envisions the reconciliation of the individual with the whole, of desire with realization, of happiness with reason. While this harmony has been removed into utopia by the established reality principle, phantasy insists that it must and can become real, that behind the illusion lies *knowledge*. The truths of the imagination are first realized when phantasy itself takes form, when it creates a universe of perception and comprehension—a subjective and at the same time objective universe. This occurs in *art*. . . . The artistic imagination shapes the "unconscious memory of the liberation that failed, of the promise that was betrayed. . . . Art opposes to institutionalized repression the "image of man as a free subject. . . ."[56]

For Marcuse, then, "art is opposition." The oppositional qualities of the work of art, however, are for him confined to its form, and the

final result is a tragic paradox: "The very commitment of art to form vitiates the negation of unfreedom in art." Thus, rather than providing the basis for a genuine liberation, art at best can only exercise a dual function: "both to oppose and to reconcile; both to indict and to acquit; both to recall the repressed [image of liberation] and to repress it again—'purified.' "[57]

Stanley Aronowitz, meditating on the oppositional potential of the film medium, on the one hand locates it at the level of form and, on the other, suggests that it is at present defined by and confined in "the play of contradictions" between the (ultimately futile because unfeasible) return to the "*relative* autonomy of the artisan mode of artistic production" and an equally untenable resignation in the face of existing production conditions as structured by late capitalism.[58]

But to return is not necessarily to revert. The "risk of privileging an anterior art, one that corresponds to handicraft production,"[59] should not blind us to the constructive, transformative potential of opting for and demonstrating, however microcosmically, a less alienated and alienating mode of artistic production. As Sylvia Harvey correctly perceived, a "hangover" from a prior mode may act as a harbinger of a future mode:

> Just as there is a possibility that a particular form of cultural production may be a "survival," an anachronistic hangover from the class needs of an earlier epoch, so also it is theoretically possible for cultural production to *anticipate* future class needs, and to play a part in the transference of political hegemony from one class to another in advance of a radical change in the relations of production.[60]

"De-Alienation" as a Strategy for Social and Artistic Transformation

In their search for alternatives to the dominant capitalist mode of filmic production and consumption, Latin American filmmakers not only drew upon past modes, they also attempted to anticipate future ones. These attempts to create cinema under alternative conditions have constituted a kind of "utopian" impulse to live out, at least in miniature, other, less alienating social forms. The parameters of this quest have allowed for a broad range of experiments:

* a "one-man" film like Mario Handler's *I Like Students* (Uruguay, 1968)—conceived, shot, edited, and (initially) exhibited by its maker, who only made one copy of a film which was to become a banner of the international student movement because he thought that

such a crude and imperfect little short "was not going to interest anyone;"

* a film school like Fernando Birri's Escuela Documental de Santa Fe;
* the semi-clandestine activity of groups like Patricio Guzmán's *Grupo Tercer Año* in Allende's Chile or Jorge Sanjinés' *Grupo Ukamau* in Bolivia;
* the fully clandestine elaboration and dissemination of *The Hour of the Furnaces* by a pair of filmmakers who supported their efforts to produce "guerrilla" cinema by working in commercial publicity;
* the attempts at producers' cooperatives organized by members of Brazil's Cinema Novo movement and Mexico's Nuevo Cine;
* the attempts at nationalization of production, distribution, and exhibition by Chile Films under the Allende government;
* the creation of the first socialist film industry in the Americas in Cuba.

Naturally, this explosion of alternative models exerted a marked impact on the content and the form of the works produced, but these innovations are best understood as the result of a larger quest to transform the modes of filmic production and consumption.

Where the dominant cinema prioritized exchange value, oppositional filmmakers emphasized use values. Where dominant procedures turned filmmakers into virtual "piece workers" or managers, alternative procedures sought a reintegration at all levels of the creative process. Where the dominant practices required large amounts of capital, a complex infrastructure, expensive equipment, studio sets, professional actors, elaborate systems for lighting and camera movement, professional screenplays, and fixed shooting schedules, oppositional filmmakers, in Glauber Rocha's phrase, simply went out to the streets "with a camera in their hands and an idea in their heads." Where the structures and conventions of traditional filmmaking required a passive and socially fragmented audience, relatively heterogeneous and isolated, who did their viewing in the "ritualized" space of the conventional movie theater, their opponents sought organizational and stylistic forms to encourage audience participation, response and feedback. These included bringing films to the targeted audiences through mobile cinema projects or 16mm "parallel circuits" which would temporarily appropriate the communal space of schools, union halls, community centers, or public squares.

The common thread which links all of these efforts is the will to "de-alienate" alienated and alienating social relations. In the last analysis, all social commitment and transformation is actualized at the level of individual experience. Latin American filmmakers' attempt to

create a revolutionary cinema took as its point of departure not simply the introduction of a new content or the transformation of cinematic forms, but the transformation of the subjective conditions of film production and film viewing. However "unconscious," uneven, and discontinuous these efforts, they have been consistent with the view that social change has its deepest roots in self-realization and that, furthermore, (proto-revolutionary) "subjectivity must have a material basis within the process of production, in the alienation of human labor from itself. . . ."[61] The sense of personal integration into a common project and of interpersonal unity generated by a common purpose is apparent in the writings, declarations, and practice of many Latin American filmmakers. To close with a single example—Patricio Guzmán's recollections of the experience of shooting what was to become *The Battle of Chile*:

> We went out to film almost every day. We had a clearly defined work plan. We came to be so in tune with one another that in the final months of the filming . . . communication between us on the shoot was virtually reduced to an exchange of glances.
>
> We usually ate in the same factories where we were filming. Often we would sleep in the truck. There was a great sense of fraternity generated by this process, not just because we were . . . all very fond of one another, but also because we understood one another, and knew that what we were doing together was of crucial importance. We were all convinced of the relevance of the project, and that was extremely important in binding us together and in helping us to develop a smooth work process.
>
> . . . The film was an incomparably intense experience for all involved, not just in its historical dimension or for whatever virtues it may have as cinema, or because of the fact that we managed to rescue it from the chaos and devastation that followed the coup, but because it was a monumental experience in each of our lives. . . . It marked us all, forever. Everything else is merely a figure of speech.[62]

Notes

1. Gerard Leblanc, "Direction," *Cinéthique* No. 5 (Paris) September–October, 1969 (translated by Susan Bennett) in *Screen Reader #1: Cinema/Ideology/Politics* (London: The Society for Education in Film and Television, 1977), p. 18.

2. The gunshots which caused Argentine Leonardo Heinrickson to lose control of his camera were, in fact, fatal.

3. Film titles given in English indicate availability through U.S. distributors; Spanish-language titles indicate films which are not in distribution here (except in those rare cases when the original title has been retained).

4. "Editorial," *Cine al día* (Caracas), 6 (December 1968), 2. Unless otherwise specified, all translations are my own and all indications of emphasis in quotations appear in the original.

5. Fernando Solanas and Octavio Getino, "Hacia un tercer cine," *Cine, cultura y descolonización* (Buenos Aires: Siglo XXI, 1973), p. 88.

6. Julio García Espinosa, "Por un cine imperfecto," *Pensamiento crítico* (Havana, 1970). English translation, "For an Imperfect Cinema," by Julianne Burton in *Jump/Cut: A Review of Contemporary Cinema* 20 (May 1979), 24–26.

7. Julio García Espinosa, "Carta a la revista chilena *Primer plano*," in *Una imagen recorre el mundo* (Havana: Editorial Letras Cubanas, 1979), 26–27.

8. Glauber Rocha, in Gordon Hitchens, "An Interview with Glauber Rocha," *Filmmakers' Newsletter*, 3:2 (September 1970), 21.

9. Jorge Sanjinés, "Cine revolucionario: La experiencia boliviana," *Cine cubano* 76/77 (n.d.), 7.

10. *Cine de la Base* declaration, September 1974 (Distributed in mimeographed form at the Mostra Internazionale del Nuovo Cinema, Pesaro, Italy, September 1975).

11. Gerardo Chijona, "Gutiérrez Alea: An Interview," *Framework: A Film Journal* (Norwich, England) 10 (Spring 1979), 29. (Reprinted from *Cine cubano* 93).

12. Fernando Birri, *La Escuela Documental de Santa Fe* (Santa Fe, Argentina: Editorial Documento del Instituto de Cinematografía de la Universidad Nacional del Litoral, 1964), p. 14.

13. *Ibid.*, p. 13.

14. Gustavo Montiel Pages, "Entrevista a Fernando Birri," *Imágenes* (Mexico) 5 (February 1980).

15. Christine Gledhill, "Recent Developments in Feminist Criticism," *Quarterly Review of Film Studies* 3/4 (Fall 1978), 462.

16. Patricio Guzmán, "La Batalla de Chile: El Golpe" (translated by Don Ranvaud), *Framework: A Film Journal* 10 (Spring 1979), 14.

17. Jean-Luc Godard, quoted in Sylvia Harvey, *May '68 and Film Culture* (London: British Film Institute, 1978), p. 66.

18. *Ibid.*, p. 71. For a comprehensive discussion of the problematics of realism, see Terry Lovell, *Pictures of Reality: Aesthetics, Politics and Pleasure* (London: BFI, 1980).

19. Octavio Getino, *Cine y dependencia: El cine en la Argentina* (Buenos Aires/Lima: Cine Liberacion, 1976/1978) (mimeo), p. 87.

20. Marc Zimmerman, "Exchange and Production: Structuralist and Marxist Approaches to Literary Theory," *Praxis* 4 (1978), 152.

21. Armando Roffe, "Problemas de la elaboración," *Cine al día* 6 (December 1968), 12.

22. Armand Mattelart, *Mass Media, Idéologies, Mouvement Révolution-aire* (Paris: Ed. Anthropos, 1974), p. 38.

23. From a personal interview, December 1979.

24. Jacobo Borges, "Cineastas frente al tercer cine: Una encuesta," *Cine al día* 14 (November 1971), 4.

25. Osvaldo Capriles, Peran Erminy, Fernando Rodriguez, "Por la linea viva del Cinema Novo: Entrevista con Leon Hirszman," *Cine al día* 19 (March 1975), 10.

26. Jean-Claude Bernardet, "Le 'Cinema Novo' Bresilien," in Guy Henne-belle (ed.), *Quinze ans de cinema mondial* (Paris: Editions du Cerf, 1975), p. 201.

27. Borges, *op. cit.*, p. 4.

28. Walter Benjamin, "The Author as Producer," *The New Left Review* 62 (July–August 1970), 85.

29. *Ibid.*, 89.

30. *Ibid.*, 89.

31. *Ibid.*, 93.

32. *Ibid.*, 93.

33. Raymond Williams, *Marxism and Literature* (Oxford University Press, 1977), pp. 139–140.

34. Néstor García Canclini, *La producción simbólica: Teoría y método en sociología del arte* (Mexico: Siglo XXI, 1979), p. 73.

35. *Ibid.*, p. 28.

36. A reference to an important article by Terry Lovell, "The Social Relations of Cultural Production: Absent Centre of a New Discourse," in Simon Clarke et al., *One-Dimensional Marxism: Althusser and the Politics of Culture* (London: Allison & Busby, 1980), pp. 323–356.

37. Williams, *op. cit.*, p. 212.

38. Terry Eagleton, "Pierre Macherey and the Theory of Literary Production," *The Minnesota Review* 5 (Fall 1975), 134.

39. *Ibid.*, 137.

40. Karl Marx, *Capital* Vol. II, as cited in John G. Taylor, *From Modernization to Modes of Production: A Critique of the Sociologies of Development and Underdevelopment* (Atlantic Highlands, N.J.: Humanities Press, 1979), p. 107.

41. Taylor, *ibid.*, p, 107.

42. Karl Marx, *Gründrisse: Foundations of the Critique of Political Economy*, translated by Martin Nicolaus (London, 1973), p. 92.

43. Cited in Aidan Foster-Carter, "The Modes of Production Controversy," *New Left Review* 107 (January–February 1978), 69.

44. Taylor, *op. cit.*, pp. 101–103.

45. Taylor, *op. cit.*, p. 103.

46. Taylor, *op. cit.*, pp. 236–237.

47. David Gartman, "Marx and the Labor Process: An Interpretation," *The Insurgent Sociologist* VIII:2 & 3 (Fall 1978), 100.

48. Harvey, *op. cit.*, p. 92.

49. This insight is drawn from a conversation with Brazilian director-exhibitor Gerardo Sarno and Uruguayan producer-distributor Walter Achugar, Havana, 1979.

50. Quoted in Foster-Carter, *op. cit.*, 74.

51. Dziga Vertov, *Articles, journeaux, projects*, quoted in Hennebelle, *op. cit.*, p. 295.

52. Stanley Aronowitz, "Film—The Art Form of Late Capitalism," *Social Text* 1 (Winter 1979), 115.

53. Stanley Aronowitz, "Marx, Braverman and the Logic of Capital," *The Insurgent Sociologist* VIII:2 & 3 (Fall 1978), 130.

54. Tabloid Collective, "On/Against Mass Culture," *Tabloid: A Review of Mass Culture and Everyday Life* (Stanford, California) 1 & 2 (Summer 1980), 1–2.

55. García Canclini, *op. cit.*, p. 72.

56. Herbert Marcuse, *Eros and Civilization: A Philosophical Inquiry into Freud* (New York: Vintage, 1955), p. 130.

57. *Ibid.*, pp. 131–132.

58. Aronowitz, "Film—The Art Form of Late Capitalism," *op. cit.*, 127–128.

59. *Ibid.*, 127.

60. Harvey, *op. cit.*, p. 105.

61. Karl Marx, cited in Stanley Aronowitz, "Marx, Braverman and the Logic of Capital," *op. cit.*, 137.

62. Julianne Burton, *Politics and the Documentary in People's Chile: An Interview with Patricio Guzmán on the Battle of Chile* (Somerville, Mass.: New England Free Press, 1978), pp. 12, 33.

The Economic Condition of Cinema in Latin America

Michael Chanan

The intention of this essay is not to provide a guided tour to the film industries of Latin America today, or a comprehensive survey of any kind. Its purpose is to understand the problem. For, like everywhere else, the film industry in Latin America is costly, suffers disproportionate risks, it is insecure. These problems, which are found in the film industries of the metropolis too, take on special features in the countries of the Third World. To understand the economics of cinema at all, it is necessary to understand the history and mode of operation of the culture industry of which it is a part. To understand the economics of cinema in a Third World continent like Latin America, it is necessary to understand that facet of the culture industry which may be properly termed "cultural imperialism."

We know that cultural imperialism is not just a phenomenon of the contemporary world. Before the flooding of the market with the products of the transnational entertainments corporations, there was the colonization of literary taste, for example, the whole process described by the Peruvian José Carlos Mariátegui in the last of his epochal *Siete ensayos de interpretación de la realidad Peruana (Seven Essays of Interpretation of Peruvian Reality)* of 1928. Cultural imperialism lies in the way in which these historical processes are consciously wielded by the imperialist power. As Joseph Klapper of CBS told the U.S. House of Representatives Committee on Foreign Affairs in 1967, The broadcasting of popular music is not likely to have any immediate

Altaf Gauhar, ed., *Third World Affairs 1985*. London: Third World Foundation, 1985, pp. 379–389. By permission of the publisher.

effect on the audience's political attitude, but this kind of communication nevertheless provides a sort of entryway of Western ideas and Western concepts, even though these concepts may not be explicitly and completely stated at any one particular moment in the communication."[1]

The process started with the arrival of the *conquistadores*. As Alejo Carpentier explains in the opening lines of his great historical study of music in Cuba:

> The degree of riches, vigor and power of resistance of the civilizations which the *conquistadores* discovered in the New World always determined, one way or another, the greater or lesser activity of the European invader in the construction of architectural works and musical indoctrination. When the peoples to be subjugated were already sufficiently strong, intelligent and industrious enough to build a Tenochtitlán or conceive a fortress of Allanta, the Christian bricklayer and chorister went into action with the greatest diligence, with the mission of the men of war scarcely fulfilled. Once the battle of bodies was over, there began the battle of the symbol.[2]

The power of the symbol, make no mistake, is a material power, for though intangible and subject to ambiguity, it has the durability of generations. It operates frequently in the guise of myths, including the modern myths which take on their paradigmatic forms in the movies, in the genres of the western, the gangster movie, the thriller, the romance, the stories of rags-to-riches and all the rest. It is possible that the situation of the Hollywood film industry gave it special insight into the ideological needs of imperialism. In any event, as the filmmakers mastered the new narrative art, it and they were pressed into telling tales which, in order to fulfill the function of a modern mythology, suppressed, as Roland Barthes has put it, the memory of their fabrication and origins. The control of this symbolizing, mythologizing faculty, has been as much the object of the Hollywood monopolies as its economic functions, however unconscious and disguised by ideological rationalizations. (For in Hollywood, as the critic Paul Mayesburg has somewhere said, conscience doth make heroes of them all.)

In 1945, the U.S. Department of Commerce publication *Industrial Reference Service* (later *World Trade in Commodities*) reported on the development of a new market in Cuba:

The market potentialities for the sale to amateur users in Cuba of United States motion-picture cameras and projectors are fair. It is estimated that upon termination of the war about $3,500 worth of 16mm sound projectors and $2,400 worth of silent 16mm projectors can be sold. Sales of 8mm motion-picture cameras are expected to be somewhat higher.[3]

This was the last paragraph in a detailed report that examined prospects for the sale of various kinds of equipment in both the theatrical and the non-theatrical markets. Non-theatrical users included schools, the army and navy, commercial users and amateurs. The expected sales were not particularly large, even allowing for the higher value of the dollar at the time. Yet apart from the fact that capitalists are miserly and like to count every prospective penny, Cuba had been of interest to the United States for some time as a kind of offshore testing laboratory for trying out new technologies and techniques in the fields of media and communication.

Back in the mid-1920s, Cuba, together with Puerto Rico, was the birthplace of the now massive communications corporation ITT—the same ITT that offered $1m to the CIA to "destabilize" the Popular Unity Government in Chile at the beginning of the 1970s. ITT was set up by the sugar brokers Sosthenes and Hernand Behn after they acquired a tiny Puerto Rican telephone business in settlement of a bad debt. The company was then built up on the success of the underwater cable link they laid between Havana and Miami.[4] At the same time, radio arrived. The first transmissions in Cuba took place in 1922. One of the first stations was owned by the proprietors of a newspaper, *Diario de la Marina*. Cuba quickly became one of Latin America's most intensely developed broadcasting markets. By 1939 it had no less than eighty-eight radio stations and about 150,000 receivers. Mexico, by comparison, though many times larger, had only 100 stations and no more than 300,000 receivers. Argentina had about 1.1m receivers, but only about fifty stations. This gave Argentina the best ratio of sets to inhabitants in Latin America, approximately 1:12, but the Cuba ratio, 1:30, was better than the Mexican, 1:64. The ratio in the U.S.A. at the same time was 1:3.5 and in Europe between 1:6 and 1:11.[5]

Local capital found entry into certain parts of the culture industry, while other areas remained the prerogative of foreign capital, because of what we nowadays think of as the problem of software, and the opportunities which this provided. Because of language and national musical idioms and tastes, local entertainment capital had the advantage in the market for radio and records. These two media—which are

intimately linked—were also cheaper to enter and to operate than film production after its earliest years. Two Cuban commentators mention that after the collapse of international sugar prices in 1920, two of the pioneers of the Cuban film business, Santos and Artega, only survived by returning to their earlier activity as circus proprietors, and that after this, local capital preferred to look to the new activity of radio.[6] As for records, early technology was almost artisanal and easily permitted small-scale local production, and remained so for longer than film. What the advent of electrical recording in 1925 did was to give the North American companies new ways of moving in on the Latin American market, but their control was still necessarily indirect. They built factories for the manufacture of records made by local musicians and produced by local companies who knew the market, and used radio stations both as their aural shopwindow and to discover new talent.

These media are different from both telephones and cables and from electricity, which in Cuba at the time of the revolution, were 90 per cent in the hands of U.S. companies who owned and controlled them directly, while in the entertainments sector a large part of the infrastructure belonged to local capital. Throughout Latin America, foreign and transnational companies hold considerable and direct interests in energy, while they control the culture industries often indirectly and without necessarily being involved in local production.

Electricity is a universal energy source requiring powerful and expensive generators as well as a guaranteed constant fuel supply; telephones and cables are first and foremost instruments of communication for commercial and industrial intelligence and traffic, both nationally and internationally. The telephone combines this with the appeal of a luxury item for personal use by the same class that uses it commercially and in government and administration, but its general availability in developing countries, like that of electricity, is always restricted. The entertainments media, in contrast, are primarily directed to the exploitation of something called consumer leisure time, across the widest possible social spectrum. They aim in developing countries to include the people who don't have electricity and telephones in their homes—or didn't. Nowadays, the shanty towns which encircle the cities often do have electricity, and hence television, though they still lack not only telephones but also a water supply and drainage system.

Every communications technology and each entertainments medium manifests its own peculiarities and idiosyncrasies as a commodity, which vary with the precise conditions of the environment in which they are installed. The telephone everywhere accelerated, in-

creased and extended commercial intercourse; but in Cuba it also served to let North American companies run their Cuban operations not as fully-fledged overseas offices but like local branches. It made it unnecessary for them to hold large stocks of raw materials or spare parts when they could get on the telephone and have them rapidly shipped or flown in from mainland depots when they were needed. The same methods are nowadays employed by transnational corporations throughout the world on the much larger scale made possible by computerization, satellite communication, and jet air transport. The advantages are not only economic: the corporations are also in this way lifted beyond the control of the countries in which their various branches are situated. Even in its simpler form twenty-five years ago in Cuba, the system confronted the revolutionaries with difficult problems when the companies were easily able to operate an embargo on supplies in the attempt to destabilize the new government. But it is also very easy for the major cinema distributors to control supply. There is a history of embargoes they have laid against different countries every time one of them tries to erect barriers against them in order to protect or succor a national film industry.

The problem of creating a national film industry has existed since the beginning and to analyze the early development of cinema in Latin America is the best way to tease out what it really consists in. To begin with, early exhibition was substantially an activity of *comicos de la legua* (itinerant showmen) just like everywhere else. In most Latin American countries, however, the geographical spread of film was largely restricted to the reach of the railways and not far beyond. Along the railway lines, a regular supply of new films from the capital city encouraged permanent cinemas. There was a limited hinterland where travelling showmen found places to set up in, like barns and yards, but transport and surface communications throughout Latin America were underdeveloped and there were vast remote areas which they never visited at all.

In any case, rural populations in Latin America offered very little scope for making money out of them. There is no reason to suppose that peasant communities would not have been just as receptive to films as urban workers, only they existed beyond the cash nexus and were economically marginal. (Their labor was still largely extracted by the quasi-feudal means inherited and evolved from the Spanish Conquest; there were a few exceptions in places like Cuba where there was a rural proletariat).

The spread of cinema in Latin America was largely due to the intensity of foreign exploitation, principally that of the U.S., but it was accomplished through intermediaries. The emerging pattern of exploi-

tation in the film industry did not require that the dominating country actually own the cinemas, it was enough for them to dominate the mentality of the economically dependent "tribe" of creole capitalists. In all Latin American countries, the cinemas came to be owned by the commercial classes, the same local business people who also set up the multitude of small commercial radio stations which spread throughout the continent during the 1930s, following the model of exploitation developed north of the Rio Grande.

Film, a new invention, became a major branch of what the Frankfurt sociologists in the 1930s, Adorno and the others, identified as the culture industry, financed by entertainment capital. This industry is characteristically imperialistic, dominated by North American interests and closely linked with the electrical industry. Even at the beginning, when the technology was still primitive, the expressive means still poor, the infant film business in each country was nonetheless only able to satisfy demand with difficulty, and through the international character which its trading patterns even then revealed, cinema showed itself a child of late capitalism and the giant electric companies in which Lenin saw the paradigmatic form of economic imperialism. So explosively did film catch on that rates of growth were unprecedented, and for several years there was no country able to produce enough for its own home market.

If the colonizers of Hollywood were able to turn these conditions to their especial advantage, this is because they were the first to obtain the backing of finance capital. They were late starters. Their entry into international competition was constrained during cinema's first twenty years or so by the ravages of the Motion Pictures Patents War, in which the companies battled viciously against each other to establish ownership of the industry's patents. But the Patents War over, the process upon which the North American film business then entered rapidly altered the prospects of creole capital more rapidly and radically than it affected the big European film companies. The companies in Europe had been seriously weakened by the war but they still had an industrial base and national roots. In the countries of the imperialized periphery these conditions were entirely absent, and the local operators either left the business or rapidly gravitated into exhibition. Distribution concentrated on a small number of companies, principally North American subsidiaries. Production was left to a few adventurists, children of the bourgeoisie with a little money to spare and the fancy to make a movie, or those who found the backing of *caballos blancos* ("white horses"), as the theatrical backers known in England as "angels" are called in Latin America.

A key moment in early cinema history had been when the dealers shifted from selling films to exhibitors to renting them instead. This change-over laid the basis for subsequent market domination by the North American distributors. They became the majors because they had understood that control of distribution was the dominant position in the industry. As the film economist Peter Bachlin has explained:

> The distributor takes over the risks of purchasing the films while the exhibitor only has to rent them; the distributor's mediation improves economic conditions for the exhibitor by allowing a more rapid change of programs. For the producers, this development signals a growth in the market, with films able to reach consumers more rapidly and in greater number, whilst also constituting a kind of sales guarantee for their films. In general, the distributor buys the prints of one or more films from one or more producers and rents them to numerous exhibitors; in the process he's able to extract a sum considerably greater than his costs.[7]

The balance of power thus shifts to the distributor. But since cinemas in the capitalist system exist to provide not films for audiences, but audiences for films, so exhibitors in turn serve as fodder for the distributors and the producers they are in league with.

The 1920s, in the North American film industry, became the period in which dealers-turned-distributors learnt the tricks of the trade and battled for control of the exhibition market with the emerging Hollywood studios, who were trying to extend their own control over the industry. It was the period when the peculiarities of the film as a commodity first clearly emerged. The film is consumed *in situ*, not through the physical exchange of the object but by an act of symbolic exchange, the exchange of its impression. William Marston Seabury, a North American film lawyer, explained that "In the picture industry the public may be regarded as the ultimate consumer but in reality the public consumes nothing. It pays an admission price at a theatre from which it takes away nothing but a mental impression of whatever it has been permitted to see."[8] Correspondingly, the exchange value of the film is realized not through physical exchange of the object itself, but through gate money, the price of admission, in this way manifesting its affinity with other forms of cultural production and entertainment. But if it does not need to pass physically into the hands of the consumer, nor does the film need to pass into the legal ownership of the exhibitor. He need only rent it.

By this means, the exhibitor becomes the prey of the ways the distributors find to manipulate the conditions of rental. "Block booking" and "blind booking," for example, in which they force exhibitors to take pictures they do not want and sometimes have not seen in order to get the ones they do want. Nonetheless, Seabury insists that film is entirely different from the commercial operation of the chain stores with which people began to compare the cinema. Bachlin is in agreement with this. It is, he says, "of great importance for the forms of concentration and monopoly which arise within the industry. The principles of price fixing and ways of dominating the market will be different from those which relate to products which involve only a single act of purchase by the consumer, that is to say, products which disappear from the market in one transaction."[9] In Europe, the North American distributors found resistance to their various malpractices, and European countries during the 1920s progressively erected legal barriers to protect their own film industries, with varying degrees of success. They were barriers of which it was practically impossible to conceive in developing countries. Even had governments had the will, what should they try to protect? The only Latin American country which ever tried it until Cuba, was Mexico, in the early 1920s, in revolutionary anger at the offensive representation of their country in the Hollywood picture.

The U.S. majors had begun to move in on Cuba while World War I was in progress: Paramount was first, in 1917. By 1926, Cuba represented 1.25 per cent of U.S. foreign distribution, according to the tables published in the *Film Year Book*. It is small in comparison with Europe, where Britain commanded a huge 40 percent and Germany came a distant second with 10 per cent, although several European markets were much smaller than Cuba: Switzerland, Holland, Czechoslovakia and Poland were only 1 per cent each, while Yugoslavia, Romania, Bulgaria, Turkey and Greece represented 1 per cent between them. In Latin America, Brazil had 2.5 per cent, Mexico 2, Panama and Central America 0.75, and Argentina, Uruguay, Paraguay, Chile, Peru, Bolivia and Ecuador, 6 per cent between them.[10] None of this made it easier for local producers. The director of a Cuban film of 1925 commented that if the film failed commercially even though the public had applauded it, this was because of the foreign distribution companies who were anxious to prevent the development of Cuban film production.[11] "Foreign" is a euphemism for North American.

How did the distributors achieve this kind of market dominance, from which they could dictate their will? They engaged not only in the malpractices already mentioned. Seabury quotes an independent

exhibitor in the U.S. commenting upon the variants of the rental system, complaining that they were designed to provide the distributor with a guarantee plus a percentage, which makes the percentage "excess profit." But the bigger the surplus profit, the more investment you can attract. The industry leaders knew this perfectly well. According to one spokesman, discussing before an audience at the Harvard Business School in 1926 the question of "how we are trying to lessen sales resistance in those countries that want to build up their own industries":

> We are trying to do that by internationalizing this art, by drawing on old countries for the best talent that they possess in the way of artists, directors and technicians, and bringing these people over to our country, by drawing on their literary talents, taking their choicest stories and producing them in our own way, and sending them back into the countries where they are famous. In doing that, however, we must always keep in mind the revenue end of it. Out of every dollar received, about 75 cents still comes out of America and only 25 cents out of all the foreign countries combined. Therefore you must have in mind a picture that will first bring in that very necessary 75 cents and that secondly will please the other 25 per cent that you want to please. If you please the 25 per cent of foreigners to the detriment of your home market, you can see what happens. Of course, the profit is in that last 25 per cent.[12]

Or rather, the surplus profit. This is cardinal, because it is not ordinary but surplus profits that attract investment capital, and this is ultimately how Hollywood came to dominate world cinema. They gleaned a surplus profit from the market which gave them the backing of Wall Street, the most substantial and modern fund of investment capital in the world at that time. The result was that the North American film industry underwent in the 1920s a rapid process of vertical integration, in which not only did the production studios and the distributors combine, but they began to acquire their own cinemas. This was to combat the formation of circuits among independent exhibitors where booking arrangements were pooled in retaliation against the methods of the renters. But abroad in Latin America the distributors faced no such organized resistance, since the exhibitors had neither the capital resources nor the bargaining power to fight, and the distributors therefore had no need to acquire cinemas to break the exhibitors' backs and bully them into submission. They acquired no more than a handful in each country, to serve as showcases. When foreign-owned cine-

mas were taken over in the Cuban nationalizations on 14 October 1960, there were no more than eleven of them.

The film as a commodity has another peculiarity, which has been observed by the North American economist, Thomas Guback. He points out that the cost of making prints for distribution is an extremely small fraction of the total costs of production, what the industry call the "negative costs," the costs of getting to the finished negative of the complete film from which the prints are made. Indeed this proportion has grown progressively smaller over the course of the history of cinema, as production budgets have grown larger and larger. It means that films can be exported without having to divert the product away from the home market (whereas with many commodities, especially in developing countries, the home market must be deprived in order to be able to export). In Guback's words, "The cost of an extra copy is the price of the raw stock, duplicating and processing —incremental costs . . . a motion picture is a commodity one can duplicate indefinitely without substantially adding to the cost of the first unit produced . . . a given film tends to be an infinitely exportable commodity; prints exported do not affect domestic supplies nor the revenue resulting from domestic exhibition. . . . We can have our film and foreigners can have it too."[13]

When you add that the United States soon developed into the largest internal film market in the world at the time, it is clear why it was irresistible. Because it was so big, U.S. producers were able to recover negative costs on the home market alone, and the distributors were therefore able to supply the foreign market at discount prices that undercut foreign producers in their own territories. They also undercut European competitors.

Guback does not quite get things right, however. He has an empirical approach which is misleading over the shape of Hollywood's foreign policy. He somehow thinks that the overseas offensive of the U.S. film industry dates only from after World War II, when the contraction of the cinema audience following the introduction of television made foreign revenue increasingly necessary for profitability. He claims that before that, "American films were sold abroad but the resulting revenue hardly compared to what the domestic market yielded." This is true, it was 25 per cent. He added that "Foreign revenue was simply an additional increment, extra profit upon which the American film companies did not depend." But we saw that they depended on it for surplus profit. His conclusion is that "The foreign market did not warrant enough attention to force Hollywood to modify significantly the content of its films to suit tastes abroad, nor to induce the film companies to maintain elaborate overseas organiza-

tions."[14] This is what is misleading: they did not have to. Their methods were those extolled in the *Washington Post*'s declaration at the beginning of the century about wanting the territories acquired from the defeated Spanish "because they will one day become purchasers at our bargain basements."

With the coming of sound also came a development which, were Guback right, would be rather strange: Hollywood began making films in Spanish. The first was actually an independent production by a successful Cuban actor, René Cardon, with the title *Sombras habañeras (Shadows of Havana)*. But then the big Hollywood companies got involved and spent two or three years making Spanish-language versions of regular Hollywood movies. They were not dubbed, for this was beyond the technical means which the talkies started with. They were remakes in Spanish, with Spanish-speaking actors and a Spanish-speaking director, but otherwise exactly the same. *The Big House*, directed by George Hill in 1930 with Wallace Beery and John Gilbert, became *El presidio*, with Juan de Landa and Tito Davison; Tod Browning's 1931 *Dracula* with Bela Lugosi was remade under the same title with Carlos Villarfas and Lupita Tovar; and there were many others.[15] They just went in and took over the sets and the shooting script and did exactly the same thing, only in Spanish.

These films didn't make money directly. They were essentially a sales device for selling the talkies, for goading Latin American exhibitors to convert to sound. The talkies represented a major investment by the U.S. film industry, with an intricate history of competition between the studios, which was undertaken in the face of the threat of falling audiences. It was an investment which Hollywood needed to recoup as fast as possible. It was essential that exhibitors abroad were rapidly induced to spend the money necessary to convert their cinemas, otherwise the 25 per cent surplus profit from the foreign market would begin to drain away. In the case of Britain, William Fox was smart enough to persuade the Gaumont circuit into it by arranging for £80m for the purpose to be subscribed by banks in the City of London. A very large part of that was the purchase of equipment from the United States. This kind of finance was much more difficult to achieve in Latin America, but the fact that here too the cinemas were owned by local capital—though there were very few significant circuits—served their purposes. Making Spanish-language films and putting them into their showcases served to bully the local cinema-owners to find the means or risk going under. They made these films for this purpose as a loss-leader, and it ceased as soon as the techniques of re-recording were brought to the point, in the mid-1930s, that allowed

the original production to be dubbed into any foreign language required.

These are the techniques by which the U.S. film majors acquired global dominance over the cinema, and, although modern developments have altered the relationship between cinema and the rest of the culture industry, the result remains a distortion in the infrastructure throughout Latin America which impedes the development of local production.

Of course, the precise nature of the problem varies from country to country, which broadly speaking fall into three groups. The first comprises the three largest countries, Mexico, Argentina and Brazil, where the size of the home market allowed indigenous industries to function. These industries are unstable. They have flourished only at intermittent intervals, and have required increasing support and privileges from the state in order to survive. The other two groups are, on the one hand, countries of the second order in size, where one could imagine a small film industry being able to function under equitable conditions but it needs decisive state action to get one off the ground; and, on the other, the smallest countries, where everything would seem to be against the idea.

The most successful attempt within the first group to provide state aid is the example of Brazil and Embrafilme. In Brazil itself, Embrafilme has often been the subject of intense debate, and its history deserves to be studied in detail. Suffice it here to say that it was set up after the military came to power in 1964 as a state film agency mainly intended, at the beginning, as an agency for promotion and distribution of Brazilian films abroad, part of the effort of the Brazilian military to create a positive image internationally. Its internal role evolved over a period of time as its funds increased, and it developed systems for subsidizing distribution and subscribing advances for production. Naturally, it also served as a censorship agency. It clearly functions much more efficiently and successfully than in Mexico, where the industry has been substantialiy nationalized and the state even owns the principal exhibition circuits, but under an unwieldy system of government administration subject to systematic corruption and the personal favors of the country's president. It remains true in Brazil, however, that more than half the annual production rate of about 100 features are still the most cheaply made commercial product of the *pornochanchada* (roughly, porno-musical) industry of São Paulo.

Of the second group, the two most important examples were the efforts made by Salvador Allende's Popular Unity government in Chile, and the Venezuelan case, which includes the novel feature of direct subsidies to film authors—in effect the directors—rather than produc-

ers. Here too, systematic study of these operations is needed.[16] But the most interesting example, because the most unexpected, comes from the third group.

In 1958, an article appeared in the Havana journal *Carteles* entitled "The possibilities of a film industry in Cuba: considerations."[17] The central question which the article raised was "Is the home market sufficient to sustain a film industry?" The author, Oscar Pino Santos, began his answer by pointing out that the average Cuban expenditure at the cinema over the years 1948–57 was 0.7 per cent of the national income, as against 0.5 per cent in the United States. (His figures differ from those covering the same period given in 1960 by Francisco Mota, from which an even higher average expenditure of 0.9 per cent can be derived.)[18] There were fifteen people for every cinema seat in Cuba, which had no film production of its own to speak of, while in Mexico and Brazil, with substantial industries producing, in their best years, as many as a hundred features a year, there were eighteen and twenty-five respectively. The fact was, said Pino Santos, that the Cuban market simply wasn't big enough, even if they did spend more on cinema than in the Mecca of the north. The total average income for a film exhibited in Cuba he estimated at some 26,000 pesos. Out of this sum, for a Cuban film, about 15,600 pesos went to the distributor, about 6,300 to the producer, and the rest to the exhibitor. Was it possible to make films on this little money? No way.

Again the figures which Mota gives are a bit different, but he is talking about imported films, for which, he reported, the royalty was said to be 40 per cent, although only half this sum actually left the country after various deductions. (In 1954, *Variety* reported that a new tax threatened the U.S. film industry in Cuba, a 20 per cent levy on top of the existing 3 per cent they had previously always managed to avoid. The article mentioned that Cuba rated as a 3 million dollar market for the U.S. companies.[19] Pino Santos's figures gave the exhibitors' share at 16 per cent; Mota estimated 20 per cent to the exhibitors. But even this difference isn't material. The point was that unless a very much higher sum—double or even more—went back to the producer, not even a cheaply made film could recoup its cost. Even the 33 per cent which the commission established by Prio effectively granted against losses was insufficient. It could only really serve as a subsidy to attract foreign, mainly Mexican, co-production.

What chances then for the project of the Cuban revolutionaries in 1959 to establish a film institute to create a national film industry? What cheek they had, if they thought they could really create a film industry that wouldn't need constant and enormous subsidy! Could a developing country afford such luxuries? The answer is that this line

of reasoning only applies under capitalist conditions: conditions in which the middlemen, the distributors, and the retailers, the exhibitors, rake off the profits before anything gets back to the producer. The provisions that were made in the decree by which the Cuban film institute ICAIC (Instituto Cubano de Arte y Industria Cinematográficos) was set up, envisioned and empowered it to intervene in order to alter these conditions, not only as a production house but also as both distributor and exhibitor, knowing that unless they indeed were altered, films produced in Cuba would never stand a chance—the same provisions that have now been made in Nicaragua, too.

Of course ICAIC has needed subsidy. Not, however, because they don't make enough money at the Cuban box office. They do so sometimes very rapidly. In 1977, *El brigadista* attracted 2 million people, almost half the population of Havana, in the space of its first six-week run in seven cinemas; *Retrato de Teresa* attracted 250,000 in only two weeks. Time and again, their own films have made more than enough money at the box office to cover the costs of production—except for one thing: the problem of foreign exchange. The exclusion of Cuban films from many parts of the foreign market prevents them earning enough freely exchangeable currency entirely to cover the inevitable foreign costs of the enterprise. Two, above all: the costs of purchasing films for distribution, and, in order to make their own, those of the industry's most monopolized resource: film stock, of which there are no more than half a dozen manufacturing companies in the world. Some of the foreign exchange ICAIC needs is saved by trade agreements with socialist countries which supply about 40 per cent of the new films distributed annually; and by the expedient of purchasing film stock for distribution copies of their own films from East Germany. They would prefer to shoot their films on Eastmancolor, which the U.S. blockade makes it difficult and expensive for them to obtain, so they generally shoot instead on Fuji, but this still requires foreign exchange.

ICAIC, for much of its existence, has been financed according to what socialist economic planning calls the system of central budgeting. Profitability plays no role in this system in the evaluation of the enterprise, which instead receives a pre-arranged sum; and in which any net income is returned to the treasury from which central budgeting funds are allocated. In recent years ICAIC's annual production budget has stood at 7 million pesos. In other words, its entire production program, which has averaged out around three or four feature-length movies every year, more than forty documentaries, a dozen or so cartoons and the weekly newsreel, all this is accomplished on less

than the cost of a single big-budget movie in Hollywood, or under half the cost of quite a few individual blockbusters.

Since the peculiarities of the film industry also apply within socialist economies, ICAIC's financial system includes special arrangements. Apart from the *cinemateca* and a small circuit of first-run houses of its own, the commercial cinemas are run, since the instigation of the system of Popular Power in the mid-1970s, by the local administrations, which also run such things as shops and petrol stations. Box office earnings pay for running the cinemas and for renting the films from ICAIC's distribution wing. The net takings go back to the central bank.

The system could be improved, but has clearly shown that it works. Internally, the costs of production are recovered from the home market successfully enough. Two other factors contribute to keeping production costs down, both of them the fruits of the Revolution in the relations of production. One is that the economics of the star system no longer exert any influence. Since the Revolution has established control over inflation and rationalized salaries and wages, there is no longer pressure to keep putting up the pay of actors and the specialized technical personnel—a major factor in the constantly increasing costs of production in the capitalist film industries. At the same time, the plan for ICAIC to become a fully equipped production house envisaged and accomplished the elimination of the different individual companies which buy and sell each other their services and facilities in every capitalist film industry, each one raking off its own profit in the process. Under such a system again the costs tend upwards, production is risky, employment uncertain. In ICAIC today, where about a thousand people are employed in production, such uncertainty, which was always worse in Cuba because production was underdeveloped and fragile, has become a thing of the past.

Notes

1. Quoted in Herbert Schiller, *Mass Communications and American Empire*, Boston: Beacon, 1971, p. 106.

2. Alejo Carpentier, *La música en Cuba*. Havana: Editorial Letras Cubanas, 1979, p. 17.

3. Nathan D. Golden, "Postwar market potentialities for motion picture equipment in Cuba," in *Industrial Reference Service*, Washington DC: U.S. Department of Commerce. August 1945, Vol. 3 Part 3, No. 7.

4. See Anthony Sampson, *The Sovereign State: The Secret History of ITT*, London: Coronet, 1974.

5. Figures extrapolated from Warren Dygart, *Radio as an Advertising Medium*, New York: McGraw Hill, 1939, pp. 231–33.

6. Rolando Díaz Rodriguez and Lazaro Buria Pérez, "Un caso de colonización cinematográfica," *Caimán Barbudo* (85), December 1975.

7. Peter Bachlin, *Histoire Economique du Cinéma*, Paris: La Nouvelle Edition, 1947, p. 21.

8. William Marston Seabury, *The Public and the Motion Picture Industry*, New York: Macmillan, 1926, p. 39.

9. Bachlin, *op. cit.*, p. 127.

10. Seabury, *op. cit.*, p. 283.

11. Quoted in Agramonte, *Cronologia del cine cubano*, Havana: Ediciones ICAIC, 1966, p. 42.

12. "Distributing the product" in J. P. Kennedy (ed.), *The Story of the Film*, A. W. Shaw & Co., 1927, pp. 225–26.

13. *The International Film Industry*, Bloomington: Indiana University Press, 1969, pp. 7–8.

14. *ibid.*, p. 3.

15. See Emilio García Riera, *Historia documental del cine mexicano* (Vol. 1), Mexico City: Ediciones Era, 1969.

16. See, on Chile, Michael Chanan (ed.), *Chilean Cinema*, London: British Film Institute. 1976.

17. Oscar Pino Santos, "Las posibilidades de una industria cinematográfica en Cuba: consideracions," *Carteles* (Havana), 30 November 1958.

18. Francisco Mota, "12 aspectos economicos de la cinematografía cubana," *Lunes de Revolución* (Havana), 6 February 1961.

19. "Cuba tax in new vexation," *Variety* (New York), 27 January 1954.

Rediscovering Documentary

Cultural Context and Intentionality

Michael Chanan

For more than twenty-five years a new cinema has been developing in Latin America, carving out spaces for itself even under the most inimical circumstances, a cinema devoted to the denunciation of misery and the celebration of protest. When these diverse films first began to arrive in Europe and North America in the 1960s, they challenged many of the norms of established film narrative, unequivocally announcing the existence of a new avant-garde in world cinema: Nelson Pereira dos Santos and Glauber Rocha in Brazil, Tomás Gutiérrez Alea and Humberto Solás in Cuba, Miguel Littín in Chile, Jorge Sanjinés in Bolivia, and many others.

Among these films were several eye-opening documentaries. From Cuba, a number of explosive short films by Santiago Alvarez—among them *Now* (1965) and *LBJ* (1968), with their biting satire and sense of urgency—seemed to reinvent the concept of agit-prop. From Uruguay Mario Handler's *Me gustan los estudiantes* (*I Like Students*, 1967), another modest masterpiece of agit-prop, captured the explosive energy of the national student movement. From Argentina, a mammoth four-hour film in three parts, *La hora de los hornos* (*The Hour of the Furnaces*, 1968), made by Fernando Solanas and Octavio Getino, described by its makers as "an act of liberation," caused a sensation at its European premiere in Pesaro, Italy. From Colombia, *Chircales*

Julianne Burton, ed., *The Social Documentary in Latin America*. Pittsburgh, PA: University of Pittsburgh Press, 1990, pp. 31–47. A version of this essay first appeared in Michael Chanan's *The Cuban Image*. London: BFI, 1985. By permission of the publisher.

(Brickmakers) by Jorge Silva and Marta Rodríguez, extended ethnography into systematic political analysis.

These were only isolated examples of a growing mass of films and filmmakers throughout Latin America. In this burgeoning movement that would become known as the New Latin American Cinema, documentary held a central position. Part of the originality of numerous fiction films derived from their incorporation of documentary techniques and styles.

The question has been asked whether all this activity really amounts to an artistic movement, whether these characteristics are concrete and specific enough to give a sense of unity to the extremely diverse ways in which they are employed. This is a question, however, as much about the forms of cultural development in Latin America as about cinema per se. First of all, not all artistic movements have the same kind of logic. There are significant differences among, for example, impressionism, fauvism, futurism, surrealism, and so forth. Second, we should not assume that artistic movements work the same way in Latin America, Africa, or Asia. Is it not possible that the basic concepts of cultural history enlisted to identify broad cultural movements like Renaissance humanism, classicism, or modernism are quintessentially European?

The New Latin American Cinema, whether or not it is thought of as a movement, certainly possesses a bewildering diversity of styles and forms. Cuban filmmakers are given to observe that the idea of socialist realism is an empty one if it can be taken to include both a Bondarchuk and a Tarkovsky. What should we say of the contrast between Rocha and dos Santos, or Sanjinés and Antonio Equino, his former cameraman? Or between the vastly different works of other directors? What do Latin American filmmakers mean by the New Latin American Cinema, a term they themselves often greet with suspicion? Is it, perhaps a piece of bravura?

The paradigmatic role of documentary cinema can shed light on these complex questions. Nowhere can documentary's importance be observed more vividly than in Cuba. As a kind of testing laboratory for the New Latin American Cinema, Cuba has produced the most fascinating and contradictory findings. Before the 1959 revolution, Cuba had been a leading Latin American producer of commercial radio and television and a leading consumer of Hollywood movies. The chronic absence or distortion of images of national life in films before 1959 helps explain why documentary would carry such weight in Cuba's postrevolutionary film production.

The historical moment of the Cuban revolution was also, by coincidence, a period of aesthetic revolution in documentary cinema. Within

the space of a few years, 16mm, previously regarded as a substandard format like 8mm or half-inch video today, became viable. Technical developments, inspired by the needs of space technology as well as television, stimulated the production of high-quality 16mm cameras light enough to be raised on the shoulder and equipped with fast lenses and film stocks that reduced or even eliminated the need for artificial lighting. Portable tape recorders and improved microphones provided synchronous sound, allowing the sound technician a mobility commensurate to that of the camera operator. No longer forced to shoot with bulky 35mm equipment that restricted them to studios or prepared locations, documentarists felt as if reborn. New-style documentary filmmakers sprung up on both sides of the Atlantic. In Europe the style became known as cinema verité, in the United States as direct cinema.

The concepts and practices of documentary film go back to the 1920s and three developments in particular: the appearance of a small avant-garde movement in European cinema; the work of a maverick filmmaker of Irish descent in North America, Robert Flaherty; and the creation of a revolutionary film industry in Soviet Russia which included the agit-prop of Dziga Vertov and the comrades of the Kino-Train. These developments were consolidated in Britain during the 1930s at the GPO Film Unit under the leadership of John Grierson.

With the coming of sound, documentarists had responded at first with more imagination than was characteristic of other branches of cinema. The rich principles of montage developed in the 1920s were applied, within the technological limitations of early sound systems, to the construction of the sound track. But the cumbersome equipment and the narrative and ideological requirements of the commercial film industry constrained and even strait-jacketed the development of the form. The message of the sponsor was required to dominate, directly or indirectly, the prerogatives of imagination. Only the special conditions of the Second World War kept a small space open for aesthetic exploration by a few gifted propagandists like Britain's Humphrey Jennings.

For the most part, however, the documentary was free to develop only within the bounds of a conventional sense of realism that had become pretty well established by the end of the 1930s. Ideologically consolidated in the postwar period, this is the basis of the aesthetic which was then inherited by television, a style many filmmakers felt excessively confining.

Grierson had argued for a concept of documentary as a didactic and social rather than a poetic and individual form, within which the image was to be employed for its status as a plain, authentic record of

the actual. This aesthetic was based on a thoroughly empiricist philosophy that closely corresponded to certain practices in journalism. Though Grierson didn't put it this way himself, he wanted the documentarist to regard the nonfictional image as an authentic document of social reality (to be filmed as artistically as one likes but with appropriate discretion) in rather the same way that journalists take documents like parliamentary reports or the sworn statements of witnesses as authoritative and unimpeachable versions of events. For the journalist actually to believe the authority of such documents, however, is plainly naive, and tends to cause problems. On similar grounds, the aesthetic that treats the authenticity of the film image uncritically can be called naive realism. There is an antagonistic tension, a contradiction, between the material capacity of the camera to make a record of a segment of the real world, and the way in which this capacity comes to be treated, which the documentary revolution at the end of the 1950s both exposed and intensified.

The constraints of 35mm encouraged documentarists to resort to filming reenactments according to the rules that had been developed in commercial cinema for the fictional narrative, adding an explanatory commentary. The rise of commentary reduced large chunks of the image to the status of mere illustration, and in the face of the demands of the sponsor, the ideals that inspired the first flowering of the social documentary now dissolved. The best documentaries in the postwar years mostly took the shape of individual poetic essays by directors like Georges Franju and Alain Resnais.

It would be natural to suppose that the Cubans eagerly took up the revolution in documentary occurring at the same moment as their own political and social revolution. Watching the documentaries of the revolution's early years, however, one rapidly discovers that this was not the case. Sometimes, indeed, the styles and forms of cinema verité are most noticeable by virtue of their absence. One reason is that the first task of the new film institute, ICAIC, was to set up operations in 35mm. By the time this was accomplished, the U.S. blockade had been imposed and there were no longer funds available for developing 16mm. One is tempted to ask, would it have been any different if there had been? Examination of the evidence both on and off screen leads to the conclusion that it would not.[1]

The rapid expansion of ICAIC's documentary output, from four films in 1959 to twenty-one the following year and forty in 1965, makes it a hopeless task to attempt to survey these films individually without looking for a way to categorize them. This exercise is fraught with the most thorny problems. Any system of classification is liable to backfire, through imposing a conceptual scheme foreign to the ma-

terial it is trying to classify. Caution therefore urges that we look first at systems of classification the Cubans themselves have employed.

In an interview published in 1971, Julio García Espinosa was asked how nonfiction output was classified.[2] He cited four categories: popularizing documentaries (*documentales de divulgación*), scientific subjects for popular consumption, newsreels, and cartoons. These divisions correspond to the way production in ICAIC was organized. The first is a general category; the second refers to specifically didactic films. (A department for didactic documentaries was set up in 1960, and though the catalogue classification under this heading came to an end in 1970, the types of films it included continued to be made. There was also a series entitled Popular Encyclopedia for which thirty-one films were produced during 1961–1962.)[3] The last two categories refer to the departments of newsreel and animation headed by Santiago Alvarez and Juan Padrón, respectively, which continued to function as separate units within ICAIC through the 1980s because their specific organizational requirements remained distinct.

Clearly these categories do not have any great aesthetic relevance. It would be more useful to look for a system of classification according to subject or theme, which might at least tell us something about the relative weight the Cubans have given to different fields of interest and could also serve as a starting point for more detailed analysis. A group of students under Mario Piedra, using ICAIC's own Cuban-as-sembled computer, have analyzed the institute's documentary output over the years 1959–1982.[4] Using thirty-three categories, they made a simple count of the numbers in nine broad thematic groups, and arrived at the following percentages:

working-class themes (*tematica social-obrera*): 24.27
artistic or cultural topics: 20.38
international topics:15.25
didactic topics: 13.45
educational topics: 7.35
historical topics: 6.38
sports: 5.68
problems in the construction of socialist society: 4.02
other: 3.19

This kind of typology, though it seems to offer a fair guide to the range of subjects treated by Cuban documentary, is not a satisfactory classification system because it gives no idea of stylistic variety. Certain films elude confinement to a single category; many films fall under one heading or another only ambiguously or incompletely.

Themes that are less often treated are not necessarily less important. Finally, some films reveal the extent of their importance only over time, like the modest six-minute montage experiment made by Santiago Alvarez in 1976 called *Now*, widely regarded as a classic of social protest.

Another question raised by this classification system involves defining exactly what a didactic film is. Within a set of terms referring to subject areas, the category seems anomalous, for it delimits not so much subject as treatment. It really belongs to a different set of terms altogether, the set which rather than dealing with subject matter, identifies the intention with which the film is made. Though it does not constitute a systematic classification scheme, the categorization of documentary according to intention represents the way documentary is thought of in Latin America, because it arises directly from the conditions under which filmmakers at the receiving end of imperialism have to operate. These terms are far more aesthetically compelling than the previous schema. In addition to *cine didáctico*, they include:

cine celebrativo—celebrational cinema
cine de combate—the combat film
cine denuncia—the protest film
cine encuesta—investigative documentary
cine ensayo—the film essay
cine reportaje—reportage (overlaps with cine encuesta)
cine rescate—films that "rescue" aspects of national or regional history or culture
cine testimonio—the testimonial film

This list is neither exhaustive nor definitive. There is no single source from which it is drawn. These are only the most frequently used of a series of terms that occur across the whole range of literature about Cuban and radical Latin American film, writings that express the preoccupations and objectives of the New Latin American Cinema movement. They can be found in film journals from several countries, including Peru (*Hablemos de Cine*), Venezuela (*Cine al Día*), Chile (*Primer Plano*), Mexico (*Octubre*), and Cuba (*Cine Cubano*), to cite only the most important.

The distinctive feature of all the terms listed is precisely their intentional character. They indicate a variety of purposes: to teach, to offer testimony, to denounce, to investigate, to bring history alive, to celebrate revolutionary achievement, to provide space for reflection, to report, to express solidarity, to militate for a cause. These are all needs of revolutionary struggle, both before and after the conquest of

power, when they become part of the process of consolidating, deepening, and extending the revolution.

An unsympathetic critic from the metropolis would quite likely dismiss the entire list with a single term: propaganda. Bourgeois ideologies have always equated propaganda with mere rhetoric, the selective use of evidence to persuade. (Or, as a Cambridge professor once put it, "a branch of the art of lying which consists in very nearly deceiving your friends while not quite deceiving your enemies.") Propaganda and didacticism are usually considered incompatible. Every revolutionary aesthetic finds this a false and mendacious antinomy. Revolutionary propaganda is the creative use of demonstration and example to teach revolutionary principles, and of dialectical argument to mobilize intelligence toward self-liberation. It seeks—and when it hits its target it gets—an active not a passive response from the spectator. As the Argentinian filmmakers Fernando Solanas and Octavio Getino put it, "Revolutionary cinema does not illustrate, document or establish a situation passively; it attempts instead to intervene in that situation as a way of providing impetus towards its correction."[5] There is obviously a didactic element in this, but there's a difference: the aim of teaching is not immediately to inspire action, but to impart the means for the acquisition of more and better knowledge upon which action may be premised. Accordingly, there's a practical difference in revolutionary aesthetics, too, between the propaganda film and the didactic film.

Ten years before Solanas and Getino made *The Hour of the Furnaces*, another Argentinian, Fernando Birri, set up the film school at the Universidad del Litoral in his native Santa Fe. He based the idea of the kind of cinema he was aiming for on two main sources: Italian neorealism, and the idea of the social documentary associated with John Grierson. Both precedents are conventionally dominated by a naive realist aesthetic, so it is not surprising to find Colombian filmmaker Jorge Silva saying in an interview a few years later. "At the inception of the militant film movement, it was said that the essential thing was simply to capture reality and nothing more, and to make reality manifest. Afterwards this formulation began to seem insufficient."[6]

However, it was not as if Birri or anyone else involved meant these paradigms to be accepted uncritically. The way Birri saw it, to apply the humanistic ideas behind neorealism and the social documentary to the context of underdevelopment immediately gave them a dialectical edge. In an interview in *Cine Cubano* in 1963, he explained the function of the documentary in Latin America by means of a play on the word *underdevelopment*—in Spanish, *subdesarrollo*. In opposition to

the false images of Latin American commercial cinema, documentary was called to present an image of authentic reality as it was and could not in all conscience otherwise be shown. It would thus bear critical witness by showing itself to be a subreality (*subrealidad*), that is to say, a reality suppressed and full of misfortune. In doing this, says Birri, "*it denies it* [reality as conventionally depicted]. It disowns it, judges it, criticizes it, dissects it: because it shows things as they irrefutably are, not as we would like them to be (or how they would have us, in good or bad faith, believe that they are)." At the same time, "as a balance to this function of negation, realist cinema fulfills another, one of affirming the positive values in the society: the values of the people, their reserves of strength, their labors, their joys, their struggles, their dreams." Hence the motivation and the consequence of the social documentary, says Birri, is knowledge of reality and the grasp of awareness of it—*toma de conciencia* in Spanish, *prise de conscience* in French. (What Brecht wanted his theater to be.) Birri summarizes: "Problematic: The change from sub-life to life." In practical terms: "To place oneself in front of the reality with a camera and film this reality, film it critically, film underdevelopment with a popular optic." Otherwise, you get a cinema that becomes the accomplice of underdevelopment, which is to say, a subcinema (*subcine*, like *subdesarrollo*).[7]

This is not just a play upon words. Implicit in Birri's approach is an idea that has come to be associated with one of the leading thinkers of the philosophy of liberation in Latin America and the Third World generally, the Brazilian educator Paulo Freire, namely, the idea of *concientización* (conscientization). Freire's philosophical arguments draw on Hegelian philosophy and existentialism as well as radical Christianity, but he's thoroughly materialist in his understanding of social reality; what he proposes is a philosophy of praxis. He argues that self-knowledge is possible only because human beings are able to gain objective distance from the world in which they live, and "only beings who can reflect upon the fact that they are determined are capable of freeing themselves."[8] In consequence, they become capable of acting upon the world to transform it, and through understanding the significance of human action upon objective reality, consciousness takes on a critical and dialectical form. It is never, says Freire, "a mere reflection of, but reflection upon, material reality."[9] In the same way, Birri wants to say that the documentary film is the production of images that are not a simple reflection of reality, but become in the film-act a reflection upon it—first by the filmmakers and then for the audience. This is clearly not the position of a naive realist. But it's not the position of an idealist either. It can best be called *critical realism*.

A film may thus break through the *culture of silence*—Freire's term for the condition of ignorance, political powerlessness, lack of means of expression, backwardness, misery—in short, dehumanization of the popular masses. It can promote the recognition of the conditions in which the people live and how they are conditioned, and can sometimes even seem to give them their voice. In this way it succors *concientización*, which is viable, says Freire, only "because human consciousness, although conditioned, can recognize that it is conditioned."[10] Hence the possibility of popular consciousness whose emergence is, if not an overcoming of the culture of silence, at least the entry of the masses into the historical process.

The power elite of the ruling classes are extremely sensitive to this process. Their own form of consciousness develops as an attempt to keep pace with it. There is always an intimate relationship between the ruler and the ruled (as in Hegel between master and slave). "In a structure of domination, the silence of the popular masses would not exist but for the power elites who silence them; nor would there be a power elite without the masses," says Freire. "Just as there is a moment of surprise among the masses when they begin to see what they did not see before, there is a corresponding surprise among the elites in power when they find themselves unmasked by the masses."[11]

The conscientious documentarist is bound to serve as a witness in this process of twofold unveiling, as Freire calls it, which provokes anxieties in both the masses and the power elite: in doing so the very idea of the social documentary is transformed. For in this transitional process, says Freire, contradictions come to the surface and increasingly provoke conflict. The masses become anxious to overcome the silence in which they seem always to have existed; the elite becomes more and more anxious to maintain the status quo. As the lines of conflict become more sharply etched, the contradictions of dependency come into focus, and "groups of intellectuals and students, who themselves belong to the privileged elite, seek to become engaged in social reality," critically rejecting imported schema and prefabricated solutions. "The arts gradually cease to be the mere expression of the easy life of the affluent bourgeoisie and begin to find their inspiration in the hard life of the people. Poets begin to write about more than their lost loves, and even the theme of lost love becomes less maudlin, more objective and lyrical. They speak now of the field hand and the worker not as abstract and metaphysical concepts, but as concrete people with concrete lives."[12] Since the middle fifties, filmmakers have been in the forefront of this process in Latin America, beginning with the social documentary and moving on to explore a whole range of militant modes of filmmaking.

Cine testimonio, or testimonial cinema, is another central category, one with two distinct strands. One of them is well represented by the Mexican documentarist Eduardo Maldonado, founder in 1969 of a group which took the term itself as its name: Grupo Cine Testimonio. According to Maldonado, *cine testimonio* is concerned to put cinema at the service of social groups which lack access to the means of mass communication, in order to make their point of view public. In the process, he says, the film collaborates in the *concientización* of the group concerned. At the same time, the filmmaker's awareness is directed towards the process of the film. The process of shooting becomes one of investigation and discovery which reaches, he believes, its final and highest stage in the editing. The film thus embodies "the aesthetic approach to *concientización*."[13]

The style which attracted Maldonado as most appropriate to these purposes was that of direct cinema. "We're not interested in propagandistic documentary work," he said, "because we find it very boring. Nor are we interested in fictional filmmaking with big stars and big screens. Instead, what we're after is a kind of direct cinema, a way of making films quickly like cinema verité, which seeks to film events in the flesh, with the people who are the protagonists of real occurrences. This type of cinema tries to penetrate reality, to find the internal and external contradictions in order finally to discover the meaning behind things." He continues:

> Observation and analysis are the basis for this kind of film making, both as the means of capturing reality and of finding the particular dialectical interpretation in each instance.
>
> We do not wish to impose our blueprints or mental categories on reality. To do this would only mean that our films would become tracts. And that would be meaningless when compared to the standards of truth and interpretation to which the people being filmed are exposed.
>
> The basis of our films is our personal testimony, so we have to respect what people think about their own circumstances. Do we want to know how the subjects of the film live and how they think? Then we have to let the facts speak for themselves.[14]

Although Maldonado falls back into the language of empirical subjectivism, it's not as if these ideas are those of naive realism any more than Birri's, only that the formulation is careless. At the same time, it may appear that in distancing the aims of the group from propaganda and in disparaging the film-tract, Maldonado is explaining the position of filmmakers who were not party militants. There are, however, a

good many filmmakers in Latin America who, though they are indeed party militants, would substantially agree with Maldonado. They would agree with the search for a dialectical interpretation of reality, with the reluctance to impose alien blueprints and mental categories on the popular classes, and with the need to respect what people think about their own circumstances. Above all, Latin American filmmakers from across a broad spectrum of political affiliations would agree that in confronting the ruling elite, a film has to struggle against standards of truth that are no truth at all.

The other strand of *cine testimonio* is literary in origin and particularly strong in Cuba. The earliest paradigms are found in the *literatura de campaña* ("campaign literature") of the nineteenth-century Cuban wars of independence: the memoirs, chronicles, and diaries of Máximo Gómez, Manuel de Céspedes, José Martí, and others. These are the accounts of participants writing in the heat and haste of events, aware of their necessarily partial but privileged perspective. Che Guevara followed the same imperatives in his accounts of the Cuban revolutionary war in the 1950s and the Bolivian campaign of the 1960s. Cuban documentarist Victor Casaus has traced this testimonial genre through Cuban journalists of the 1930s, particularly Pablo de la Torriente Brau.[15] Numerous writers of the 1970s and 1980s—the Argentinian Rodolfo Walsh, the Salvadorean Roque Dalton, the Uruguayan Eduardo Galeano, the Nicaraguan Omar Cabezas—continue to cultivate the genre.

Filmmakers have also developed their own testimonial subgenres, according to Casaus. The ICAIC newsreel was the first of these because its character as a week-by-week chronicle is not a simple piecemeal record of the events but, under the guidance of Santiago Alvarez, became their interpretative analysis. It is obviously essential to the idea of the testimonial that it convey a sense of lived history. This means, in cinema, that the camera is not to be a passive witness. The newsreel learned how to insert itself into the events it recorded by breaking the conventional structure of the newsreel form and converting itself into a laboratory for the development of filmic language. This influenced the whole field of documentary, with its already obvious affinities to testimonial literature.

Casaus specifies four characteristics of *cine testimonio*: first, rapid and flexible filming of unfolding reality without subjecting it to a preplanned narrative mise-en-scène; second, choosing themes of broad national importance; third, employing an audacious and intuitive style of montage, of which the outstanding exponent is Santiago Alvarez; and last, using directly filmed interviews both for the narrative functions they are able to fulfill and because they provide the means of

bringing popular speech to the screen. (This was the last of Casaus's four principles actually to be incorporated into the Cuban documentary, since the Cubans initially lacked the technical capacity for direct sound filming.)

What Casaus seems to be arguing is that the vocation of documentary is testimonial, though in a sense this is an a priori argument that cannot explain the different kinds of film which have appeared. At the same time, the Cubans have given a great deal of thought to the question of *cine didáctico*, a form that becomes particularly important after a revolution reaches power. What changes in cinema with the accession to power is not just that militant filmmakers are no longer forced to work clandestinely or semiclandestinely, but that the whole emphasis of their art is altered. The tasks for which films are intended qualitatively shift, and nowhere is this more marked than in the scope that opens up for didactic cinema. As Pastor Vega explained in an article dating from 1970 entitled "Didactic Cinema and Tactics," when ICAIC set up a didactic films department in 1960, dealing with a whole range of scientific and technical subjects, not all the necessary conditions for such a project existed, "but it wasn't possible to wait for them; . . . the demands of a revolution which alters the dynamic of history in all its dimensions leave no alternative."[16] ICAIC recognized that it was necessary to create a whole new batch of filmmakers without having the time to give them proper training. They would have to learn on the job, jumping in at the deep end. The didactic film has to become didactic in more ways than one; the films would educate their makers in the process of attempting to educate their audiences. What the filmmaker has to learn takes on a double aspect—there is the subject on which the film is to be made, and at the same time, learning how to make this kind of film. Formally speaking, these are two separate functions, but in the circumstances they get completely intertwined. *Cine didáctico* thus becomes a paradigm for new ways of thinking about film.

The new documentary becomes the essential training ground in Cuban cinema because the filmmaker has to learn to treat reality by engaging with the people the film is for. *Cine didáctico* teaches that the value of communication is of paramount concern because the film would achieve nothing if it didn't succeed in its primary function, which is instruction (in the broadest sense). This theme was taken up in a paper presented jointly to the National Congress of Culture and Education in 1971 by Jorge Fraga, Estrella Pantín, and Julio García Espinosa, "Toward a Definition of the Didactic Documentary."[17]

The authors discuss the idea of the didactic documentary in light of the preoccupations that had been animating their work over the pre-

vious decade. Their line of argument is itself eminently didactic. Much of what they say is philosophically grounded in the analysis of commodity fetishism and alienation, but they appeal in equal measure to more accessible concepts and ideas. They argue that a cultural heritage distorted by imperialism produces a way of thinking that perceives things in a dissociated way, that sees things only as results, without grasping the processes that create them. Underdeveloped thinking comes to be ruled by a sense of contingency and fatalism, which harkens back to the magical (but the magical now shorn of most of its previous cultural legitimacy). They observe, "After twelve years of revolution, we still find examples of this way of thinking even in our own communications media, mostly modelled after the tendency to exalt results and omit the process which led up to those results."[18]

But, they continue, cinema possesses the very qualities needed not only to communicate knowledge and skills effectively, but also to educate for a rational, concrete, and dialectical way of thinking—because it is capable of reproducing reality in motion and therefore of demonstrating processes and, further, because it's capable of revealing relationships between elements that come from the most dissimilar conditions of time and place. Utilitarian conceptions of the didactic documentary limit its potential: the result is sterile and ahistorical. Capitalist cinema conventionally deals with the problem of the genre's dryness by adding enticements to the treatment of the film, sugarcoating the pill—a technique known from advertising as "the snare." Advertising "appeals to stimuli which have nothing to do with the nature of the product in order to create more demand for it or stimulate the consumer's interest: sex, desire for recognition and prestige, fear of feelings of inferiority—anything apart from concrete demonstration of the actual properties of the object." This mentality that thinks only in terms of selling becomes all-pervasive, and everything, including ideas and feelings, is reduced to bundles of exchange values. To fall in with all this was obviously hardly acceptable. The didactic documentary, they argue, must break once and for all with this retrogressive tradition; it must link itself with the urgency of its subjects and themes. The formal techniques employed "must be derived from the theme and put at its service. It's the old moral demand for unity between form and content."[19]

Pastor Vega's account of the didactic film has the same moral emphasis, and his arguments are similarly built on an historical materialist analysis. The socioeconomic transformation created by the revolution, he explains, has propelled the newly literate peasant from the Middle Ages into the second half of the twentieth century where

he becomes an operator of tractors and agricultural machinery. This accelerated passage through multiple stages of development involved in the sudden acquisition of the products of modern science and technology, requires a qualitative leap in the process of mass education. The didactic film must be transformed accordingly, throwing off the molds of the form as it originated in the developed countries and going in search of the originality that arises from very different socialist patterns of development. The filmmaker must acquire new perspectives and seek a different filmic language than the archetypes of the documentary tradition. The didactic film must be seen as a new aesthetic category in which the artist and the pedagogue meet.

Many of the principles evolved in the course of development of the social documentary in the new Latin American cinema, particularly in Cuba, have strong parallels with positions that have been taken up within radical film practices in Europe and North America over the same period. The Venezuelan critic Raúl Beceyro is effectively speaking for both when he writes that "one of the initial tasks of 'new cinemas' all over the world has been to destroy certain norms of grammatical construction. . . . A cinema which aspires to establish new ties with the spectators or which intends to modify the role which spectators assign themselves, could not continue to use the formal structures [of what preceded it]."[20] But in certain respects the radical film cultures of the metropolis and of Latin America think rather differently.

Both would agree about naive realism. As the French art critic Pierre Francastel wrote in 1951:

> What appears on the screen, which our sensibility works on, is not reality but a sign. The great error which has regularly been committed is to embark upon the study of film as if the spectacle of cinema placed us in the presence of a double of reality. It should never be forgotten that film is constituted by images, that is to say, objects which are fragmentary, limited and fleeting, like all objects. What materializes on the screen is neither reality, nor the image conceived in the brain of the film maker, nor the image which forms itself in our own brain, but a sign in the proper sense of the term.[21]

But what *is* a sign in the proper sense of the term? This is where the trouble begins. Following Saussure, the founder of modern linguistics, as interpreted by structuralists of various disciplines, a strong current within the new radical film theory in the metropolis has come to re-

gard the sign as a very peculiar kind of symbol. As Fredric Jameson has written:

> The philosophical suggestion behind all this is that it is not so much the individual word or sentence [or image in the case of film] that "stands for" or "reflects" the individual object or event in the real world, but rather that the entire system of signs . . . lies parallel to reality itself; that it is the totality of systematic language, in other words, which is analogous to whatever organized structures exist in the world of reality, and that our understanding proceeds from one whole or Gestalt to the other, rather than on a one-to-one basis. But, of course, it is enough to present the problem in these terms, for the whole notion of reality itself to become suddenly problematical.[22]

The notion of reality itself becomes problematical, however, in quite a different way in cultures that bear the imprint of underdevelopment because the whole concept of truth is different. Truth, in the structuralist system, says Jameson, becomes a somewhat redundant idea, as it must when there is nothing to which it can be unproblematically referred. An image in a film, therefore, is not to be thought of as truthful because it pictures something real, even though the automatic mechanism of the camera would lead us to believe that there must indeed be some element of truth in this. Instead, it is said to yield meaning only because it stands in a certain relationship to the other images through which it is—so to speak—refracted. The trouble is that the result of this way of thinking in aesthetic practice is often a superficial and rigid formalism.

In any radical film practice in the underdeveloped world, truth is far more immediate and material. It is not simply a question of the accuracy or fullness of fit of the image to what it pictures, since everyone knows that this can never be complete. Rather, truth lies in the relationship with the audience, in the film's mode of address, because the meaning of what is shown depends on the viewer's position. This recognition has also been of great concern to radical film theorists in the metropolis. The new Latin American filmmakers, however, have been worried less about the way the filmic discourse positions the spectator, and rather more about whether it adequately recognizes where the spectator is already. This emphasis requires a more conscious political position on the part of the filmmaker.

The biggest difference is in the practice of cultural politics—or, more precisely, the cultural-political field within which the filmmaker intervenes. In the metropolis, there is little to stop the film "texts," the

"discourses" of cinema, from becoming dissociated objects in themselves. For the new cinema in Latin America, in contrast, "the filmmaker becomes more and more involved in the process of the masses" and "the film must become an auxiliary part of this whole formative process."[23] This dialectic promotes a very different attitude toward both the idea and the criteria of truth, not because the masses are seen as repositories of truth in the mechanistic manner of lazy Marxism, to borrow Sartre's phrase, but because the filmmaker is involved in a process of *concientización* in which truth undergoes redefinition. The philosophy of liberation holds this to be an inherent potential of underdevelopment. That is why the new cinema in Latin America, and particularly in Cuba, cannot be properly understood without grasping, across the divide of cultural imperialism, the radically different ways in which oppositional cinema positions both the viewer and the filmmaker.

Notes

1. The reasons for this are examined at length in the book from which these paragraphs are taken. In the paragraphs that follow, I present some of the findings.

2. Julio García Espinosa, "El cine documental cubano," *Pensamiento crítico*, no. 40 (July 1970), 81–87.

3. Today films for strictly educational use are made primarily by the film section of the Ministry of Education, while a range of military instructional films and television programs are made by the film section of the armed forces.

4. Mario Piedra, "El documental cubano a mil carácteres por minuto," *Cine cubano*, no. 108 (1984), 43–49.

5. Fernando Solanas and Octavio Getino, "Hacia un tercer cine," *Tricontinental*, no. 13 (October 1969); rpt. in Solanas and Getino, *Cine, cultura y descolonización* (Mexico City: Siglo Veintiuno Editores, 1973). An English translation by Michael Chanan and Julianne Burton, "Towards a Third Cinema," appears in *Twenty-Five Years of the New Latin American Cinema*, ed. Chanan (London: British Film Institute and Channel Four Television, 1983), pp. 17–27. See part 1 of this volume for the complete text of this essay.

6. Interview with Jorge Silva and Marta Rodríguez by Andrés Caicedo and Luis Ospina, *Ojo al cine*, no. 1 (1974), 35–43. An excerpted translation appears in *Cinema and Social Change in Latin America: Conversations with Filmmakers*, ed. Julianne Burton (Austin: University of Texas Press, 1986).

7. "Cinema and Underdevelopment, An Interview with Fernando Birri," *Cine cubano*, nos. 42–44 (1963), 13–21; translated in *Twenty-Five Years of the New Latin American Cinema*, ed. Chanan, pp. 9–12.

8. Paulo Freire, *Cultural Action for Freedom* (Harmondsworth, Middlesex: Penguin, 1972), p. 52.

9. Ibid., p. 53.

10. Ibid., p. 54.

11. Ibid., p. 65.

12. Ibid., p. 66.

13. Interview with Eduardo Maldonado by Andrés de Luna and Susana Chaurand, *Otro cine*, no. 6 (April–June 1976); unpublished translation by Julianne Burton.

14. Ibid.

15. Victor Casaus, "El género testimonio en el cine cubano," *Cine cubano*, no. 101 (1982), 116–25.

16. Pastor Vega, "El documental didáctico y la táctica," *Pensamiento crítico*, no. 42 (July 1970), 99–103.

17. Fraga, Pantín, García Espinosa, "El cine didáctico," *Cine cubano*, nos. 69–70, translated as "Toward a Definition of the Didactic Documentary," in *Latin American Film Makers and the Third Cinema*, ed. Zuzana Pick (Ottawa: Carleton University Film Studies Program, 1978), p. 200.

18. Ibid., p. 206.

19. Ibid.

20. Raúl Beceyro, *Cine y política* (Caracas: Dirección General de Cultura, 1976), p. 27.

21. Pierre Francastel, "Espace et Illusion," *Revue Internationale de Filmologie* 2, no. 5 (1951).

22. Fredric Jameson, *The Prison-House of Language* (Princeton, N.J.: Princeton University Press, 1972), pp. 32–33.

23. Interview with Jorge Silva and Marta Rodríguez.

Part 3
Transcontinental Articulations

The Third Cinema Question

Notes and Reflections

Paul Willemen

In 1986, for its fortieth anniversary, the Edinburgh International Film Festival (EIFF) hosted a three-day conference organized by Jim Pines, June Givanni and myself, addressing the idea of a Third Cinema and its relevance to contemporary film culture.[1] Previous gatherings had been held in London and in Manchester to promote black film- and video-makers, but these events had concentrated on the presentation of that international sector's achievements and had addressed the most immediately pressing organizational and economic questions facing the practitioners involved.

In line with its traditional emphasis on the exploration of cultural issues, the EIFF set out to raise a different set of questions, described in the festival program booklet in the following terms:

> With the major political and economic changes experienced in both the Euro-American sphere and in the so-called Third World since the late 70s, the issue of cultural specificity (the need to know which specific social-historical processes are at work in the generation of cultural products) and the question of how pre-cisely social existence overdetermines cultural practices have taken on a new and crucial importance. The complexity of the shifting dynamics between intra- and inter-national differences and power relations has shown simple models of class domina-tion at home and imperialism abroad to be totally inadequate.

Jim Pines and Paul Willemen, eds., *Questions of Third Cinema*. London: British Film Institute, 1989, pp. 1–29. By permission of the publisher.

In addition, the blatantly ethnocentric aspects of 70s cultural theory have developed into crippling handicaps which under the pressure of current political and economic policies have caused Euro-American cultural theory to stagnate or, worse, to degenerate into either a naively sentimental leftism including its Third Worldist variant, or into "post-modernism," with its contradictory thrust towards a pre-industrial nostalgia and towards bringing cultural-educational practice in line with the needs of a market economy and the entrepreneurial ideologies it requires.

Cultural activists outside the white Euro-American sphere, while taking note of 70s theory and its genuine achievements, have continued their own work throughout this period, formulating both in practice and in theory—in so far as these can be separated—a sophisticated approach to questions of domination/subordination, center/periphery and, above all, resistance/hegemony. This work is of fundamental importance today, not only because of its ability to unblock the dead-ends of 70s cultural theories, but also and primarily because it opens out onto new practices of cinema: a cinema no longer captivated by the mirrors of dominance/independence or commerce/art, but grounded in an understanding of the dialectical relationship between social existence and cultural practice. The Edinburgh Conference will address the relevance and the implications of such a notion of Third Cinema.

The EIFF seemed the appropriate place for such an ambitious undertaking to initiate a fundamental critique of current European approaches to "popular culture" by proposing that the notion of Third Cinema is far more relevant to contemporary cultural issues than any form of post-structural or any other kind of "post-" theory. The implied polemical position in the way the conference was set up had a double thrust: by turning to Third Cinema as a potential way forward, the conference implied that left cultural theory in the U.K. and in the U.S. has become a serious handicap in that it has become hypocritically opportunist (for example, the proliferation of attempts to validate the most debilitating forms of consumerism, with academics cynically extolling the virtues of the stunted products of cultural as well as political defeat) or has degenerated into a comatose repetition of 70s deconstructivist rituals. The turn to Third Cinema with all its Latin American connotations also repeated a gesture which had proved extremely productive in the early 70s: then a determined and systematic injection of "foreign" cultural theories ranging from Althusser to Brecht, from Eco to the Soviet Formalists and from Lacan to Saussure had proved capable of reanimating the petrified body of English cul-

tural criticism. Faced with a relapse into a state of suspended animation or worse, a reverting to "left laborism" of the most parochially populist type (see, for example, the ideology of "the community" in current cultural discourses), the conference was designed to draw attention to different, non-English approaches to cultural politics.

Mainly because the productivity and genuine achievements of British cultural criticism in the 70s must be seen as stemming from a salutary anti-Englishness and because the current degeneration of cultural theory correlates exactly with the abandonment of a critical rejection of English forms of cultural populism, the turn to Third Cinema can be seen as a rejection of parochialism as well as a critical engagement with the positive aspects of 70s theory. The political-cultural trends of the 80s have demonstrated the need for a drastic reappraisal of the terms in which radical practice had been conceived in the 70s: questions of gender and of cultural identity received new inflections, and traditional notions of class-determined identity were seen to be as inadequate as the forms of syndicalist struggle that corresponded to them. Some of the issues raised at the Edinburgh conference, such as the questions of Brechtian cinema and of cultural identity, received a new urgency but were now posed in a different context where not the radical white intelligentsia but the militant black cultural practitioners constituted the cutting edge of cultural politics and innovation. Their terms of reference were derived from a wide variety of sources and included 70s theories of subjectivity and Marxism in addition to the work of Fanon, C. L. R. James, black American writers and activists, Latin American and African filmmakers, West Indian, Pakistani and Indian cultural traditions and intellectuals, etc. The cultural practices grounded in those—from an English point of view—"other" currents, together with the impact of a whole series of physical acts of collective self-defense and resistance, offer the best chance yet to challenge and break down the ruling English Ideology, described so vividly in all its suffocating decrepitude in Tom Nairn's classic essay, "The English Literary Intelligentsia" (*Bananas*, no. 3, 1976).

The notion of Third Cinema (and most emphatically not Third World Cinema) was selected as the central concept for a conference in Edinburgh in 1986, partly to re-pose the question of the relations between the cultural and the political, and partly to discuss whether there is indeed a kind of international cinematic tradition which exceeds the limits of both the national-industrial cinemas and those of Euro-American as well as English cultural theories.

The latter consideration is still very much a hypothesis relating to the emergence on an international scale of a kind of cinema to which the familiar realism vs modernism or post-modernism debates are

simply irrelevant, at least in the forms to which Western critics have
become accustomed. This trend is not unprecedented, but it appears to
be gaining strength. One of its more readily noticeable characteristics
seems to be the adoption of a historically analytic yet culturally spe-
cific mode of cinematic discourse, perhaps best exemplified by Amos
Gitai's work, Cinema Action's *Rocinanté*, Angelopoulos' *Travelling
Players*, the films of Souleyman Cissé, Haile Gerima and Ousmane
Sembene, Kumar Shahani's *Maya Darpan* and *Tarang*, Theuring and
Engström's *Escape Route to Marseilles*, the work of Safi Faye, the re-
cent films of Yussif Chahine, Edward Yang's *Taipei Story*, Chen
Kaige's *Yellow Earth*, the work of Allen Fong, the two black British
films *Handsworth Songs* and *The Passion of Remembrance*, the Bra-
zilian films of Joaquim Pedro de Andrade and Carlos Reichenbach,
etc. The masters of this growing but still threatened current can be
identified as Nelson Pereira dos Santos, Ousmane Sembene and Ri-
twik Ghatak, each summing up and reformulating the encounter of di-
verse cultural traditions into new, politically as well as cinematically
illuminating types of filmic discourse, critical of, yet firmly anchored
in, their respective social-historical situations. Each of them refused to
oppose a simplistic notion of national identity or of cultural authentic-
ity to the values of colonial or imperial predators. Instead, they started
from a recognition of the many-layeredness of their own cultural-his-
torical formations, with each layer being shaped by complex connec-
tions between intra- as well as inter-national forces and traditions. In
this way, the three cited filmmakers exemplify a way of inhabiting
one's culture which is neither myopically nationalist nor evasively
cosmopolitan. Their film work is not particularly exemplary in the
sense of displaying stylistically innovative devices to be imitated by
others who wish to avoid appearing outdated. On the contrary, it is
their way of inhabiting their cultures, their grasp of the relations
between the cultural and the social, which founded the search for a
cinematic discourse able to convey their sense of a "diagnostic under-
standing" (to borrow a happy phrase from Raymond Williams) of the
situation in which they worked and to which their work was primarily
addressed.

Third Cinema: Part I

The notion of a Third Cinema was first advanced as a rallying cry in
the late 60s in Latin America and has recently been taken up again in
the wake of Teshome Gabriel's book *Third Cinema in the Third
World—The Aesthetics of Liberation* (1982). As an idea, its immediate
inspiration was rooted in the Cuban Revolution (1959) and in Brazil's

Cinema Novo, where Glauber Rocha provided an impetus with the publication of a passionate polemic entitled "The Aesthetics of Hunger" (or "The Aesthetics of Violence": *Revista Civilizacâo Brasileira* no. 3, July 1965; reprinted in part 1 of this volume). But as Michael Chanan reminded us in his introduction to *Twenty-five Years of the New Latin American Cinema* (British Film Institute and Channel 4, 1983), even at that stage the elaboration of an aesthetic felt to be appropriate to conditions in Latin America drew on the ideals of such far from revolutionary currents as Italian neo-realism and Grierson's notion of the social documentary, as well as on various kinds of Marxist aesthetics. What is becoming clearer now is that the various manifestos and polemics arguing for a Third Cinema fused a number of European, Soviet and Latin American ideas about cultural practice into a new, more powerful (in the sense that it was able to conceptualize the connections between more areas of socio-cultural life than contemporary European aesthetic ideologies) program for the political practice of cinema.

Two particular aspects of neo-realism and of the Griersonian approach may have recommended themselves to the many Latin American intellectuals who studied in Europe, which included such influential figures as Fernando Birri, Tomás Gutiérrez Alea and Julio García Espinosa, who all studied at the Centro Sperimentale in Rome. Firstly, both neo-realism and the British documentary were examples of an artisanal, relatively low-cost cinema working with a mixture of public and private funds, enabling directors to work in a different way and on a different economic scale from that required by Hollywood and its various national-industrial rivals. Secondly, contrary to the unifying and homogenizing work of mainstream industrial cinemas, this artisanal cinema allowed, at least in principle and sometimes in practice, a more focused address of the "national," revealing divisions and stratifications within a national formation, ranging from regional dialects to class and political antagonisms. What the Latin Americans appear to have picked up on was the potential for different cinematic practices offered by the European examples, rather than their actual trajectories and philosophies. Consequently, they did not follow the evolution of neo-realism into European art-house cinema, nor the relentless trek of the British documentary via Woodfall into the gooey humanism of TV plays and serials, while debased forms of the Griersonian documentary, lacking that genre's acute sense of aesthetic stylization, survive in stunted forms in the backwaters of the British state-funded video sector.

The term Third Cinema was launched by the Argentinian filmmakers Fernando Solanas and the Spanish-born Octavio Getino, who had

made *La Hora de los Hornos* (1968) and published "Hacia un Tercer
Cine" ("Towards a Third Cinema," *Tricontinental* no. 13, October
1969; reprinted in part 1 of this volume). This was followed by the
Cuban Julio García Espinosa's classic avant-gardist manifesto, "For
an Imperfect Cinema" (written in 1969 and published in *Cine Cubano*
no. 66/67, 1970; reprinted in part 1 of this volume), which argued for
an end to the division between art and life and therefore between
professional, full-time intellectuals such as filmmakers or critics and
"the people." This utopian text, foreshadowing policies advocated dur-
ing the Chinese Cultural Revolution, was followed by numerous writ-
ings both in Latin America and in post-68 Europe, in which notions of
Third Cinema, Third World Cinema and Revolutionary Cinema
tended to get lumped together to the point where they became synony-
mous. Simultaneously, in North Africa, a number of texts appeared
advocating approaches similar to the ones outlined in the Latin Ameri-
can texts: in 1967–8, in Cairo, a few critics and cineastes published
the manifesto "Jamaat as Cinima al jadida" ("Movement of the New
Cinema"), and in Morocco the journal *Cinema 3*, founded by Nour-
dine Saïl, also published Third Cinema arguments. As Férid Boughe-
dir pointed out, other manifestos followed in the early 70s: "Cinima al
Badil" ("Alternative Cinema"), published in 1972 on behalf of a num-
ber of Arab cineastes in the Egyptian journal *At-Tariq*; the "First
Manifesto for a Palestinian Cinema" in 1972, issued at the Damascus
Festival; and the "Second Manifesto" issued later that year at the Car-
thage Festival, etc.

However, what seems to have happened with the public reception
of these manifestos is that a number of crucial distinctions, often only
marginally present in founding texts written under the pressures of ur-
gent necessity, were overlooked. Firstly, the authors of the classic
manifestos, collected by Chanan in *Twenty-five Years of the New
Latin American Cinema*, forcefully state their opposition to a slogan-
ized cinema of emotional manipulation. Any cinema that seeks to
smother thought, including a cinema that relies on advertising tech-
niques, is roundly condemned. Sanjinés even accuses such strategies
of going against revolutionary morality. In other words, a cinema that
invites belief and adherence rather than promoting a critical under-
standing of social dynamics is regarded as worse than useless. All au-
thors, from Birri to Espinosa and even the mystically inclined Glauber
Rocha, stress the need for a cinema of lucidity. The widely expressed
antagonism towards professional intellectuals is in fact an opposition
to colonial and imperialist intellectuals, and this antagonism is never
used to devalue the need for the most lucid possible critical intelli-
gence to be deployed as an absolutely necessary part of making films.

What is at stake here is the yoking together of the cognitive and the emotive aspects of the cinema. As Espinosa put it, this cinema is addressed "in a separate or co-ordinated fashion at the intelligence, the emotions, the powers of intuition." A major lesson to be learned from these manifestos is that they consistently warn against drifting into anti-intellectualism or, worse, shoddy intellectualism, emphasizing the need to learn. What they do condemn is a particular kind of middle-class intellectual, not intellectual activity *per se*. The intellectuals condemned are only those whose "expertise has usually been a service rendered, and sold, to the central authority of society," as Edward Said put it in *The Writer, the Text, and the Critic* (London, Faber & Faber, 1984, p. 2).

Secondly, the manifestos refuse to prescribe an aesthetics. The authors broadly agree about which aesthetic forms are not appropriate or are even damaging, but they also refuse to identify a particular formal strategy as the only way to achieve the activation of a revolutionary consciousness. Following Brecht, who vigorously protested against the attempt to elevate the use of "distanciation devices" into an obligatory procedure, the Latin Americans insisted on the legitimacy of any procedure which was likely to achieve the desired results, i.e. an analytically informed understanding of the social formation and how to change it in a socialist direction. In Espinosa's words: "Imperfect cinema can make use of the documentary or the fictional mode, or both. It can use whatever genre, or all genres . . . It can use cinema as a pluralistic art form or as a specialized form of expression." Solanas and Getino talk about "the infinite categories" of Third Cinema, and Sanjinés noted that the forms of Revolutionary Cinema must change as the relations between "author" and people change in particular circumstances. There are no general prescriptions other than negative ones in the sense that certain roads have been explored and found to be dead ends or traps. Glauber Rocha once recalled Nelson Pereira dos Santos quoting a line from a Portuguese poet: "I don't know where I'm going, but I know you can't get there that way."

One of the main differences between Third Cinema and the European notion of counter-cinema is this awareness of the historical variability of the necessary aesthetic strategies to be adopted. Whatever the explanation—and the weight of the modernist tradition in the arts may be a crucial factor here—and regardless of the political intentions involved, the notion of counter-cinema tends to conjure up a prescriptive aesthetics: to do the opposite of what dominant cinema does. Hence the descriptive definition of dominant cinema will dictate the prescriptive definition of counter-cinema. The proponents of Third Cinema were just as hostile to dominant cinemas but refused to let the

industrially and ideologically dominant cinemas dictate the terms in which they were to be opposed.

To be fair, the two main U.K. counter-cinema theorists, Peter Wollen and Claire Johnston, never argued that the strategies and characteristics of counter-cinema should be canonized and frozen into a prescriptive aesthetics. They pointed to the importance of cinematic strategies designed to explore what dominant regimes of signification were unable to deal with. Theirs was a politics of deconstruction, not an aesthetics of deconstruction. The difference is worth noting. A politics of deconstruction insists on the need to oppose particular institutionally dominant regimes of making particular kinds of sense, excluding or marginalizing others. An aesthetics of deconstruction proceeds from the traumatic discovery that language is not a homogeneous, self-sufficient system. Allon White put it most succinctly in an essay on "Bakhtin, Sociolinguistics and Deconstruction" (in *The Theory of Reading*, ed. Frank Gloversmith, Sussex, 1984, pp. 138–9):

> only for those who identify language as such with Saussurean *langue* does it appear paradoxical and impossible that dispersal, *différance*, lacks, absence, traces and all the modes of radical heterogeneity should be there at the heart of discourses which pretend to be complete. Much of the time, deconstruction is rediscovering in texts, with a kind of bemused fascination, all the indices of heteroglossia which Saussure excluded from consideration in his own model, by consigning them to the trashcan of *parole*. To discover that rationality (the logic of the signified) may be subverted by writing itself (the logic of the signifier) seems to put the "whole Western episteme" into jeopardy, but is in fact a fairly trivial business.

The politics of deconstruction, then, insists on the need to say something different; an aesthetics of deconstruction dissolves into endlessly repeated difference-games, i.e. into the Varietal Thesis, as Meaghan Morris once put it.

Nevertheless, even a politics of deconstruction is circumscribed by its attention to the limits of dominant regimes of signification, whereas the Third Cinema polemicists avoided that trap—admittedly at the price of rather unhelpfully homogenizing "dominant cinema" itself, a mistake later corrected by Nelson Pereira dos Santos' *O Amuleto de Ogum* and *Na Estrada da Vida*, showing what can be done with a selective redeployment of the dominant cinema's generic elements while refusing to reduce the films to, or to imprison them in, that "varietal" relationship. Dos Santos' films do not "quote" elements

of the dominant cinema in order to provide a nostalgic updating of a kind of cinema now associated with the past; he proposes instead a transformation of cinema which refuses to jettison all the components and aspects of that "old" dominant cinema merely because they formed part of an unacceptable cinematic regime.

Thirdly, and most importantly, the Latin Americans based their notion of Third Cinema on an approach to the relations between signification and the social. They advocated a practice of cinema which, although conditioned by and tailored to the situations prevailing in Latin America, cannot be limited to that continent alone, nor for that matter to the Third World, however it is defined. The classic manifestos are fairly ambiguous on this point, making rather cursory references to Asian and African cinemas as well as to the work of Chris Marker or Joris Ivens. The clear, though not often explicitly stated, implication is that although Third Cinema is discussed in relation to Latin America, the authors of the manifestos see it as an attitude applicable anywhere. In *CinémAction* no. l, Solanas took the opportunity to clarify the issue. It is worth quoting him at some length since he corrects many misconceptions that have accrued to the notion of Third Cinema:

> First cinema expresses imperialist, capitalist, bourgeois ideas. Big monopoly capital finances big spectacle cinema as well as authorial and informational cinema. Any cinematographic expression . . . likely to respond to the aspirations of big capital, I call first cinema. Our definition of second cinema is all that expresses the aspirations of the middle stratum, the petit bourgeoisie. . . .
>
> Second cinema is often nihilistic, mystificatory. It runs in circles. It is cut off from reality. In the second cinema, just as in the first cinema, you can find documentaries, political and militant cinema. So-called author cinema often belongs in the second cinema, but both good and bad authors may be found in the first and in the third cinemas as well. For us, third cinema is the expression of a new culture and of social changes. Generally speaking, Third Cinema gives an account of reality and history. It is also linked with national culture . . . It is the way the world is conceptualized and not the genre nor the explicitly political character of a film which makes it belong to Third Cinema . . . Third Cinema is an open category, unfinished, incomplete. It is a research category. It is a democratic, national, popular cinema. Third Cinema is also an experimental cinema, but it is not practiced in the solitude of one's home or in a laboratory because it conducts research into communication. What is required is to

make that Third Cinema gain space, everywhere, in all its forms
. . . But it must be stressed that there are 36 different kinds of
Third Cinema. (Reprinted in *L'Influence du troisième cinéma
dans le monde*, ed. by *CinémAction*, 1979.)

Of course, these definitions beg a great many questions, the most im-
mediate one being that of the viewers: is it possible to see a First Cin-
ema film in a Third Cinema way? In Europe, most Third Cinema
products have definitely been consumed in a Second Cinema way,
bracketing the politics in favor of an appreciation of the authorial art-
istry. A pessimist might argue that the deeper a film is anchored in its
social situation, the more likely it is that it will be "secondarized"
when viewed elsewhere or at a different time unless the viewers are
prepared to interest themselves precisely in the particularities of the
socio-cultural nexus addressed, which is still a very rare occurrence.
Another point of interest is that the categories are not aligned with
Marxist notions of class, presumably since all filmmakers would then
have to be seen as middle-class entrepreneurs, which is indeed what
they are, even when making films clandestinely. Espinosa tackled that
problem by arguing that no filmmaker should be a full-time profes-
sional. Instead Solanas aligns First, Second and Third Cinemas with
three social strata: the bourgeoisie, the petit bourgeoisie and the peo-
ple, the latter including industrial workers, small and landless peas-
ants, the unemployed, the lumpenproletariat, students, etc. As a
category, "the people" seems to be used as a catch-all term designat-
ing all who are left after the bourgeoisie and most of the petit bour-
geoisie have been deducted. This gives Third Cinema a basically
negative definition. Moreover, if First Cinema was a capitalist-in-
dustrial-imperialist cinema and Second Cinema an individualist-petit
bourgeois or unhappily capitalist one, Third Cinema is definitely pre-
sented as a socialist cinema. But the possibility of an anti-capitalist
cinema drawing inspiration from precapitalist, feudal nostalgia is not
taken into account. Neither did the authors of the manifestos always
avoid attributing an essentially revolutionary consciousness to "the
people," the oppressed. As if the experience of oppression itself did
not also have ideologically damaging effects, which is why a cinema
of lucidity is such an essential prerequisite for a socialist cultural
practice.

The manifestos also omit any mention of an aristocracy, as if that
class simply didn't count in the cultural configuration. While this may
be true to a large extent in Latin America, it is most certainly a handi-
cap when considering Asian countries, not to mention European ones
or the African social stratifications. Moreover, neither ethnic nor gen-

der divisions are acknowledged in any of the manifestos, which confuses matters still further. These aspects of the Third Cinema texts do reinforce the impression that it was a notion developed by Latin Americans for Latin Americans and that the general applicability of the approach was added as an afterthought.

However, even though in this respect Third Cinema is not exactly defined with precision, two characteristics must be singled out as especially useful and of lasting value. One is the insistence on its flexibility, its status as research and experimentation, a cinema forever in need of adaptation to the shifting dynamics at work in social struggles. Because it is part of constantly changing social processes, that cinema cannot but change with them, making an all-encompassing definition impossible and even undesirable. The second useful aspect follows from this fundamental flexibility: the only stable thing about Third Cinema is its attempt to speak a socially pertinent discourse which both the mainstream and the authorial cinemas exclude from their regimes of signification. Third Cinema seeks to articulate a different set of aspirations out of the raw materials provided by the culture, its traditions, art forms etc., the complex interactions and condensations of which shape the "national" cultural space inhabited by the filmmakers as well as their audiences.

Lineages

The Latin American manifestos must also be seen in the context of Marxist or Marxist-inspired cultural theories in general, where they mark a significant additional current with linkages passing both through Cuba and through Italy, as well as developing homegrown traditions of socialist and avant-gardist thought. The most direct connections in this respect, for a European reader, are with German cultural theory of the 1930s, with Brecht and also with Benjamin.

The relation with Brecht has been referred to earlier and may seem obvious, but the Benjamin connection is less well known. Susan Buck-Moss, one of the most perceptive and best informed commentators on Benjamin's work, drew attention to his statement about history writing which, *mutatis mutandis*, also applies to cinematic discourses and evokes the relationship which Solanas and Getino posited between filmmaking and the context within which filmmakers work. In her essay "The Flâneur, the Sandwichman and the Whore: The Politics of Loitering" (in *New German Critique*, no. 39, 1986), she quoted Benjamin: "The events surrounding the historian and in which he takes part will underlie his presentation like a text written in invisible ink." Similarly, underlining phrases from the *Passagenwerk*, she

described a mode of inhabiting one's culture which comes close to the ideas put forward in the manifestos, except that Benjamin uses a characteristic metaphor to sum up the approach:

> In the face of "the wind of history, [. . .] thinking means setting sails. How they are set is the important thing. What for others are digressions are for me the data that determine my course." But this course is precarious. To cut the lines that have traditionally anchored Marxist discourse in production and sail off into the dreamy waters of consumption is to risk, politically, running aground. (*New German Critique*, op. cit., p. 107.)

Criticising the evocation of emotion without providing the knowledge that could change the situation, Benjamin's theory on dialectical images, although not mentioned in the manifestos, is present in their margins as they stress the relations with the viewer as being the productive site of cinematic signification. Paraphrasing Susan Buck-Morss, one could say that once "the sails are set," it is not within the cinematic discourse but in the spaces between the referential world it conjures up and the real that the cognitive process is propelled.

Finally, in a direct parallelism with the aspirations of the Latin American cineastes, Benjamin wrote that he saw his work as one of educating "the image-creating medium within us to see dimensionally, stereoscopically, into the depths of the historical shade." Perhaps these echoes of Benjamin can be explained by the fact that "It is in Benjamin's work of the 1930s that the hidden dialectic between avant-garde art and the utopian hope for an emancipatory mass culture can be grasped alive for the last time," according to Andreas Huyssen in the best book to date on contemporary cultural dynamics, *After the Great Divide* (Indiana University Press, 1986, p. 16). He should have added: in the West, because the work resurfaced and continued in Latin America and in India in the 60s, although in modified forms.

In fact, the lineage goes back to the Soviet avant-gardes. Espinosa echoes Bogdanov's insistence that art practices must address the "organization of emotion and thought." Rocha's violently emotional work echoes Tretyakov's reliance on shock to alter the psyche of the recipient of art. The Latin Americans' emphasis on lucidity echoes Brecht's confidence in the emancipatory power of reason, something he shared with many Soviet artists allied to Lunacharsky's Commissariat of the Enlightenment and their "goal to forge a new unity of art and life by creating a new art and a new life" (ibid., p. 12) in one and the same movement. There are, then, clear continuities running from

the Soviet artists via Tretyakov to Rocha, via Brecht to Solanas and
via Benjamin to . . . E. Said?

However, it would be misleading to overlook the differences be-
tween the Brecht-Benjamin nexus and the Latin American manifestos.
In the displacement of the political-cultural avant-garde from Europe
to Latin America, some themes fell by the wayside while others were
modified. Technological utopianism was the first casualty, as evi-
denced by Espinosa's notion of a technologically, as well as financial-
ly, poor cinema as being the most effective way forward for artists
opposed to the Hollywood-dominated consciousness industries. The
recourse to poor technology (e.g., black and white 16mm handheld
camera techniques as opposed to studio technology, etc.) had become
a necessity not only in Latin America but for all those who wished
(and still wish) to contest the industrial cinema's domination. Second-
ly, compared to the Soviet and German socialist avant-gardes, the
Latin Americans put an extraordinary, almost desperate stress on the
need for lucidity in the struggle for a renewed attempt to integrate art
and life. It is easy to see how changes that had come about since the
30s could give rise to a feeling of desperation in this respect. As
Andreas Huyssen put it:

> The legitimate place of a cultural avant-garde which once car-
> ried with it the utopian hope for an emancipatory mass culture
> under socialism has been preempted by the rise of mass me-
> diated culture and its supporting industries and institutions. It
> was the culture industry, not the avant-garde, which succeeded
> in transforming everyday life in the 20th century. And yet—the
> utopian hopes of the historical avant-garde are preserved, even
> though in distorted form, in this system of secondary exploita-
> tion euphemistically called mass culture.
>
> (ibid., p. 15)

The Latin American, Asian and African filmmakers were, and to a
large extent still are, caught between the contradictions of technolog-
ized mass culture (its need to activate emancipatory wishes in order to
redirect or defuse them by invoking an array of pleasures and organiz-
ing them in such a way that the dominant pleasures become associated
with conservative or individualist gratifications) and the need to de-
velop a different kind of mass culture while being denied the finan-
cial, technological and institutional support to do so. Since the culture
industry has become extremely adept at orchestrating emotionality
while deliberately atrophying the desire for understanding and intel-
lectuality, it makes sense for the Latin American avant-gardes to

emphasize lucidity and the cognitive aspects of cultural work, thus reversing the hierarchy between the cognitive and the emotive, while of course maintaining the need to involve both.

The third main difference is due to two absences in Latin America. The absence of a powerful fascist culture with its aestheticization of politics, as exemplified in Nazi Germany. In Latin America, political power has been wielded in more nakedly repressive ways, perhaps because the populist ideologies required by national-fascist regimes could never be successfully passed off as a domestic aspiration: imperialist forces were too obviously in play for that strategy to work. The second absence is the experience of Stalinism's rigorous subordination of cultural workers to the requirements of the elite of the Party bureaucracy. Whatever could be said of Cuba's cultural policies, the effervescence of Cuba's cinema in the 60s was such a welcome contrast to the cinemas of other "existing socialisms" that the shortcomings of prevailing Marxist theories of culture were not a major issue for Latin American cultural practitioners. The Allende period in Chile only reinforced this optimism for a while. Consequently the Latin Americans were better able to reconnect with the emancipatory drive of 20s and 30s cultural theory than their European counterparts, who had been traumatized by the experience of World War Two and by the degeneration of the once revered Soviet regime. For them, the dangers inherent in the avant-garde rhetoric about the fusion of art and life were all too apparent. It took the Latin Americans' reformulations under different circumstances, and in the context of a wave of successful independence struggles, to put the question back on the political-cultural agenda. Their emphasis on lucidity also functioned positively in that respect as a warning against subordinating the critical-cognitive dimensions of cultural work to the emotive-utopian harnessing of popular aspirations to a (necessarily) centrally dictated strategy of a political party (if that party is at all serious about gaining power).

Finally, the Latin Americans also pioneered, alongside their filmmaking work, a "Third Cinema" critical practice which proceeded from the same impulses towards "historical lucidity," something which the Europeans never achieved as far as cinema was/is concerned. Not only did the cineastes write manifestos, they also engaged in a critical reconstruction of their cinematic histories. In conjunction with them, historian-critics such as Paulo Emilio Salles Gomes and Jean-Claude Bernadet in Brazil consistently worked towards a type of criticism that sought to understand individual texts and contemporary trends in filmmaking in relation to the historical processes, institutions and struggles from which these texts and currents received their formative impulses. It took longer for those critical practices to travel to

Europe than it took the films. Only recently, and indirectly, has the critical equivalent of Third Cinema gained ground in the West and, not surprisingly, it is mainly (but not exclusively: see for instance Meaghan Morris on *Crocodile Dundee* in *Art & Text*, no. 25) practiced by critics and theorists who themselves try to reconnect with as well as extend aspects of 30s German cultural theories: for example, the work of Fredric Jameson, Eric Rentschler, Miriam Hansen, writers associated with the U.S.-based journal *New German Critique*, the writings of Alexander Kluge. In Britain, the work on British and Irish cinema published by the Ireland-based John Hill and the work of Peter Wollen come to mind, along with Claire Johnston's essay on *Maeve*, as all too rare examples. Perhaps fittingly, this return to critical theory went together with a rediscovery of the massive importance of a Soviet theoretician's long neglected work: that of Mikhail Bakhtin.

Third Cinema: Part II

Recently, Teshome Gabriel reformulated some of the Third Cinema theses, pointing out that "Third Cinema includes an infinity of subjects and styles as varied as the lives of the people it portrays . . . [its] principal characteristic is really not so much where it is made, or even who makes it, but, rather, the ideology it espouses and the consciousness it displays." Although still confining it *de facto* to so-called Third World countries, nearly always overlooking Asia (which may be due to the difficulty of obtaining prints for study rather than to oversight), Gabriel's unambiguous affirmation that Third Cinema can be praised anywhere opens the way towards a different conceptualization of Third Cinema and its contemporary relevance. Instead of Epstein's notion of "photogenie" or difference theory (the "varietal thesis"), which are theories of consumption, Third Cinema refers to production, and its corresponding theory of consumption would then be Bakhtin's theory of reading, including its emphases on inner speech and the profoundly social aspects of discourse.

However, perhaps because of his committed internationalism, Gabriel risks contradicting himself by not facing head on the question of the national. If Third Cinema is as varied as the lives of the people it portrays (I would prefer to say: as varied as the social processes it inhabits), it must follow that it espouses nationally specific forms, since the lives of people are governed and circumscribed by histories and institutions made "nationally specific" by the very existence of the boundaries framing the terrain where a particular government's writ runs, by the legal and educational systems in place there, etc.

Nevertheless, Gabriel also wrote *Towards a Critical Theory of Third World Films* in which Third Cinema and genuine Third World cinema expressive of Third World needs are equated. Whether or not China, India or South Korea can meaningfully be regarded as Third World areas, Gabriel's essay raises another serious problem: is it theoretically possible to find a unifying aesthetic for non-Euro-American cinemas? If the answer is "yes" as his otherwise stimulating analyses tend to suggest, then Third Cinema is undoubtedly not nearly as varied as the lives of the people it portrays. But, going one step further, the way Gabriel seeks to substantiate the argument for a unifying aesthetic leads to two conflicting results. Firstly, and in spite of the stated contrary intention, Third Cinema is once more defined in terms of its difference from Euro-American cinema, thus implicitly using Hollywood and its national-industrial rivals as the yardstick against which to measure the other's otherness. Secondly, Gabriel demonstrates also that the various non-Euro-American cinematic regimes organize time and space in their own specific ways. That is to say, using a Bakhtinian term, non-Euro-American cinema is characterized by a different chronotope. In his study of Bakhtin's work, Tzvetan Todorov defined the chronotope as "the set of distinctive features of time and space within each literary genre" (*Mikhail Bakhtin: The Dialogical Principle*, Manchester University Press, 1984, p. 83). Bakhtin himself was a little less restrictive. He talked about an image of "historical time condensed in space" (*Speech Genres & Other Late Essays*, University of Texas Press, 1986, p. 49) and of

> the ability to *see time*, to *read time*, in the spatial whole of the world and, on the other hand, to perceive the filling of space not as an immobile background, a given that is completed once and for all, but as an emerging whole, an event—this is the ability to read in everything *signs that show time in its course*, beginning with nature and ending with human customs and ideas (all the way to abstract concepts) . . . The work of the seeing eye joins here with the most complex thought processes.
>
> (ibid., p. 24)

Consequently, chronotopes are time-space articulations characteristic of particular, historically determined conceptions of the relations between the human, the social and the natural world, i.e. ways of conceptualizing social existence. Gabriel's argument that a different chronotope determines the narrative images and rhythms of non-Euro-American cinemas is convincing. However, his analysis stops short of specifying how, for instance, the chronotope of Ghatak's films, with

their intricate interweaving of historical, biographical, natural and emotional temporal rhythms, not to mention musical and speech rhythms, in spaces disrupted by edges and boundaries themselves condensing historical and symbolic meanings, differs from Joaquim Pedro de Andrade's telescoping of historical, allegorical and fantasy times in *O Homem do Pau Brasil*, or the representation of historical time in terms of the relation between linear-evential time and cyclical-ritual time in a space divided according to varieties of sacred-profane oppositions, as in Sembene's *Ceddo*. Secondly, the chronotopes of neither the first nor the second cinemas are as homogeneous as Gabriel's argument (and the use of the term Euro-American in these notes) would suggest. Chantal Akerman and Bette Gordon's films each in their own way deploy space-time worlds at variance with dominant Euro-American cinemas. Similarly, some of Mario Bava's horror films operate within the confines of fantasy time and logic (in which the narrative is propelled by the working through of a single, highly condensed but basically static fantasy structure), whereas Roger Corman's work is marked by the imbrication of sacred-ritual and profane-linear time structures, although both tend to use space in very similar ways. Then there is the question of the differences between the chronotopes of "commercial" Indian cinemas and those of Japanese, Hollywood or Latin American ones. In addition, there appear to be marked differences between black British and black American films in spite of their shared opposition to Hollywood. These differences relate more to the varying relations between these films and their respective "host" cinemas, a relationship that also informs the differences between British and American independent-political cinemas in general. For example, the black British cinema can be seen as organizing time-space relations differently from both dominant and experimental-independent British cinemas, and this complex differentiation from its immediate industrial-social-cultural context is a more pertinent (over)determining process than, for example, any reference to black African cinemas. Moreover, within the black British cinema there are further important distinctions to be made between films drawing on Asian and on Caribbean cultural discourses and histories.

Gabriel's homogenization of the Third Cinema chronotope into a single aesthetic "family" is thus premature, although the analysis of the differentiation between Euro-American cinema and its "other" constitutes the necessary first step in this politically indispensable and urgent task of expelling the Euro-American conceptions of cinema from the center of film history and critical theory. The difficulties of such a project are not to be underestimated, as is demonstrated by the consistent shorthand usage of the term Euro-American in this discus-

sion: readers of these notes are bound to have some idea of what is meant by that term, while a distinction between Islamic and Buddhist cinemas is likely to be received with puzzlement, although it is in all probability a pertinent distinction to make.

The national

One important factor which programs Gabriel's premature rehomogenization of Third Cinema, after his insistence on its infinite variability, is his principled but costly avoidance of the national question. The effectiveness with which the national socio-cultural formations determine particular signifying practices is not addressed. Admittedly, the national question itself has a different weight in various parts of the globe, but the forced as well as the elective internationalism of cinema —especially of a cinema with inadequately developed industrial infrastructures—tends to bracket national-cultural issues too quickly. And yet if any cinema is determinedly "national," even "regional," in its address and aspirations, it is Third Cinema.

Since Hollywood established its dominance in the world market, from 1919 onwards, the call for a cinema rooted in national cultures has been repeated in a variety of ways, perhaps most vocally by national bourgeoisies cynically invoking the "national culture" in order to get the state to help them monopolize the domestic market. Initially, these calls took the form of arguments for an authorial cinema, within a national industry if possible, outside of its institutions if necessary. The split between a national-dominant cinema competing with Hollywood and a national authorial cinema—which also existed within Hollywood, as Solanas acknowledged—has been mirrored in the split between a politically oriented militant cinema opposing mainstream entertainment cinema and a personal-experimental cinema opposing the literariness of author-cinema, even if these categories tended to overlap at times. These mirror-divisions have developed since the mid-70s, each giving rise to its own institutions but none being able to challenge the industrial-political domination of Hollywood. At best, some countries (especially in Asia) have managed to prevent Hollywood from destroying their local film industry, but even these countries failed to make a significant international impact. The post-World War Two era up to 1975 (the Vietnamese victory over the U.S.) has been characterized by intense struggles over "national" film cultures, and has seen the rise of authorial cinemas while the dominant industrial cinemas' ideological and economic functions within national as well as in international capitalist structures began to shift towards television. In countries without advanced film production sec-

tors, the question of the national was also and immediately a political question, i.e. the question of national liberation and the right to speak in one's own cultural idioms. But although these questions are fairly recent ones as far as cinema is concerned, they had been rehearsed for over a century in relation to literature, the fine arts, theatre, music, etc.

In fact, the West invented nationalism, initially in the form of imperialism as nation-states extended their domination over others, creating at one and the same time the hegemonic sense of the "national culture" and the "problem" of national identity for the colonized territories. The issue of national-cultural identity arises only in response to a challenge posed by the other, so that any discourse of national-cultural identity is always and from the outset oppositional, although not necessarily conducive to progressive positions. This holds true for the colonizing nation as well as for the colonized one(s) it calls into being. The responses to this reciprocal but antagonistic formation of identities fall into three types.

The first option is to identify with the dominant and dominating culture, which is easy for the metropolitan intelligentsia such as the infamous Thomas Macaulay, who disguised armed and economic force under the cloak of cultural superiority. This option is less comfortable for the colonized intelligentsia who may aspire to the hegemonic culture but can never really belong to it. However, the rewards for such an aspiration are sufficiently attractive for many of them to pursue it with vigor: there is the promise of advancement under colonial rule and of becoming the "national" leadership to which a retreating colonizer will wish to bequeath power.

The second option is to develop the antagonistic sense of national identity by seeking to reconnect with traditions that got lost or were displaced or distorted by colonial rule or by the impact of Western industrial-military power. In spite of the undoubted mobilizing power of such national-populist ideologies, this option presents considerable difficulties and dangers. The main ones derive from the need to reinvent traditions, to conjure up an image of pre-colonial innocence and authenticity, since the national-cultural identity must by definition be founded on what has been suppressed or distorted. The result is mostly a nostalgia for a pre-colonial society which in fact never existed, full of idyllic villages and communities peopled by "authentic" (read folkloric) innocents in touch with the "real" values perverted by imperialism or, in the most naive versions, perverted by technology.

Alternatively, particular aspects of some culture are selected and elevated into essentialized symbols of the national identity: the local answer to imperialism's stereotypes. Mirroring imperialism's practices,

such efforts mostly wind up presenting previously existing relations of domination and subordination as the "natural" state of things.

And then, of course, there are the political monstrosities that occur when such idealized and essentialized notions of national identity achieve some kind of power: for example, the wholesale massacres of "others," the "others" required to define the "national identity" and to function as scapegoats for the fact that the "original idyllic existence" still seems as far away as ever.

African and Asian as well as Latin American intelligentsia have negotiated these problems for a very long time and have come up with a variety of solutions, among which are Third Worldist types of internationalism (the displacement from national identity to continental identity), the controlled mixture of feudalism and advanced capitalism practiced in Japan, the displacement of the national to the racial (Negritude, for example), etc. In the second half of the 20th century, however, together with the widespread struggles for national liberation and independence, a different approach has gained strength. Although often still riddled with residues of backward-looking idealizations of what the "original" culture must have been like before the impact of Western rapaciousness, this third option refused both national chauvinism and identification with the aggressor in favor of a more complex view of social formations and their dynamics, including the fraught relationship with the West. As the Moroccan Zaghloul Morsy put it: "Whether we try to refute it, liberate ourselves from it or assent to it . . . the West is here with us as a prime fact, and ignorance or imperfect knowledge of it has a nullifying effect on all serious reflection and genuinely artistic expression" (*Main Trends in Aesthetics and the Sciences of Art*, ed. M. Dufrenne, New York, 1979, p. 40).

It is one of the contentions of these notes that the opposite holds true as well: Asian, African and Latin American cultures are with us as a fact and ignorance of them has an equally nullifying effect on all serious reflection . . . in the West. While the bourgeois nationalist intellectuals of the liberated countries talked about effecting a synthesis of East and West or of North and South in order to forge a new hegemony, militant intellectuals rejected that illusion and opted for a rhetoric of becoming: the national culture would emerge from a struggle waged by the existing people and not by the idealized figment of a ruralist fantasy. It is in this process of struggle that the intellectuals would find a role. In that context, liberation did not refer to the freeing of some previously existing but temporarily suppressed state of culture. On the contrary, political and economic liberation would be a necessary precondition for the emergence of a popular culture, a point most cogently made by Solanas when he stressed the experimen-

tal nature of Third Cinema. In each case, the specific circumstances of the country involved—its pre-colonial as well as colonial history, etc. —would determine the particular shape and dynamics of the culture once it has been freed to evolve according to its own needs and aspirations. Consequently, the question of the national became not irrelevant but secondary: the primary task was to address the existing situation in all its often contradictory and confusing intricacy with the maximum lucidity. The expression of cultural and national identity as well as personal identity would be an inevitable by-product in the sense that a discourse about and addressing particular social processes would necessarily bear the imprint of those processes in the same way that any discourse bears the imprint of those it addresses, along with the traces of the (over)determining forces that shape it. Cultural identity no longer precedes the discourse as something to be recovered; it is by trying to put an understanding of the multifarious social-historical processes at work in a given situation into discourse that the national-cultural-popular identity begins to find a voice. Tradition(s) can no longer be seen as sacred cows: some are to be criticized, others to be mobilized or inflected—an attitude exemplified by Sembene's and Cissé's work. Nationalist solidarity thus gives way to the need for critical lucidity which becomes the intellectual's special task. His/her contribution becomes the provision of a critical understanding likely to assist the struggles at hand. As Louis Althusser put it in a letter to Régis Debray: "[Intellectuals] are entrusted by the people in arms with the guardianship and extension of scientifc knowledge. They must fulfill this mission with the utmost care, following in the footsteps of Marx, who was convinced that nothing was more important for the struggles of the workers' movements and those waging those struggles than the most profound and accurate knowledge" (in Debray, *A Critique of Arms*, Penguin, 1977, p. 267).

Edward Said formulated it in this way: "The history of thought, to say nothing of political movements, is extravagantly illustrative of how the dictum 'solidarity before criticism' means the end of criticism." And he went on to say: "Even in the very midst of a battle in which one is unmistakably on one side against another, there should be criticism, because there must be critical consciousness if there are to be issues, problems, values, even lives to be fought for" (*The World, the Text, and the Critic*, London, Faber & Faber, 1984, p. 28). So although the national may indeed not be the most important issue, to skip the question of the national and slide directly towards an international aesthetic also eliminates the defining characteristics of Third Cinema itself: the aim of rendering a particular social situation

intelligible to those engaged in a struggle to change it in a socialist direction.

That the question of the national cannot be divorced from the question of Third Cinema is also evident from an example which most Third Cinema theorists tend to overlook in spite of the striking similarities presented by it: the cultural practice advocated at Santiniketan in India in the 20s and 30s. The Tagore-founded institution in Bengal developed an aesthetic on the interface between nature and culture, unifying the Janus-faced relationship of the artist to both under the terms of the "environment" and the "living tradition." It saw culture as layered into regional specificities while insisting on a critical internationalism. In Geeta Kapur's words:

> As an artist, Rabindranath's commitment to the living tradition came first and foremost through his creative choices, through his working the great range of artistic forms [. . .] as for example his use as a poet of Upanishadic verse, Baul songs and folk lullabies. At the same time he enjoined his colleagues to resist spiritual and aesthetic (as for that matter political) codification of forms on any rigid national or ethnic grounds, to open themselves out to the world art movements, thus enlivening their own practice and making it internationally viable and contemporary. (In *K. G. Subramanyan*, Lalit Kala Akademi, New Delhi, 1987, p. 17)

She added: "This after all would be the best test of a living tradition." At Santiniketan, a concerted attempt was made to organize the liberating effects of such an orientation towards the complexities of a contemporary "environment" and of vernacular vocabulary and skills into a coherent aesthetic approach which was deeply embedded in the Indian national independence movement. The political and the cultural were fused into a radical curriculum in which students at Santiniketan

> were introduced to craftsmen at work; they were encouraged to rework traditional materials and techniques and the objects produced were exhibited and sold in local fairs [an equivalent of the exhibition practices associated with Third Cinema and its screenings at informal popular gatherings as well as in student milieu and in radical institutions] with the hope of recycling the taste and skills of craftsmen-artists into the urban middle-class milieu with the young artist forming a double link. A new Indian sensibility was to be hypothesized, created, designed . . . [Popular art] inclined them to visual narratives (derived from the

great myths as well as from tribal fables), to hybrid figural icon-
ography and swift stylistic abbreviations.

(ibid, p. 18)

Summing up the pedagogic approach of Nandalal Bose, "the most
courageous artist of the nationalist period," Geeta Kapur emphasizes
that this constituted a practice of images derived from popular sources
serving political-populist purposes with a radical effect on both"
(ibid., p. 19). The dialogic relation with the popular, the stress on the
vernacular, the double reference to both the regional and the interna-
tional, the hybridization practices, the recourse to the most inexpen-
sive means of artistic production, the project of creating a new
national culture, all these features recur in the writings of the Third
Cinema polemicists. In addition, the Cuban as well as the Indian vari-
eties of this current were deeply embedded in anti-imperialist strug-
gles for national-cultural as well as political and economic autonomy.

This should not, of course, obscure the differences between Santi-
niketan and the Latin Americans, the most obvious of which are the
latter's overtly Marxist approach and the fact that the political practice
of a capital-intensive, inherently "modern" mass-media technology
such as cinema required a drastic reconceptualization of the nature of
the dialogue with the popular. Moreover, Santiniketan is not the only
antecedent of Third Cinema in this respect: the Brazilian theatrical
and literary avant-gardes of the 20s, especially those associated with
Oswald de Andrade, the Pau Brasil and the Anthropofagia manifestos,
come to mind, as do the Mexican muralists in the 30s, etc., all of
which address similar sets of tensions and contradictions. In that re-
gard, the references to Italian neo-realism and to Grierson in the mani-
festos cannot be taken at face value. They function as a symptom. The
European reference is then a symptom of the productive cultural hy-
bridization inherent in the position from which the Latin American ci-
neastes speak, rather than functioning as a designation of origins.
Finally, the absence in that context of references to Jean Rouch also
speaks volumes. Rouch is a reference for African filmmakers as op-
posed to Latin American ones, except for the rather jokey allusions in
the Brazilian comedy *Ladroes de Cinema* (1977). His absence from
the classic Third Cinema manifestos thus operates as a marker of the
marginalization of African cinemas by the Latin Americans at the
time. The argument that it might have been overlooked because of
Rouch's ethnographic rather than explicitly political discourse would
not be very convincing, since Griersonian social democracy and its
admiration for strongly centralized (but benevolent) state authority
does figure in the texts in spite of its dubious politics. Moreover,

Rouch can be seen as a most intriguing father figure for Third Cine-
ma, more so than Ivens or Marker, since it is with *Moi un noir* (1957)
that he invented an African Third Cinema style of filmmaking—and
that precisely because of the dialogic relation set up between Rouch
and his main protagonist, "Robinson" (i.e. Oumarou Ganda), which
structures the filmic process, its stylistic aspects along with its fiction
(see for example the points made by Jim Hillier in *Cahiers du Ciné-
ma*, vol. 2, London, Routledge & Kegan Paul/British Film Institute,
1986, pp. 223–25). It is significant that Rouch's film and the emer-
gence of a Third Cinema in Africa date back to the very year in which
Ghana became the first African nation-state to gain independence
from its colonizing power.

Bakhtin

For the theoretical elaboration of the interplay between utterances and
their socio-historical setting(s), the most useful inspiration available to
date is the work of Mikhail Bakhtin. In particular, his concepts of dia-
logue, otherness and the chronotope provide productive ways in which
Teshome Gabriel's pioneering work might be built upon, allowing us
to rethink the whole issue of cultural politics in the process. Although
Bakhtin does not directly address the question of the national, he is
very much concerned with the issue of socio-historical specificity. His
discussion of discursive genres outlines the way he poses the problem:

> The work is oriented, first, towards its [. . .] recipients, and to-
> wards certain conditions of performance and perception. Second,
> the work is oriented towards life, from the inside, so to speak,
> by its thematic content. [. . .] Every genre has its methods, its
> ways of seeing and understanding reality, and these methods are
> its exclusive characteristic. The artist must learn to see reality
> through the eyes of the genre. [. . .] The field of representation
> changes from genre to genre [. . .] it delineates itself differently
> as space and time. This field is always specific.
> (Quoted in T. Todorov, op. cit., pp. 82–3)

Bakhtin then goes on to make another link by defining genre as a
fragment of collective memory:

> Cultural and literary traditions [. . .] are preserved and continue
> to live, not in the subjective memory of the individual nor in
> some collective "psyche," but in the objective forms of culture
> itself. [. . .] In this sense, they are intersubjective and interindi-
> vidual, and therefore social. [. . .] The individual memory of

creative individuals almost does not come into play.
(Quoted in T. Todorov, op. cit., p. 85)

Bakhtin's translators, biographers and commentators, K. Clark and M. Holquist, emphasise the proximity of such an approach to cultural tradition to Bakhtin's concept of the chronotope:

> In each place and period a different set of time/space categories obtained, and what it meant to be human was in a large measure determined by these categories. The Greeks saw time as cyclical, for example, while the Hebrews assigned greatest value to the future.
> (*Mikhail Bakhtin*, Harvard University Press, 1984, p. 278)

The component parts of discourses/utterances are themselves "socialized":

> Within the arena of [. . .] every utterance an intense conflict between one's own and another's word is being fought out. Each word is a little arena for the clash of and criss-crossing of differently oriented social accents. A word in the mouth of a particular individual is a product of the living interaction of social forces.
> (Quoted in Clark and Holquist, op. cit., p. 220)

The reason for this is that

> No utterance can be attributed to the speaker exclusively; it is the *product of the interaction of the interlocutors*, and, broadly speaking, the product of the whole complex *social situation* in which it has occurred.
> (Quoted in T. Todorov, op. cit., p. 30, original emphases)

Bakhtin goes so far as to characterize individual utterances as corridors in which echo a multiplicity of voices, a corridor shaped by the interaction, whether direct or indirect, delayed or anticipated, between interlocutors, so that what is actively unspoken or what is simply, silently assumed, exerts as effective a determining force upon the discourse as the speaker's project. In addition to the interlocutors and to the social situation—itself alive with remembered, half-remembered, anticipated and temporarily dormant discourses—there is the echo of the generic whole that resounds in every word that functions within it. However, Bakhtin's plurivocal cultural spaces do not present some

egalitarian jostle of intersecting voices of the type that deconstructive notions of intertextuality evoke. On the contrary:

> Just as [social diversity] is constrained by the rules imposed by the single state, the diversity of discourses is fought against by the aspiration, correlative to all power, to institute a common language. [. . .] The common language is never given but in fact always ordained, and at every moment of the life of the language it is opposed to genuine heterology.
>
> (Todorov, op. cit., p. 57)

Cultural specificity is thus never a closed, static terrain; it is never a systemic whole like a code:

> Culture cannot be enclosed within itself as something ready made. The unity of a particular culture is an open unity [in which] lie immense semantic possibilities that have remained undisclosed, unrecognized, and unutilized.
>
> (*Speech Genres & Other Late Essays*, pp. 5–6)

The clear implication here is that just as there is a hierarchy imposed upon the diversity of discourses, the institutionalized exercise of power bears upon which semantic possibilities shall remain unrecognized or unutilized. In the case of cinema, this means that social power has its word to say in what kind of discourses are made as well as in how people read them. The silence of the oppressed may be an active form of resistance, a refusal. It may also be the result of a socially induced incapacity to activate certain registers of meaning, the exercise of social power having succeeded in blocking access to a number of semantic possibilities. It is important to stress this particular effect of power, since it is often overlooked by people who study the way consumers use products of the cultural industries: questions of pleasure are often emphasized at the expense of an examination of the stunting and restrictive effects of dominant discursive regimes which constantly repeat the ruling out of certain types of making sense.

Having sketched the parameters of a possible typology of the dynamics shaping cultural formations, Bakhtin makes some particularly challenging points with far-reaching implications, especially for the community-oriented populist tendencies currently dominant among left cultural practitioners in the U.K. as well as in the U.S.. In a short journalistic piece he warned:

In our enthusiasm for specification we have ignored questions of the interconnection and interdependence of various areas of culture; we have frequently forgotten that the boundaries of these areas are not absolute, that in various epochs they have been drawn in various ways; and we have not taken into account that the most intense and productive life of culture takes place on the boundaries of its individual areas and not in places where these areas have become enclosed in their own specificity.

(*Speech Genres*, p. 2)

This warning helps to explain the sterility of classic modernist positions but also, and more importantly, of attempts to enclose cultural practices within class or ethnic or gender specificities. This point is developed into a fully fledged critique of practices that advocate identification between the intellectual-artist and "the people" or any other social grouping. In the following quotation, Bakhtin refers to attempts to understand "foreign cultures," but his remarks apply with equal force and pertinence to social strata other than one's own, regardless of whether these strata are defined in terms of class, ethnicity or gender. Bakhtin wrote:

There exists a very strong, but one-sided and thus untrustworthy idea that in order better to understand a foreign culture, one must enter into it, forgetting one's own, and view the world through the eyes of this foreign culture. [. . .] Of course, the possibility of seeing the world through its eyes is a necessary part of the process of understanding it; but if this were the only aspect [. . .] it would merely be duplication and would not entail anything enriching. *Creative understanding* does not renounce itself, its own place and time, its own culture; and it forgets nothing. In order to understand, it is immensely important for the person who understands to be *located outside* the object of his or her creative understanding—in time, in space, in culture. In the realm of culture, outsideness is a most powerful factor in understanding. [. . .] We raise new questions for a foreign culture, ones that it did not raise for itself; we seek answers to our own questions in it; and the foreign culture responds to us by revealing to us its new aspects and new semantic depths. Without *one's own* questions one cannot creatively understand anything other or foreign. Such a dialogic encounter of two cultures does not result in merging or mixing. Each retains its own unity and *open* totality, but they are mutually enriched.

(*Speech Genres*, pp. 6–7)

One must be "other" oneself if anything is to be learned about the
meanings of limits, or borderlines; of the areas where "the most in-
tense and productive life of culture takes place."

Trinh T. Minh-ha, in an equally provocative introduction to a spe-
cial issue of *Discourse* (no. 8, 1986–7), echoes Bakhtin's concern
with the productivity of otherness:

> Otherness has its own laws and interdictions. [. . .] And differ-
> ence in this context undermines opposition as well as separa-
> tism. Neither a claim for special treatment, nor a return to an
> authentic core (the "unspoiled" Real Other), it acknowledges in
> each of its moves the coming together and drifting apart both
> within and between identity/ies. What is at stake is not only the
> hegemony of Western cultures, but also their identities as uni-
> fied cultures: in other words, the realization that there is a Third
> World in every First World, and vice-versa. (p. 3)

Remembering Bakhtin's point about the unequal power relations be-
tween discourses, these considerations lead us far from the post-mod-
ern or the multiculturalist free play of differences, the republican
carnival of voices, towards a politics of otherness as the precondition
for any cultural politics. If outsideness is the prerequisite for creative
understanding, it also follows that outsideness is a position as threat-
ening as it is productive. Threatening for the "insider" whose limits
become visible in ways not accessible to him/her; productive precisely
in so far as structuring limits, horizons, boundaries, become visible
and available for understanding.

If we return to the Latin American manifestos through the prism of
Bakhtin's theories, their insistence on a lucid presentation of social
forces and of reality, coupled with the pursuit of socialist aspirations,
can be seen in a somewhat different light. Viewed from this perspec-
tive, Third Cinema is a cinema neither of nor for "the people," nor is
it simply a matter of expressing opposition to imperialism or to bour-
geois rule. It is a cinema made by intellectuals who, for political and
artistic reasons at one and the same time, assume their responsibilities
as socialist intellectuals and seek to achieve through their work the
production of social intelligibility. Moreover, remembering Edward
Said's point about the need for criticism, their pursuit of the creative
understanding of particular social realities takes the form of a critical
dialogue—hence the need for both lucidity and close contact with
popular discourses and aspirations—with a people itself engaged in
bringing about social change. Theirs is not an audience in the Holly-
wood or in the televisual sense, where popularity is equated with con-

sumer satisfaction and where pleasure is measured in terms of units of the local currency entered on the balance sheet. Theirs, like Brecht's, is a fighting notion of popularity, as is clear from Solanas' insistence on Third Cinema being an experimental cinema engaged in a constant process of research. And like Brecht, the Latin Americans reserve the right to resort to any formal device they deem necessary to achieve their goals, as is clear from their refusal to straitjacket themselves into a codified Third Cinema aesthetic.

Speaking in the forms of cinema, i.e. making films, or in other genres of audiovisual discourse, thus necessarily means entering into a dialogue, not only with the historical uses of these genres—since these discourses inevitably reverberate in, for example, Third Cinema's sound-image articulations—but also with the power relations enshrined in those historical uses of dominant narrative regimes, along with the entire cultural networks within which the experiences of making and viewing are located. Third Cinema is most emphatically not simply concerned with "letting the oppressed speak with their own voices": that would be a one-sided and therefore an untrustworthy position. Those voices will only speak the experience of oppression, including the debilitating aspects of that condition. Third Cinema does not seek to induce guilt in or to solicit sympathy from its interlocutors. Instead, it addresses the issue of social power from a critical-but-committed position, articulating the joining of "the intelligence, the emotions, the powers of intuition," as Espinosa put it, so as to help achieve socialist ideals.

Because of the realization of the social nature of discourse, the Third Cinema project summons to the place of the viewer social-historical knowledges, rather than art-historical, narrowly aesthetic ones. These latter knowledges would be relevant only in so far as they form part of the particular nexus of socio-historical processes addressed.

As for Third Cinema and otherness or outsideness, it is no accident but a logical consequence that a sense of non-belonging, non-identity with the culture one inhabits, whether it be nationally defined, ethnically or in any other way, is a precondition for "the most intense and productive aspects of cultural life." Although that may be too strong a formulation since it obviously is possible to be "other" in some respects and to be "in and of" the culture at the same time, the fact remains that it is in this disjuncture, in this in-between position, that the production of social intelligibility thrives, at least as far as socialist cultural practices are concerned. The price paid for such a position is invariably the hostility of representatives of the hegemonic culture, whether these are active apologists for the ruling ideologies or merely guilty intellectuals who hope to wash away the taint of their middle-

class position by abdicating all intellectual responsibilities. But that hostility is actively to be welcomed as an indication that we are on the right track.

What is at stake, from my point of view, in the re-actualization of the Third Cinema debates in the U.K. in the 80s, is the conviction that outsideness/otherness is the only vantage point from which a viable cultural politics may be conducted in the U.K.. The negotiation of the problems involved in otherness as a positional necessity is the precondition for a critical-cultural practice in Britain, as witnessed by the work of black filmmakers who now constitute the most intellectually and cinematically innovative edge of British cultural politics, along with a few "others" such as Cinema Action (the makers of the most intelligent film about Englishness in the 80s, *Rocinante*), Mark Karlin (whose programs on Nicaragua constitute an example of Third Cinema's adaptability to televisual modes of discourse) and some filmmakers such as Pat Murphy who move between Ireland and the U.K.. While the work of these filmmakers seems to have little in common from a formal, aesthetic point of view, they nevertheless share a systematic demarcation from the genres to which they ostensibly belong: *Burning an Illusion* is as different from the prevailing social-realist dramas as *Territories* is from modernist-experimental video- and filmmaking; *Rocinante* is as different from road movie romances as *Anne Devlin* is from biographical films with strong, political heroines, etc. In each case, the difference is not generated by a surfeit of formal innovation or by the pursuit of a marketable variation on a theme, but because the prevailing generic codifications are too restrictive for the articulation of their social-analytical purposes.

Together with these filmmaking activities, theoretical-critical work also needs to address its Englishness, its parochial limits, its ethnocentricity and insularity. This requires a particular emphasis to be given to "otherness," to the dialogue with unfamiliar cultural practices and traditions, while refusing to homogenize every non-Euro-American culture into a globalized "other." The challenge to English aspirations towards universality is not to pose a counter-universality but actively to seek to learn about as well as promote other ways of making sense. When we learn how the work of Ritwik Ghatak, Kumar Shahani or Carlos Reichenbach is "specific" to the cultural formations that produced them, perhaps we will learn to see better how our homegrown theories and films bear the imprint of an incapacitatingly restrictive Englishness (Americans may substitute their own-ness where appropriate). Therefore, the notion of Third Cinema is relevant to the U.K. for its exemplification of an approach to the relations between the social and the cultural as well as for its very "otherness" in the sense of

something it is necessary both to learn from and about: to learn from Third Cinema filmmakers and intellectuals while endeavoring to make more breathing space within the U.K. for the emergence of otherness as a challenge to the English Ideology.

Consequently, my primary aim in drawing attention to the issues which the notion of Third Cinema allows me to raise is an attempt to help change the (film) culture which I inhabit by evoking a historical narrative, of sorts, which is intended to conjure up an anticipated, desirable but necessarily utopian image of what a socialist critical-cultural practice might/should be.

Note

1. A version of this essay was published in *Framework* no. 34, 1987.

Resolutions of the Third World Filmmakers Meeting Algiers, Dec. 5–14 (1973)

Cineaste (Pamphlet No. 1)

The Third World filmmakers meeting, sponsored by the National Office for Cinematographic Commerce and Industry (O.N.C.I.C.) and the cultural information center, was held in Algiers from December 5–14, 1973. The meeting brought together filmmakers from all areas of the Third World for the purpose of discussing common problems and goals and to lay the groundwork for an organization of third world filmmakers.

The filmmakers attending the conference organized themselves into separate committees to discuss the specific areas of production and distribution as well as how the filmmaker fits into the political struggle of the Third World.

The resolutions of the various committees are published here as they were released in Algiers, with only slight modifications in grammar and spelling.

Committee 1: Peoples Cinema

The Committee on Peoples Cinema—the role of cinema and filmmakers in the Third World against imperialism and neo-colonialism—consisted of the following filmmakers and observers: Fernando Birri (Argentina); Humberto Rios (Bolivia); Manuel Perez (Cuba); Jorge Silva (Colombia); Jorge Cedron (Argentina); Moussa Diakite (Republic of Guinea); Flora Gomez (Guinea-Bissau); Mohamed Abdelwahad (Morocco); El Hachmi Cherif (Algeria); Lamine Merbah (Algeria);

This document was first published by Cineaste Publishers, Inc.

Mache Khaled (Algeria); Fettar Sid Ali (Algeria); Bensalah Mohamed (Algeria); Meziani Abdelhakim (Algeria). Observers: Jan Lindquist (Sweden); Josephine (Guinea-Bissau) and Salvatore Piscicelli (Italy).

The Committee met on December 11, 12 and 13, 1973, in Algiers, under the chairmanship of Lamine Merbah. At the close of its deliberations, the Committee adopted the following analysis.

So-called "underdevelopment" is first of all an economic phenomenon which has direct repercussions on the social and cultural sectors. To analyze such a phenomenon we must refer to the dialectics of the development of capitalism on a world scale.

At a historically determined moment in its development, capitalism extended itself beyond the framework of the national European boundaries and spread—a necessary condition for its growth—to other regions of the world in which the forces of production, being only slightly developed, provided favorable ground for the expansion of capitalism through the existence of immense and virgin material resources, and available and cheap manpower reserves which constituted a new, potential market for the products of capitalist industry.

This expansion manifested itself in different regions, given the power relationships, and in different ways:

a) Through direct and total colonization implying violent invasion and the setting up of an economic and social infrastructure which does not correspond to the real needs of the people but serves more, or exclusively, the interests of the metropolitan countries;
b) In a more or less disguised manner leaving to the countries in question a pretence of autonomy;
c) Finally, through a system of domination of a new type—neo-colonialism.

The result has been that these countries undergo, on the one hand, varying degrees of development and, on the other hand, extremely varied levels of dependency with respect to imperialism: domination, influence and pressures.

The different forms of exploitation and systematic plundering of the natural resources have had grave consequences on the economic, social and cultural levels for the so-called "underdeveloped" countries, resulting in the fact that even though these countries are undergoing extremely diversified degrees of development, they face in their struggle for independence and social progress a common enemy: imperialism which stands in their way as the principal obstacle to their development.

Its consequences can be seen in:

a) The articulation of the economic sectors: imbalance of develop-
 ment on the national level with the creation of poles of economic
 attraction incompatible with the development of a proportionally
 planned national economy and with the interests of the popular
 masses, thereby giving rise to zones of artificial prosperity.
b) The imbalance on the regional and continental levels, thereby re-
 vealing the determination of imperialism to create zones of attrac-
 tion favorable for its own expansion and which are presented as
 models of development in order to retard the peoples' struggle for
 real political and economic independence.

The repercussions on the social plane are as serious as they are
numerous: they lead to characteristic impoverishment of the majority
for the benefit in the first instance of the dominating forces and the
national bourgeoisie of which one sector is objectively interested in
independent national development, while another sector is parasitic
and comprador, the interests of which are bound to those of the domi-
nating forces.

The differentiations and social inequities have seriously affected
the living standard of the people, mainly in the rural areas where the
expropriated or impoverished peasants find it impossible to reinvest
on the spot in order to subsist. Reduced in their majority to self-con-
sumption, unemployment and rural exodus, these factors lead to an in-
tensification of unemployment and increase under-employment in the
urban centers.

In order to legitimize and strengthen its hold over the economies of
the colonized and neo-colonized countries, imperialism has recourse
to a systematic enterprise of deculturation and acculturation of the
people of the Third World.

That deculturation consists of depersonalizing their peoples, of dis-
crediting their culture by presenting it as inferior and inoperative, of
blocking their specific development, and of disfiguring their history
. . . In other words, creating an actual cultural vacuum favorable to a
simultaneous process of acculturation through which the dominator
endeavors to make his domination legitimate by introducing his own
moral values, his life and thought patterns, his explanation of history:
in a word, his culture.

Imperialism, being obliged to take into account the fact that colo-
nized or dominated peoples have their own culture and defend it, infil-
trates the culture of the colonized, entertains relationships with it and
takes over those elements which it believes it can turn to its favor.
This is done by using the social forces which they make their own,
the retrogade elements of this culture. In this way, the language of the

colonized, which is the carrier of culture, becomes inferior or foreign; it is used only in the family circle or in restricted social circles. It is no longer, therefore, a vehicle for education, culture and science, because in the schools the language of the colonizer is taught, it being indispensable to know it in order to work, to subsist and to assert oneself. Gradually, it infiltrates the social and even the family relationships of the colonized. Language itself becomes a means of alienation, in that the colonized has a tendency to practice the language of the colonizer, while his own language, as well as his personality, his culture and his moral values, become foreign to him.

In the same line of thought, the social sciences, such as sociology, archaeology and ethnology, are for the most part in the service of the colonizer and the dominant class so as to perfect the work of alienation of the people through a pseudo-scientific process which has in fact simply consisted of a retrospective justification for the presence of the colonizer and therefore of the new established order.

This is how sociological studies have attempted to explain social phenomena by fatalistic determinism, foreign to the conscience and the will of man. In the ethnological field, the enterprise has consisted of rooting in the minds of the colonized prejudices of racial and original inferiority and complexes of inadequacy for the mastering of the various acquisitions of knowledge and man's production. Among the colonized people, imperialism has endeavored to play on the pseudo-racial and community differences, giving privilege to one or another ethnic grouping.

As for archaeology, its role in cultural alienation has contributed to distorting history by putting emphasis on the interests and efforts of research and the excavations of historical vestiges which justify the definite paternity of European civilization sublimated and presented as being eternally superior to other civilizations whose slightest traces have been buried.

Whereas, in certain countries, the national culture has continued to develop while at the same time being retarded by the dominant forces, in other countries, given the long period of direct domination, it has been marked by discontinuity which has blocked it in its specific development, so that all that remains are traces of it which are scarcely capable of serving as a basis for a real cultural renaissance, unless it is raised to the present level of development of national and international productive forces.

It should be stated, however, that the culture of the colonizer, while alienating the colonized peoples, does the same to the peoples of the colonizing countries who are themselves exploited by the capitalist system. Cultural alienation presents, therefore, a dual character—

national against the totality of the colonized peoples, and social against the working classes in the colonizing countries as well as in the colonized countries.

Imperialist economic, political and social domination, in order to subsist and to reinforce itself, takes root in an ideological system articulated through various channels and mainly through cinema which is in a position to influence the majority of the popular masses because its essential importance is at one and the same time artistic, aesthetic, economic and sociological, affecting to a major degree the training of the mind. Cinema, also being an industry, is subjected to the same development as material production within the capitalist system and through the very fact that the North American economy is preponderant with respect to world capitalist production, its cinema becomes preponderant as well and succeeds in invading the screens of the capitalist world and consequently those of the Third World where it contributes to hiding inequalities, referring them to that ideology which governs the world imperialist system dominated by the United States of America.

With the birth of the national liberation movement, the struggle for independence takes on a certain depth implying, on one hand, the revalorization of national cultural heritage in marking it with a dynamism made necessary by the development of contradictions. On the other hand, the contribution of progressive cultural factors borrowed from the field of universal culture.

The Role of Cinema

The role of cinema in this process consists of manufacturing films reflecting the objective conditions in which the struggling peoples are developing, i.e., films which bring about disalienation of the colonized peoples at the same time as they contribute sound and objective information for the peoples of the entire world, including the oppressed classes of the colonizing countries, and place the struggle of their peoples back in the general context of the struggle of the countries and peoples of the Third World. This requires from the militant filmmaker a dialectical analysis of the socio-historic phenomenon of colonization.

Reciprocally, cinema in the already liberated countries and in the progressive countries must accomplish, as their own national tasks, active solidarity with the peoples and filmmakers of countries still under colonial and neo-colonial domination and which are struggling for their genuine national sovereignty. The countries enjoying political independence and struggling for varied development are aware of the fact that the struggle against imperialism on the political, economic

and social levels is inseparable from its ideological content and that, consequently, action must be taken to seize from imperialism the means to influence ideologically, and forge new methods adapted in content and form to the interests of the struggle of their peoples. This implies control by the people's state of all cultural activities and, in respect to cinema, nationalization in the interest of the masses of people: production, distribution and commercialization. So as to make such a policy operative, it has been seen that the best path requires quantitative and qualitative development of national production capable, with the acquisition of films from the Third World countries and the progressive countries, of swinging the balance of the power relationship in favor of using cinema in the interest of the masses. While influencing the general environment, conditions must be created for a greater awareness on the part of the masses, for the development of their critical senses and varied participation in the cultural life of their countries.

A firm policy based on principle must be introduced in this field so as to eliminate once and for all the films which the foreign monopolies continue to impose upon us either directly or indirectly and which generate reactionary culture and, as a result, thought patterns in contradiction with the basic choices of our people.

The question, however, is not one of separating cinema from the overall cultural context which prevails in our countries, for we must consider that, on the one hand, the action of cinema is accompanied by that of other informational and cultural media, and, on the other hand, cinema operates with materials which are drawn from reality and already existing cultural forms of expression in order to function and operate. It is also necessary to be vigilant and eliminate nefarious action which the information media can have and to purify the forms of popular expression (folklore, music, theatre, etc.) and to modernize them.

The cinema language being thereby linked to other cultural forms, the development of cinema, while demanding the raising of the general cultural level, contributes to this task in an efficient way and can even become an excellent means for the polarization of the various action fields as well as cultural radiation.

Films being a social act within a historical reality, it follows that the task of the Third World filmmaker is no longer limited to the making of films but is extended to other fields of action such as: articulating, fostering and making the new films understandable to the masses of people by associating himself with the promoters of people's cinemas, clubs and itinerant film groups in their dynamic action aimed at disalienation and sensitization in favor of a cinema which satisfies the

interests of the masses, for at the same time that the struggle against imperialism and for progress develops on the economic, social and political levels, a greater and greater awareness of the masses develops, associating cinema in a more concrete way in this struggle.

In other words, the question of knowing how cinema will develop is linked in a decisive way to the solutions which must be provided to all the problems with which our peoples are confronted and which cinema must face and contribute to resolving. The task of the Third World filmmaker thereby becomes even more important and implies that the struggle waged by cinema for independence, freedom and progress must go, and already goes, hand in hand with the struggle within and without the field of cinema, but always in alliance with the popular masses for the triumph of the ideas of freedom and progress.

In these conditions, it becomes obvious that the freedom of expression and movement, the right to practice cinema and research are essential demands of the filmmakers of the Third World—freedoms and rights which they have already committed to invest in the service of the working masses against imperialism, colonialism and neo-colonialism for the general emancipation of their peoples.

United and in solidarity against American imperialism, at the head of world imperialism, and direct or indirect aggressor in Vietnam, Cambodia, Laos, Palestine, in Africa through the intermediary of NATO, SEATO and CENTO, and in Latin America, hiding itself behind the fascist coup d'etat of the Chilean military junta and the other oligarchies in power, the filmmakers present here in Algiers, certain that they express the opinion of their filmmaker comrades of the Third World, condemn the interventions, aggressions and pressures of imperialism, condemn the persecutions to which the filmmakers of certain Third World countries are subjected and demand the immediate liberation of the filmmakers detained and imprisoned and the cessation of measures restricting their freedom.

Committee 2: Production/Co-production

The Committee on Production/Co-Production, appointed by the General Assembly of the Third World Filmmakers Meeting in Algeria, met on December 11, 12 and 13, 1973, under the chairmanship of Ousmane Sembene. The Committee, which devoted itself to the problems of film production and co-production in the Third World countries, included the following filmmakers and observers: Ousmane Sembene (Senegal); Sergio Castilla (Chile); Santiago Alvarez (Cuba); Sebastien Kainba (Congo); Mamadou Sidibe (Mali); Benamar Bakhti (Algeria); Nourredine Touazi (Algeria); Hedi Ben Khelifa (Tunisia);

Mostefa Bouali (Palestine); Med Hondo (Mauritania). Observers: Simon Hartog (Great Britain), representing the British filmmakers' union, and Theo Robichet (France), Humberto Rios (Argentina) presented an information report to the Committee.

The delegates present, after reporting on the natural production and co-production conditions and the organization of the cinema industries in their countries, noted that the role of cinema in the Third World is to promote culture through films, which are a weapon as well as a means of expression for the development of the awareness of the people, and that the cinema falls within the framework of the class struggle.

Considering:

— that the problems of cinema production in the countries of the Third World are closely linked to the economic, political and social realities of each of them;
— that, consequently, cinema activity does not develop in a similar fashion:
a) in those countries which are waging a liberation struggle,
b) in those countries which have conquered their political independence and which have founded states,
c) in those countries which, while being sovereign, are struggling to seize their economic and cultural independence;
— that those countries which are waging wars of liberation lack a film infrastructure and specialized cadres and, as a result, their production is limited, achieved in difficult circumstances and very often is supported by or is dependent upon sporadic initiatives;
— that in those countries struggling for their economic and cultural independence, the principal characteristic is a private infrastructure which enables them to realize only a portion of their production within the national territory, the remainder being handled in the capitalist countries;
This leads to an appreciable loss of foreign currency and considerable delays which impede the development of an authentic national production.
— that in those countries in which the State assumes the responsibility for production and incorporates it in its cultural activity, there is, nevertheless, in a majority of cases, a lack of technical and industrial development in the cinema field and, as a consequence, production remains limited and does not manage to cover the needs for films in those countries. The national screens, therefore, are submerged with foreign productions coming, for the most part, from the capitalist countries.
— that, if we add as well the fact that world production is economically and ideologically controlled by these countries and, in

addition, is of very mediocre quality, our screens bring in an ideo-
logical product which serves the interests of the colonizers, creat-
ing moreover the habit of seeing films in which lies and social
prejudice are the choice subjects and in which these manufacturers
of individualistic ideology constantly encourage the habits of an
arbitrary and wasteful consumer society;

— that co-productions must, first and foremost, be for the countries of
the Third World, a manifestation of anti-imperialist solidarity, al-
though their characteristics may vary and cover different aspects.
We do not believe in co-productions in which an imperialist coun-
try participates, given the following risks:

1) the imperialist country can shed influence through production
 methods which are foreign to the realities of our countries,

2) the examples of co-productions have given rise to cases of profit
 and the cultural and economic exploitation of our countries.

The participants in the Committee therefore concluded that it is
necessary to seek jointly concrete means to foster the production and
co-production of national films within the Third World countries.

In line with this, a certain number of recommendations were unani-
mously adopted:

— to provide the revolutionary filmmakers of the Third World with
national cinema infrastructures;

— to put aside the conceptions and film production means of the capi-
talist countries and to seek new forms, taking into account the au-
thenticity and the realities of the economic means and possibilities
of the Third World countries;

— to develop national cinema and television agreements for the bene-
fit of the production and distribution of Third World films and to
seek such agreements where they do not exist and to exchange reg-
ular programs;

— to organize and develop the teaching of film techniques, to wel-
come the nationals of countries in which the training is not en-
sured;

— to use all the audio-visual means available for the political, eco-
nomic and cultural development of the countries of the Third
World;

— to promote co-productions with independent, revolutionary film-
makers, while leaving to each country the task of determining the
characteristics of these productions;

— to include in the governmental agreements between countries of the
Third World those measures likely to facilitate co-productions and
film exchanges;

— to influence the establishment of co-productions between national
organizations of the Third World in endeavoring to have them

accepted by the governmental and professional institutions of their respective countries (through the influence, in particular, of the acting president of the non-aligned countries, Mr. Houari Boumediene);
— to propose the need for the creation of an organization of Third World filmmakers, the permanent secretariat of which should be set up in Cuba. While awaiting the creation of this organization, the UAAV (Union of Audio-Visual Arts of Algeria) will provide a temporary secretariat.

The filmmakers will henceforth keep each other informed of their respective approaches undertaken within the framework of the FE-PACI (Pan-African Federation of Cineastes).

Committee 3: Distribution

The Committee in charge of the distribution of Third World films, after consideration of the different remarks of the members present, proposes: the creation of an office to be called the Third World Cinema Office.

It will be composed of four members including a resident coordinator and one representative per continent. The Committee, in reply to the offer made by Algeria, proposes that the permanent headquarters of the office be established in Algiers.

The goals of the office will be:

1) To coordinate efforts for the production and distribution of Third World films,
2) To establish and strengthen existing relations between Third World filmmakers and cinema industries by:
a) the editing of a permanent information bulletin (filmography, technical data sheets, etc. in four languages: Arabic, English, French and Spanish,
b) making a census of existing documentation on Third World cinema for the elaboration and distribution of a catalogue on the cinema production of the countries of the Third World,
c) fostering other festivals, film markets and film days on the Third World level, alongside the other existing events,
d) the editing of a general compilation of official cinema legislation in the Third World countries (problems of censorship, distribution of film copies, copyright, customs, etc.).
3) To take those measures required for the creation of regional and continental organization leading to the creation of a tricontinental organization for film distribution,

4) To prospect the foreign markets in order to secure other outlets for the productions of the Third World countries (commercial and non-commercial rights, TV and cassettes).

The office will approach the authorities of the OAU, the Arab League and UNESCO in order to obtain from these organizations financial assistance for its functioning. It will also approach the authorities of those countries having effective control of their cinema industries, i.e.: Algeria, Guinea, Upper Volta, Mali, Uganda, Syria and Cuba, as well as other countries which manifest a real desire to struggle against the imperialist monopoly. In addition to the above-mentioned assistance, the operating budget of the office will be composed of donations, grants and commissions on all transactions of Third World films entrusted to the office.

Europe

An Indispensable Link in the Production and Circulation of Latin American Cinema

Antonio Skármeta

In 1972, when the Popular Unity government of Salvador Allende was at its strongest in Chile, the director, Patricio Guzmán, conceived the idea for the film *The Battle of Chile*. This film was to place him in the forefront of contemporary documentary filmmakers. It was a film in which contemporary events in Chile were portrayed both by and for the benefit of its chief protagonists: the poor of the country. Yet, though the political climate was highly favorable to his project, this talented filmmaker was forced to write to Chris Marker in France in the following terms: "due to the United States' economic blockade, it could take up to a year or more for reels of blank film to get into Chile . . . that's why we were thinking of an alternative method for obtaining the film. Which means that basically we were thinking of you. . . ."

I quote from this dramatic letter to underline from the outset the undeniable paradox that it was only with the exile of Chile's talents—both novices and the established—that Chilean cinema really began to develop. Previously it had operated on a makeshift, almost candlelit basis.

In 1981, the magazine *Araucaria* published an incomplete list of 137 films which had been either directed or written by a Chilean, or which had a Chilean theme. There must be dozens more films since then that could be added to the list. According to Alicia Vega's conclusions in her *Re-vision of Chilean cinema* (1979), this rate suggests

Altaf Gauhar, ed., *Third World Affairs 1988*. London: Third World Foundation, 1988, pp. 169–172. By permission of the publisher.

that production since the 1973 coup has been double that of the pre-
vious sixty years of Chilean cinema. This is because it was only
through the exile occasioned by the coup that Chilean directors gained
access to a proper film industry. The facilities offered for short films
even to novices in Europe would have been more than sufficient to
make full-length feature films in Chile. In the early days there were
limitless resources available for attempts to reconstruct Chile's drama,
whose impact had been felt everywhere. Unfortunately, this political
need to reconstruct produced few aesthetically convincing results, ex-
cept in the case of those filmmakers who had already begun a particu-
lar work *before* their exile. These included the Chileans, Raul Ruiz
and Miguel Littín, who with *El Chacal De Nahueltoro* (The Jackal of
Nahueltoro) and *La Tierra Prometida* (The Promised Land) or *Tres
Tristes Tigres* (Three Trapped Tigers) and *Nadie Dijo Nada* (Nobody
Said Anything) had already won over international criticism before
the coup of 1973. I feel that only these two Chilean filmmakers merit
the stress being put on *filmmaker* before *Chilean*. It is true that Littín
did not abandon his favorite political themes, but he began to expand
them with a Latin American literary fantasy clearly related to Carpen-
tier and García Márquez. It is hardly surprising, therefore, that two of
his films are based on works by these masters: *La Viuda De Montiel*
(The Widow of Montiel) and *El Recurso Del Método* (The Means of
the Method). I believe that it is precisely this tendency of Littín to
mythify the everyday, to regard what is "Chilean" from a more fantas-
tic point of view, that has consolidated his name on the world scene.

By other means, Raul Ruiz has produced a body of work, notably
in France, which distinguishes him professionally. This producer with
a versatile and international output, made films in Chile that were
quintessentially Chilean in their psychology, character and language.
He has had such great success in European vanguard circles and
amongst the most sophisticated critics that in 1983 he earned the
honor of a special issue of *Cahiers du Cinéma*. In the preface to this
issue, Serge Toubiana says something strange which he accentuates in
black letters: "Suddenly each film is a labyrinth, it suggests a game
for one to lose one's way (he wants the viewer to be as great an ac-
complice and as lucid as the film), a story which unfolds infinitely, an
opacity peculiar to the fictions of the exile."

As far as I know, all other Chilean films made by exiles have been
linked thematically to the situation in Chile before and after the coup,
or to the fortunes of the exile. The latest of this latter type is *El Color
De Su Destino* (The Color of his Fate) by Jorge Durán, who lives in
Brazil.

Here lies the merit and simultaneously, the limitation, of Chilean cinema in exile: with commendable loyalty to an alternative politics of Chile, it persistently documents repression, the Church's communal work, and images of protests or of settlers organizing themselves, while it proclaims, with some degree of wishful thinking, as I see it, the imminent end of the dictatorship. So much for documentaries. As regards works of fiction, apart from a moment in the past when a film by Helvio Soto, *Llueve sobre Santiago* (Rain over Santiago) based on the last days of Chile up to and including the coup, was circulated (though it received little enthusiastic criticism), I do not believe there have been any Chilean filmmakers who have achieved recognition beyond professional cinema circles, or outside the country where they live and where their films are financed.

Films about the exile of Chileans are usually of two types. Some show a) the unwavering desire of Chileans to return to their country as soon as circumstances allow (only partly verified by reality); together with b) a lack of adaptation to the environment in which they have come to live; yet c) their despairing affirmation of their belonging to Chile through a political rhetoric aimed at the maintenance of noble ideas and utopias (which same rhetoric prevents the road towards the utopias and ideals from being passable). All this amidst (d) the meals and scenery of their surroundings.

The others prefer to center on the children's conflicts—those who went into exile as youngsters, after a few years learning the language or customs of their host country, and letting themselves be won over by its possibilities. They came into contact with the environment (in both senses of being accepted and discriminated against) and into conflict with their parents who wished their children to maintain as intense a relationship as their own with their country of origin.

The films which depart from this pattern are few and far between. The Chilean filmmaker in exile is now presented with an attractive possibility: that of being a filmmaker in exile in his own country.

In contemporary Chile there are in effect certain areas—culture among them—where there is greater freedom than in others. Some intellectuals who have been allowed to return from exile work in different fields of film production. Those not dedicated to publicity depend totally on foreign financing for their films, where institutions such as the Film Board of Canada, British television's Channel Four, and Das Kleine Fernsehspiel of West Germany play a decisive role. They commission films, without any aid from Chilean capital, whose privileged destination is television, primarily in the country which produced them, or on the cultural and less popular channels with which the producing country has an exchange or the chance of a sale.

While one cannot talk of co-production since Chile contributes almost nothing apart from the crew, the return of exiled artists, whether permanently or temporarily, is contributing towards a pool of cinematographic skill. Some European or American productions employ Chilean projectionists, cameramen and ultimately, assistant directors, who continue to accumulate projects without managing to finance them.

This situation of returning into the midst of a country which is full of contradictions is of the utmost interest. Shortly after the coup all filming activity was completely suspended. With cinema being something essentially from the streets, and with cameramen and other filmmakers having been victims of the repression, this new beginning is encouraging, but its significance is as yet uncertain. While Chile is some way away from democracy, a measure of liberalism in its cultural policies can be traced in the attitude of the government. Here we would have to specify "tolerance" towards culture, since almost all artists and intellectuals are part of the opposition. Here all the cards are on the table. Cultural works in Chile, even when the contents are not directly political, signify adherence to the fraternal and democratic values that praise the opposition and criticize the repressiveness and authoritarianism of the regime.

While some Chilean films reach the public in exile, such as Littín's *Viva El Presidente*, which attracted 30 per cent of viewers on French television, the realities of Chile, the lack of money and accumulating debts which never get paid, do not gain viewers within the country. *Los Deseos Concebidos* (Conceived Desires) by Cristián Sánchez was praised by some critics in the Berlin *Forum* as an exciting film; nobody, however, saw it in Chile. The Critics' Circle which give the awards to the best productions of the year, despite the film's impact in Europe, declared the prize void. Two films were made in Chile in 1986: *Hechos Consumados* (Accomplished Facts) by Luis Vera, an exile returned from Romania, and *Nemesio* by Cristián Sánchez. Neither of the two achieved a thousand viewers in one week of showings, and they had to be removed from the program. Only a patriotic film with plenty of support through free television propaganda, *El Último Grumete* (The Last Cabin-Boy) could achieve box-office success.

The painful truth is that Chilean films lack both a public and distributors in Chile. Even the big international successes of national cinema scare off the distributors. In the face of this evidence it can no longer be surmised that political considerations are the inhibiting factor. On the contrary, the censors have shown themselves to be particularly lenient towards films preceded by a reputation for controversy such as the Argentinian *La Historia Oficial* (The Official Version) by Puenzo. This film, which links the drama of a family with the *desapa-*

recidos ("disappeared")—a case which has its equivalent in Chile and which even today is a contentious subject for the military regime— was shown in Chile to practically empty cinemas. And for those who like to hear the full story, let us not forget that *The Official Version* won the Oscar for Best Foreign Film in 1986. The film had its premiere in Chile, and the regime was able to display its dose of liberalism. In this sense, one might point to the neutralization of viewers attained after years of the regime's total rule over television, where not even the slightest opposing argument was allowed until the visit of the Pope in 1987. This neutralization was unfortunately achieved through a cultural policy which reared television viewers on the philosophy of consumption—which unleashed a boom in the advertising trade—and on the perception of culture as "healthy entertainment." Those who view works constructed around contemporary history and its real anguish are only the students, the unwavering political youth, the cinema addicts.

Thus Chilean films from exile are seen in Chile only on artisan private videos which left-wing cultural clubs show virtually free of charge in small rooms.

One might think that the situation of these films would be different in an international context. Unfortunately, it is not. France, which has been considering for a long time how to encourage North-South dialogue in the area of culture, recognized in the person of Mitterand himself the distance between the French viewer and films from the Third World in Mexico in 1982: "Of 240 foreign films scheduled for French television in 1980, almost 200 were American—and not always the best ones—30 European and 10 films were grouped together under the pleasant heading of "various." Ten films to present an entire half of the planet: from Japan to Latin America, from Africa to Asia."

And films with a great public impact, such as *Pixote* by Babenco, an Argentinian exiled in Brazil, which was seen by up to 130,000 people after its accolade of international prizes, are anomalous within Latin American cinema, and only slightly vary the rule: Latin American cinema is not seen in Europe, except in cinema clubs and on cultural television channels in absolutely minimal and insufficient proportions. Compared with the increased exposure of Latin American writers, the filmmakers are known minimally in the aforementioned circles, little in their country of origin, and not at all in the rest of Latin America.

There are further relevant examples. Some European films with Latin American subjects, obviously in favor of democracy and strongly critical of the Chilean regime, or of regimes *like* that of Chile, are passed by the censors. The next step for these films ought

to be the finding of a cinema. With distributors being committed to in-
ternational agencies which show commercial cinema, however, they
do not see why they should risk established business and eventually
their own "health" and that of their cinemas by showing films which
confront the viewer with his own drama and where the criterion of
providing entertainment does not take first place.

With the evaporation of the euphoria over new Brazilian cinema,
from Glauber Rocha to Diegues with his successful *Bye, Bye, Brazil*,
Latin American films have acquired more reputation than substance in
Europe and the U.S.A., and their viewers, even in the case of a box-
office success, see themselves as part of a solidarity movement with
South America. Thus in Britain, according to Michael Chanan in "The
Cinema as a Reality of the Other," the cinema of Latin America al-
most always occupies a political position and one with a marginal
scope. The situation in the U.S.A. is similar, with the aggravating fac-
tor indicated by the specialist Julianne Burton in "Latin America Yes,
Hollywood No . . .": "My banishment as a critic is the result of the
fragmentation and incoherence of the left wing in my country, and on
the other hand reflects the fact that cinema production, which is my
business, is not very far-reaching." It is clearly apparent that the
viewer of this art belongs to a fixed minority political circle. Yet, this
modest outlet is virtually the Latin American filmmaker's sole resort.

South America, where its own cinema has no market (except in a
few instances in the filmmaker's country of origin), needs Europe.
That is to say, it needs its small European audience—be they critics,
viewers, television programmers—in order to survive, to consolidate
or project an image in Europe or America, since it is pointless to talk
of Africa and Asia. As regards cultural exchange, Peru is equally far
from Chile as from Cameroon. This insufficient number of viewers
and promoters of Latin American cinema, besieged by difficulties in
demonstrating to the European public a different mentality, a different
political tone (not free from pathos), different morals and fantasies,
now sees its chances threatened as television channels are privatized
with blithe liberal banality, and the public channels see the time,
space and budget for the heading "various" cut, a result of the in-
crease in conservative political strength, in which there is no lack of
the odd element of racism, nationalism and affection for an art of
leisure.

In meetings between Third World intellectuals and the warm, sup-
portive European host, the European usually asks the same question:
"What can be done?" My practical answer is always the same: Do not
propose utopian or superhuman tasks, do not be so foolish or suicidal
as to want to impose on a greater number of viewers a work of art the

keys to which are usually unclear and which tends to give the impression of being exotic. Yet do try to build on what has already been founded: build bridges across those spaces of solidarity, political awareness, cultural unease, where there is a sureness that contrast and cultural dialogue enriches man rather than endangering his cultural identity. A distribution network of South American cinema on a Pan-European level could be the first major step. However much a Greek differs from a Dane, an Englishman from a German, when these people are "over on this side," an unstoppable flow of sympathy and dialogue results. Initiatives can be created to unite municipal, private and state forces behind the establishment in various cities of cinema-rooms for the permanent showing of Third World cinema, and this idea can surely be improved upon.

Yet for me, the question "What can be done?" has a direct answer, not apparently tied in with the Third World, which however is the condition by which our presence in Europe may grow. It is this: defend the progressive and supportive places you have earned in public life; remember that the only way to keep a democracy alive is by strengthening it; resist the outbursts of the reactionaries and inspire yourselves to grow and have greater power. The fraternal gesture to the Third World and its cinema will be a natural continuation of the wider and more urgent movement in defense of the culture and democracy on which they are set.

Translated from the Spanish by Michael J. Crooks

Part 4
New Latin American
Cinema Revisited

An/Other View of New Latin American Cinema

B. Ruby Rich

Everyday events proceed now in another way. The image of revolution
has become ordinary, familiar. In some ways we're achieving transfor-
mations even more profound than earlier ones, but ones that aren't so
"apparent" now, not immediately visible to the observer. (. . .) Thus we
find it no longer sufficient just to take cameras out in the street and
capture fragments of that reality. (. . .) The filmmaker is immersed in a
complex milieu, the profound significance of which does not lie on the
surface.

<div align="right">Tomás Gutiérrez Alea, The Viewer's Dialectic[1]</div>

The critics of our movement see it with eyes that do not comprehend
what is going on in our movement. Anything that doesn't correspond to
the old formulas, they don't recognize as being genuine New Latin
American Cinema. In other words, they're trying to impose a model on
us which is alien.

<div align="right">Ruy Guerra & Fernando Birri, Park City, Utah, 1989[2]</div>

I

The films and filmmakers of the New Latin American Cinema move-
ment have in recent years become the victim of a stereotype, in that
the entire history of New Latin American Cinema has come to be
judged by the yardstick of its early classics—as though history were

IRIS, no. 13, 1991, pp. 5–27. By permission of the author.

static, as though the relationship of aesthetics to politics, once fixed, must remain in that same equation forever. Because Latin American cinema was able to penetrate North American and European consciousness and markets with its own particular style and set of concerns, the terms of that debut have continued to set the standard governing the interpretation of all the work that has followed.

In fact, the 1980s have seen a profound transformation of that history and a marked change in what the "new" New Latin American Cinema may be seen to represent, in the people who are creating it, and in the context within which its works are now being produced and exhibited.[3] Of course, history has never really been a matter of linear progress marching ever more efficiently and homogenously toward the horizon. There are refinements, reversals, denials, rebellions, leaps forward, regressions, revivals, and wholly new developments that appear to hold no echo of the past whatsoever.

Before assessing the present, a return to the past is in order. The New Latin American Cinema had a beginning far more complex than usually acknowledged and a development that has in fact been less hegemonic than perceived. The starting point is the 1950s, the post-World War II moment in our global cultural history. It is in part an anti-hegemonic moment, in that it signified a rupture both with previous balances of power and with previous modes of representation in cinema (with causes at once economic, philosophical, political, and technological). At the very least, it predated the U.S. global ascendancy that would last for some 30 years, right up to the 1980s. Significantly, this post-war period gave rise, in Italy, to neo-realism, which would cross over to Latin America in three steps.

The first crossing was made from Europe to Mexico, when Luis Buñuel went there to live and work, and ended up making, among other films, *Los olvidados*. Given its emphasis on the dispossessed, the "real" life of the Third World, on pictures not pretty enough to have made it into the movies before and a camera style fluid enough to match, the film is a portent of things to come. But Buñuel wasn't Mexican. Despite the shared language between Mexico and Spain, Buñuel's film was not aimed at evolving a national identity or a Latin American aesthetic. It was, however, a forceful announcement, in 1950, that neo-realism had arrived (though Buñuel, of course, was himself pre-neo-realist in his aesthetic strategies) and could have a role to play in Latin American cinema.

The second crossing was a roundtrip. During 1952–55, four young Latin Americans travelled to Italy to study at the legendary Centro Sperimentale (Center for Experimental Cinematography) at the University of Rome: Tomás Gutiérrez Alea, Fernando Birri, Julio García

Espinosa, and Gabriel García Márquez. When Birri returned to Argentina, he founded the Film School of Santa Fe, now legendary for the generation of filmmakers he trained there. When Tomás Gutiérrez Alea and Julio García Espinosa returned to Cuba, they collaborated on *El megano*. This first work of the new Cuban cinema was completed in 1954 and banned by Batista. In the insurgency period, Espinosa became the head of "Cine rebelde."[4] Both thus became key participants in the fashioning of a cinema that would attempt to fuse new subjects with new forms and in so doing set a standard for the New Latin American Cinema movement. Though Gabriel García Márquez, the would-be screenwriter, first turned to literature, in the past few years he has become a singular influence upon Latin American filmmaking: through his role as head of the FNCL (New Latin American Cinema Foundation) which oversees the film school established in 1986 in Cuba to train young filmmakers; through the screen adaptations of his writings and his own screenplays; and, in 1987, through the screenplays for the *Amores difíciles* series of six co-productions with Latin American or Spanish filmmakers for Spanish television, all based on García Márquez stories or ideas.

Finally, the third step illustrates that the influence of Italian neo-realism was not limited to those who physically journeyed to the mecca of Rome to study with its masters. Nelson Pereira dos Santos, back in Brazil, was part of a circle that recognized the import of this aesthetic and political strategy for Brazilian cinema. This circle was stimulated by the arrival of Alberto Cavalcanti, who exposed the young cinephiles to neo-realist cinema. Pereira dos Santos's first short film, *Juventude*, was made at the same time as Buñuel's Mexican debut (produced for the Brazilian Communist Party, it was lost when sent to a European festival) and his first feature, *Rio 40 Degrees*, built on the neo-realist example to become the founding work of *cinema novo* in 1955. Pereira dos Santos recalls:

> Without neorealism, we would have never started, and I think no country with a weak film economy could have made self-portraying films, were it not for that precedent.[5]

The influence of Italian neo-realism coincided with political shifts in Latin America: then, as now, aesthetics and politics could not be sequestered into separate arenas. In Brazil, Pereira dos Santos's stance was part of a larger position articulated through two key film industry conferences (of 1952 and 1953). The growth of a cinema defined by its national position, in turn, was made possible by the nationalistic government of Getúlio Vargas (1937–45 and 1951–54), nurtured by

the atmosphere of increasing democratization under the elected gov-
ernment of Juscelino Kubitschek in 1955, and stunted by the military
coup that overthrew João Goulart in 1964.[6] Then, the coup within a
coup of 1968 greatly eroded the cultural zones of tolerance, and led to
the emphasis in Brazilian cinema of this period upon metaphor and
symbolic allusion. The establishment of Embrafilme in Brazil in 1969,
ironically, provided an ambiguous freedom of expression for filmmak-
ers during the years of military rule: Embrafilme itself was notable for
its lack of censorship, but the produced films were frequently cen-
sored by the government.[7]

The political stage was never incidental. Fernando Birri could re-
turn to Argentina in 1956 because of the ouster of Perón; the film
school which he established upon his return could flourish in part due
to the democratic Frondizi government (which fell in 1962, the begin-
ning of Birri's long exile).

Fernando Solanas and Octavio Getino's *La hora de los hornos* has
been long acknowledged for its cinematic rupture of the preexisting
spectator/film relationship. Less acknowledged has been the explicit
political agenda that led to the creation of the third part of the trilogy
(so clearly peronist that it was largely omitted from screening after
Perón's disastrous return to power in 1973) or to Getino's service as
head of the film censorship board under Perón.

In Cuba, extraordinary films could be made not simply because of
a particularly inspired generation, but because of the massive change
in social, economic, political, and—yes—aesthetic relations caused by
the Revolution in 1959. Because of the promising conjunctural rela-
tions (and of the new cinema that might be created within a revolu-
tionary context) Fidel Castro's government, as one of its first official
acts, founded ICAIC, the Cuban Film Institute. It is no coincidence
that *La batalla de Chile* was shot during the period of Allende's presi-
dency in Chile (though finished, of course, tragically, after), nor that
Allende's brief term as president coincided with a film renaissance in
Chile as filmmakers sought to implement the ideals of his government
at an aesthetic level. After the coup of September 11, 1973, the mili-
tary immediately destroyed the university's film equipment and
banned all the films made by Chile Films in the preceding three
years.[8]

In sum, the emergence of the New Latin American Cinema cannot
be separated from the political events during the period of its "uneven
development" in the distinct regions that make up Latin America, nor
can its different direction today be separated from the political cir-
cumstances of our decade.[9] For a (North American and European)
critical perspective that tends always toward some form of auteurism,

toward a celebration of individualism and heroic genius, the funda-mentally political preconditions of cinematic achievement in Latin America may seem beside the point. But they have been very much the point throughout the history of the New Latin American Cinema movement, and continue to be today. Just as Latin American culture is a nexus between nationalism and regional coherence, and the New Latin American Cinema a crossroads of aesthetic innovation and ideo-logical motivation, so too have politically-committed filmmakers posi-tioned themselves between individualism and identification with the popular sectors.

II

The early years of the New Latin American Cinema were character-ized by a neo-realist style adapted to meet Latin American needs and realities. Objecting to the long-dominant Hollywood style of studio shooting and seamlessly composed narratives, the artists of the New Latin American Cinema immersed themselves in the opposite. Freeing the camera from its confinement and isolation, the eye of this political movement roamed the streets. Instead of the customary replication of the Hollywood studio system, nonprofessional actors replaced the stars. The preoccupations of a leisure class, and the presentation of a sanitized history, were replaced by the here-and-now, historical recla-mations, the lives of a class that had not seen itself reflected in the cinema. It was an oppositional cinema at every level, self-consciously searching out new forms for the new sentiments of a Latin American reality just being recovered. It was a cinema dedicated to decoloniali-zation, at every level including, frequently, that of cinematic language. A cinema of necessity, it was different things in different countries: in Cuba, an "imperfect cinema"; in Brazil, an "aesthetics of hunger"; in Argentina, a "third cinema."

As the films appeared on U.S. and European screens, their image was imprinted on the critics who, just discovering Latin American cinema, would name them classics. Even in the beginning, however, the New Latin American Cinema was more complex than such a uni-lateral model would indicate. In Brazil, for example, the eloquent grit-tiness of the neo-realist cinema was paralleled by the baroque mysticism of Glauber Rocha (to take just one example). In Cuba, To-más Gutiérrez Alea was to make *Memorias de subdesarrollo*, but he had also made *Las doce sillas*, a madcap comedy, six years earlier. Only one year after *La hora de los hornos* was made in Argentina, Brazilian director Joaquim Pedro de Andrade made *Macunaíma*, a film which drew on a Brazilian visionary Modernist novel to create a

film that was anti-rational, anarchistic, and fantastical in its mix of
folkloric and pop-culture iconography.

Were this not enough, consider the example of Fernando Birri. For
years, the legendary film *Tire dié* was considered the prime example
of the New Latin American Cinema movement due to its unprece-
dented portrayal of marginal life among the trash-pickers of Santa Fe
and the boys who ran along the train trestles, risking or suffering an
early death for a few pennies tossed by wealthier travellers from the
comfort of their railroad cars. Birri's reputation and the birthright of
New Latin American Cinema rested on this work. Shortly after mak-
ing *Tire dié*, however, Birri made another film: *Los inundados*.[10] The
railroad motif reappears, inverted, because this time around Birri
made a comedy—a comedy about the homeless and dispossessed. *Los
inundados* is important because it establishes an initial parallel devel-
opment internal to New Latin American Cinema that would be unac-
knowledged in the First World reception to the movement's new film
strategies and aesthetic evolutions. It testifies to the *joie de vivre* of a
cinematic movement that became more acceptable (perhaps more mar-
ketable) when it could be packaged as the testimony of victims or the
exoticism of underdevelopment.

III

Suggesting a redefinition of appropriate subject and style for the New
Latin American Cinema of today, Latin American filmmakers rightly
contend that "there is no aesthetics without politics." I would argue
that the reverse is also true: each political moment demands a specific
aesthetic strategy. The 1980s have been very different from the 1960s,
and so are the films. Current concerns and strategies are visible in a
trio of key films from the past (specifically *La negra Angustias* from
Mexico in 1949, *Los inundados* from Argentina in 1962, and *De
cierta manera* from Cuba in 1974). Each film was an anomaly, partic-
ularly since two of the filmmakers were women, a startling amend-
ment to the virtually all-male pantheon of the New Latin American
Cinema. Clearly, the project of this article is the construction of a re-
visionist history.

In 1949, the Mexican director Matilde Landeta made her second
feature film, *La negra Angustias*.[11] This was a contradictory period for
women in Mexico: the Cárdenas presidency (1934–1940) was a time
of immense progressive movement, land reform, an opening up of so-
ciety—and the denial of the vote to women, due to Cárdenas' fear that
women would represent a reactionary force and vote against him. It
would be 1953 before women obtained the right to vote in Mexico.[12]

Landeta created a film in which the daughter of a famous revolutionary is ostracized for her refusal to marry and her insistence on maintaining her manly *marimacho* attributes long past adolescence. After the death of her father, she becomes a revolutionary in her own right. Yet the film turns the codes of revolutionary cinema upside down: the scenes of heroic action turn out not to fit so naturally with a woman protagonist, and the true passion and drama of the film increasingly occur, not between revolutionary fighters and a corrupt government, but in the battles between men and women.

The film's most notable battle occurs in two parts: a would-be rapist's assault on Angustias, and her later revenge when she captures him and has him castrated (off-screen). The greatest struggle takes place, not on a battlefield, but on the field of emotions, as Angustias struggles to differentiate her role as a woman from that of a leader of men, and seeks to find a way out of the trap in which her purportedly female heart has landed her. Thus, the film's dramatic line is drawn consistently along the ground of sexuality, as Angustias seeks over and over to reconcile competing gender identities and demands.

Apart from its prescient attention to race and gender, roles and contradictions, *La negra Angustias* is unusual for its ending, which leaves Angustias strong, active, and fighting still after her momentary surrender to the subjugation of romantic love. In an era when Mexican cinema routinely relegated women to positions of subservience—if not throughout the film, then certainly in its final scenes—this was a radical break. If, as Jean Franco has suggested, films such as these (made by El Indio Fernández, et al) were key to a national agenda for a family model within which women were subservient, then Landeta's film has a landmark political importance. She laid the groundwork for the Latin American women's films of the 1980s, which began to incorporate women's struggles for identity and autonomy as a necessary part of a truly contemporary New Latin American Cinema.

In Argentina in 1962, when Fernando Birri was installed in what was in retrospect a temporary bastion, his film school of Santa Fe, he conceived *Los inundados*, mentioned above. The film's most striking feature is Birri's insistence on joy, his emphasis on the vital subjectivities that characterized the squatter colony and the family's buoyant responses to its sequence of reversals. Equally important is the film's creation of particularized characters who do not so much as stand in for "types," let alone archetypes, but rather, manifest marked identities, an expansion of individualism rather than a denial of it. With this film, Birri shifted the terms in which the downtrodden of society had been viewed, exchanging the singular term of "the people" for the third-person plural, persons, so seldom used rhetorically. In this sense,

Birri created the preconditions necessary for the attention to subjectiv-
ity characteristic of the New Latin American Cinema of the 1980s.

Moving as did Birri from documentary to fiction, but in quite a dif-
ferent context, Cuban director Sara Gómez made *De cierta manera* in
1974 (due to her death during post-production and damage to the neg-
ative, the film wasn't released until 1978).[13] The film makes its points
formally and ideologically, using documentary and fiction against
each other, interrupting its own melodrama to insert an intertitle intro-
ducing "a real person in this movie" or intercutting a social worker's
smug summations with documentary footage to delegitimate her. Its
story of a love affair between Yolanda and Mario becomes the story
of the couple's sociocultural formations and deformations in terms of
the differences between the bourgeois class and marginal class, blacks
and whites, men and women, official prescriptions and subcultural tra-
ditions—a story, in short, of unresolved contradictions. In the end,
Yolanda must learn how to deal respectfully with the children and
mothers in the "marginal" neighborhood where she's teaching, while
Mario must decide whether to expose an unregenerate friend who has
cut out of his factory job to shack up with a girlfriend, claiming to be
at his mother's hospital bedside.

Long exemplary for its formal innovations, *De cierta manera* be-
comes important, in the context of this overall history, for its chal-
lenge—posed in both psychological and experiential terms—to
ideological and sociological assumptions. Gómez systematically re-
futes Revolutionary platitudes and politically-correct analyses in favor
of depicting the full scope of life in the black and "lumpen" neighbor-
hoods she knew so well. Virtually the only woman ever to direct a
feature film in Cuba, she offers clear critiques of machismo and the
consequences of male pride.

Combining humor with documentary-like exposé, Gómez repeats
Birri's achievement in claiming the strengths of both. Focusing on
both race and gender, she follows Landeta's success in initiating a
narrative examination of both. Perhaps *De cierta manera*, in its as-
sessment of problems neither caused by nor cured by the Revolution,
but fast becoming endemic to its existence, is the first "post-Revolu-
tionary" Cuban film. In this sense, it demonstrates an early awareness
of a potential disjunction between the portrayal of the individual and
that of society, with an influential demonstration that new aesthetic al-
ternatives would have to be investigated for this trajectory to continue.

All three films—*La negra Angustias, Los inundados, De cierta
manera*—share a refusal to attribute "otherness" to subjects formerly
marked as such, accompanied by a commitment to the narrative in-
scription of an "other" selfhood, identity, and subjectivity. In this

sense, all three share a contemporaneity with our current concerns that lift them even further out of the historical moment of their making, in which, at any rate, they were so anomalous, each in its own very different national and historical context.

If the period of the early New Latin American Cinema movement was strongly identified with the reclaiming of the dispossessed and with the portrayal of the sweep of history, in both ideological and folkloric terms—and if exceptions to this tendency, like the three mentioned here, were either written out of the histories or perceived as solitary exceptions—then it is fitting that the current phase of the New Latin American Cinema should follow the lead of these films, turning away from the epic toward the chronicle, a record of a time in which no spectacular events occur but in which the extraordinary nature of the everyday is allowed to surface. Its films mark a shift from "exteriority" to "interiority." In place of the explicitly and predictably political, at the level of labor or agrarian struggles or mass mobilization, we often find an attention to the implicitly political, at the level of banality, fantasy, and desire, and a corresponding shift in aesthetic strategies. Such a shift has also, not coincidentally, opened up the field to women.

The move from exteriority to interiority holds implications for our sense of individualism and collectivity. The new films advance a reclaiming of the individual (which can hold either progressive or reactionary consequences, as the very concept and practice of individualism carries the potential for either direction). In today's New Latin American Cinema, the old phrase "the personal is political" can almost be heard, murmuring below the surface. Its expression, however, is not a privatized one at all but very much social, political, public.

The films of the New Latin American Cinema of the 1980s are engaged in the creation, in cinematic terms, of what I would term a "collective subjectivity." They are concerned, nearly obsessed, with a new form of looking inward that offers the possibility of a radical break with the past, with an approach that can put on the screen, now for the first time, the interior world of persons whose lives first reached these same screens, in their stage of struggle, more than thirty years ago.

And the reasons for such a redirection? Just as the earlier development of the movement had its roots in the political climates of the distinct nation-states that pass for a single entity under the misleading term of Latin America, and which do nevertheless have a common unity in spite of their different cultures and histories, so too do the films of the 1980s reflect the political circumstances of the continent

at the time of their making. The early 1980s were a time of sweeping change for a number of Latin American countries. In Cuba, the Mariel exodus led to changes and reassessments. In Argentina, the defeat of the military in the Malvinas led to an end of military rule and a new elected government. In Brazil, the military surrendered power through a national process instituting a constitutional government. In Uruguay, too, the years of dictatorship came to an end. And in Venezuela, the end of the oil boom shifted society from largesse to shortfall.

To be sure, the democracies that have superceded military rule in Argentina, Brazil, and Uruguay may well be pseudo-democracies, unstable and vulnerable to both military and economic pressures. Many in the hemisphere are rightly suspicious of the U.S. agenda behind the election panacea. Even more to the point, the crisis in Latin America today is more apt to center on the economic than the governmental, as the foreign debt becomes a sinister updated name for imperialism. Even so, the 1980s were indisputably different from the 1960s, and filmmakers—even those veterans who continued to work and produce films throughout this brief history of the New Latin American Cinema —demonstrated in their narrative strategies that they knew the difference.

IV

When a dictatorship falls, the people become great devourers of culture. They need to exorcise the horror.

Beatriz Guido[14]

As political frameworks change, from anti-fascist to post-fascist, for example, an oppositional cinema inherits the same obligation to change as do the oppositional parties in the electoral sector. In this new environment, a cinema which turns inward and which begins to enable viewers to construct an alternate relationship—not only with their government but with an authentic sense of self—is an indispensable element in the evolution of a new sociopolitical environment. Slogans, pamphlets, and organizing have been key to political change: character, identity, empathy, and, most importantly, a sense of personal agency, now are of equal importance to political evolution.

It could perhaps be argued that the democratic (or pseudo-democratic) process has itself become the foremost aesthetic influence on contemporary New Latin American Cinema, given its shift in emphasis from the "revolutionary" to the "revelatory." Just as oppositional political action demanded one kind of cinema, so does the individual's open participation in a newly-legitimatized form of government de-

mand another. To quote a young Brazilian critic, Joao Carlos Velho, from the *Jornal do Brasil:* the "aesthetics of hunger" of *cinema novo* has given way to a "hunger for aesthetics."[15] Similarly, an Argentine actress at the women's symposium of the International Festival of New Latin American Cinema in Havana in 1986 told of the explosion of new body workshops and body-therapy classes then taking place, as people tried to discharge the years of repression literally, physically, from their bodies. In this same period, an article appeared in the *New York Times* detailing the therapy methods being employed to ease the pain of the children of the disappeared, concluding that the most effective therapeutic intervention thus far had been the coming of democracy, because it allowed the telling of secrets necessary to drain the political—and emotional—wounds.

The telling of secrets is an important theme in recent works of the New Latin American Cinema. In Argentina in 1987, the young filmmaker Carlos Echeverría used the documentary form to try to dig up secrets that were no longer welcome in a society more intent on creating a picture of so-called normalization. His *Juan: Como si nada hubiera sucedido* set out to investigate the case of one disappeared youth. In the film, a young radio journalist, alter ego to the disappeared youth, fronts for the filmmaker as they journey through Argentine society like the most dogged of detectives, interviewing on camera all the surviving principals of the original scenario. The film's grim lesson is that secrets are only liberating to the extent that they imply some action, to the extent that they are examined and not just buried once again. In this film, however, there is no happy ending, no "truth" to be uncovered, only a persistent trail of deception and subterfuge leading up to the *punto final* ruling that ensured future immunity for the military.

Similarly, Eduardo Coutinho's *Twenty Years After* (*Cabra Marcado Para morrer*, 1984) could not function without the telling of a major secret: the identity of a legendary figure in the history of labor struggles (the widow of a martyred union leader who has been in hiding under an assumed identity for twenty years), whom Coutinho and his camera crew track down. Coutinho pushes his unearthing of secrets from the publically political to the familial, finally tracking down her children and investigating the emotional consequences of the military repression that fractured the family. The film was the hit of the first Rio film festival in 1984, and was awarded a standing ovation just at the moment of the transition to democracy. Significantly, Coutinho makes the telling of private secrets as important as the public ones and, in so doing, reflects the increased emphasis on the personal

that is so central a feature of the current wave of New Latin American Cinema.

Raúl Tosso's *Gerónima* mixes documentary with fiction to expose another kind of secret: the survival of Indians despite the official proclamation in Argentina of their extinction. By describing in visceral detail the incarceration and interrogation of Gerónima and her children in a hospital for the singular sin of living a non-assimilationist life marked by Indian customs, Tosso makes his point that ethnocide is as bad as genocide. He inscribes the private as a sphere of struggle, particularly since all that is meant by "cultural" is sequestered within the unstable receptacle of individual identity. The point is made particularly chilling by two aspects of the film: first, the role of Gerónima Sande is played by an actress who is herself a member and activist of the same tribe (the Mapuches) to which Gerónima belonged: and second, the soundtrack is composed predominantly of Gerónima's voice, taped during her interrogation sessions by the hospital personnel. Here, then, psychic alienation is equated with, and leads to, death.

The uncovering of secrets in these films is one aspect of the move toward "interiority," but it is carried further away from the concrete and into the imaginary by the fiction films of the decade. In the recent Busi Cortés feature, *El secreto de Romelia*, the secret turns out to be a quintessentially feminine one: virginity itself. Based on a Rosario Castelanos story, the film charts the costly collision (for the woman, of course) between the cult of female virginity and the cult of male honor. Cortés demonstrates to what extent women filmmakers can rework/imagine even the classic scenarios of family, purity, and revenge.

It is in the arena of fiction that the influence of women directors and feminist ideas regarding behavior, gesture, and pacing, is most pronounced. Interiority in this sense is not a retreat from society, but an altered formal engagement. New social orders mandate a narrative cinema that constructs a new spectator, both through deploying processes of identification and through the structuring of new formal strategies; while the first has been more widespread than the second, both may be found represented in the New Latin American Cinema of the 1980s.

From this perspective, Suzana Amaral's *Hora da estrela* is a key work (see the interview with Amaral by the editor in volume 2). Her subject may be classically oppositional (story of a downtrodden Northeasterner who comes to the big city and has the life smashed out of her) but her treatment owes nothing to historical or sociological perspectives:

> What's important is what's behind people, the interior life (. . .)
> The facts may be important, but what's more important is
> what's behind the facts. (. . .) My film shows that poor people
> also have fantasies, that they, too, dream and want to be stars.[16]

Her central character in the film, Macabea, is a regendered update
and revision of the above-mentioned *Macunaíma:* her inchoate self
becomes both a metaphor and a concrete representation of Brazil. For
Macabea isn't just an anti-hero, she's virtually an anti-character in a
film that Amaral has termed "anti-melodrama." Macabea has a terrible
job that she performs terribly; marginal or exploitative relationships
with her co-workers, roommates, and boyfriend; a terror, awe, attrac-
tion and repulsion of/to men; and a fearsome faith in the detritus of
modern consumer culture.

Amaral explicitly critiques the role of mass culture in the lives of
the disenfranchised, showing, for example, the rush of Macabea and
her roommates to watch the daily *telenovela* through the window of a
neighbor's adjoining apartment. Similarly, she represents the reality of
lumpen consciousness through its mass-media determinant: Radio Re-
loj, a station that constantly broadcasts meaningless information which
Macabea, its devoted listener, repeats throughout the film. Amaral
uses the film's ending (Macabea's hallucination of herself at the mo-
ment of her death—as a *telenovela* heroine) to summarize the effects
of underdevelopment, neocolonialism, and the mass media. Macabea
embraces this pop-culture fantasy as her last will and desire, but be-
cause of its very origins, such a fantasy can be nothing other than ob-
scene . . . and fatal.

One scene in the film signifies most unambiguously the distance
travelled emotionally and ideologically from the early years to the
present: it is the one in which Macabea orchestrates a moment alone
in her room, illicitly, during the day. Locking herself in, she turns up
her beloved radio, swings the sheet off her bed, and begins to dance
around the room. It is her first moment of solitude, probably unlikely
to recur for a hundred years, and it's represented with all the desperate
urgency of a commodity. It is also Macabea's first moment of experi-
encing the self, the person who had never had the luxury of taking
shape before. In her alternation between feeling and seeing (herself in
the mirror), listening and luxuriating, she presents the audience with a
scene of victory every bit as glorious, as liberating in its implications,
as heroic in its triumph, as those reflected in the films of the 1960s.
This moment of self-identification and self-definition, in a space that
feels at first like a vacuum for its removal from the domain of pseudo-
information that has permeated Macabea's environment, is emblematic

of the new cinematic direction that is becoming so marked, yet still so unremarked by First World critics or audiences.

Other films made by Latin American women directors in the 1980s further strengthen the case for seeing emotional life as a site of struggle and identity equal to those more traditional sites by which the New Latin American Cinema was once, and continues to be, defined. Tizuka Yamasaki is an interesting case in point, for her *Patriamada* (1985) tries mixing documentary with fiction to get at the emotions behind events.[17] Filming at the time that all of Brazil was debating its transition to a civilian government, Yamasaki took three actors along on all her shoots of mass public events and historic meetings, and managed to insert her own melodrama into the proceedings. Her film, which illustrates just how contradictory the codes of fiction and documentary can be from one another, insists upon the equality of private and public, man and woman, the sexual and the political. Taking this insistence to the extreme, the film posits the planning of a baby and the planning of a government as mutually metaphoric.

Thus, it may be no accident that Maria Luisa Bemberg was filming *Camila* as democracy came to Argentina in mid-shoot. *Camila* pointedly redefined the site of political struggle as the sexual, in her interpretation of the famous story of an aristocratic young woman and a priest, whose love affair presented the ultimate challenge to the repressive patriarchalism of their day and whose ultimate murder proved the equation between sexuality and liberation inherent in the narrative. By seeing the sexual struggle as one on an equal plane with other kinds of ideological struggle, Bemberg was able to include women in the ranks of heroes and freedom-fighters without falling prey to the contradictions with which the character of Angustias, years earlier, in Mexico, had to contend. In this case, the radical shift in the area of inquiry was not accompanied by a parallel formal shift but rather by a dedication to creating seamless art cinema (lush, transparent, and perfect periodicity) in the service of a new idea.

Similarly, Bemberg's *Miss Mary* (1986) situated rebellion in the realm of sexuality, both for the children of the aristocrats that a governess (played by Julie Christie) is brought to oversee and for the repressed British governess herself. The plot concerns the self-realization of the governess and the coming of age of her charges, set within the world of wealthy Anglophile Argentines on the eve of World War II. The elaboration of the girls' sexual identity and the patriarchal modes of its repression are explicitly made parallel to the rise of peronism by Bemberg's intercutting of archival footage in the midst of otherwise flawless art-direction. For Bemberg, women are the

lynchpin in the ongoing battle between repression and liberation, a battle which she views atomistically as launched inside the family to explode throughout society. In this film, then, menstruation is trauma, sexual acts involve psychic risk, and peronism is built in the bedrooms of the nation.

In Mexico at a time when there was as yet no sign on the horizon of any fracture in the endless fortification of PRI, the party seemingly sworn to rule the country forever, Paul Leduc fractured cinematic traditions with *Frida* (1985). The film emerged from this very traditional national filmmaking tradition to call into question its comfortable assumptions, both cinematic and ideological. Leduc's film was inspired by the life of Frida Kahlo, an artist whose reputation today is an accurate index of the difference made by recent feminist scholarship and the reevaluation of art-history hierarchies. This difference, precisely that between the public and private, parallels exactly the shift being described herein from the early days of the New Latin American Cinema movement to the present and is echoed interestingly by Leduc's own evolution from the public canvas of *Reed: México insurgente* (1971) to the private one of *Frida*.

Frida Kahlo is now known for a variety of reasons: revered painter, wife of Diego Rivera, victim of physical disabilities caused by accident, intimate of Leon Trotsky, supporter of the Communist Party, wearer of Indian costume, collector of folk art, lover of her own sex. Leduc chose to eschew none of this and to subordinate no one part to the demands of the other. He followed the lead taken by so many historians of submerged "others" and relied, not on the obfuscating texts but, rather, on what he termed "the history of gossip" to compose the details of her life. Even more radically, he chose to reprise Kahlo's commitment to the visual, basing his film in image, color, gesture, and sensuality instead of the relentless dialogue more common to Mexican cinema.

Probably the most formally daring of the recent films here enumerated, *Frida* as a project carries a particular ideological importance as well. Kahlo's paintings were long ignored or undervalued precisely because they represented woman, the body, a gendered pain, a psychic split. At a time when politically-correct art pictured workers (not braces or babies) and when the acceptable scale was massive and public (that is, murals) not small and enclosed, the paintings of Frida Kahlo were doomed to be dismissed as an eccentric avocation, the irrelevant pastime of an otherwise politically-committed person who, alas, was born female. Given the evolution from exteriority to interiority that this article seeks to describe, Paul Leduc could hardly have

chosen a more relevant subject. He is aware of the implications of his choice: "Frida was closed up in her body, in her house, in her studio. In the midst of all these *noises* of her time (the politics, the demonstrations, in which she also took part), there was her expressive silence. Of images."[18] By according Frida Kahlo's journey inward a place in history equal to that of John Reed's journey outward, Leduc cast his hat into the ring of a bold revisionism committed to replacing the epic with the chronicle and to synthesizing a new sense of pleasure with the pain that has been present all along.

Jorge Toledo's *Vera*, made in Brazil later (1987) in the democratization process than Bemberg's films, fits well onto the trajectory pioneered by Leduc since it carries the examination of sexual identity as political act even further. Taking as its starting point the release of a young woman from an orphanage/reform school, Toledo's film traces Vera's life backwards and forwards as she attempts to unravel her particular riddle of gender and reinvent herself, literally, as a man. Her ambition survives the sadistic prison administrator's attempt to humiliate her and her kind: "I'm concerned about this butch-girl business. . . . Okay, you're so butch, let's see your pricks." He tries to topple the standards by setting up dances with a brother institution, importing real boys to dance with the femmes. Meanwhile, the girls discuss among themselves the ambiguity of life outside the joint, where guaranteed butch-girls have been known to get knocked up.

In her total isolation, self-invention, alienation, and hopelessness, the character of Vera (based in part upon an actual woman who came out of a similar joint, wrote poetry and the story of her life, and killed herself) has much in common with the everywoman figure of Macabea. Taking anti-hero as heroine, Toledo anchors his tragedy in the details of gender identity and sexual structuring. It is a drama that is specifically, achingly, female. It is a drama that is concerned most fundamentally, not with action, but with language itself: at the keyboard of the word processor, Vera meets a defeat as total as she met in the bed. Yet, nonetheless, Toledo never quite abandons metaphor, the possibility that Vera represents not only a woman, not exactly a lesbian, not just a woman who wants to be a man, but perhaps Brazil itself—the country that emerged so recently from prison, unsure of its identity, formed and deformed by its captivity, cast so adrift in the land of object-choice that its own desires are opaque, unspoken, transgressive but unattainable. *Vera* orchestrates its erotic tension so successfully that finally the struggle for gender definition seems to the viewer as worthy of respect as any other fight in the Latin American struggle for self-determination.

V

We fought for the people to have a right to education, a right to hous-
ing, a right to food, but forgot that people also have el derecho a la
alegria, the right to joy.

Ruy Guerra[19]

If Paul Leduc can be seen to have made a film that is nearly the oppo-
site of the one that first established him in the canon of the New Latin
American Cinema, how much more so Fernando E. Solanas, *auteur* of
the classic of Third World revolutionary theory, *La hora de los hor-
nos*, who went on to make, of all things, musicals: *Tangos: El exilio
de Gardel* (1985) and the recent *Sur* (1987). In *Sur*, as in Toledo's
film, prison plays a central role. This time, however, in a thematic
strategy that would seem to invert Solanas' early tenets, he posits as
the central drama not the released man's political re-engagement but
how and whether he'll be able to reclaim his emotional life by forgiv-
ing his wife her infidelity during his years in jail. It is the private life
which is assigned priority; now the emotions demand as much com-
mitment, engagement, and action, as events did a few decades earlier.

Solanas thus takes the notion of interiority and transforms it into an
aesthetic. The urban landscape of Buenos Aires is made artificial, its
streets a cityscape of the soul, a theatrical space in which memories
and longings can be enacted. The film's drama is an interior one made
exterior, as the protagonist passes his long first night of freedom de-
bating the figures of his imagination on street corners suffused with
the mysterious smoke and fog of memory.

After years of exile, Solanas was able to return at last to Argentina
to continue his filmmaking. Back at the time of *La hora de los hor-
nos*, it would have been the spirit of Che or Perón that presided over
Argentina. Now, with *Sur*, it is the spirit of Carlos Gardel—redolent
of nostalgia, romance, feeling—that Solanas chooses to enshrine. The
time in jail was matched to the political activity that preceded it: the
future is tied to acts of emotional restoration that can activate the feel-
ings shut down during years of military rule.

Ruy Guerra, the Brazilian director who like Solanas is identified
with the early golden age of New Latin American Cinema and in his
case specifically the foundations of *cinema novo*, also returned from
long exile to make a musical. His *Opera do Malandro* mixes romance
and rebellion, this time in the unlikely setting of Brecht's *Threepenny
Opera*, rescripted for the underworld of Rio on the eve of World War
II and rescored by Chico Buarque. Ruy Guerra defends his move from
post-neo-realism to musical: "opera is a political form." The late Man-
uel Octavio Gómez would agree. His penultimate film, and Cuba's

first musical, *Patakín*, paid homage to the subcultural powers of *san-
tería* with ritual characters who acted out the oldest struggles of all:
man versus woman, good versus bad, industry versus sloth, all coded
to signify commentary on the state of the Cuban revolution in the
1980s.

The contemporary search for the meaning of pleasure and the plea-
sure of meaning in a post-fascist or post-revolutionary or post-eco-
nomic boom society reaches a suggestive apotheosis in *Best Wishes*, a
recent film by Brazilian director Teresa Trautman. Here, numerous
themes already activated by other Latin American directors take an
even more surprising form than the recycling of the musical: melodra-
ma, nearly soap opera, reclaimed. Like many of her fellow filmmak-
ers, Trautman concerns herself with the telling of secrets, the breaking
of prohibition, the speaking of the unspeakable. Like fellow Brazilian
Toledo, she situates sexual construction at the center of political life.

Best Wishes takes a formulaic pace and structure—an aristocratic
family gathering at its summer estate for one last weekend before
mother sells it off, complete with a long cathartic night in which se-
crets are revealed and couples realigned—and sneaks ideological
meaning into the mix. She makes explicit her insistence upon chal-
lenging the old order of political priorities with a new gender agenda
which combines a transgressively female comic sense with an epi-
phanic revelation that disrupts the previous patriarchal order. The
film's central family is dedicated to the memory of its favorite son, a
desaparecido who vanished during the years of military rule. When
the daughter of the lifelong family groundskeeper, drunk and panicked
over where she and her aged father and adolescent daughter will live
after this last night, finally reveals the identity of her daughter's father
—he turns out to be this very same beloved son, who had raped her,
those many years ago. This is dangerous stuff, mixing political mes-
sages into the genre of sex comedy, but it suggests how far the New
Latin American Cinema has come in reconsidering its own issues and
history from new perspectives.

Certainly the presence of women directors where almost none had
ever tread is a factor in this reconsideration. If *Best Wishes* took the
figure of the *desaparecido* and insisted on a revision of his idealiza-
tion from a gendered perspective, then a recent dramatic documentary
can be seen to take a related step—the gendering of assassination and
torture, through the testimony of women survivors.

In *Que Bom Te Ver Viva* (1989), Brazilian director Lúcia Murat
focuses upon a figure that must itself embody a contradiction in the
Latin American context: the figure (in the sense of the representative
as well as the body itself) of the woman guerilla fighter who survives

martyrdom to speak.[20] And speak she does, as the director interviews a number of women, former militants in the armed struggle against the military dictatorship, who'd been captured, jailed, tortured, and managed to survive "without going crazy." The documentary mixes direct interview footage, usually conducted on videotape, with footage of the women contextualized within their daily lives, older footage of their lives in the period of the dictatorship (sometimes limited to newspaper headlines of their capture), home movies of one of the women in jail, and the women's reflections both on that period and on contemporary attitudes toward them in post-military Brazil.

Ironically, this explicit attempt to write gender into the survival narratives is the one that fails: the use of an actress to address the camera which is variously, torturer, lover, friend, or audience, and to speak the unspoken. The unspoken turns out to be, as one survivor puts it during her interview, not the mechanics of torture, which are by now so well known, but rather the emotional mechanics of surviv- al, the literal subjectivity of the tortured. It is the riskier testimony of love, sex, intimacy, and social nicety that director Murat, in a gesture no doubt of emotional identification with her subjects, puts into the mouth of a well-known actress to present to the audience, thereby avoiding the added disapproval that would have met such pronounce- ments by any non-fictional woman.

Perhaps it is the acting style (overwrought, stagey, arch-ironic) that dooms the strategy, but it is just as likely that the very taboos that Murat sought to bypass return nonetheless to sabotage the detour. For if the figure of the woman fighter is always, in patriarchal societies, an oxymoron, then the fact of any woman's survival (not, Tania-style, her martyrdom) becomes a triple contradiction when she is converted into the mother and, in fact, bases her claim to sanity and survival upon that same motherhood. As Murat tries to demolish the very con- structions of myth that have been the habitual last resort of reaction to such figures, she occasionally founders. Nevertheless, the testimony of her subjects speaking almost transparently to the audience across a wide range of devices of attempted distanciation moves the viewer with long-dormant inspiration. *Que Bom Te Ver Viva* re-genders the *guerrillera* and, in the process, poses a series of retroactive questions to the historical construction of the male hero.

VI

An idea about the cinema that reigned when we began on this road is today dead. (. . .) We need to look collectively toward the future. As cinema becomes an extinct dinosaur, lizards and salamanders appear

that survive the catastrophe. Today, facing reconversion and crisis, the response must be to include the species. It must derive from collective action and solidarity. (. . .) We have a lot to do. To survive. Yes. To survive not only as filmmakers or videomakers, but as cultures, as exemplars of national dignity.

Paul Leduc[21]

In the 1980s, national debt is the biggest problem. (. . .) It would seem we've gone backwards, as though we haven't made any progress. It may seem that the 1960s were radical, and the 1980s regressive. (. . .) The danger now is an attempt to make a "more perfect" cinema to try to attract a public. Its a danger because politics cannot regress, but cinema can.

Julio García Espinosa[22]

The conference in Bellagio which occasioned this paper had hardly begun before we participants were spending our spare time, huddled in the library, trying to translate from the Italian papers the news of the food riots that had broken out in Venezuela. In Venezuela! It shattered all the fondest stereotypes of Latin American stability. So much for the vaunted promise of democracy, when faced with the international pincers of economic shortfall and IMF negotiations. Notions of self-determination had already been crushed, anyway, with PRI's theft of the Mexican election just months before. Soon after the Venezuela debacle, Brazil witnessed the murder of Chico Mendes and the intensification of the Amazon crisis, Cuba underwent the disaster of the Ochoa revelations (and the ongoing, equally serious, challenge of its government's seige-like response to *perestroika* and *glasnost*), and Argentina suffered its own food riots, an unimaginable inflation rate, and the election of Menem, its contemporary peronist president. The last year of the decade turned out to be a costly one for the continent. Within each country, the economics confronting film production are disastrous: local markets that can no longer return the investment necessary for late-1980s budgets, plans that require international stars and co-production money to get off the ground, movie theaters that are closing down by the hundreds as a combination of videocassette distribution and operating costs make them unprofitable.

The 1980s were a time for optimism regarding the revision and reinvention of the New Latin American Cinema in a contemporary guise. The breaking of taboo and prohibition, the freeing of the imagination to fantasy, a respect for the mundane and everyday, the introduction of humor and music, the construction of new narrative strategies, and the reconsideration of the relationship to the audience,

have all contributed to what I've identified as the monumental task of forging a new "collective subjectivity." While I've chosen to interpret these tendencies optimistically, I could also make another point about the less salutary effects of a certain kind of individualism at the level of *auteur*.

In tracing the kind of strategies that have become necessary in the wake of the declining film economies of Latin America and the loss of self-sufficiency they have brought about, I would identify as significant the recent alliance between a traditional, essentially conservative, form of authorship and a traditional, international form of co-production. The *Amores difíciles* was a series, mentioned earlier, based upon ideas or scripts by Gabriel García Márquez, utilizing the talents of notable Latin American or Spanish filmmakers, and produced by and for Spanish television. The deal, jokingly referred to as the "return of the conquistadors,"[23] got terrific ratings on its Spanish broadcast, and has won limited festival inclusion as well as theatrical, public television and video release.

Some of the films are excellent, but there are numerous problems with the series, not least of which is the absence of a single woman director in the line-up of filmmakers.[24] The very real danger of such a series is that it tends to remove any political specificity from the works that comprise it. Packaged as a Gabriel García Márquez commodity, it falls easily into the co-production pattern: the novelist is just slotted into the attraction slot in place of a famous actor. Just so are the qualities of individual national cinemas subordinated to the creation of a homogenous product, one that often (and predictably, given its *raison d'etre*) valorizes the novelistic qualities of cinema by valuing the screenplay over all other elements. Obscuring questions of intentionality and urgency, *Amores difíciles* sells itself as a product on the marketable *don Gabo*. Meanwhile, the dependence of the entire package upon García Márquez's participation gives him inordinate control over the contracting of principals and the handling of the treatments.[25]

The threat of such packaging under the sign of a single personality is that, should its success and the concomitant lack of financial alternatives lead to a proliferation, the New Latin American Cinema could enter a baroque phase: historical subjects would no longer be chosen for their particular ideological implications for a particular country at this juncture, contemporary fictional themes would no longer arise out of the specificity of an identifiable set of national circumstances, documentary would be decisively marginalized and no longer inhabit any place at all, and the very real heterogeneity that has always made "Latin America" itself such a near-fictional construct would vanish

under the homogeneity of brand-name magic realism flying a multinational banner.[26] Still, given economic forces arrayed against cinema (and life itself, sheer survival) in most of Latin America, it is not surprising that most filmmakers are grateful that Gabriel García Márquez is committed to film production and that Spanish television has seen fit to bankroll his film ideas. With Spanish television recently poised to expand this entry into a large-scale agenda of co-productions, similar fears regarding the influence of such European input must again be weighed against the necessity for just such marketing and financing strategies if the New Latin American Cinema is to survive to the turn of the century (at least Spanish money doesn't demand English as the production language).

Meanwhile, the influence of the political and economic situation in each Latin American country continues to affect its cinema far more forcefully and decisively than any co-production deal could ever dream of. In Argentina, on the eve of Menem's election, not a single film was in production thanks to the hyper-inflation ravaging the economy. In Chile, on the other hand, in the wake of the "no" vote in favor of ending Pinochet's reign, the strength of its recent cinema is starting to attract notice at film festivals internationally. The school established by Birri and García Márquez in Cuba already has its own victories and problems, its own student insurrections, and the energy of a new generation of filmmakers from throughout Latin America.

Such a constantly evolving situation demands an improvisational rigor from Latin American filmmakers, but equally demands that critics and audiences outside of Latin America give up their attachment to outmoded scales of value in assessing the cinemas that emerge from such conditions. *La lucha continúa*, the struggle continues, but the site of the battle and the choice of weapons changes by the decade. The New Latin American Cinema is dead, long live the New Latin American Cinema.

Notes

This essay was commissioned for the conference "High Culture/Popular Culture: Media Representation of the Other" held at the Rockefeller Foundation's Bellagio Study and Conference Center in Bellagio, Italy, February 27 to March 4, 1989. The proceedings of the conference will be published in the forthcoming book *Other Representations: Cross-Cultural Media Theory*, ed. by John G. Hanhardt and Steven D. Levine.

The original inspiration for the essay was the massive retrospective, "The Winds of Change," organized by the Toronto Festival of Festivals in September 1986, and the women's symposium at the International Festival of New Latin American Cinema in Havana, December 1986. A preliminary version

appeared as "After the Revolutions: The New New Latin American Cinema," in the *Village Voice*, February 10, 1987.

My thanks to my fellow participants in the Bellagio conference for their responses to the version of this paper delivered there from notes, in particular to Tomás Gutiérrez Alea, Julio García Espinosa, Nelson Pereira dos Santos, Jean Franco, Juan Downey, Trinh T. Minh-ha and Lourdes Portillo. Thanks to Paul Lenti for his subsequent careful reading and helpful suggestions. Finally, thanks to Norma Iglesias Prieto, co-organizer of the conference "Cruzando Fronteras/Crossing Borders," held in November 1990 at the Colegio de la Frontera Norte in Tijuana, Mexico, for creating a forum for this work there; and to my co-participants, especially Rosa Linda Fregoso, Sonia Fritz, Carmen Huaco-Nuzum, Lillian Jímenez, Lillian Liberman and Patricia Vega, for their support and encouragement.

1. Tomás Gutiérrez Alea, "The Viewer's Dialectic" in *Reviewing Histories: Selections From the New Latin American Cinema*, ed. Coco Fusco (Buffalo, NY: Hallwalls, 1987), p. 179.

2. Panel on New Latin American Cinema, moderated by author, U.S. Film Festival, Park City, Utah, January 26, 1989.

3. Recent writing has begun to take note of this evolution. See, for example: the special "Nuevo Cine Latinoamericano" issue of *Areito* (ed. Lisa Davis and Sonia Rivera), Volume X No. 37, 1984; Pat Aufderheide, "Awake Argentina," *Film Comment*, April 1986, ps. 51–55, and "Cultural Democracy: Non-Commercial Film Distribution in Latin America," *Afterimage*, November 1986, p. 12 ff; Julianne Burton, *Cinema and Social Change in Latin America: Conversations with Filmmakers* (Austin: University of Texas Press, 1986); my own "New Argentine Cinema" essay in the U.S. Film Festival catalogue, Park City, Utah, 1988; and most recently, *Latin American Visions* (ed. Pat Aufderheide and Lois Fishman), catalogue commissioned for the Latin American Visions retrospective organized by Linda Blackaby and Beatriz Vieira of the Neighborhood Film/Video Project of International House, Philadelphia.

4. Julianne Burton, *Cinema and Social Change in Latin America*, chapters 9 and 19.

5. Luis Elbert, "Neorealism," in *Latin American Visions*, p. 27.

6. Randal Johnson, *Cinema Novo X 5* (Austin: University of Texas Press, 1984), p. 2.

7. For descriptions of this period, see Guillermo Zapiola, "Cinema Under Dictatorship" in *Latin American Visions*, ps. 38–39 and Richard Peña, "The Legacy of Cinema Novo: An Interview With Nelson Pereira Dos Santos" in *Reviewing Histories: Selections From New Latin American Cinema*, ps. 51–52.

8. E. Bradford Burns, *Latin American Cinema* (L.A.: UCLA Latin American Center, 1975), p. 27.

9. Similarly, the development of Latin American Cinema in the post-war period cannot be separated from the U.S. embargo of Argentina during World War II, part of then Secretary of State Cornell Hull's overall agenda for overthrowing the Argentine government. In 1942, allegedly punishing Argentina

for its neutrality in the war, the U.S. placed an embargo on the shipment of raw film stock to the country, a policy initiated by Nelson Rockefeller's Office for the Coordination of Inter-American Affairs (CIAA) and its Motion Picture Division. At the same time, U.S. interests (including Rockefeller) began investing capital rapidly in Mexico instead. This tactic led to the decline of Argentina as the preeminent film producer to the continent and to the rise of Mexico as its market competitor. See Tim Barnard, "Popular Cinema and Populist Politics" in Barnard (ed.), *Argentine Cinema* (Toronto: Nightwood Editions, 1986), p. 32–39, and John King, "The Social and Cultural Context" in *The Gardens of Forking Paths: Argentine Cinema* (ed. John King and Nissa Torrents, The British Film Institute, 1987), pp. 1–15.

10. Long unseen and lacking any North American distribution, *Los inundados* was shown for the first time ever with English subtitles at the Toronto Festival of Festivals and Pacific Film Archive in 1986. A 16mm print was struck for the Latin American Visions series by the Neighborhood Film/Video Project, and will be distributed by the Museum of Modern Art Circulating Film Department after its initial tour.

11. Born in 1913, Matilde Landeta was unknown in the U.S. and long ignored in Mexico until "rediscovered" when she came to Havana to attend the women's symposium of 1986, bringing this film under her arm. For a full theoretical discussion of the film itself, as well as the history of its making and of Landeta's career, see: Carmen Huaco-Nuzum, "Matilde Landeta: An Introduction to the Work of A Pioneer Mexican Filmmaker," *Screen*, Volume 28 No. 4, Autumn 1987, p. 96–105. The unsubtitled film was shown for the first time in the U.S. in the "Corrective Cinema" series curated by Yvonne Rainer and Berenice Reynaud at the Collective for Living Cinema in 1988. Marcela Fernández Violante directed a film on Landeta's life for Mexican television in 1983, and subsequently published "Mexican Women Film Directors" in *Voices of Mexico*, No. 6, Dec. 1987–Feb, 1988 (Universidad Nacional Autónoma de México, México City).

12. See Jean Franco's *Plotting Women: Gender and Representation in Mexico* (New York, Columbia UP, 1989) for further discussion of Mexico in this period.

13. The film was completed by Tomás Gutiérrez Alea, who had been Gómez's mentor and has been the most dedicated champion of her memory and her example.

14. Nissa Torrents, "An Interview With Beatriz Guido" in *The Garden of Forking Paths*, op cit., p. 47.

15. Thanks to Joao Luis Vieira for this citation.

16. Personal interview with author, Toronto Festival of Festivals, September 1986.

17. For an in-depth analysis of both this film and the Coutinho film, see: Julianne Burton, "Transitional States: Creative Complicities with the Real" in *Man Marked to Die: Twenty Years Later* and *Patriamada*," *Studies in Latin American Popular Culture*, Volume 7, 1988, p. 139–155.

18. Personal interview with author, Toronto Festival of Festivals, September 1986.

19. Personal interview with author, Toronto Festival of Festivals, September 1986.

20. The film premiered at the International Festival of New Latin American Cinema in Havana, December 1989, where it received a jury prize; its U.S. premiere took place in spring 1990 at the San Francisco Film Festival.

21. Paul Leduc, "Dinosaurs and Lizards" in *Latin American Visions*, p. 59.

22. Statement in response to this paper, Bellagio, Italy, 1989, author's notes.

23. "The return of the conquistadors" is taken from comments to me by Helga Stephenson, director of the Toronto Festival of Festivals, as published in my article on the series in the *New York Times* in August, 1989.

24. The Venezuelan film, *Un domingo feliz (A Happy Sunday)*, was originally slated for direction by Fina Torres, who dropped out of the picture, reportedly after irreconcilable differences with García Márquez.

25. This threat is heightened by García Márquez's role as the presiding patriarch of the *Fundación*, which, with offices in Havana and Mexico City, has become the prime hope of Latin American filmmakers in search of production and co-production monies.

26. I'd argue that it's not just coincidence that makes *Milagro en Roma (Miracle in Rome)* the very best of the series. In part due to the extraordinary talent of director Lisandro Duque, its success may also be ascribed to its being the only Colombian production in the series and thus benefitting from a grounding in the specificity of García Márquez's own culture.

The New Latin American Cinema

A Modernist Critique of Modernity

Zuzana M. Pick

The ideological agenda of the New Latin American Cinema cannot be detached from historical discourses on regional identity through which the specificity of Latin American cultural practices has been defined. Its distinctive profile as a cinematographic movement is grounded in the idea of unity within diversity. The movement developed historically within the recognition of dialectic interactions between regional expressions, national projects, and continental ideals, thus linking its project to the idea of Latin America as a historical entity.

This idea of Latin America, in the words of José Luis Avellán, "expresses the consciousness of a cultural unity capable of extending itself to the rest of the continent."[1] Furthermore, as Angel Rama pointed out, this idea "is founded on persuasive arguments and supported by concrete and powerful unifying forces. Most reside in the past and have profoundly shaped the life of nations ranging from a common history to a common language and similar models of behavior. Others are contemporary, their minority status is compensated by significant promise: they react to universal economic and political impulses brought about by the expansion of the dominant civilizations of the planet."[2]

The idea of a continental identity emerged as a means of questioning the positivist utopias of progress that displaced the colonial legacy after Latin American countries consolidated themselves as modern

nation-states. This ontological search for distinctiveness was based on a sense of a shared destiny and a common identity. But, as Rama stated, "underneath unity, concrete as a project and real as the bases that sustain it, unfolds an internal diversity that defines the continent more precisely."[3] This diversity is made up of regional cultures that form, to quote Rama again, "a second Latin American map more accurate and concrete than the official."[4]

Latin Americans have assumed the history and envisioned the future of the continent in the layering of regional specificities (those inflected by locality) and through narrative negotiations of nation, class, race (of which the exclusion of native American and African populations cannot be overlooked), and gender. In this way Latin Americans have endowed themselves with a continental identity, "a grand historical narrative" that, as Gerald Martin writes, "is the continent's own dominant self-interpretation."[5] This continental identity has permitted Latin Americans "to move beyond the futile limitations of national identity in the direction of some humanistic continental culture as part of the global community of tomorrow."[6] By ascertaining the symbolic power of continental nationalism, this identity produces a sense of shared community that recognizes itself within interregional (and intraregional) variations, countering state-defined allegiances and differences.

Hence, this idea of Latin America is more than simply a myth or a utopia. It is a discursive formation whereby the history and imagination of the continent can be reclaimed. As a discourse, this idea operates both within the fleeting memories of the past and the material concreteness of the present. On the one hand, this idea has served to articulate regional autonomy and self-determination, countervailing the historical failure of countries to set up durable pan-Latin American political and economic organizations. On the other hand, the idea of Latin America is grounded in the desire of self-definition as well as the struggle for the control and autonomy of culture and identity.

This determination has as much to do with ideology as with the characteristic resilience of concepts of Latin American culture and identity. As Edward Said suggests, "Culture is used to designate not merely something to which one belongs but something that one possesses and, along with that proprietary process, culture also designates a boundary by which the concepts of what is extrinsic or intrinsic to the culture come into forceful play."[7] From this perspective, cultural historians in Latin America have consistently sought to discuss identity neither as an apparently obvious nor a transparent position of self-recognition.

If the idea of Latin America is a construct, an imaginative and evolving projection (not less imagined than the communities that are represented by it and represent themselves in it), it is "one possessing all the institutional force and affect of the real."[8] The search for means of representing national and continental realities, collective and individual identity, is the keyword that best characterizes the creative and political projects of Latin America. Nowhere is this search more explicit than in artistic practices, in visual arts, music, cinema, and literature.

Maybe a few examples are in order. The Uruguayan painter José Gamarra, as Oriana Baddeley and Valerie Fraser point out, "combines an ideal image of the tropical Latin American landscape with an acute awareness of the irony of the parallel history of conquest, colonization and exploitation."[9] Set within the luxurious jungle vegetation are tiny figures of people and objects, sometimes narrating an incident, like the beheading of a nun in *From the Series of Masked Aggressions* (1983), which refers to the rape and murder of American nuns by the Salvadorean army in 1980. In this painting, the tropical forest is invoked simultaneously as a mythical and an actual place, the site upon which Europe imagined the Americas and the place where Latin America's violent history is still being played out.

Another example of the powerful effect of the idea of Latin America can be found in Barroco (1989), a film by Paul Leduc that attempts a synthesis of what Gabriel García Márquez called the "outsized reality" of Latin America.[10] Based on *Concierto barroco* (1974), a novella by Alejo Carpentier in which the Cuban writer pays tribute to his lifelong passion for music, this formally ambitious and complex film celebrates the syncretism, the cultural cross-fertilization of the Old World and the New World. Juxtaposing high culture and popular art, indigenous, Afro-Caribbean, and European music, dance, and performance, the film explores the intertextual expressiveness of the Latin American imagination.

Moreover, the idiosyncratic distinctiveness of this construct (the idea of Latin America), in regard to more discrete formations like nations, is its composite character. The national becomes international, superseding—without overriding—individuation. To the extent that Latin America is imagined as a "Patria Grande," the mutual and interlocking awareness of diversity within a relative cultural homogeneity has (more often than not) been concurrently inflected by nationalism and internationalism. Promoted as a polemical objection to traditional nationalist or universalist ideologies, the idea has historically been a battlefield where national, regional, and continental identities are

contested and renamed. It has been continuously questioned and rede-fined.

Debates about national (or, for that matter, continental) identity have often revolved around the values defined either as authentic or derivative. This dichotomy has tended to obscure the conscious accep-tance of the ambivalent origins of identity, what Robert Stam calls the "ironic echo" of Latin American practices, and is suggestive of the fu-sion of European and Latin American modernism.[11] In other words, identity is both already available—in the form of historical traditions—and still to be achieved—in the form of a modernist break with the past. This de-centered, yet historical, notion of identity is reflective and self-reflective. It implies an awareness of a history determined by conquest and revolution, by dependence and autonomy.

The cultural consciousness of nations and regions, communities and classes, languages and representations has been forged against state-imposed hegemony and in resistance. As Carlos Fuentes sug-gests, "The complexity of the cultural struggles underlying our politi-cal and economic struggles has to do with unresolved tensions, sometimes as old as the conflict between pantheism and monotheism, or as recent as the conflict between tradition and modernity."[12] The idea of Latin America is obsessed concurrently with the past and the present, with narratives of injustice and protest. These narratives are essentially modern. They promote discourses aimed at locating, identi-fying, and engaging with concepts of progress and projects of moder-nization, either to commend or censure them.

To attach the idea of Latin America to modernity requires a clarifi-cation of what is meant by modernity. To this purpose, I favor seeing modernity in the terms suggested by the Mexican cultural critic Carlos Monsiváis. In his address to the prestigious Coloquio de Invierno held in Mexico City in 1992, Monsiváis remarked on the modernity (and liberating agency) of social and cultural projects motivated by criti-cism, free expression, and tolerance. Because, as he says, "in the de-bate of modernity, democracy is central to the renewal of the forms and contents of political and cultural life, and it may be, or not, a bar-rier against authoritarianism. . . ."[13] In other words, modernity is "an inevitable paradigm" that calls forth and contests visions of tradition and progress, and a site that "engenders a sense of the future, so irre-futable because it is so unstoppable."[14]

From this perspective, the distinctive effort of self-definition that characterizes the New Latin American Cinema can be seen as a con-scious attempt to assume the idea of Latin America as its ideological foundation. Moreover, the movement has articulated its continental project within a modernist contestation of tradition. At its inception in

the late 1960s, the movement broke with the national cinemas, such as those of Argentina and Mexico, that once dominated Spanish-language production. The manifestos and critical essays written by the filmmakers are polemical—even dogmatic—in their dismissal of what the filmmakers called the *old* cinemas of Latin America.

Through this conscious rupture with traditional cinemas, the New Latin American Cinema launched a project of cinematographic renewal that was defined from the outset as revolutionary and anti-imperialist. Through this agenda the movement asserted the creation of new expressive spaces and the rejection of traditional genres. The movement challenged the hegemony of North American and European models of cinematographic production and consumption. In this way, filmmakers advocated an oppositional and innovative cinema. As militants and artists, they saw themselves capable of transforming the existing structures of filmmaking. In the 1960s the movement's cultural politics converged (at least through its most militant practices) with left-wing insurrectional tactics that spread throughout Latin America after the Cuban Revolution. As I have written elsewhere, the films of the movement called for "direct political action: denouncing injustice, misery and exploitation, analyzing [their] causes and consequences, replacing humanism by violence."[15]

Concurrently, the movement addressed from the onset contextually specific and distinctive issues. Through discussions generated by filmmakers in different countries, the movement debated, as John King remarks, "the question of the appropriate filmic language for particular situations; the whole vexed question of what was a 'national reality'; the uneasy relationship between filmmakers (largely middle-class intellectuals) and the 'people' they hoped to represent; and the nature of popular culture."[16] In this manner, the movement furthered critical and reflective approaches to cultural production and representation. It sanctioned an aesthetic capable of rearticulating itself into the collective by breaking hierarchical modes of address. The films sought to assert new forms of dialogue and contest the master narratives of the status quo.

By bringing together filmmakers, the movement encouraged generational and regional solidarity. It also stimulated projects committed to an alternative modernism which, in Marshall Berman's words, "assert[s] the presence and the dignity of all the people who have been left out."[17] Although the anti-imperialist rhetoric and the cultural nationalism of the 1960s concealed the term *modernity* under the guises of Marxist theories of dependency and cultural resistance, the issue of modernity was not extraneous to the New Latin American Cinema.[18] Filmmakers problematized either through their films or their

writings what has been termed the "discourse of present-ness," a discourse that "takes into account its own presentness, in order to find its place, to pronounce its own meaning, and to specify the mode of action which it is capable of exercising within this present."[19]

This "discourse of present-ness" is crucial to many of the films of New Latin American Cinema. As filmmakers have sought to insert themselves into the social and political spheres, they consciously assumed their role as initiators of change. Through critical writings and manifestos, they proposed modes suitable to distinct forms of creative and political militancy. Their films served to make ideological positions explicit and to intervene ideologically in favor of social change through aesthetic strategies that link interactively the process of production and the moment of reception.

To the extent that a self-declared community of activist filmmakers assumed (through the works of its members) the role of an artistic and political vanguard, the project of the New Latin American Cinema suggests comparisons with groups whose agendas were defined in terms of cultural nationalism. Ambrosio Fornet, for instance, suggests that by the end of the 1960s, the New Latin American Cinema "has definitely acquired the orientation and the physiognomy which, without doubt, will filter through the history of Latin American culture as one of the most innovative and astonishing phenomena of this century. In fact, the only valid precedent could be found in the Mexican muralist movement: the same search for native roots, the same eagerness of decolonization, the same will to create a new language that would be, in the context of world painting, a contemporary language."[20]

This comparison should not be taken as a self-serving accolade, but rather as a critical projection aimed at reclaiming, through parallelisms, the historical legacy of cultural nationalism. Hence, it is useful to recall a statement by Diego Rivera, the most prominent of the Mexican muralists, who wrote: "I had the ambition to reflect the genuine essential expression of the land. I wanted my pictures to mirror the social life of Mexico as I saw it and through the reality and arrangement of the present, the masses were to be shown the possibilities of the future. I sought to be . . . a condenser of the striving and longing of the masses and a transmitter providing for the masses a synthesis of their wishes so as to serve them as an organizer of consciousness and aid their social organization."[21]

Similarly, Robert Stam and Ismail Xavier link the modernist-internationalist inflections of Brazilian tropicalist films, such as *Macunaíma* (Joaquim Pedro de Andrade, 1968) and *Red Light Bandit* (Rogerio Szangarela), to Oswald de Andrade's anticolonial metaphor

of "anthropophagy" defined in the 1920s. As Stam and Xavier write, tropicalist modernism "was a kind of artistic shock treatment designed to sabotage a falsely optimistic nationalism. The tropicalist allegory presented its diagnosis by mingling the native and the foreign, the folkloric and the industrial, the supermodern and the hyper-archaic, provoking the aesthetic prejudices of the middle class audience by foregrounding all that was incongruous and grotesque in Brazilian society."[22]

The cultural nationalism of the New Latin American Cinema signals an engagement not only with a contemporary anti-imperialist rhetoric but also with the history of movements which, in different countries, sought to radicalize cultural practices. It should not come as a surprise that practitioners of the New Latin American Cinema in the 1960s would reinstate the ideals of cultural nationalism that emerged in the 1920s, a period of intense social and political upheaval. Jean Franco's comments on Brazil are equally applicable to other Latin American countries. She has written that cultural life has been characterized by "the tension between the need for roots and the urge for modernity, between those who want to stress local or regional characteristics and those who want Brazil to be in the forefront of world culture."[23]

For instance, the notion of popular cinema developed by Latin American filmmakers (as an agent of change, requiring political choices and innovative aesthetic options to release popular creativity) reflects this tension between tradition and modernity. Not only has this popular (and reflective) cinema reconstructed the subversive power of popular traditions and historical memory, but deconstructed the representations and discourses that have limited the self-representation of Latin American peoples. Thus, the filmmakers of the New Latin American Cinema have reacted to—but not acquiesced to—hegemonic discourses on modernity. On the contrary, their radical project is characterized by the need to engage critically with the issue of modernity, either as an ideology of progress or an avant-garde aesthetic.

By operating within the dynamic dialectics of modernity, the movement has (like other cultural practices in Latin America) coalesced into formative impulses—what Rama called *impulsos modeladores*—grounded in the search for autonomy, originality, and representativity.[24] These formative impulses constitute precisely the basis upon which the New Latin American Cinema has periodically redefined its ideological and aesthetic project.

To assert the autonomy of cinematographic practices, the filmmakers associated with the movement have identified elements relevant to

changing cultural, social, and political conditions. They have drawn upon cinematographic concepts advanced in other historical contexts only to transform them, to make them more suitable to national and continental realities. On the influence of Italian neorealism, for instance, Fernando Birri has said, "Neo-realism was the cinema that discovered amidst the clothing and the rhetoric of development another Italy, the Italy of underdevelopment. It was a cinema of the humble and the offended which could be readily taken up by filmmakers all over what has since come to be called the third world."[25]

The New Latin American Cinema has also sought to authorize distinct conceptual frameworks through manifestos and critical essays written by its filmmakers. Julio García Espinosa's "For an Imperfect Cinema," for instance, has contributed to the originality of the movement's agenda. The impossibility of practicing art as an impartial activity and popular art conceived as a dynamically active entity have been revolutionary alternatives that "can supply an entirely new response [and] enable us to do away once and for all with elitist concepts and practices in art."[26]

Moreover, the representativity of the movement has been validated by the international and continental circulation of the ideas and films associated with the New Latin American Cinema. Although film historians, critics, and researchers in Latin America and elsewhere are beginning to take a serious look at the cinemas produced before the emergence of the movement, the movement prevails as a referential term of Latin American cinemas. As John King writes, it "show[s] that there is a network of formal and informal contacts that unites film-making practices across and within their national diversities."[27]

To confront the pervasive contradictions of political, social, and economic processes in Latin America, the movement reasserted the role of cinema as a critically interactive space of communication. Insofar as filmmakers began exploring the realities of their countries, as Michael Chanan points out, they discovered "a subjective world, made up of the oral culture that is called folklore, and the amalgam of religious and magical beliefs that are sustained by the misfortune and ignorance of underdevelopment."[28] Rather than forfeiting the militancy of the 1960s, filmmakers sought to remap the intricate dialectics of history and class struggle, memory and representation.

Consistently preoccupied with political agency and social process, and critical of the modernization tendencies of nation-states, the filmmakers of the New Latin American Cinema denounced a modernity based on self-confident promises of progress. Mostly in the 1960s, films stressed class struggle as the only possible way out of social injustice. To restore the subject into history, filmmakers systematically

addressed in their writings national identity through the pervading
usage of an all-encompassing notion of national reality. Yet the films
studied in this book [Pick, New Latin American Cinema] (in contrast
to the writings of Latin American filmmakers) problematize the era-
sure of regional, social, racial, and sexual differences implied by the
term *national reality* and privilege subjective and collective identities
as embattled sites of representation and discourse. In its project to
rearrange the terms that have served to construct national identities,
the films of the New Latin American Cinema expose the evolving,
rather than foundational, essence of the national. By the 1980s, for in-
stance, filmmakers addressing issues of gender and ethnicity have
questioned ahistorical presumptions and romantic celebrations of cul-
tural difference and have freed gender and ethnicity from their prob-
lematic appropriation in national allegories.

Once armed with a critical agenda, the movement was capable of
projecting its history into the future. Through a self-defined identity,
as a regional enterprise, the movement has been able to persist as a
valid political endeavor. Throughout the 1970s, for instance, the
movement weathered speculations about an impending collapse. As
Ana López points out, "The New Latin American Cinema, often
forced into exile or silenced by censorship and repression at a national
level, assumed an increasingly pan-Latin American character [see Ló-
pez essay in part 1 of this volume.]"[29] Moreover, institutional rear-
rangements and economic growth were promoting commercial trends
that affected national practices profoundly. But filmmakers also found
in new institutional arrangements the possibility of relocating initia-
tives, previously supported only by the movement, into national prac-
tices. Their initiatives energized rather than weakened the movement
and the New Cinema of Latin America integrated these national in-
flections into its supranational design.

The films of the 1970s opted for narrative and aesthetic strategies
(sometimes self-reflexive but always critical) capable of resolving the
anachronism of underdevelopment. Moreover, the movement sought
to expand its terms of reference and, rather than narrowing itself by
prescriptive definitions, set out to disengage its innovational goals
from the confining rhetoric of the militant 1960s. The term Third Cin-
ema, for instance, often used to describe the politics of Latin Ameri-
can cinemas, was rearticulated to reflect its original impulse as a
critically conscious and experimental agency of signification. In 1979
Fernando Ezequiel Solanas explained again that the Third Cinema
"is the way the world is conceptualized and not the genre nor the ex-
plicitly political character of a film. . . . Third Cinema is an open

category, unfinished, incomplete. It is a research category. It is a democratic, national, popular cinema."[30]

By the 1980s, the New Latin American Cinema identified much more closely with a modernist aesthetic. What Fernando Birri called the "nationalist, realist, critical, and popular" practices of the New Latin American Cinema in the early 1980s are "a poetics of the transformation of reality . . . [that] generates a creative energy which through cinema aspires to modify the reality upon which it is projected."[31] At the basis of this poetics is a critical impulse that can reinvent itself in and through the heterogeneous elements and contradictory discourses of a continent at once unitary and diverse.

The experience of exile, for instance, has been crucial to the production of a new political agency whereby community associations are relocated, cultural specificity is renegotiated, and cultural affiliations are reconstructed. Geographic and cultural displacement has fostered decentered views on identity and nationality, stressed the dialectics of historical and personal circumstance, and validated autobiography as a reflective site. If this aspect is most prominent in films produced in exile, it can also be found in other films of the New Cinema of Latin America which evidence a greater variety of approaches to the political.

While the movement's history provides a framework for understanding the ever-fluctuating situation of filmmaking practices, its conceptual agenda provides insights into the dialectics of representation and cultural politics in Latin America. As Julianne Burton has pointed out, "More than the determination to give expression to new forms and new contents, the most significant aspect of oppositional film movements in the Third World has been their fundamental commitment to transforming existing modes of film production, diffusion and reception."[32]

The movement has sought to integrate culture and politics, to construct instances in which cinematic practices intersect with social change. Therefore, the political and cultural agenda of the New Latin American Cinema has advocated grassroots forms of participation and supported film and video collectives that seek to channel the aspirations of social movements. The movement has contributed to increasing collaborative ventures between filmmakers from countries where the survival of nationally based initiatives has been threatened.

The movement's historical agency—its capacity of self-definition and self-regulation—is grounded in a political and aesthetic agenda (rather than the formal affinity of its national components). As a discursive formation and a cultural practice, the movement has accommodated ideological and contextual realignments. Therefore, it is

essential to understand that the movement's specificity resides in the convergence of nationally based practices, including the infrastructural changes affecting filmmakers and their practices, with a pan-continental project.

Insofar as the movement's unified sense of purpose has been capable of controlling the diversity of production strategies, a flexible (rather than a restrictive) approach is required to grasp the impact of infrastructural and organizational changes on the historical consciousness of the New Latin American Cinema. This approach allows an understanding of how the movement's continental orientation, through a process of self-definition, controls the eclecticism of its cinematographic practices.

But in reaction to the movement's singular process of self-definition, Latin American film historians and critics have tended to contest a perceived erasure of contextual considerations.[33] Notwithstanding my agreement with the basic premise of some of these criticisms, I would argue that the New Latin American Cinema emerges as a site of struggle between diverging, and sometimes contentious, processes of historical construction. Latin American identity has been shaped by cultural practices that have sanctioned or contested prevalent forms of representation and social organization. By authorizing different approaches to production, distribution, and exhibition, the movement has endorsed radical forms of filmmaking capable of revolutionizing existing social relations.

By adopting critical realism and advocating modernist aesthetic options, the films of the New Latin American Cinema have served to reinterpret and redefine the place of film, as a cultural and political practice, within the often contradictory, but always material, realities of the continent. In a sense the movement is representative of what Rodolfo Parada calls the *mestizaje definitivo* of Latin America. In other words, the movement originates from an awareness and a sense of belonging produced at that "moment in our history when we acquire the notion of our worth and in which we decide to follow our ambitions. When we decide not to be imitators and followers, we begin to see the world in relation to who we really are, in relation to the Americas, as Latin Americans."[34]

Paulo Emílio Salles Gomes described this process when he wrote about Brazilian cinema: "We are neither Europeans nor North Americans. Lacking an original culture, nothing is foreign to us because everything is. The painful construction of ourselves develops within the rarefied dialectic of not being and being someone else."[35] To the extent that this "not being and being someone else" reasserts the yet untold and multiple narratives of cultural identity and national

realities, it is the principle upon which Latin Americans have challenged fixed notions and imagined new utopias.

This principle conforms to "a sense of forever-not-yet being," as Bell Gale Chevigny suggests, "which may constitute an identity in itself."[36] Moreover, this principle implies critique and renewal and is profoundly attached to an unfinished experience of modernity whereby a yet-to-be-constructed modernity can be envisioned. As far as the New Latin American Cinema is concerned, this principle is exemplified in the movement's characteristic logic: its belief that its ideological project remains unfinished.

Notes

1. José Luis Abellán, *La idea de América: Origen y evolución* (Madrid: Ediciones Istmo, 1972), p. 21.

2. Angel Rama, *Transculturación narrativa en América Latina* (Mexico City: Siglo XXI Editores, 1985), p. 57.

3. Ibid.

4. Ibid., p. 58.

5. Gerald Martin, *Journeys through the Labyrinth* (London: Verso, 1989), p. 9.

6. Ibid., p. 359.

7. Edward W. Said, *The World, the Text, and the Critic* (Cambridge, Mass.: Harvard University Press, 1983), pp. 8–9.

8. Andrew Parker, Mary Russo, Doris Sommer, and Patricia Yarger, eds., *Nationalisms and Sexualities* (New York: Routledge, Chapman and Hall, 1992), pp. 11–12.

9. Oriana Baddeley and Valerie Fraser, *Drawing the Line: Art and Cultural Identity in Contemporary Latin America* (London: Verso, 1989), p. 24.

10. Gabriel García Márquez, "The Solitude of Latin America," in Doris Meyer, ed., *Lives on the Line: The Testimony of Contemporary Latin American Authors* (Berkeley: University of California Press, 1988) pp. 230–234.

11. Robert Stam, *Subversive Pleasures: Bakhtin, Cultural Criticism, and Film* (Baltimore: Johns Hopkins University Press, p. 123.

12. Carlos Fuentes, *Myself with Others* (New York: Noonday Press, 1990), p. 205.

13. Carlos Monsiváis, "Cultura: Tradición y modernidad," *La Jornada*, February 21, 1992.

14. Ibid.

15. Zuzana M. Pick, ed., *Latin American Film Makers and the Third World* (Ottawa: Carleton University, 1978), p. 2.

16. John King, *Magical Reels: A History of Cinema in Latin America* (London: Verso, 1990), p. 69.

17. Marshall Berman, *All That Is Solid Melts into Air: The Experience of Modernity* (New York: Peguin Books), p. 8.

18. The Latin American left (particularly the one represented by mono-lithic communist parties and Marxist-Leninist factions) refused modernity be-cause modernization was presumed and understood as synonymous with capitalism and exploitation. Nonetheless, leftist rhetoric in the 1960s locked into an interpretation of modernity which, according to Monsiváis ("Cultura: Tradición y modernidad," n.p.), went as follows: "The revolution was culture (in abstract or sectarian terms), tradition (significant because it generated in the people) and modernity, without that name, because a revolutionary be-came, at once, the vanguard of humanity."

19. Michel Foucault, quoted in Gregory Jusdanis, *Belated Modernity and Aesthetic Culture: Inventing National Literature* (Minneapolis: University of Minnesota Press, 1991), p. xv.

20. Ambrosio Fornet, *Cine, literatura, sociedad* (Havana: Editorial Letas Cubanas, 1982), p. 22.

21. Bertram D. Wolfe, *Diego Rivera: His Life and Times*, quoted in Jean Franco, *The Modern Culture of Latin America: Society and the Artist* (Har-mondsworth, England: Penguin Books, 1970), p. 89.

22. Robert Stam and Ismail Xavier, "Transformation of National Allegory: Brazilian Cinema from Dictatorship to Redemocratization," in Robert Sklar and Charles Musser, eds., Resisting Images: Essays on Cinema and History (Philadelphia: Temple University Press), p. 290.

23. Franco, *The Modern Culture of Latin America*, p. 293.

24. Rama, *Transculturación narrativa en América Latina*, p. 14.

25. Quoted in Michael Chanan, ed., *Twenty-Five Years of the New Latin American Cinema* (London: BFI/Channel Four, 1983), p. 2.

26. Julio García Espinosa, "For an Imperfect Cinema," trans. Julianne Burton, in Michael Channan, ed., *Twenty-Five Years of the New Latin Ameri-can Cinema* (London: BFI/Channel Four, 1983), p. 31.

27. King, *Magical Reels*, p. 76.

28. Chanan, ed., *Twenty-Five Years of the New Latin American Cinema*, p. 5.

29. Ana López, "An 'Other' History: The New Cinema of Latin Ameri-ca," in Robert Sklar and Charles Musser, eds., Resisting Images: Essays on Cinema and History (Philadelphia: Temple University Press), p. 325.

30. Quoted in Willemen, "The Third Cinema Question: Notes and Reflec-tions," *Framework*, no. 34, p. 9; translated from Solanas's "L'influence du troisième cinéma dans le monde," which appeared in *CinémAction* and in *Re-vue Tiers Monde* 20, no. 79 (July–September 1979): 622.

31. Fernando Birri, "For a Nationalist, Realist, Critical and Popular Cine-ma," *Screen* 26, nos. 3–4 (May–August 1985), p. 90.

32. Julianne Burton, "Marginal Cinemas and Mainstream Critical Theory, "*Screen* 26, nos. 3–4 (May–August 1985), p. 12.

33. During the 1987 conference on Latin American cinema, held at the University of Iowa, two prominent critics and historians—Isaac León Frias from Peru and Jorge Ayala Blanco from Mexico—explained the inappropria-teness of the term "New Cinema" to categorize the cinematographic practices

of Latin America. They recalled that the term had historically limited the criti-
cal approach to productions reflecting the ideological agenda of the early
manifestations of the movement.

34. Roberto Parada Lillo, "Identidad cultural y política," *Literatura chi-
lena: Creación y crítica* (Los Angeles, Madrid), 10, no. 1/35 (January–March
1986): 9–10.

35. Paulo Emílio Salles Gomes, "Cinema: A Trajectory within Underde-
velopment," in Randal Johnson and Robert Stam, eds., *Brazilian Cinema*
(Austin: University of Texas Press, 1988), p. 245.

36. Bell Gale Chevigny, "'Insatiable Unease': Melville and Carpentier
and the Search for an American Hermeneutic," in Gale Chevigny and Gari
Laguardia, eds., *Reinventing the Americas: Comparative Studies of Literature
of the United Sates and Spanish America* (New York: Cambridge University
Press, 1986), p. 36.

Select Bibliography

Adelman, Alan, ed. *A Guide to Cuban Cinema*. Pittsburgh: Center for Latin American Studies, 1981.

Agosta, Diana, and Patricia Keeton. "One Way or Another: The Havana Film Festival and Contemporary Cuban Film." *Afterimage* 22, no. 2 (1994): 7–8.

Alea, Tomás Gutiérrez. *Memories of Underdevelopment*. New Brunswick, NJ: Rutgers University Press, 1990.

———. *The Viewer's Dialectic*. Havana: Jose Marti Publishing House, 1988.

Armes, Roy. *Third World Film Making and the West*. Berkeley, CA: University of California Press, 1987.

Aufderheide, Pat. "Toronto Tiempo." *Film Comment* 22, no. 6 (1986): 45–49.

Barnard, Tim. "After the Military: Film in the Southern Cone Today." *Review: Latin American Literature and Arts*, no. 46 (1992): 29–36.

———, ed. *Argentine Cinema*. Toronto: Nightwood Editions, 1986.

Berg, Charles Ramírez. *Cinema of Solitude: A Critical Study of Mexican Film, 1967–1983*. Austin: University of Texas Press, 1992.

Bernardet, Jean Claude. "A New Actor: The State." *Framework*, no. 28 (1985): 4–19.

Bruce, Graham. "Music in Glauber Rocha's Films." *Jump Cut*, no. 22 (1980): 15–18.

Burns, E. Bradford, ed. *Latin American Cinema: Film and History*. Los Angeles: UCLA Latin American Center, 1975.

———. "National Identity in Argentine Films." *Americas* 27, nos. 11–12 (1975): 4–10.

Burton, Julianne. "The Camera as 'Gun': Two Decades of Culture and Resistance in Latin America." *Latin American Perspectives*, no. 16 (1978): 49–76.

———. "The Hour of the Embers: On the Current Situation of Latin American Cinema." *Film Quarterly* 30, no. 1 (1976): 33–44.

———. *The New Latin American Cinema: An Annotated Bibliography, 1960–1980*. New York: Smyrna Press, 1983.

———. "Revolutionary Cuban Cinema." *Jump Cut*, no. 19 (1978): 17–20.

———. "Sing, the Beloved Country: An Interview with Tizuka Yamasaki on *Patriamada*." *Film Quarterly* 41, no. 1 (1987): 2–9.

———, ed. *Cinema and Social Change in Latin America: Conversations with Filmmakers*. Austin: University of Texas Press, 1986.

———. *The Social Documentary in Latin America*. Pittsburgh, PA: University of Pittsburgh Press, 1990.

Burton, Julianne, and Zuzana Pick. "The Women Behind the Camera." *Heresies*, no. 16 (1983): 46–50.

Cabral, Amilcar. *Return to the Source*. New York: Monthly Review Press, 1973.

Chanan, Michael. *The Cuban Image: Cinema and Cultural Politics in Cuba*. London: British Film Institute and Bloomington, IN.: Indiana University Press, 1985.

———, ed. *Twenty-Five Years of the New Latin American Cinema*. London: British Film Institute, 1983.

———. ed. *Chilean Cinema*. London: British Film Institute, 1977.

"Cinema Novo vs. Cultural Colonialism: An Interview with Glauber Rocha." *Cineaste* 4, no. 1 (1970): 2–9.

Corman, Tanyan. "Nicaragua's Independents Organize: An Interview with Fernando Somarriba, Director of ANCI." *Release Print* 12, no. 6 (1989): 5–6, 15–16.

Crowdus, Gary and Irwin Silber. "Film in Chile: An Interview with Miguel Littin." *Cineaste* 4, no. 4 (1971): 4–9.

Csicsery, George. "Individual Solutions: An Interview with Hector Babenco." *Film Quarterly* 36, no. 1 (1982): 2–15.

Cyr, Helen W. *A Filmography of the Third World, 1976–1983*. Metuchen, NJ: Scarecrow Press, 1985.

Desnoes, Edmundo. "The Photographic Image of Underdevelopment." *Jump Cut*, no. 33 (1988): 69–81.

Downing, John D. H., ed. *Film and Politics in the Third World*. New York: Autonomedia, 1987.

Dratch, Howard, and Barbara Margolis. "Film and Revolution in Nicaragua: An Interview with INCINE Filmmakers." *Cineaste* 15, no. 3 (1987): 27–29.

Fanon, Frantz. *The Wretched of the Earth*. New York: Grove Press, 1964.

Foster, David William. *Contemporary Argentine Cinema*. Missouri: University of Missouri Press, 1992.

Fox, Elizabeth, ed. *Media and Politics in Latin America: The Struggle for Democracy*. London: Sage Publications, 1988.

Fusco, Coco. "Choosing between Legend and History: An Interview with Carlos Diegues." *Cineaste* 15, no. 1 (1986): 12–14.

_____. "The Tango of Esthetics & Politics: An Interview with Fernando Solanas." *Cineaste* 16, no 1–2 (1987/88): 57–59.

_____. "Things Fall Apart: An Interview with Sergio Bianchi." *Afterimage* (January 1990): 15–16.

_____, ed. *Reviewing Histories: Selections from New Latin American Cinema*. Buffalo, NY: Hallwalls, 1987.

Gabriel, Teshome. *Third Cinema in the Third World: The Aesthetics of Liberation*. Ann Arbor, MI: UMI Research Press, 1982.

_____. ed. "Cinema Novo and Beyond . . . A Discussion with Nelson Pereira dos Santos." *Emergences*, no. 2 (1990): 49–82.

Garcia Tsao, Leonardo. "Mexican Tinderbox." *Film Comment* 21, no. 3 (1985): 36–38.

Gauhar, Altaf. *Third World Affairs 1985*. London: Third World Foundation, 1985.

_____. *Third World Affairs 1988*. London: Third World Foundation, 1988.

Georgakas, Dan. "Breaking the Blockade: A Conversation with Cuban Filmmaker Tomás Alea." *Radical America* 20, no. 4 (1987): 35–44.

Goldman, Ilene S. "Behind Every Flower a Death: Love, Women and Flowers." *Jump Cut*, no. 38 (1993): 33–38.

Gupta, Udayan. "Neo-Realism in Boliva: An Interview with Antonio Equino." *Cineaste* 9, no. 2 (1978/79): 26–29, 59.

Hall, Stuart. "Cultural Identity and Cinematic Representation." *Framework* 36 (1989): 68–81.

Hershfield, Joanne. "Assimiliation and Identification in Nicholas Echeverria's *Cabeza de Vaca*." *Wide Angle* 16, no. 3 (1995): 6–24.

Huaco-Nuzum, Carmen. "Matilde Landeta: An Introduction to the Work of a Pioneer Mexican Film-Maker." *Screen* 28, no. 4 (1987): 96–105.

Johnson, Randal. *Cinema Novo x 5: Masters of Contemporary Brazilian Film*. Austin, TX: University of Texas Press, 1984.

_____. *The Film Industry in Brazil*. Pittsburg, PA: University of Pittsburgh Press, 1987.

Johnson, Randal, and Robert Stam, eds. *Brazilian Cinema*. East Brunswick, NJ: Associated University Presses, 1982.

King, John. *Magical Reels: A History of Cinema in Latin America*. New York: Verso, 1990.

King, John, Ana M. López, and Manuel Alvarado, eds. *Mediating Two Worlds: Cinematic Encounters in the Americas*. London: British Film Institute, 1993.

Kleinhans, Chuck. "Afro-Cuban Filmmaking Today: *The Other Francisco* and *One Way or Another.*" *The Pan-Africanist*, no. 9 (1982): 77–79.

Kotz, Liz. "Unofficial Stories: Documentaries by Latinas and Latin American Women." *The Independent* 12, no. 4 (1989): 21–27.

Kovacs, Katherine S. "Revolutionary Consciousness and Imperfect Cinematic Forms." *Humanities in Society* 4, no. 1 (1981): 101–112.

Levinson, Sandra. *Cuba: A View from Inside: Short Films by/about Cuban Women.* New York: Center for Cuban Studies, 1992.

Littín, Miguel. "Coming Home." *American Film* 11, no. 4 (1986): 43–45.

_____. "The Nova Republica and the Crisis in Brazilian Cinema." *Latin American Research Review* 24, no. 1 (1989): 124–139.

_____. "*Xica Da Silva*: Sex, Politics, and Culture." *Jump Cut*, no.22 (1980): 18–20.

López, Ana. "The Melodrama in Latin America." *Wide Angle* 7, no. 3 (1985): 5–13.

_____. "An 'Other' History: The New Latin Amerian Cinema." *Radical History Review*, no. 41 (1988): 93–116.

_____. "The 'Other' Island: Cuban Cinema in Exile." *Jump Cut*, no. 38 (1993): 51–59.

_____. "Through Brazilian Eyes: *America.*" *Wide Angle* 13, no. 2 (1991): 20–30.

López, Ana, and Nicholas Peter Humy. "Sergio Giral on Filmmaking in Cuba." *Black Film Review* 3, no. 1 (1986/87): 4–6.

Luhr, William, ed. *World Cinema Since 1945.* New York: Ungar, 1987.

MacBean, James Roy."A Dialogue with Tomás Gutiérrez Alea on the Dialectics of the Spectator in *Hasta Cierto Punto.*" *Film Quarterly* 38, no. 3 (1985): 22–29.

_____.*Film and Revolution.* Bloomington: IN: Indiana University Press, 1975.

_____. "La Hora de los Hornos." *Film Ouarterly* 24, no. 1 (1970): 31–37.

Machado, Arlindo. "Inside Out and Upside Down—Brazilian Video Groups: TVDO and Olhar Electronico." *The Independent* 14, no. 1 (1991): 30–33.

Mattelart, Armand. *Multinational Corporations and the Control of Culture: The Ideological Apparatuses of Imperialism.* Brighton: Harvester Press, 1982.

Mongil Echandi, Ines, and Luis Rosario Albert. "Films with a Purpose: A Puerto Rican Experiment in Social Films." *The Independent* (July 1987): 11–14.

Mora, Carl J. *Mexican Cinema: Reflections of a Society, 1896–1988.* Berkeley, CA: University of California Press, 1982; 1989.

Myerson, Michael, ed. *Memories of Underdevelopment: The Revolutionary Films of Cuba.* New York: Grossman, 1973.

Naficy, Hamid. *The Making of Exile Cultures: Iranian Television in Los Angeles.* Minneapolis: University of Minnesota Press, 1993.

Newman, Kathleen, ed. *Iris*, no. 13 (1991).

Noriega, Chon A., ed. "Border Crossings: Mexican and Chicano Cinema." *Spectator* 13, no. 1 (1992).

————. *Chicanos and Film: Representation and Resistance.* Minneapolis: University of Minnesota Press, 1992.

Noriega, Chon A., and Steven Ricci, eds. *The Mexican Cinema Project.* Austin, TX: University of Texas Press, 1994.

"Nuevo Cine Latinoamericano." *Arieto* 10, no. 37 (1984).

Okrent, Neil. "At Play in the Fields of the Lord." *Cineaste* 19, no. 1 (1992): 44–47.

Osiel, Mark. "Bye Bye Boredom: Brazilian Cinema Comes of Age." *Cineaste* 14, no. 1 (1985): 30–35.

Paranagua, Paulo Antonio. "Letter from Cuba to an Unfaithful Europe: The Political Position of the Cuban Cinema." *Framework*, no. 38/39 (1992): 5–26.

————. "News from Havana: A Restructuring of the Cuban Cinema." *Framework*, no. 35 (1988): 88–103.

————. "Pioneers: Women Film-makers in Latin America." *Framework*, no. 37 (1989): 129–137.

Pena, Richard. "Nelson Pereira dos Santos: Presentation and Interview." *Framework*, no. 29 (1985): 58–75.

Pick, Zuzana M. *The New Latin American Cinema: A Continental Project.* Austin, TX: University of Texas Press, 1993.

————. "The Politics of Modernity in Latin America: Memory, Nostalgia and Desire in *Barroco*." *CineAction*, no. 34 (1994): 41–50.

Pines, Jim, and Paul Willemen, eds. *Questions of Third Cinema.* London: British Film Institute, 1989.

Ramirez, John. "*El Brigadista*: Style and Politics in a Cuban Film." *Jump Cut*, no. 35 (1990): 37–49, 58.

Ranucci, Karen. *Directory of Film and Video Production Resources in Latin America and the Caribbean.* New York: FIVF, 1989.

Ranvaud, Don. "Interview with Fernando Solanas." *Framework*, no. 10 (1979): 35–38.

———. "Interview with Raul Ruiz." *Framework*, no. 10 (1979): 16–18, 27.

Resolutions of the Third World Film-Makers Meeting, Algiers, Dec. 5–14. New York: Cineaste, 1973.

Reyes Nevares, Beatriz. *The Mexican Cinema: Interviews with Thirteen Directors.* Albuquerque, NM.: University of New Mexico Press, 1976.

Rocha, Glauber. "History of Cinema Novo." *Framework*, no. 12 (1979): 19–27.

———. "Humberto Mauro and the Historical Position of Brazilian Cinema." *Framework*, no. 11 (1979): 5–8.

Sanjinés, Jorge. "We Invent a New Language Through Popular Culture." *Framework*, no. 10 (1979): 31–33.

Sanjinés, Jorge, and the Ukamau Group. *Theory & Practice of a Cinema with the People.* Willimantic, CT: Curbstone Press, 1979; 1989.

Sauvage, Pierre. "Cine Cubano." *Film Comment* 8, no. 1 (1972): 24–31.

Schnitman, Jorge A. *Film Industries in Latin America.* Norwood, NJ: Ablex Publishing Corporation, 1984.

Shohat, Ella, and Robert Stam. *Unthinking Eurocentrism: Multiculturalism and the Media.* New York: Routledge, 1994.

Solanas, Fernando. "Cinema as a Gun: An Interview with Fernando Solanos." *Cineaste* 3, no. 1 (1960): 18–26.

Solano, Claudio. "Brazilian Independents: Some Background Notes." *Framework*, no. 28 (1985): 125–143.

Stam, Robert. "*The Fall*: Formal Innovation and Radical Critique." *Jump Cut*, no. 22 (1980): 20–21.

———. "Hour of the Furnaces and the Two Avant-Gardes." *Millenium Film Journal*, no. 7/8/9 (1980–81): 151–164.

———. "Land in Anguish: Revolutionary Lessons." *Jump Cut*, nos. 10–11 (1976): 49–51.

———. "Samba, Condomble, Quilombo: Black Performance and Brazilian Cinema." *Journal of Ethnic Studies* 13, no. 3 (1985): 55–84.

———. "Sao Nelson." *Film Comment* 31, no. 1 (1995): 82–88.

———. "Slow Fade to Afro: The Black Presence in Brazilian Cinema." *Film Quarterly* 36, no. 2 (1982–83): 16–32.

Stam, Robert, and Louise Spence. "Colonialism, Racism, and Representation." *Screen* 24, no. 2 (1983): 2–20.

Stam, Robert, and Ismail Xavier. "Recent Brazilian Cinema: Allegory/Metacinema/Carnival." *Film Quarterly* 41, no. 3 (1988): 15–30.

Steven, Peter, ed. *Jump Cut: Hollywood, Politics and Counter-Cinema*. New York: Praeger, 1985.

Straubhaar, Joseph D. "Television and Video in the Transition from Military to Civilian Rule in Brazil." *Latin American Research Review* 24, no. 1 (1989): 140–154.

Taylor, Anna Marie. "*Lucia*." *Film Quarterly* 28, no. 2 (1974/75): 53–57.

Trevino, Jesus Salvador. "The New Mexican Cinema." *Film Quarterly* 32, no. 3 (1979).

Tunstall, Jeremy. *The Media Are American: Anglo-American Media in the World*. London: Constable, 1977.

Turner, Terence. "Visual Media, Cultural Politics and Anthropological Practice." *The Independent* 14, no. 1 (1991): 34–40.

Usabel, Gaizka S. de. *The High Noon of American Films in Latin America*. Ann Arbor, MI: UMI Research Press, 1982.

Vieira, Joao Luiz, and Robert Stam. "Parody & Marginality: The Case of Brazilian Cinema." *Framework*, no. 28 (1985): 20–49.

Weber, Devra. "Revolutionary Film in El Salvador Today." *Jump Cut*, no. 33 (1988): 92–99.

West, Dennis, and Joan M. West. "Alice in a Cuban Wonderland: An Interview with Daniel Diaz Torres." *Cineaste* 20, no. 1 (1993): 24–27.

_____. "Conversation with Marta Rodriguez." *Jump Cut*, no. 38 (1993): 39–44, 19.

_____. "Reconciling Entertainment and Thought: An Interview with Julio García Espinosa." *Cineaste* 16, no. 1–2 (1987/88): 20–26, 89.

_____. "Slavery and Cinema in Cuba: The Case of Gutiérrez Alea's *The Last Supper*." *The Western Journal of Black Studies* 3, no. 2 (1979): 128–133.

_____. "*Strawberry and Chocolate*, Ice Cream and Tolerance: Interviews with Tomás Gutiérrez Alea and Juan Carlos Tabio." *Cineaste* 21, nos. 1–2 (1995): 16–20.

Will, David. "Interview with Diego Risquez." *Framework*, nos. 26–27 (1985): 122–131.

Wilson, David. "Venceremos! Aspects of Latin American Political Cinema." *Sight and Sound* 41, no. 3 (1972): 127–131.

Woll, Allen L. *The Latin Image in American Film*. Los Angeles: UCLA Latin American Center, 1977.

Wood, Robin. "Notes for the Exploration of Hermosillo." *CineAction*, no. 5 (1986): 32–38.

Contributors

Tomás Gutiérrez Alea, recently deceased, was a Cuban film director and a founding member of the *Instituto Cubano de Arte e Industria Cinematográficos* (ICAIC). He directed numerous documentary and fiction films, among them *Esta tierra nuestra* (1959); *Historias de la Revolución* (1960); *Muerte al invasor* (1961); *La muerte de un buro-crata* (1966); *Memorias del subdesarrollo* (1968); *La ultima cena* (1976); *Hasta cierto punto* (1984); and most recently, *Strawberry and Chocolate* (1993). In 1988 he published a book of essays, *Dialectica del espectador*.

Fernando Birri is a painter, poet and filmmaker, and the founder of the Documentary Film School of Santa Fe in Argentina. Among his documentaries are *Tire dié* (1960); *La pampa gringa* (1963); *Los inundados* (1962); and *Org* (1978). In 1986 Birri was appointed director of the Escuela de Cine y Television in Cuba.

Julianne Burton is professor of literature at the University of California at Santa Cruz. She is a central protagonist in the development of English-language scholarship of Latin American film and in the promotion of Latin American cinema in the U.S. Her most recent publications include *The Social Documentary in Latin America* (1990) and *Cinema and Social Change in Latin America: Conversations with Filmmakers* (1986).

Michael Chanan is a filmmaker and writer. He co-directed *El Salvador—Portrait of a Liberated Zone* (1981) and directed the documentary *New Cinema of Latin America* (1983). His most recent publications include monographs on Chilean cinema and on Santiago Alvarez (BFI), and *The Cuban Image: Cinema and Cultural Politics in Cuba* (BFI).

Julio García Espinosa is a Cuban filmmaker, writer and founding member of ICAIC. He was named director of the Cuban Film Institute in 1981. Among his films are *El mégano* (1954); *Tercer mundo, tercera guerra mundial* (1968); and *Son o no son*.

Octavio Getino is the recipient of a Casa de las Americas literary award. He returned to Argentina after the restoration of democracy in

the mid-1980s and served as director of the National Film Institute between 1989 and 1990. He has authored several books on Argentine and Latin American film, most recently *Cine y dependencia* (Buenos Aires: Puntosur, 1990). He also co-directed (with Fernando Solanas) *La hora de los hornos.*

Ana M. López is an associate professor in the Department of Communication at Tulane University. She is co-editor (with John King and Manuel Alvarado) of *Mediating Two Worlds: Cinematic Encounters in the Americas* (BFI, 1993), and author of *The New Latin American Cinema: A Continental Project* (1993).

Michael T. Martin is a professor in the Department of Africana Studies and co-director of the African American Film Institute at Wayne State University. He is co-editor of *Studies of Development and Change in the Modern World* (1989), and editor of *Cinemas of the Black Diaspora: Diversity, Dependence and Oppositionality* (1995). He has also directed and co-produced (with Robert Shepard) the award-winning feature documentary on Nicaragua, *In the Absence of Peace* (1989).

Zuzana M. Pick is an associate professor of film studies at Carleton University. Among her publications are *Latin American Film Makers and the Third Cinema* (1978) and *The New Latin American Cinema: A Continental Project* (1993).

B. Ruby Rich served as director of the Electronic Media and Film Program of the New York State Council on the Arts. She is a visiting professor in film studies at the University of California, Berkeley. Her essays on Latin American cinema appear frequently in film and cultural studies journals.

Glauber Rocha was a founding member of Cinema Novo. His films include *Barravento* (1962); *Black God, White Devil* (1964); *Antônio Das Mortes* (1968); and *Claro!* (1976).

Jorge Sanjinés is a Bolivian film director. He has worked with the pioneering Bolivian film collective, Grupo Ukamau. Films he collaborated on include *The Blood of the Condor* (1969); *The Courage of the People* (1971); and *The Principal Enemy* (1974).

Antonio Skármeta is a writer and filmmaker living in Europe. He was cultural editor of the Chilean magazines *Ercilla, Ahora* and *La Quinta Rueda* between 1967 and 1973. He has written and/or directed such films as *La Victoria; Permiso de Residencia*; and *Si Vivieramos Juntos.*

Fernando Solanas is an Argentine filmmaker whose works include *La hora de los hornos* (co-directed with Octavio Getino, 1968); *The Look of Others*; and *Tangos: The Exile of Gardel* (1985).

Paul Willemen is a film scholar and author of *Looks and Friction: Essays in Cultural Studies and Film Theory* (1994); editor of *The Films of Amos Gitai* (1994); and co-editor (with Jim Pines) of *Questions of Third Cinema* (1989).

Index

Books in the Contemporary Film and Television Series

Cinema and History, by Marc Ferro, translated by Naomi Greene, 1988

Germany on Film: Theme and Content in the Cinema of the Federal Republic of Germany, by Hans Gunther Pflaum, translated by Richard C. Helt and Roland Richter, 1990 *Canadian Dreams and American Control: The Political Economy of the Canadian Film Industry*, by Manjunath Pendakur, 1990

Imitations of Life: A Reader on Film and Television Melodrama, edited by Marcia Landy, 1991

Bertolucci's 1900: A Narrative and Historical Analysis, by Robert Burgoyne, 1991

Hitchcock's Rereleased Films: From Rope to Vertigo, edited by Walter Raubicheck and Walter Srebnick, 1991

Star Texts: Image and Performance in Film and Television, edited by Jeremy G. Butler, 1991

Sex in the Head: Visions of Femininity and Film in D. H. Lawrence, by Linda Ruth Williams, 1993

Dreams of Chaos, Visions of Order: Understanding the American Avant-garde Cinema, by James Peterson, 1994

Full of Secrets: Critical Approaches to Twin Peaks, edited by David Lavery, 1994

The Radical Faces of Godard and Bertolucci, by Yosefa Loshitzky, 1995

The End: Narration and Closure in the Cinema, by Richard Neupert, 1995

German Cinema: Texts in Context, by Marc Silberman, 1995

Cinemas of the Black Diaspora: Diversity, Dependence, and Opposition, edited by Michael T. Martin, 1995

The Cinema of Wim Wenders: Image, Narrative, and the Postmodern Condition, edited by Roger Cook and Gerd Gemünden, 1996

New Latin American Cinema (2 vols.), edited by Michael T. Martin, 1997